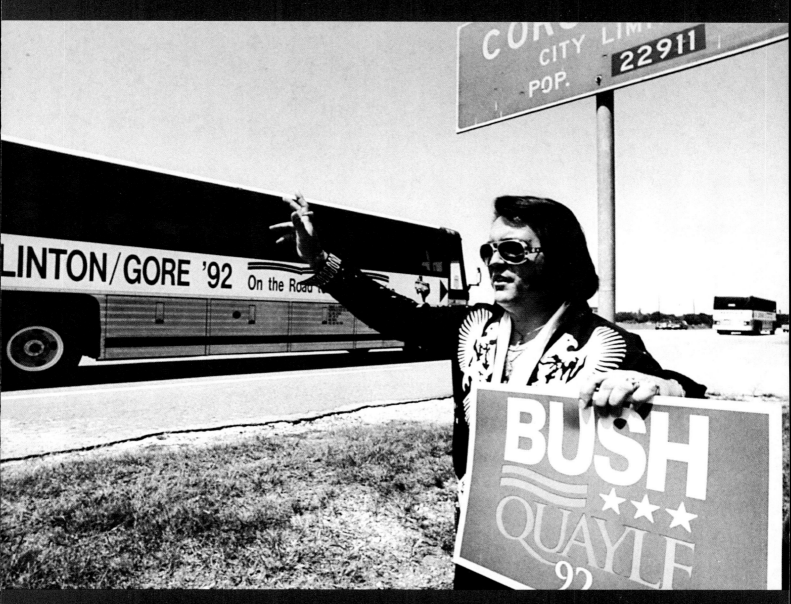

ON THE CAMPAIGN TRAIL

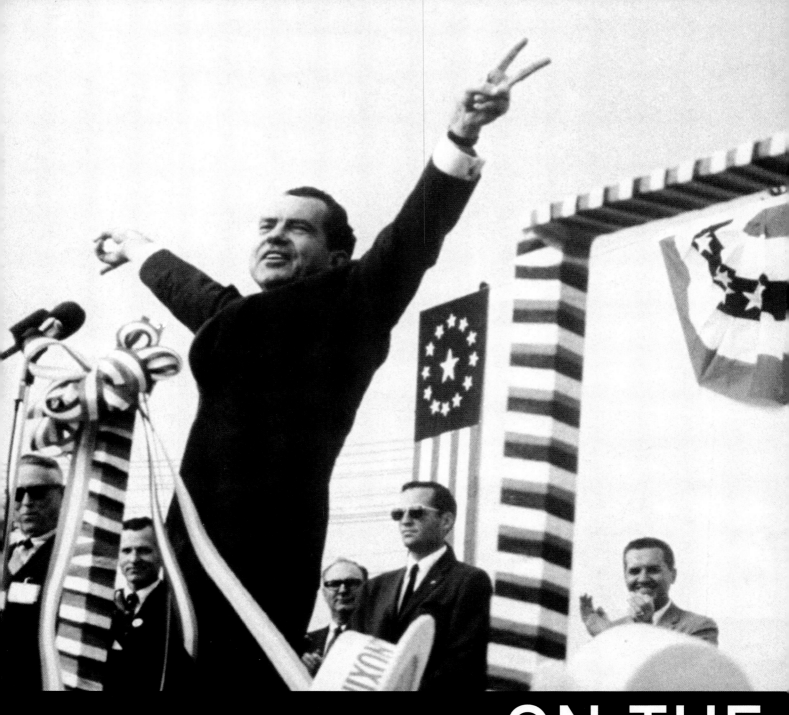

ON THE
THE LONG ROAD OF

CAMPAIGN TRAIL

PRESIDENTIAL POLITICS, 1860–2004

EDITED BY DOUGLAS E. SCHOEN

ReganBooks
Celebrating Ten Bestselling Years

HarperCollins books may be purchased
for education, business, or sales
promotional use. For information
please write:
Special Markets Department,
HarperCollins Publishers Inc.,
10 East 53rd Street, New York, NY 10022

FIRST EDITION

Art directed by Judith Regan
and Michelle Ishay
Design by Dopodomani

Printed on acid-free paper

LIBRARY OF CONGRESS
CATALOGING-IN-PUBLICATION DATA
HAS BEEN APPLIED FOR.

ISBN 0-06-075526-1 (hardcover)
ISBN 0-06-073482-5 (paperback)

04 05 06 07 08 QW 10 9 8 7 6 5 4 3 2 1
04 05 06 07 08 QW 10 9 8 7 6 5 4 3 2 1

CONTENTS

INTRODUCTION

What is it that makes American presidential elections so dramatic? Often it's the issues that capture our attention; sometimes it's the tactics or technology of campaigning. The candidates themselves can often be relied on to stir our emotions—with their charisma when they're lucky, with their missteps when they're not.

On a broader level, though, presidential campaigns are fascinating because they capture the ebb and flow of our history as a nation. The story of America's presidential elections is the story of America. Looking back through the years—through the lens of the four-year election cycle—we get a special insight into the defining moments of America's past; these snapshots of history that reveal the changing concerns, hopes, and beliefs of the American people.

Throughout America's 228 years, presidential campaigns and elections have offered American voters the ultimate arena for debating the great challenges of their times. From slavery to free silver, from the Great Depression to the Vietnam War, Americans have consistently used their vote to weigh in on the future course of their great democratic experiment.

Of course, not all elections are alike. Some years—1860, for instance, or 1932, 1968, or 1980—saw historic battles fought by seminal leaders. Others, such as the races of 1924, 1956, or 1984, were far less memorable. Yet every campaign has reflected the tenor of its times. In moments of prosperity, Americans have generally stayed the course and selected incumbent candidates or parties. In times of economic distress or great social or economic change, the occupants of the White House have been least secure.

Our chronicle of American presidential elections begins in 1860. Earlier campaigns were no less dramatic, but it was this race—which pitted Democrat Stephen A. Douglas (and two other candidates) against a new Republican leader named Abraham Lincoln—that saw the birth of the two-party system. For better or worse, Democrats have squared off against Republicans ever since.

The ideological differences dividing the two parties have hardly been minor. Frequently, they reflected profound rifts in the nation. At the dawn of the Civil War, pro-slavery forces clashed with abolitionists, who came to define the early Republican Party. Conversely, Southern Democrats were tagged as defenders of slavery—and the issue very nearly split the party in two. At the turn of the twentieth century Democrats were on the side of farmers and laborers, while Republicans were seen as the party of big business. By the late 1960s, FDR's New Deal coalition of urban ethnic voters, Catholics, union members, and African-Americans began to splinter; Republicans eagerly helped the process along by promoting middle-class values. In the 1960s, Democrats themselves were torn by the youthful counterculture and liberal interest groups that sought to influence the party. In recent times, the nation and the parties have been divided ever more sharply between the New Deal tradition—inspired by FDR and LBJ—of using government to address the nation's problems, and the conservative tradition—

invigorated by Ronald Reagan—which holds that government itself is the problem.

Over the past century and a half, the Republicans have generally carried the day in presidential elections. In the wake of the Civil War and the splintering of Democrats along regional and ideological lines, Republicans dominated the White House for much of the next half century. In the thirteen elections between 1860 and 1912, Grover Cleveland,

in 1884 and 1892, was the only Democrat to break the Grand Old Party's (GOP's) dominance. Indeed, since 1860, sixteen Republicans and only eight Democrats have won presidential elections.

The Republicans even won some of the elections they lost. In 1876, 1888, and 2000, Democrats garnered a majority of the popular vote, yet still lost the electoral college, and thus the White House.

The GOP may have a consistent record of winning presidential

contests, but contemporary readers may be surprised to realize that neither party has always been consistent in its defining philosophy. The Republicans are known today as the party of limited government—but throughout most of the ninteenth century, that banner was largely carried by the Democrats. In this era, it was the Democratic Party that fought for limited government and states' rights, while the Republicans sought to preserve the Union and abolish the scourge of slavery. In the Gilded Age, the heart of Republican economic policy was protectionism; the Democrats were free traders. The Republicans were the tax-and-spend party, while the Democrats worked to get government off the backs of the American people. Yet with Franklin Roosevelt's ascension to the presidency in 1932, the philosophies of the parties would be reversed, single-handedly changing the American political landscape.

In essence, Democrats and Republicans have done an about-face in their ideological moorings. How, then, does one explain the continued success of the GOP? Certainly the party's traditionally close relationship with business and industry has proved helpful. But the wisdom of Will Rogers may be equally relevant. "I'm a member of no organized party," he famously quipped. "I'm a Democrat."

The Democrats have indeed had a stormier history. Starting with Grover Cleveland, the party seemed to be heading in the direction of becoming the party of big business.

In 1896, though, the party began what would become a movement toward a more populist orientation when William Jennings Bryan became its presidential nominee. Bryan was a galvanizing candidate, but the party's populist bent would help to keep the Democrats out of the White House for sixteen years.

On the Republican side, the rise of Theodore Roosevelt helped foster a lasting split in the Republican coalition between conservatives and progressives. When TR jumped ship in 1912 to lead the newly formed Progressive Party—taking on his own Republican protégé, William Howard Taft, in the process—the days of the old Republican Party were over, and a new, more conservative party was born.

In many respects, the 1912 election laid the groundwork for the modern political system we know today. With the rejection of Theodore Roosevelt's Progressive agenda by the conservative wing of the Republican Party, and the Democrats' emergence as the major proponent of Progressivism, the die was cast; the resulting liberal/conservative party divide would shape American politics for most of the twentieth century.

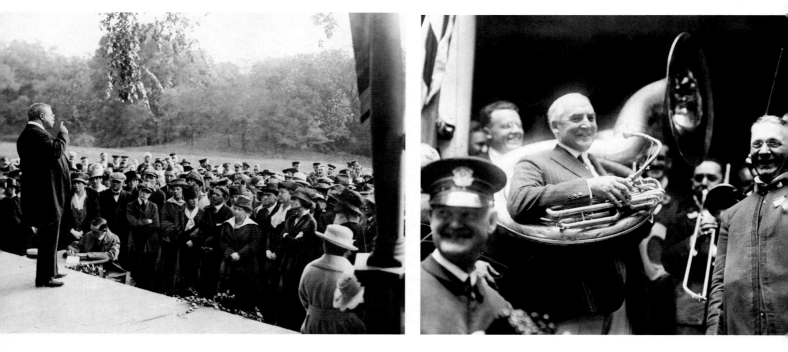

Election day in Times Square, 1919

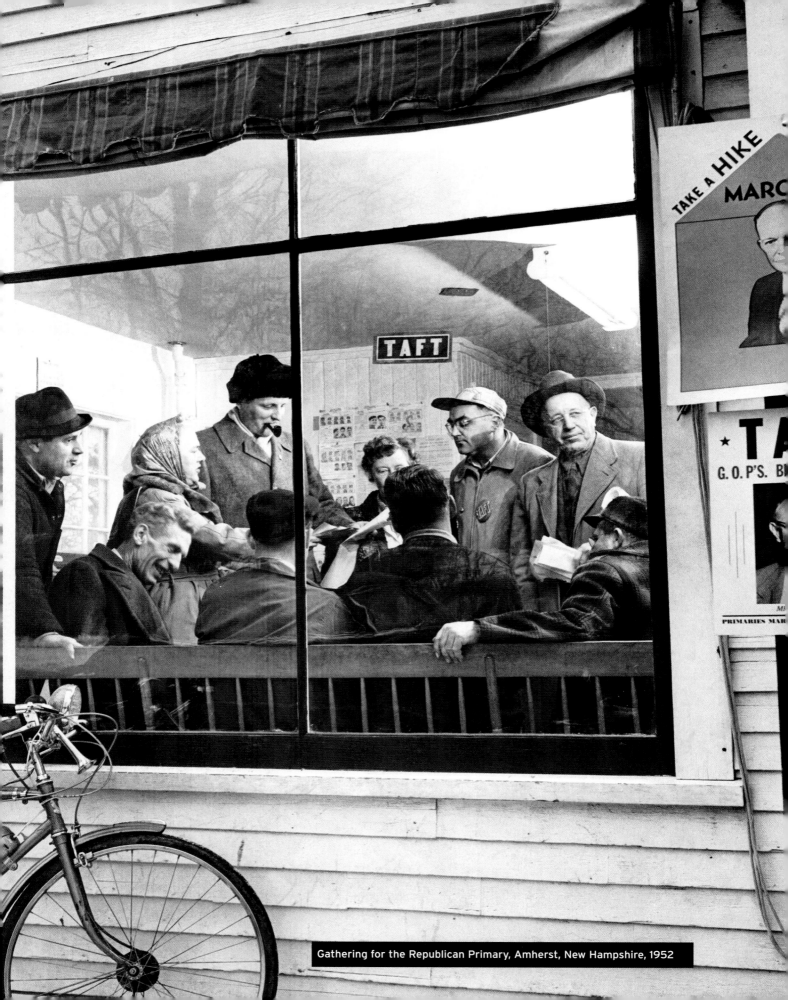

Gathering for the Republican Primary, Amherst, New Hampshire, 1952

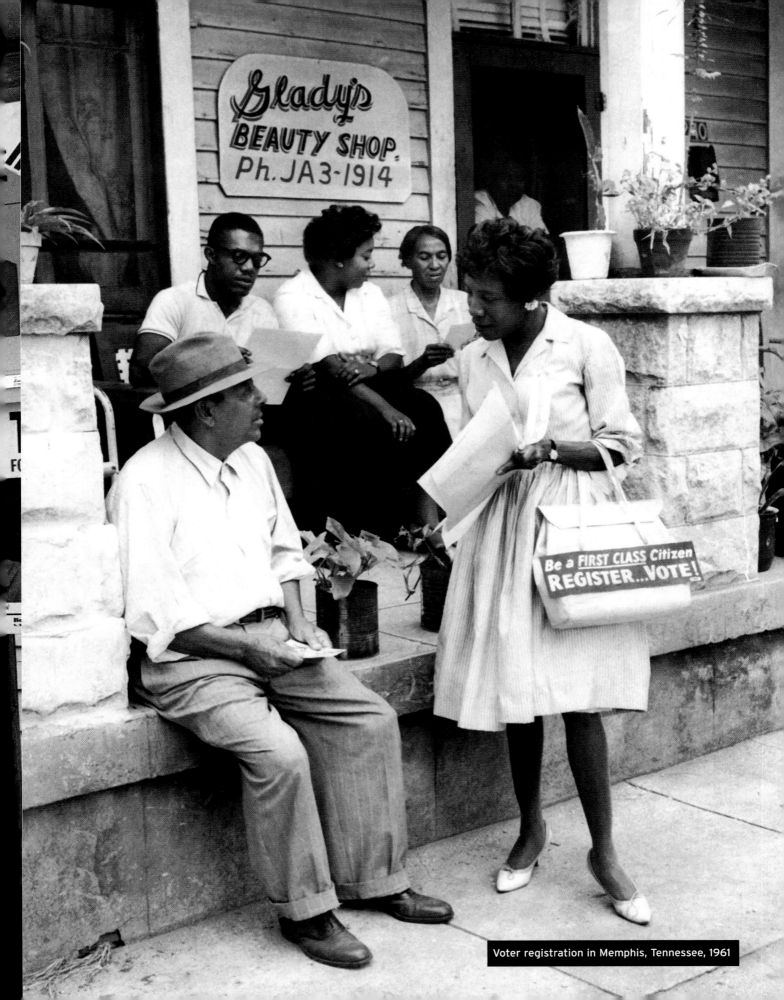

Voter registration in Memphis, Tennessee, 1961

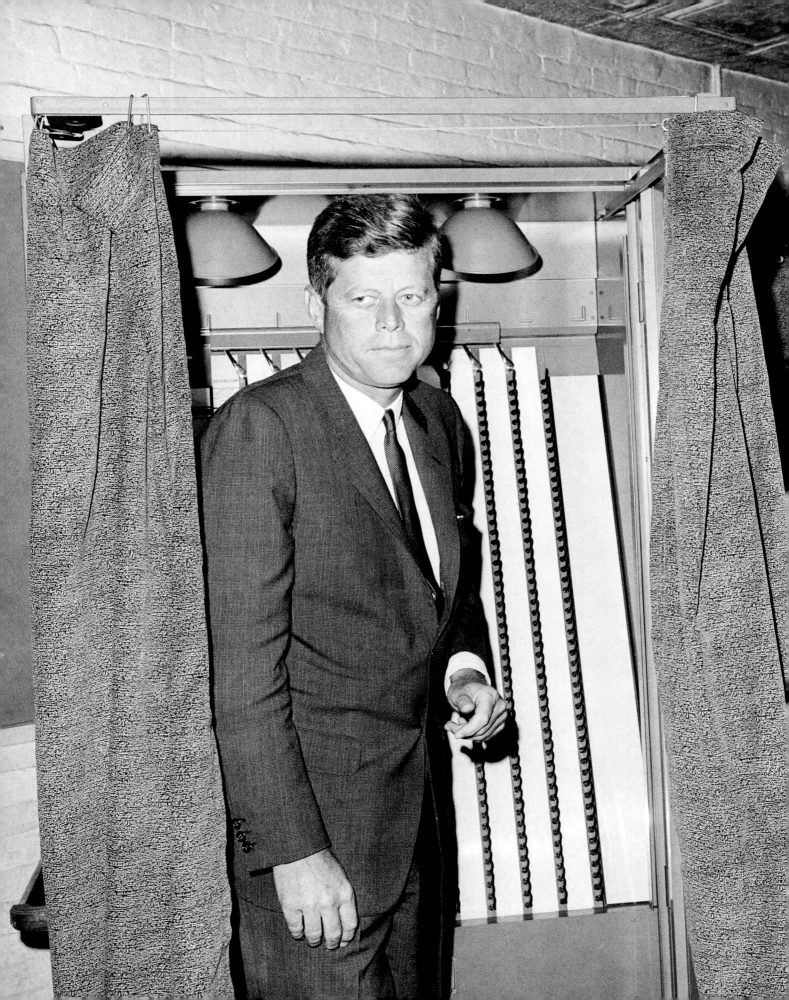

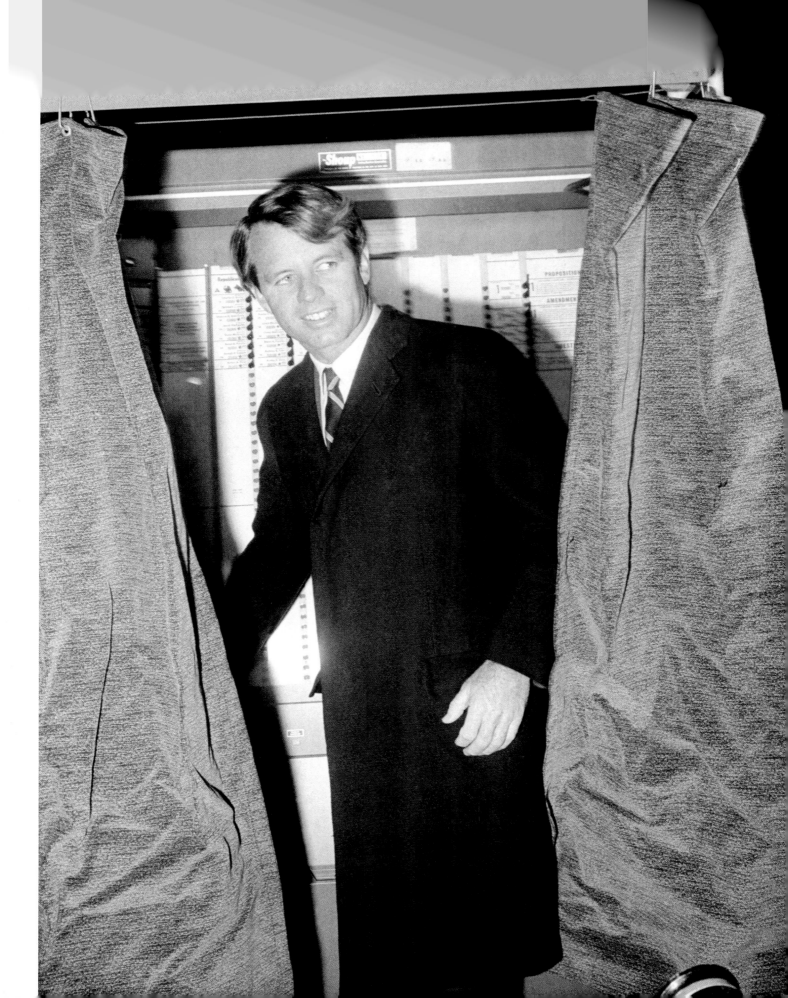

If one leader personified this profound split, it was America's most successful presidential candidate, Franklin Delano Roosevelt, who won the White House four times. Roosevelt's positions on the issues sharpened the party's clear divisions, as he crafted an ambitious government solution to the Great Depression, embraced deficit spending, and ultimately took an internationalist approach to foreign affairs, running counter to the often isolationist stance of his Republican predecessors.

The expansion of the role of government that began during the 1930s and '40s would become the decisive political issue of the second half of the century. This was manifest in 1964, when Lyndon Johnson launched his FDR-like plan for a "Great Society" and Barry Goldwater railed against "socialism" in American government, helping give birth to the modern, small-government conservative movement. The theme was articulated by Ronald Reagan in 1980 when he bemoaned the role of government in the lives of Americans. The idea of smaller government became so strong that by 1996 a Democratic president, Bill Clinton, declared in his State of the Union address that the "era of big government is over." In these critical moments, the two parties were fighting the same battles and facing the same question that accompanied the introduction of the New Deal in the 1930s: What role should government play in the lives of the American people? The election of 2004 is being played on much the same battlefield.

As party philosophies evolved, so did the techniques and technologies they used to reach out to American voters. In fact, over the past century and a half, presidential elections have mirrored America's great technological and social transformation. In the process, elections—like the nation itself—have become more open, more inclusive, and more democratic.

In the early days of the republic, state conventions selected their party's standard-bearers. Later, national conventions dominated, their frequently heated debates offering a forum for selecting presidential candidates. Today we take for granted the state primary process, but it wasn't until the second half of the twentieth century that rank-and-file primary voters were given the opportunity to affect their party's choice of nominees so directly and dramatically.

At first, too, only white, landowning men could vote. Over time, though, the right to franchise was expanded so that all Americans' voices would be heard. In 1870, the country's recently emancipated African-American slaves were granted the vote even though it took nearly a century to help guarantee that right. In 1920, all women received suffrage. In 1971, the voting age was reduced from twenty-one to eighteen. These advances changed the process of electioneering, challenging candidates to compete for every vote and reach out to a broader voting pool. Politicians faced new issues and an electorate more ethnically and culturally diverse than ever.

As new means of communication emerged, they also transformed the process of reaching voters across the country. In the mid-nineteenth century, artful campaign posters and jaunty campaign ditties were the primary tools of communication. With the campaign of 1924, the new technology of radio took center stage, bringing a chaotic Democratic convention into American living rooms for the first time. But even that new technology paled next to the birth of television as a tool of political campaigning in the 1950s. Over the past fifty years, the most essential skill for any politician has been the ability to come across well on TV. From Eisenhower's primitive ads in 1952 and Kennedy's charismatic performance in the first televised debates in 1960, to the slickly packaged "New Nixon" of 1968, Ronald Reagan's triumph as the "Great Communicator" in

1980, and the growth of talk show politics in 1992, television has become the single most vital campaign resource for Americans.

Of course, television has also helped usher the seamier side of American politics into our households—the all-pervasive attack ad comes to mind. But don't be fooled—there's always been an element of dirty politics in the campaign process. The hirsute and ungainly Abraham Lincoln was compared to an ape; the war hero Ulysses S. Grant was ridiculed for his reputed drinking. The charming slogan "Ma! Ma! Where's my Pa?" greeted Grover Cleveland when it was revealed that he had an illegitimate child. Al Smith was cruelly attacked for his Catholicism, and the great crusaders William Jennings Bryan and Franklin Delano Roosevelt were both pilloried mercilessly by their not-so-loyal opposition. President Lyndon Johnson used the image of a little girl and a mushroom cloud to paint Barry Goldwater as a trigger-happy extremist. By comparison, George Bush calling Bill Clinton and Al Gore "bozos" in the 1992 campaign seems relatively tame.

For all the dirty politicking on both sides—and despite a dip in voter turnout in recent years—Americans have always jumped at the opportunity to see their candidates up close. A century ago, hundreds of thousands of voters were actually willing to travel to the candidates' own homes. But for the most part, in the nineteenth century, many candidates didn't even bother to hit the hustings at all. Abraham Lincoln's opponent, Stephen Douglas, was ridiculed when he hit the campaign trial. President Ulysses S. Grant spent much of his reelection campaign for

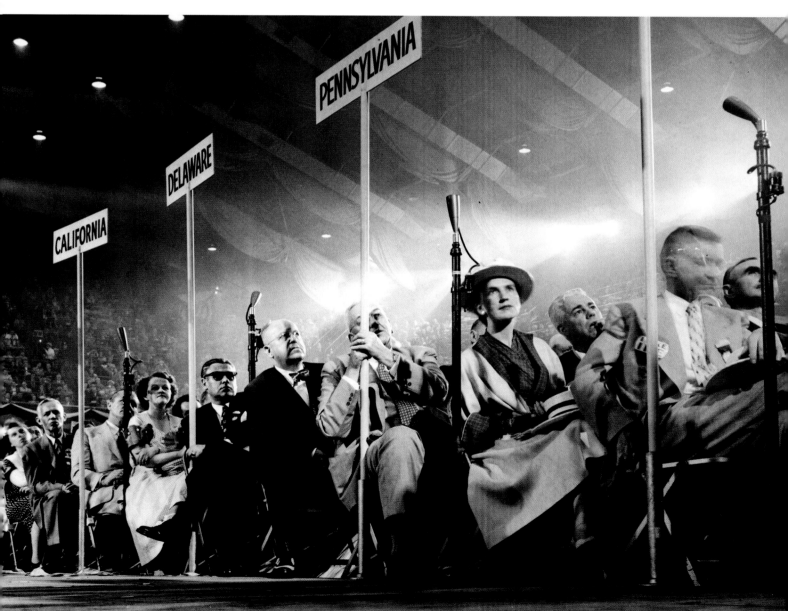

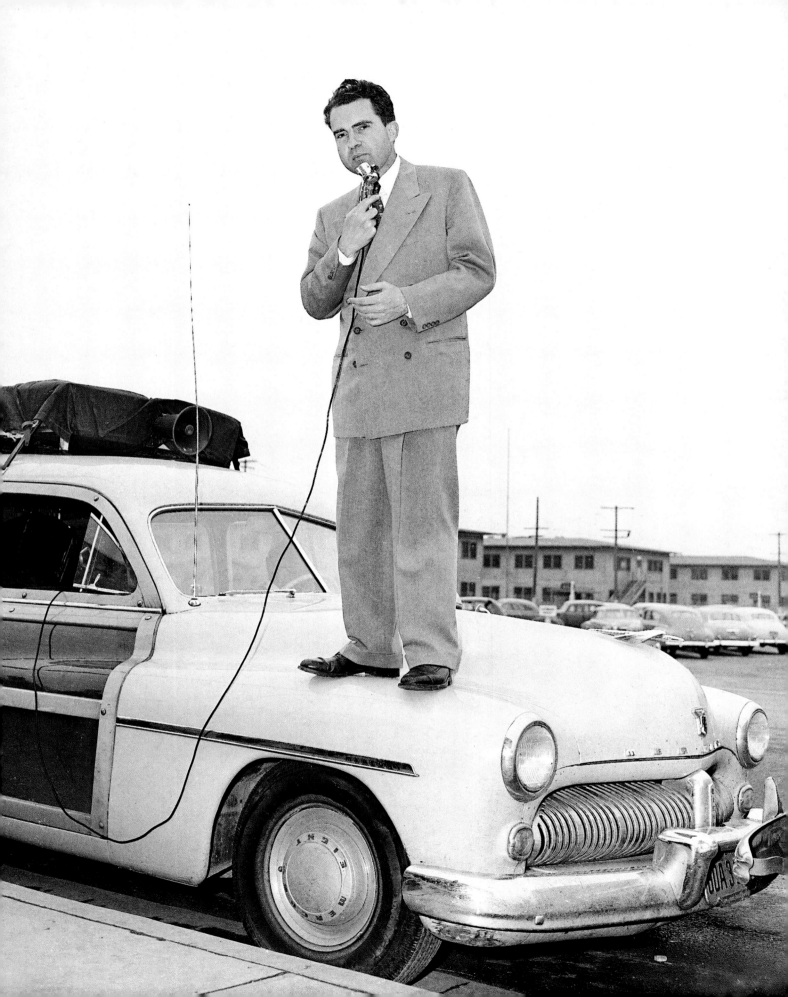

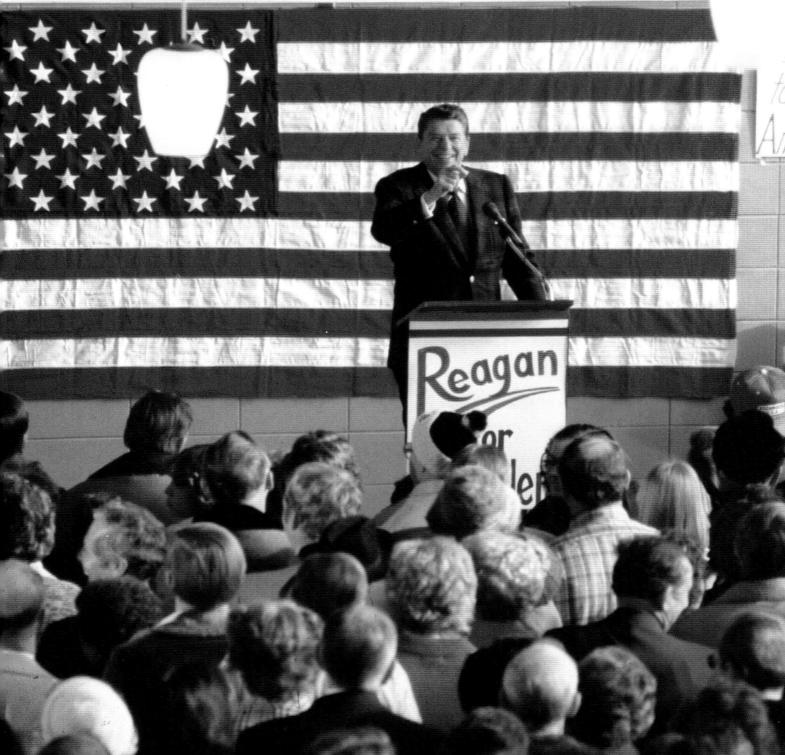

ABRAM LINCOLN.

For President

HANNIBAL HAMLIN.

For Vice President

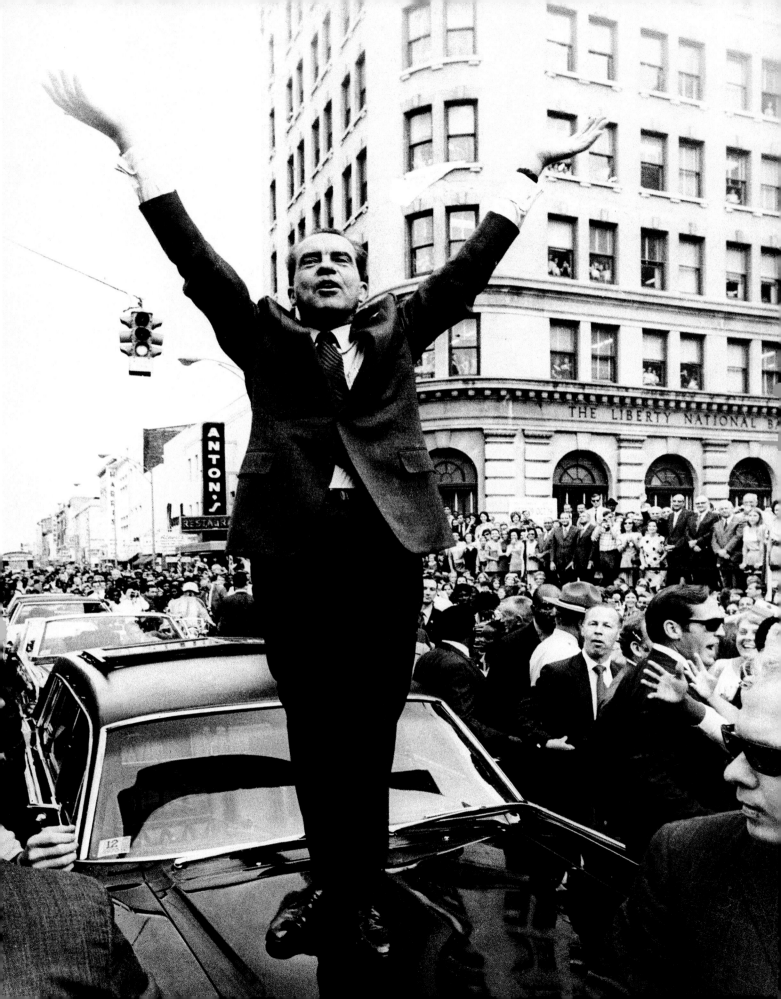

the presidency at the beach. Grover Cleveland rarely left home during his three runs for the White House. In fact, it wasn't until 1932 that a party nominee even showed up at his own convention. More often than not, surrogates and vice presidential picks were responsible for stirring the party faithful.

Today, it's taken for granted that presidential candidates will criss-cross the country, speaking to millions of voters in settings large and small. Where the candidates once spoke directly to the people—frequently from their front porches—now the people speak directly to the candidates at town hall–style meetings or through cable TV interview and call-in shows. Additionally, with the advent of public opinion research, political parties now have the opportunity to understand voters in

ways that would have been impossible a century ago.

With that insight, campaign managers have been able to adopt even more sophisticated approaches. Mailings, phone calls, even television and radio ads are all now specifically targeted to reach carefully chosen voting blocs. In earlier years, a "targeted" political ad campaign might have involved running TV ads in states with close races. Today, it means running specific ads, at specific times of day, during specific television programs to capture a particular group of voters. It also means using the Internet, which has emerged as a powerful tool for raising large amounts of money and organizing specific groups of voters, particularly young people.

But for all the changes in campaigning since 1860, the great drama and spectacle surrounding our national elections has re-

mained a constant. The images captured in *On the Campaign Trail* evoke powerful memories. Some are legendary, from the triumph of "Dewey Defeats Truman," to the tumultuous Chicago riots of 1968 and the Florida showdown of 2000. Others are more mundane, but equally evocative: the cheering crowds, the pageantry of the national convention, the whistle-stop tours, the babies being kissed, the staged shots and candid photos. It's all here, along with America's most memorable leaders: Teddy Roosevelt, Woodrow Wilson, FDR, Ike, JFK, Richard Nixon, Ronald Reagan, and Bill Clinton. Together, these photos embody not only the drama of their times, but also the great arc of American history and the resilience of our democracy.

Though bumpy at times, it's been a memorable ride. ❏

ON THE CAMPAIGN TRAIL

1860 –

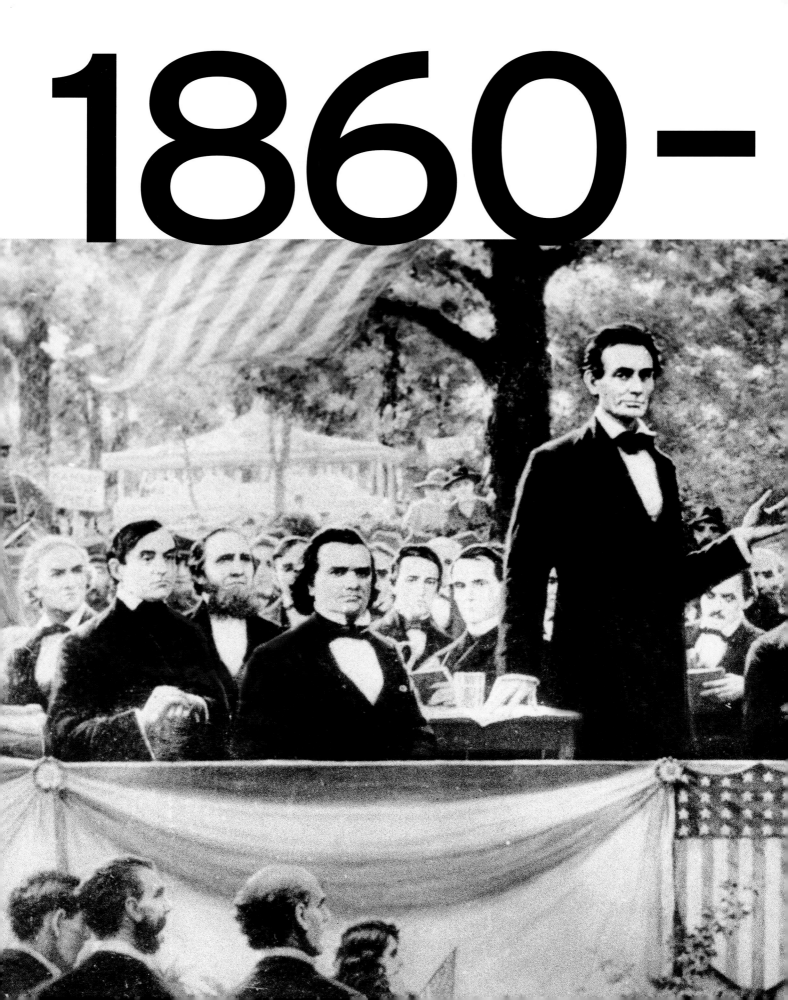

1892

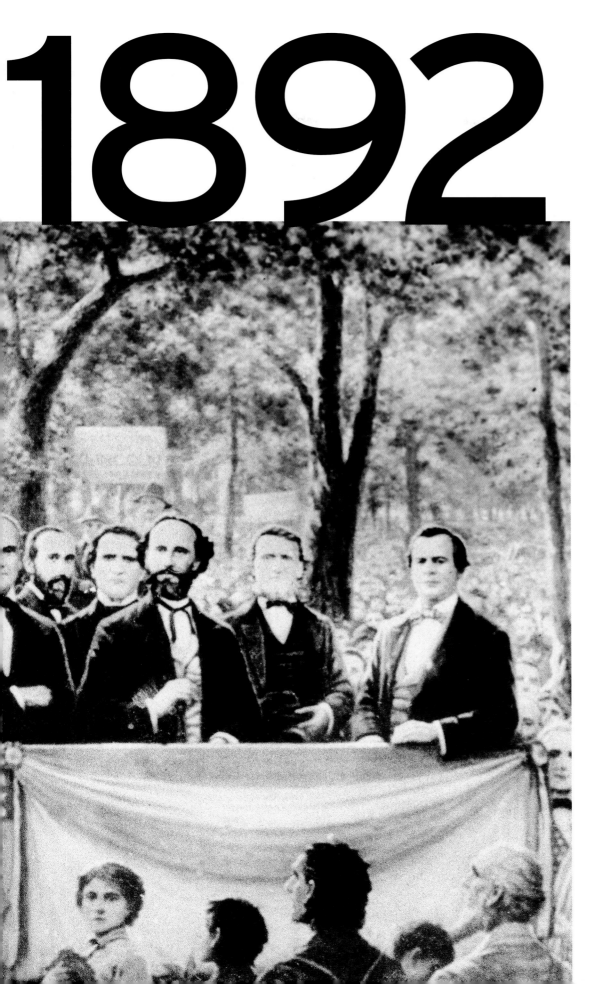

This rare "photograph" of Abraham Lincoln speaking in his hometown of Springfield, Illinois, is actually an early photo-composite.

Waving the Bloody Shirt

The second half of the nineteenth century was marked by some of the most contentious, partisan, and narrowly contested elections in American political history. Twice the winner of the popular vote lost to the electoral college victor. Elections were often decided by the slimmest of margins. Partisanship was high, campaign attacks often vicious. And for the Republicans—the "victorious party" in the Civil War—it was a fruitful and dominant era.

Running for president in nineteenth-century America was nothing like what we know today. Indeed, presidential candidates rarely ventured out on the campaign trail. Abraham Lincoln spent the entire 1860 race at his home in Springfield, Illinois, leaving his opponent, Stephen Douglas, to be ridiculed when he ventured out on the hustings to meet the people. It was considered unseemly for a presidential candidate to debase himself by actively seeking votes; candidates were content to send party surrogates out to stump on their behalf. With party identification at its strongest point ever, independent voters were rare and split-ticket voting was almost unheard of.

While Americans took their elections quite seriously, it didn't mean they weren't willing to have some fun. Political campaigns often took on a carnival-like atmosphere, with rallies, barbecues, torchlight parades, and fireworks as whole communities would gather to hear the speakers' long, sermon-like patriotic addresses. As time went on, the political parties became more ambitious in their campaigning, sending out handbills, pamphlets, and campaign manuals celebrating their party platforms, the lives of their candidates, and the texts of their most famous speeches. The print media—then highly partisan—often helped the candidates as well.

The period also marked the birth of America's modern two-party system. While the Democrats had been around since the early days of the nation, the Republican Party came to the political stage in 1854 during the crucible of America's divisive national debate over the issue of slavery. Born of a movement to stop the slow creep of slavery into new continental territories, the Republican Party was dedicated to ending this "peculiar institution." Though deeply split, Democrats worked to prevent the federal government from infringing on the right of Southern states to maintain their slave population.

Though the Democratic Party dominated electoral politics in the run-up to the Civil War, the long-standing divide between its Southern base and Northern bloc would prove to be the party's undoing. In the seminal election of **1860,** the party had two different candidates—Stephen Douglas ran as a Northern Democrat and John Breckinridge ran as a Southern Democrat—smoothing the way for the election of the nation's first Republican president, Abraham Lincoln.

The victory of Lincoln brought the slavery issue to a head as the Republican standard-bearer didn't receive a single vote in ten Southern states. The nation was plunged into a bloody Civil War as Lincoln took office. Though after his death Lincoln would become a saintly figure in the presidential pantheon, during his lifetime he was subject to the kind of virulent personal attacks rarely seen before or since in American politics. In the run-up to the election of **1864**—with things going poorly on the battlefield—many Republicans wanted Lincoln removed from the ticket. Democrats hurled their own venom, attacking Lincoln for his support of abolition and dubbing him "Abraham Africanus the First." But a late turn of military fortune in the autumn of 1864, capped by Sherman's burning of Atlanta, turned the tide for Lincoln, who was handily reelected.

The Union's eventual victory in 1865 would help to ensure the Republican Party's dominance in the years after the Civil War. The Grand Old Party (GOP) never ceased to "wave the bloody shirt," reminding Americans of how "Democratic treason" had plunged the nation into war. It was a powerful and effective attack, and one that stymied Democrats, particularly in the North, for many years. Just as many Southerners would have sooner voted for a "yellow dog" than a Republican, the same was true of many Northerners when it came to voting for Democrats.

Of course, it was more than just slavery that split the two parties. Today's political observers would be astonished at how thoroughly nineteenth-century Democrats were associated with limited government and states' rights, whereas Republicans were more likely to turn to the resources of government to solve the nation's problems. Americans generally sided with the Democrats on the issues, yet it rarely seemed to translate into electoral victory.

During the second half of the century, the number one issue on the minds of many Americans was that of protectionism. In the days before income tax, tariffs on foreign goods were one of the key revenue sources for the nation's coffers—and the issue divided the two parties. Republicans made support for the tariff the centerpiece of their economic platform. Democrats, hoping to prevent government expansion, opposed it, supporting a muscular free-trade agenda. From 1884 to 1892 the question of tariffs featured in nearly every presidential contest. Only decades later would the two parties reverse themselves, with the Democrats becoming the party of protection, and the Republicans the free traders.

The deep economic and political divide in the country also made for presidential races that were both exceptionally partisan and extraordinarily personal. In **1868,** the Civil War hero Ulysses S. Grant was labeled "Grant the Drunkard" by his Democratic opponents. One campaign song included the lines "I am Captain Grant of the Black Marines, the stupidest man that ever was seen." In the end, though, support from freed Southern slaves carried Grant to a narrow win. By **1872** the attacks were even harsher; now Grant was not merely a drunk, but crooked for good measure (and good reason, considering the rampant corruption during his first term in office).

Yet even those words paled next to the barbs suffered by Grant's opponent, newspaper editor Horace Greeley. Generally considered one of the stranger nominees in American political history, Greeley was disparaged mercilessly for his views on major issues (many of which ran counter to the Democratic platform). His unusual and active campaigning did little to help his effort; whenever he opened his mouth, Greeley seemed to do more damage to his candidacy. His vice presidential nominee, Gratz Brown, wasn't much help either, giving one of the more embarrassing political speeches during an appearance at Yale University. Clearly drunk, Brown marveled at the oversized head of his running mate, and derided Yale as an effete, Eastern school. Greeley later remarked that "I hardly knew whether I was running for the presidency or the penitentiary." It turned out he was running himself into the grave; Greeley died only a few weeks after being soundly defeated by Grant.

In **1876** the attacks were no less vicious, as Republicans played the patriotism card against the Democratic nominee, Samuel Tilden. One Republican speaker reminded Union soldiers that "every scar you have on your heroic bodies was given to you by a Democrat." Tilden was attacked as a traitor and tax cheat. The Republican standard-bearer, Rutherford B. Hayes, was even accused of shooting his own mother. The race would rank among the closest and most contested in American history: Tilden won the popular vote, but the electoral vote was unclear, as four states (including Florida) remained in dispute; the debate raged on for months. Though Tilden almost certainly should have won, the Republicans offered a deal the Democrats could hardly refuse: In return for installing Hayes in the White House, they agreed to bring an end to Reconstruction and the occupation of the South by federal troops.

The **1880** election was more listless than scurrilous, with Republican James Garfield winning a narrow victory over Civil War hero Winfield Scott Hancock. Republicans did, however, put out a cam-paign pamphlet detailing the political achievements of Hancock—it was filled with blank pages. The real fireworks came in **1884,** in a race that pitted the GOP's James Blaine against New York governor Grover Cleveland. It was very possibly the nastiest race in American history. The campaign slogans of the two parties tell much of the story: The Democrats derided their opponent as "Blaine, Blaine, the Continental Liar from the State of Maine," while the Republicans chided Cleveland—alleged to have fathered an illegitimate child—with their own vicious rhymes. Cleveland quickly came forward and admitted that the allegations were true, and his candor helped prevent the charges from seriously harming his campaign.

In fact, it was Blaine whose campaign was felled by miscues. Days before the election, at a meeting of Protestant ministers in New York, Blaine sat silently as a speaker intoned against the Democratic legacy of "Rum, Romanism and rebellion." The bigoted attack on Irish Catholics doomed Blaine's chances; he lost the election by less than 25,000 votes.

In **1888,** Republican Benjamin Harrison bested incumbent Grover Cleveland, largely through his effective attacks on the Democrats' free-trade stance. Yet the election also turned on a dirty trick—the so-called Murchison Letter. The phony letter, addressed from the British Ambassador to a fictional "Charles Murchison," pledged Britain's support for Cleveland, turning the growing Irish-American population against him. Like Hayes twelve years earlier, Harrison won the electoral college, yet lost the popular vote. He was certainly helped by the fact that Cleveland not only refused to campaign, but even forbid his cabinet from hitting the trail.

The candidates' rematch in **1892** race saw a reversal of fortune. This time Harrison barely campaigned, while the better-organized Democratic Party bought newspaper space and detailed pamphlets promoting Cleveland—ushering in a new era of sophistication in presidential advertising. The underfunded Republicans were no match for the Democrats, and Cleveland won a large victory, making him the first (and still only) American president to return to the White House for a non-consecutive second term.

By the early 1890s, then, the Democrats seemed to be in ascendancy. But the Panic of 1893, which resulted in a national economic downturn, would turn the tables and breathe new life into Republican hopes. The stage was set for the seminal **1896** election, and the dawn of a new political moment: Progressivism. ❏

It appears to me very singular that we three should strike "foal" and be "put out" while old Abe made such a "good lick". —

That's bee that confo strike with fusion wor stop" to his

UNION CLUB

FUSION.

ITTLE GIA

A cartoon captures the four candidates in the 1860 race: Northern Democrat Stephen Douglas, Southern Democrat John Breckinridge, Republican Abraham Lincoln, and the Constitutional Union Party nominee, John Bell.

THE NATIONAL

Music publishers were keen to cash in on the popularity of candidates like
Stephen Douglas—though not always so proficient at spelling their names.

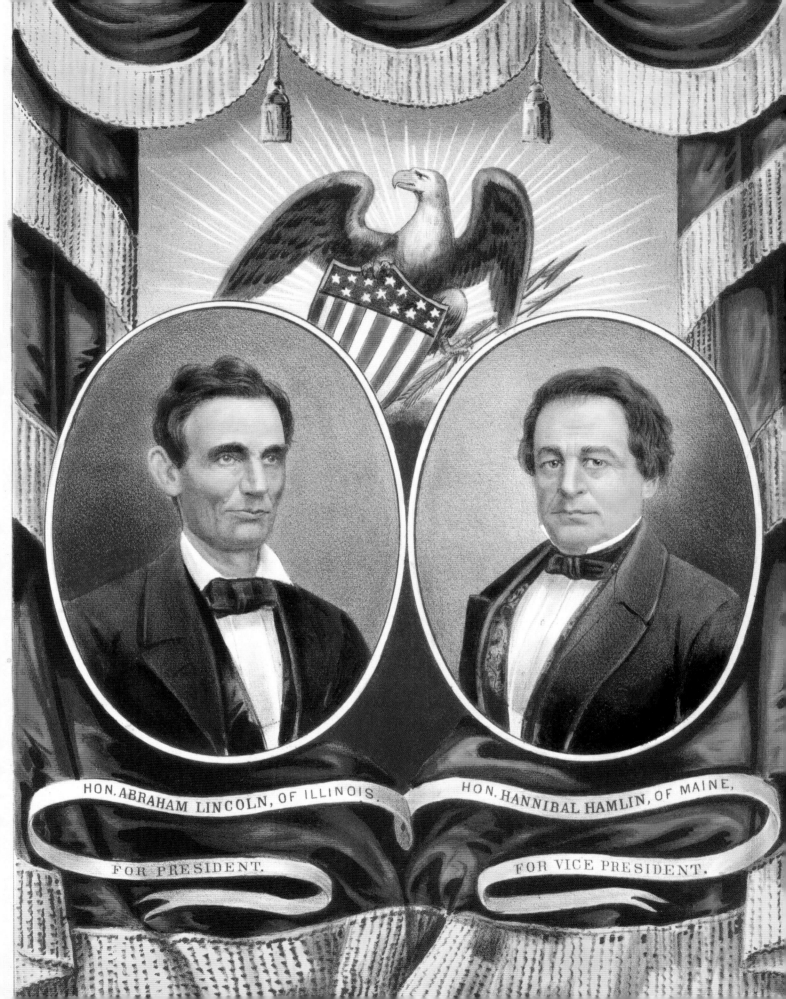

HON. ABRAHAM LINCOLN, OF ILLINOIS,

FOR PRESIDENT.

HON. HANNIBAL HAMLIN, OF MAINE,

FOR VICE PRESIDENT.

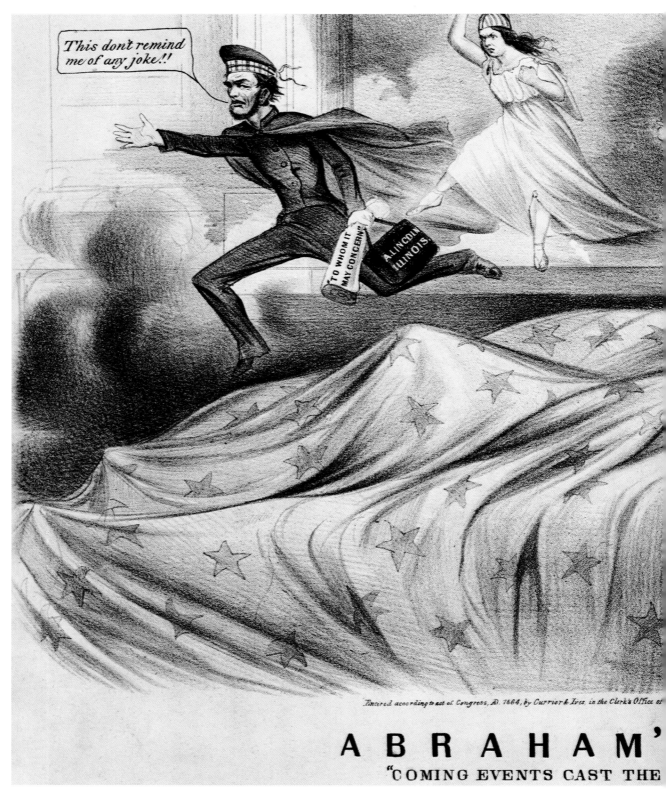

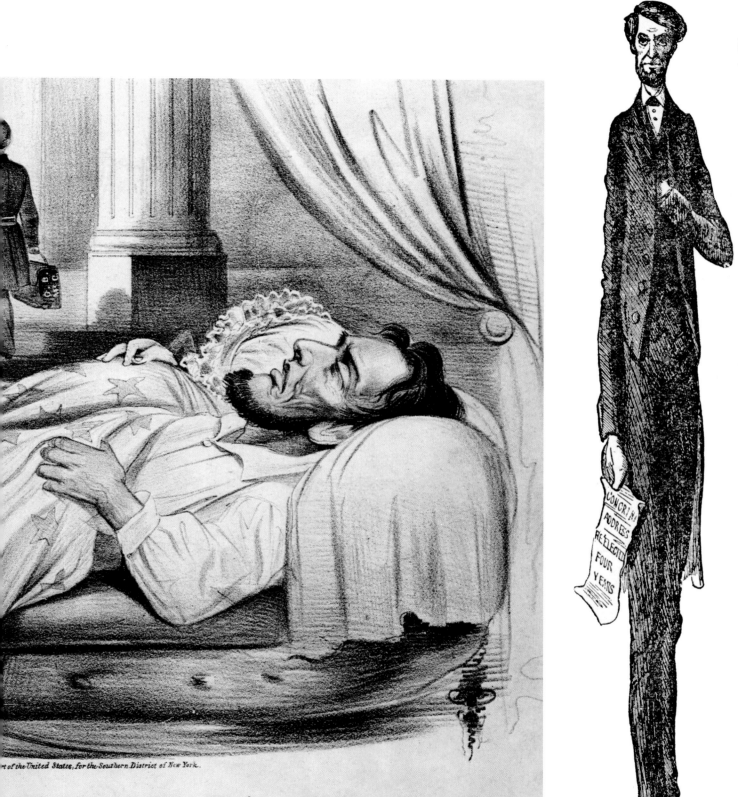

of the United States, for the Southern District of New York.

DREAM!_
HADOWS BEFORE".

Lincoln's height and appearance made him irresistible fodder for cartoonists throughout the early 1860s.

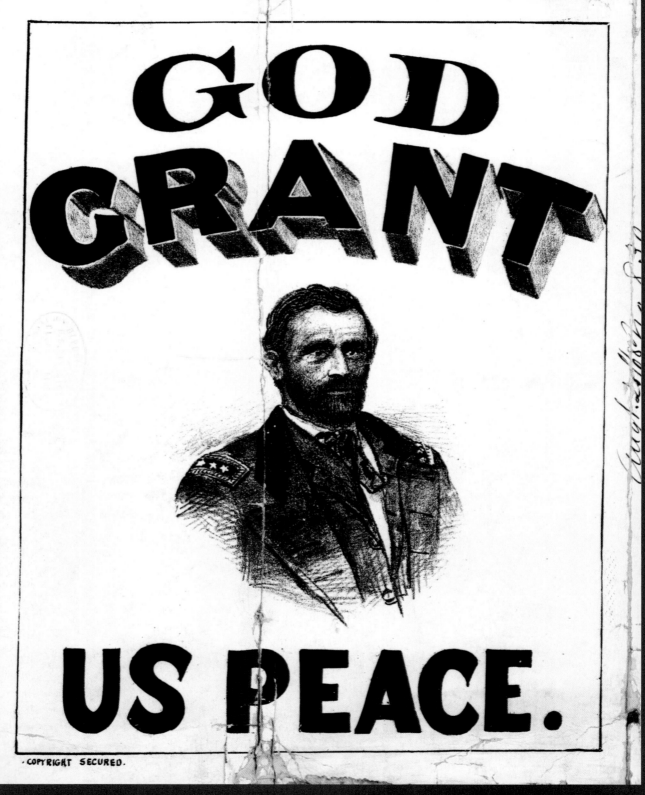

GOD GRANT

US PEACE.

·COPYRIGHT SECURED.

OPPOSITE: The 1868 election—the first after the Civil War—found the issues of race and Reconstruction infecting the campaign between Ulysses S. Grant and Horatio Seymour.

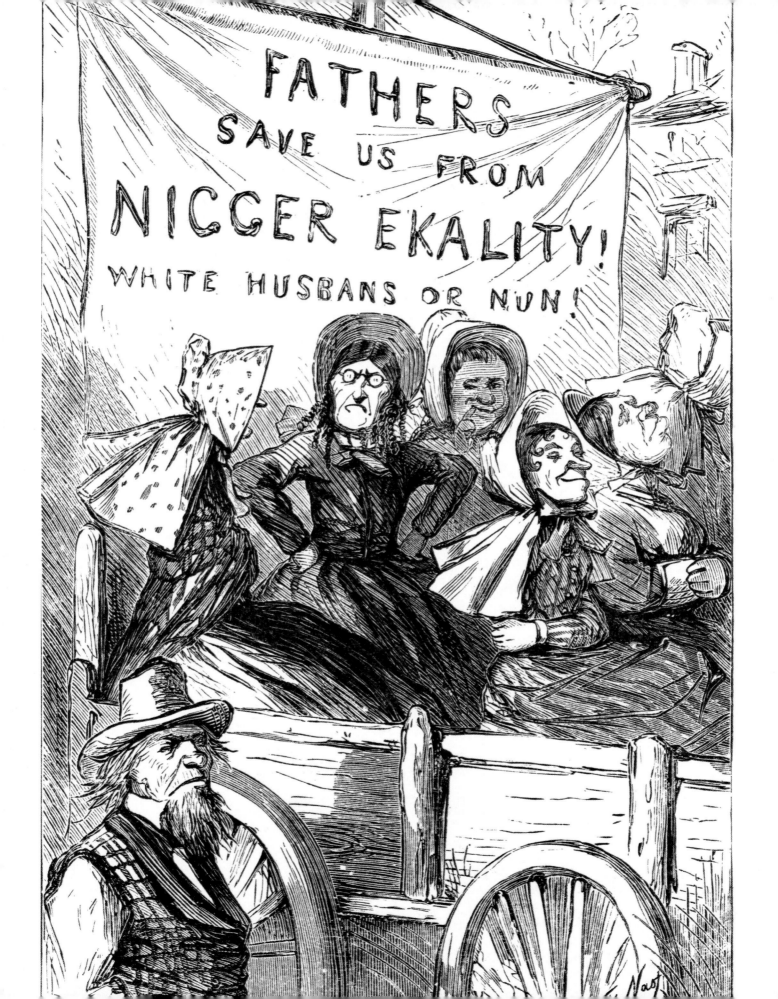

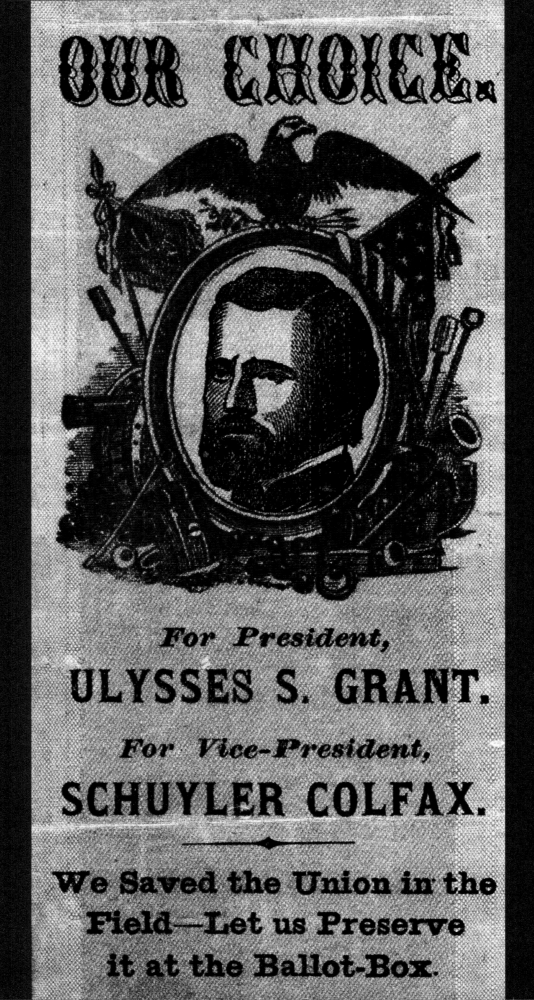

14

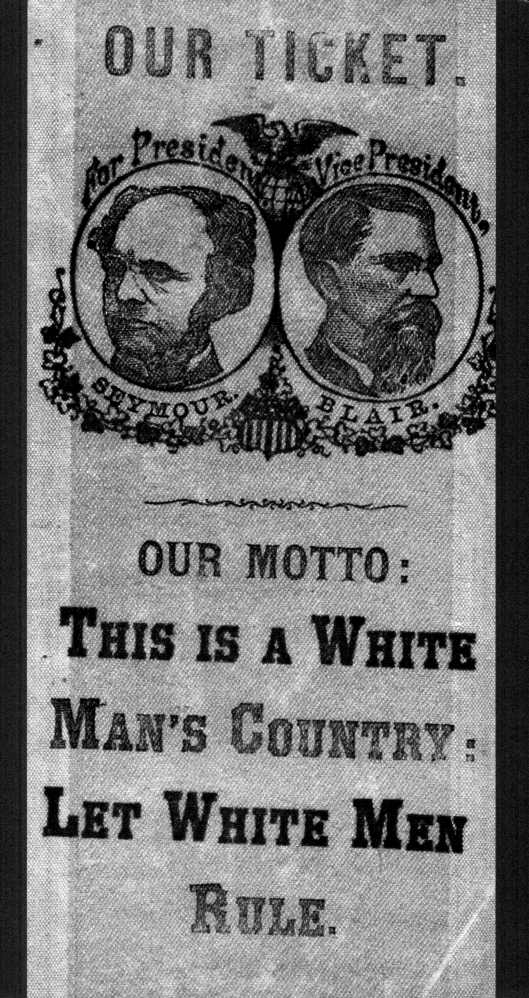

1876

DEMOCRATIC REFORMER

Chaos within the
Democratic Party: 1876.

& Ives, N.Y. 125 NASSAU ST. NEW YORK

IN SEARCH OF A HEAD.

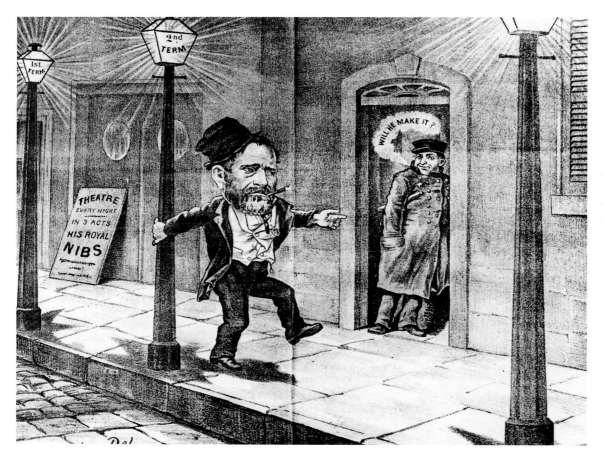

Charges of drinking dogged Ulysses S. Grant from the Civil War until the end of his presidency in 1877.

OPPOSITE: Democrats Samuel Tilden and Thomas Hendricks won the popular vote, but lost the electoral vote and the presidency in 1876.

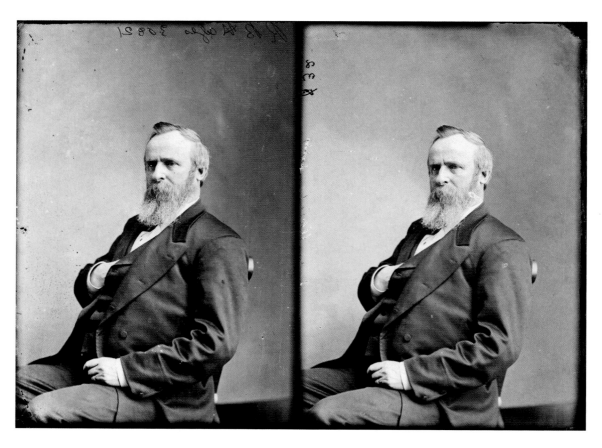

Rutherford B. Hayes, who was inaugurated as president in 1877 after one of the most bitterly contested elections in American history.

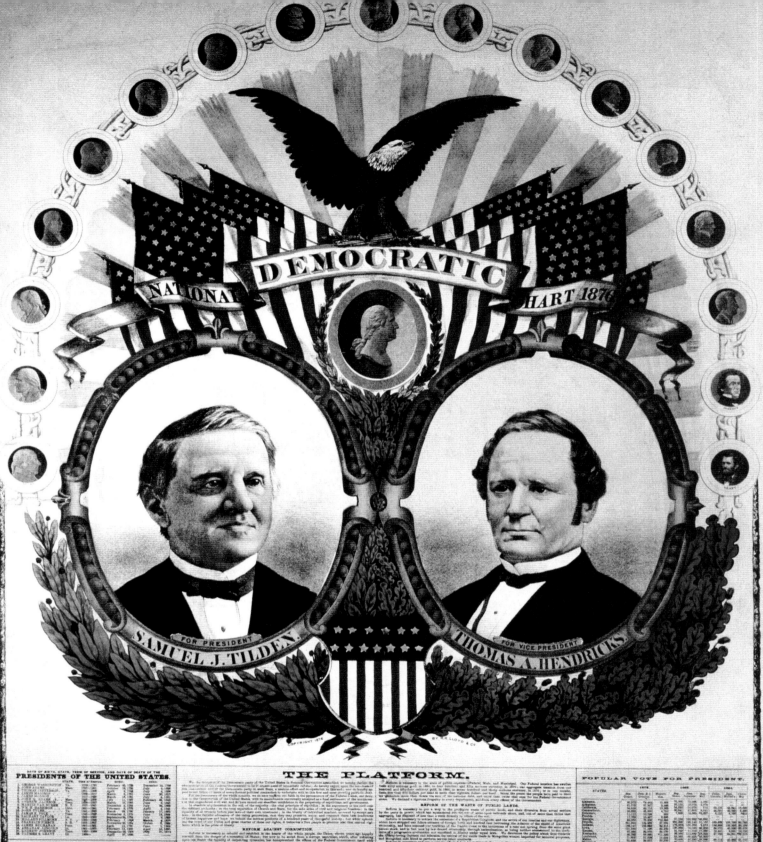

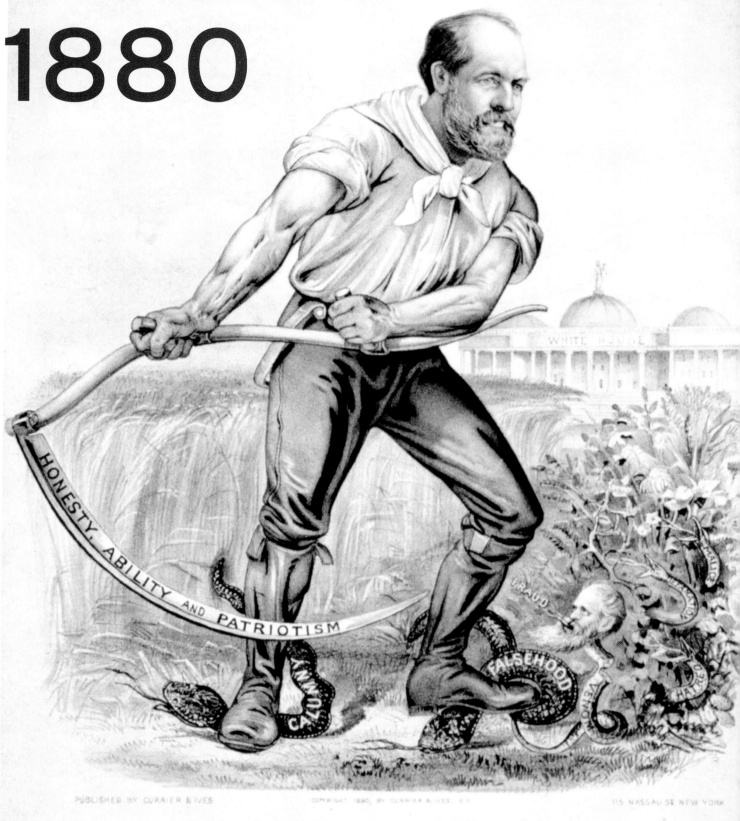

FARMER GARFIELD
Cutting a Swath to the White House.

James Garfield, the victor in 1880, "cutting a swath to the White House" with a scythe of "honesty, ability and patriotism." OPPOSITE: The raucous 1884 campaign saw Grover Cleveland accused of fathering an illegitimate child.

1884

1888

The debate over tariffs dominated the contests of 1888 and 1892.

OPPOSITE: A "comparative map" contrasting the views of Harrison and Cleveland on tariffs.

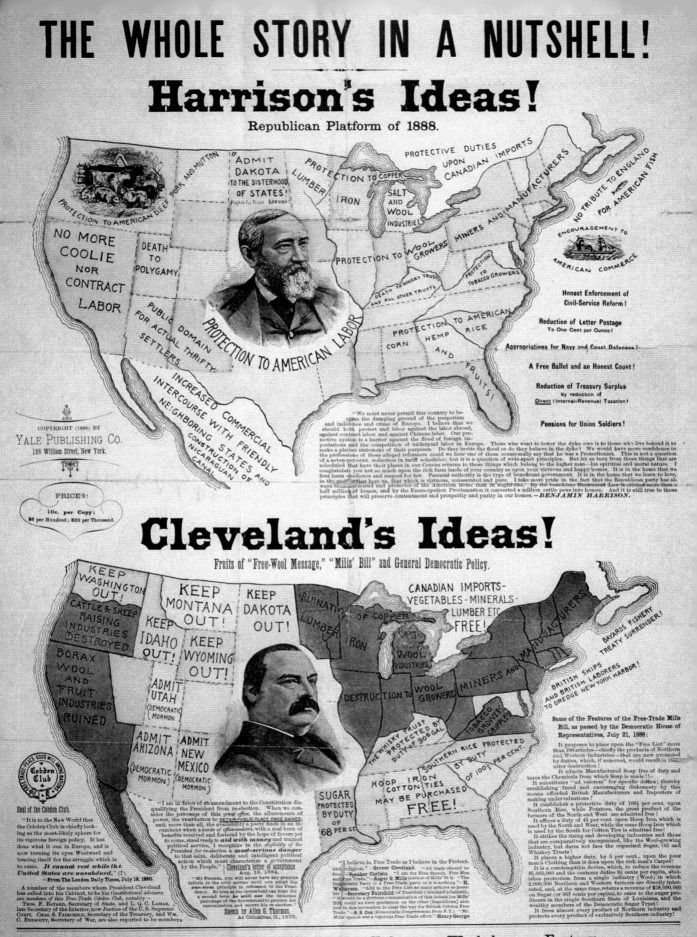

THE WHOLE STORY IN A NUTSHELL!

Harrison's Ideas!
Republican Platform of 1888.

Post this in your Home, Office, Store, Club-room, Workshop or Factory.

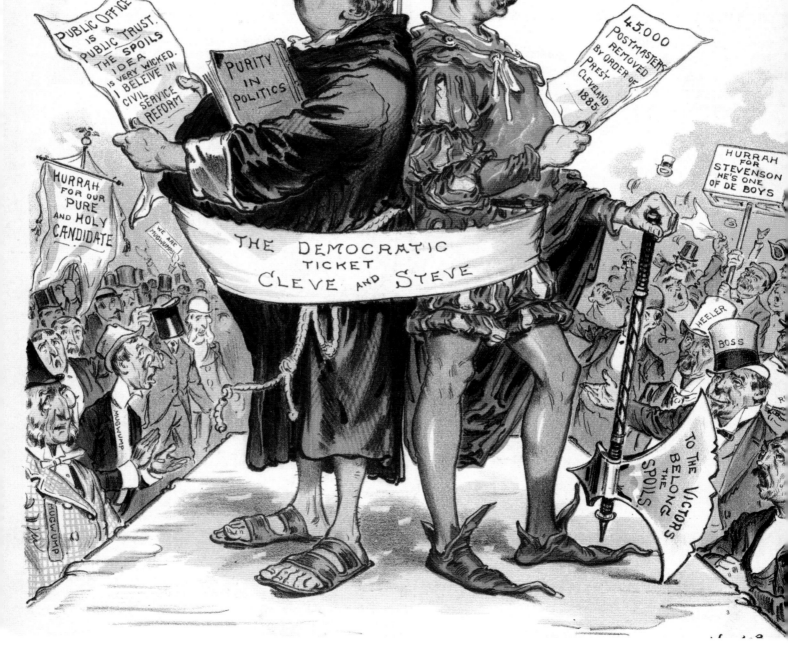

An 1892 cartoon depicting Grover Cleveland as a saint, and running mate Adlai Stevenson, grandfather of the 1952 and 1956 Democratic nominee, as a sinner.

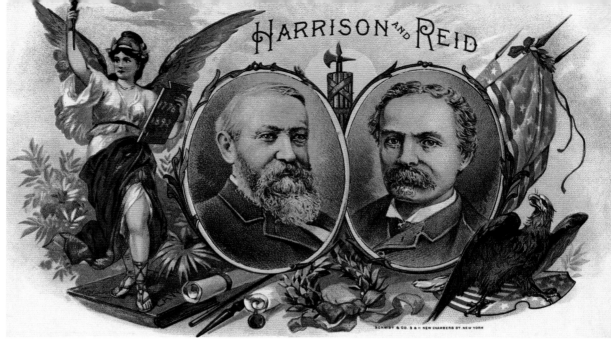

RIGHT: Republicans Benjamin Harrison and Whitelaw Reid

BELOW: A potent allegorical image: Grover Cleveland shaking hands with the independent voter

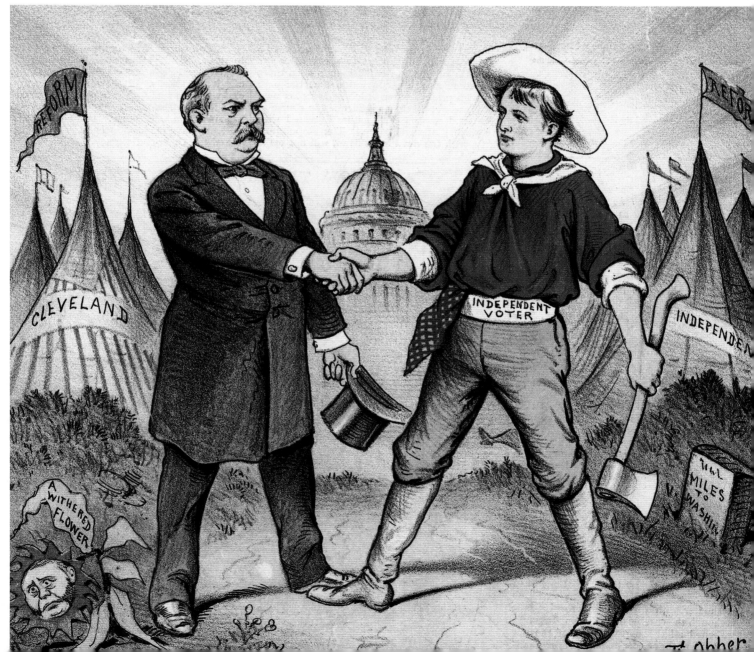

1896-

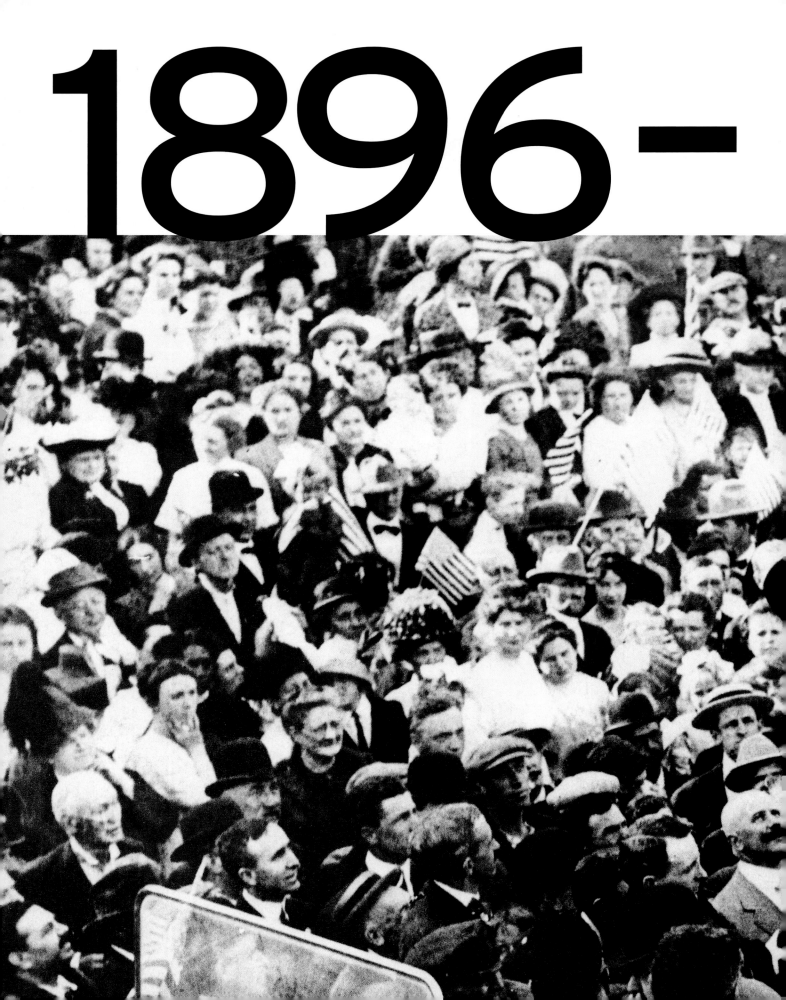

1912

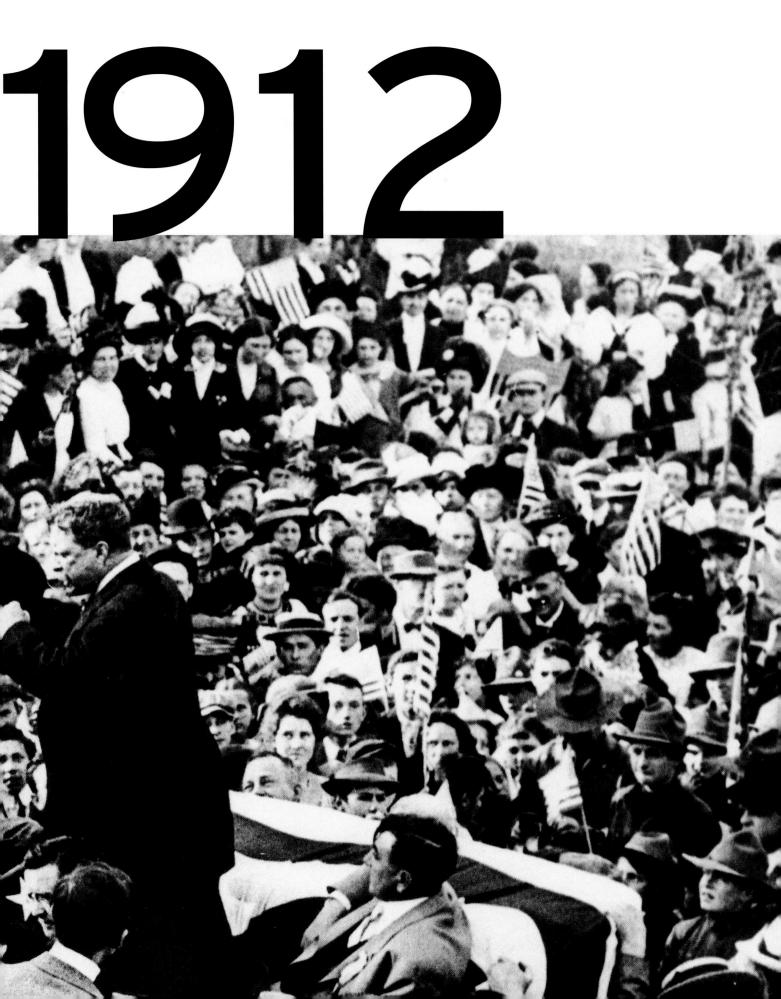

At the turn of the twentieth century, the United States was witness to one of the most influential social and political movements in the nation's history—Progressivism. Spurred by the country's widening economic divide and growing concentration of wealth, the Progressive movement sought nothing less than the transformation of American society. From suffragettes and prohibitionists to trust-busters, labor organizers, and plutocrats, activists of every stripe jockeyed for influence, and larger-than-life leaders on both sides of the political aisle called for reform. Though the Democrats failed to capture the White House until 1912, they became firmly identified with the Progressive agenda. And though one Republican president became perhaps the greatest Progressive leader of all, his eventual break with his party plunged it deeper into conservatism. The choices each party made during these sixteen years would come to shape the face of modern American politics.

In **1896,** one issue was on the minds of every American—"free silver." It's a phrase few people would recognize today, but in 1896 the question of whether the United States should maintain its allegiance to the gold standard, or attempt to spur the economy by allowing the unlimited coinage of silver, was at the center of the political maelstrom. Driving the debate was a candidate who became one of the defining figures of his era—without ever winning the office he sought in three elections.

In the days before the lengthy primary process that defines modern American politics, presidential candidates were selected on the convention floor. In 1896, Republican delegates quickly selected Governor William McKinley of Ohio. On the Democratic side, the incumbent Grover Cleveland, who was blamed for the country's economic downturn, enjoyed little popular support. Yet no clear alternative emerged until a former Nebraska congressman named William Jennings Bryan took the floor—and delivered one of the most electrifying speeches in American political history: the "Cross of Gold" speech.

Deriding the "idle holders of idle capital" who supported the gold standard, Bryan called on his fellow Democrats to side with the farmers, miners, and laborers who, he claimed, would benefit from the adoption of free silver. Whipping the crowd to a frenzy, Bryan stretched out his arms and cried, "You shall not press down upon the brow of labor this crown of thorns; you shall not crucify mankind upon a cross of gold."

As Bryan finished, an eerie silence filled the hall—then pandemonium ensued. The crowd hollered and cheered for almost an hour; a resolution supporting silver passed easily, and the thirty-six-year-old Bryan found himself at the head of the Democratic ticket.

The race of 1896 was called "The Battle of Standards," but it was also a study in contrasting styles. Bryan became the first presidential candidate to barnstorm the nation. Candidates had whistle-stopped before, but never like this. Bryan traveled 18,000 miles and spoke to more than 5 million Americans with a fervor and energy unseen before in American politics. Millions of people responded to Bryan's larger-than-life persona: Americans lined railroad tracks to see Bryan and crowds of up to 50,000 people gathered to hear "The Great Commoner" speak.

Yet Bryan's silver-tongued campaigning was met by McKinley's own bold stunt: Sticking to his own front porch in small-town Ohio, he gave countless speeches to some 750,000 Americans who traveled to hear him. The Republican Party's close ties to big business helped them to raise millions, which they used to distribute millions of pamphlets extolling McKinley's virtues. While some of the party's 1,400 surrogate speakers called the rabble-rousing Bryan a crank, a socialist, and a fanatic, McKinley cast a dignified air; his pledge to return the nation to prosperity was captured in his most popular slogan: "McKinley and the Full Dinner Pail."

Bryan's campaign struck a nerve with the growing number of Americans who were becoming concerned about the dark side of capitalism and the nation's growing inequality. In the end, however, McKinley's positive message, coupled with the failures of the outgoing Cleveland administration and Bryan's stridency, doomed the Democrats as McKinley triumphed by approximately 600,000 votes.

In **1900** the two men faced off again, but the booming economy sapped the excitement from the presidential campaign.

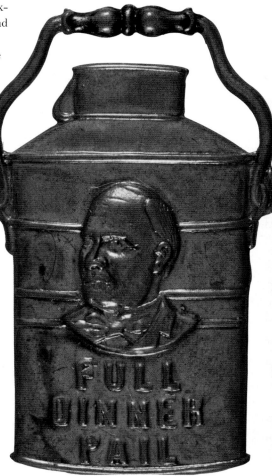

William F. McKinley's "Full Dinner Pail"

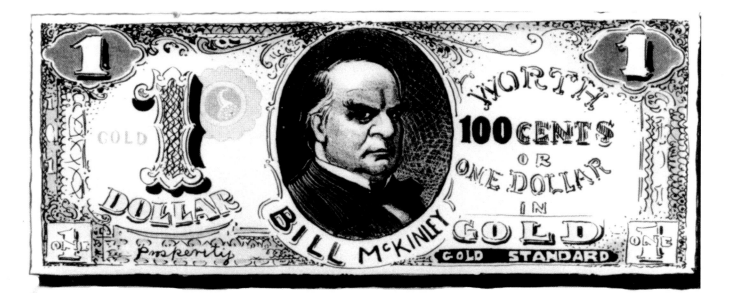

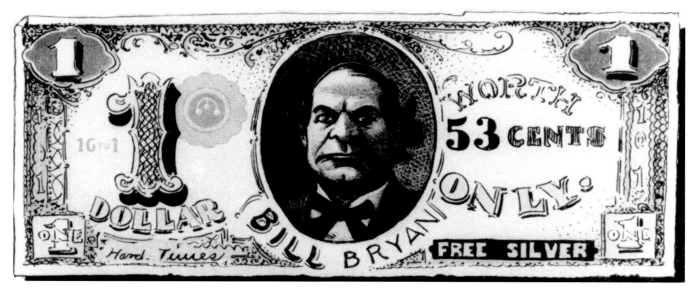

McKinley and William Jennings Bryan clashed in 1896 over free silver, but by 1900 the issue had faded.

The bottom half of the ticket, however, was a different story. Vice President Garret Hobart had died in office, and it fell to the GOP convention to select a new running mate for McKinley. Well-known for his exploits as a Rough Rider during the Spanish-American War, New York governor Theodore Roosevelt was an obvious choice. There was only one problem: He wasn't particularly interested in the job.

However, support for Roosevelt grew swiftly among party delegates and ulti-

mately he was persuaded to join the ticket. (Ironically, much of his support came from New York Republican rivals who were eager to get him out of the state.) Mark Hanna, the Republican machine boss who had helped to elect McKinley in 1896 was less than thrilled by the flamboyant TR, viewing him as unfit for the White House. When Hanna turned to McKinley for help, though, the president refused to intervene, offering no opinion on his own running mate. The delegates

overwhelmingly selected Roosevelt.

McKinley left the politicking to Roosevelt, who traveled more than 20,000 miles, warning Americans of the dangers of a Bryan presidency and pledging four more years of prosperity. On Election Day, McKinley scored the largest GOP triumph in more than twenty years.

The convention debate over McKinley's VP proved to be more than a formality. Six months after winning the White House, McKinley was gunned down by an

anarchist in Buffalo, New York, and the man Mark Hanna derided as "that damn cowboy" became the nation's youngest president.

The activist—even ebullient—Roosevelt quickly surpassed his predecessor's popularity. His Progressive agenda and "Speak softly and carry a big stick" foreign policy attracted such widespread support that by **1904** few Democrats were eager to take him on. Several prominent Democrats sought the nomination, including Bryan and newspaper magnate William Randolph Hearst. But the party's Eastern wing, eager for a "sane and safe" alternative to Roosevelt, settled on Alton Parker, chief justice of the New York Court of Appeals. But Parker proved too staid for the party's good: His attempt to run a front-porch campaign faltered when few Americans bothered to travel to his out-of-the-way home in upstate New York.

Following the incumbent tradition, Roosevelt reluctantly stayed off the campaign trail in 1904. Yet he scored a huge win, crushing the hapless Parker (who mustered only 38 percent of the vote). After thanking the country for his victory, Roosevelt made a startling announcement: He would not seek the presidency in **1908.** Roosevelt had hoped to elevate his second term above politics, but the strategy quickly backfired; TR was rendered a lame duck, and his political influence was diminished for the duration of his presidency.

The decision did little, however, to hurt Roosevelt's popularity. When he anointed his secretary of war, William Howard Taft, as his successor, the party rallied around the nominee. Still, when Roosevelt's name was invoked at the GOP convention, it received longer and louder ovations than those for Taft—a fact duly noted by Taft's wife.

William Jennings Bryan, meanwhile, was receiving ovations of his own at the Democratic convention. After handing their longtime standard-bearer a third shot at the presidency, the delegates danced and paraded in the halls for a full ninety minutes. Unfortunately, the spectacle was hardly matched on the campaign trail. Americans had grown weary of Bryan's populist rhetoric—even though many of Bryan's cherished progressive ideas had already come to fruition and now were being trumpeted by Taft.

The corpulent Taft benefited hugely from his association with Roosevelt; some journalists joked that TAFT stood for "Take Advice from Theodore." Not a fan of politics, he later complained that the time he spent running for president was the most "uncomfortable" of his life. Under TR's tutelage, however, Taft developed a strong campaign persona of his own, speaking to enthusiastic crowds as he whistle-stopped across the country. In a race called "the dullest campaign in a quar-

Our Choice

ter century," Taft won easily, though it was more a personal repudiation of Bryan than an embrace of the new president.

If the slate of candidates in 1908 was a rehash of old rivalries, four years later the cast of characters was electrifying. Taft, the incumbent, was challenged not only by a new Democratic voice—Woodrow Wilson—but by his own erstwhile sponsor, Roosevelt. Between them, these three men would win the presidency four times, and dominate the first two decades of twentieth-century politics.

Roosevelt's return to the fray was hotly anticipated. Increasingly dismayed by Taft's growing conservatism and rejection of progressive values, in February **1912** Roosevelt declared, "My hat is in the ring." Facing off in some of the first state presidential primaries, TR trounced Taft, who became the first sitting president to campaign in a state primary. Taft, however, controlled the party apparatus, and was able to retain a majority of delegates at the GOP's Chicago convention. When Taft captured the nomination, Roosevelt bolted—announcing his candidacy under the banner of the newly formed Progressive Party, dubbed "Bull Moose" by some. Taft's victory was bittersweet. With his party hopelessly divided, Taft had no chance of reelection and spent much of the campaign on the golf course. In the end, however, his convention victory helped give impetus to the modern, conservative Republican Party we know today.

The Democratic convention was equally dramatic, taking forty-six ballots to select New Jersey governor Woodrow Wilson. Though Taft remained on the ballot, in the end it was a clash of two men and their philosophies. Roosevelt, with his "New Nationalism," advocated corporate regulation and an expanded social safety net. Wilson countered with his "New Freedom," a bid to increase economic competition by breaking up "the great incubus" of trusts.

In a race filled with substance and serious policy debates, the two men ran lively whistle-stopping campaigns. Wilson, the former college president, took a thoughtful, sober approach. Roosevelt, as

Roosevelt and Johnson

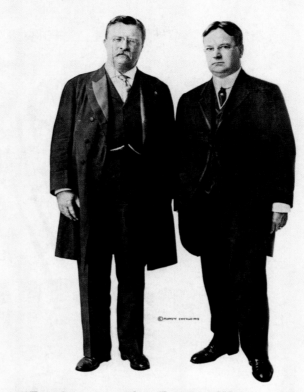

"For there is neither East nor West,
Border nor Breed nor Birth,
When two strong men stand face to face
Though they come from the ends of the earth."
—Kipling

always, was an energetic and ferocious speaker. In one of the campaign's most extraordinary moments, Roosevelt was preparing to speak at a rally in Milwaukee when a gunman opened fire—though a bullet had entered his chest, the candidate insisted on speaking. Pulling out his blood-stained speech, Roosevelt told the crowd "It takes more than that to kill a Bull Moose"—then spoke for more than an hour before getting medical care.

In the end, however, the split among Republicans was too great for Roosevelt to overcome. With the incumbent Taft winning only two states, Wilson carried the day. After sixteen years the Democrats were back in charge, and the party was now firmly identified with the Progressive agenda. ❑

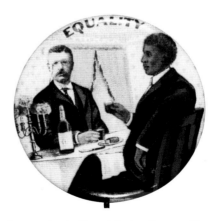

A campaign button picturing Roosevelt's celebrated lunch at the White House with Booker T. Washington. The president's invitation enraged Southern whites.

1896

William Jennings Bryan: America's
first great firebrand campaigner

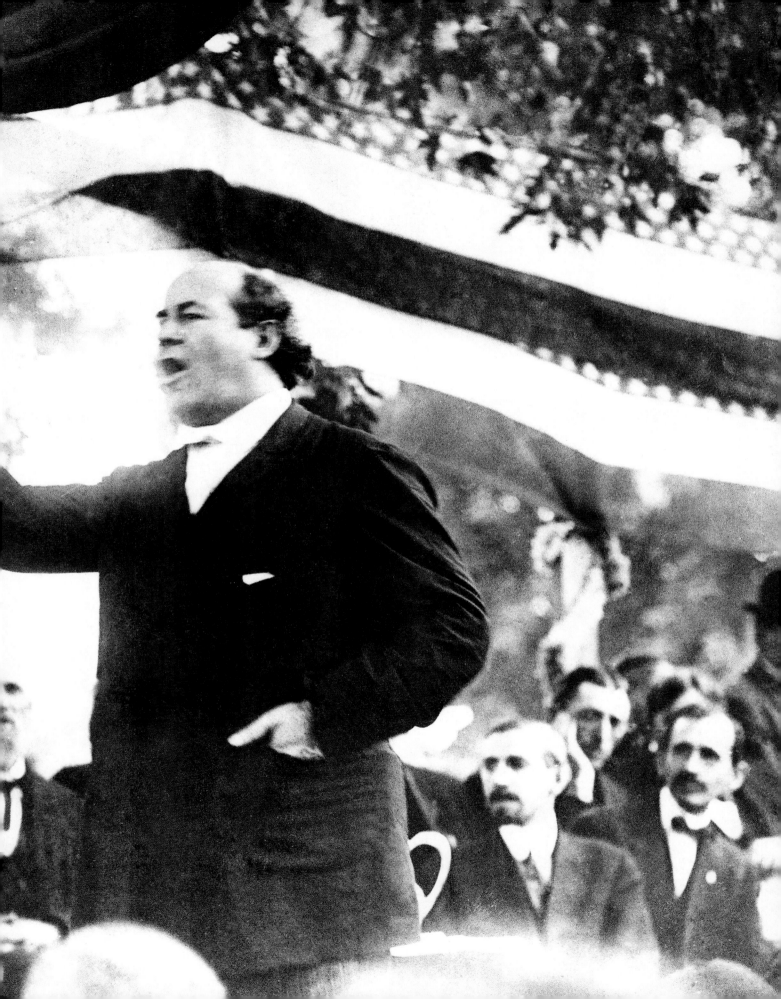

William McKinley
on his front porch
in Canton, Ohio,
from where he ran
his 1896 campaign.

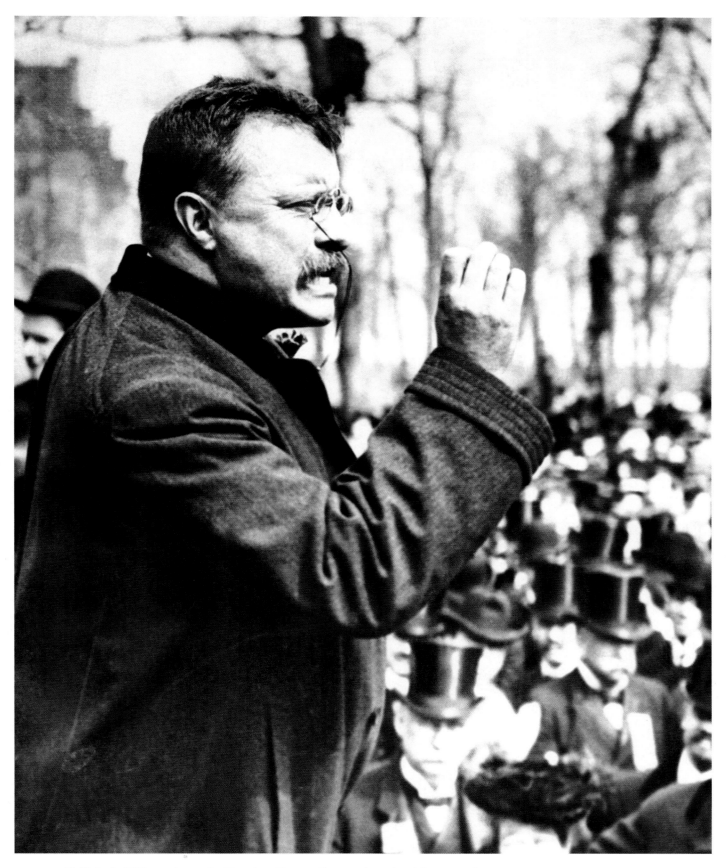

ABOVE: McKinley's 1900 running mate, Theodore Roosevelt, proved a galvanizing campaigner.

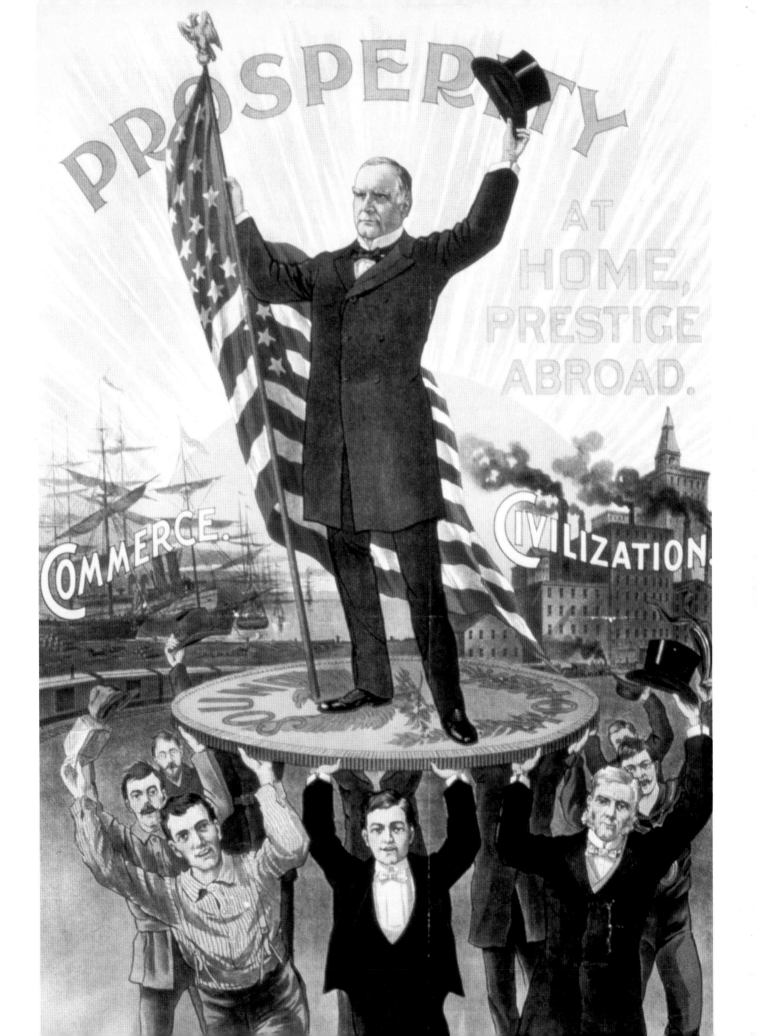

THE ADMINISTRATION'S

1896

Gone Democratic.

BANK SAVINGS DEPOSIT CLOSED

A run on the Bank

Spanish Rule in Cuba.

THE AMERIC
HAS NOT BEEN PLAN
TO ACQUIRE MO
BUT
HUMANIT

PROMISES HAVE BEEN KEPT

1900

Gone Republican.

INTEREST PAID ON DEPOSITS

SAVINGS BANK

A run to the Bank.

N FLAG
IN FOREIGN SOIL
TERRITORY
S SAKE"

PUBLIC SCHOOL

American Rule in Cuba.

(McKINLEY, JULY 12, 1900.)

1904

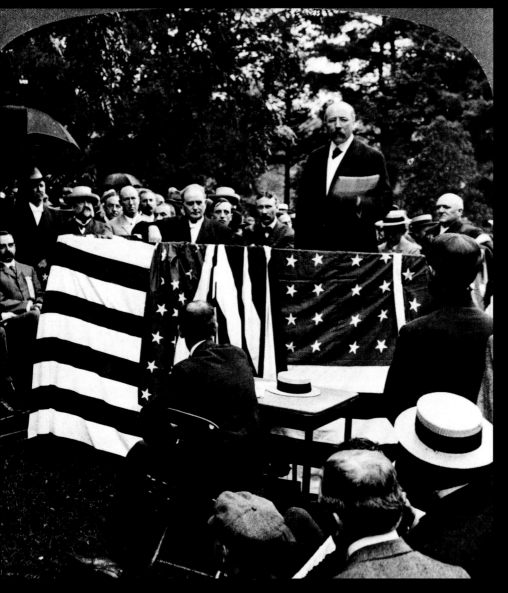

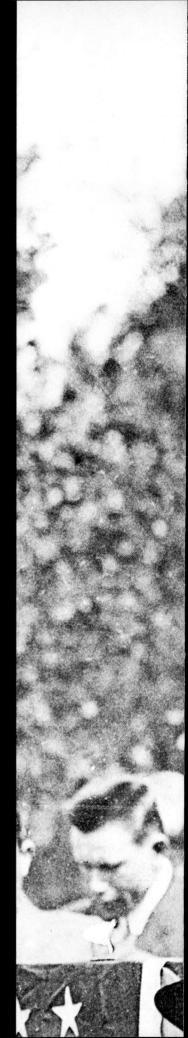

Democratic nominee Alton Parker stood little chance in 1904 against President Theodore Roosevelt.

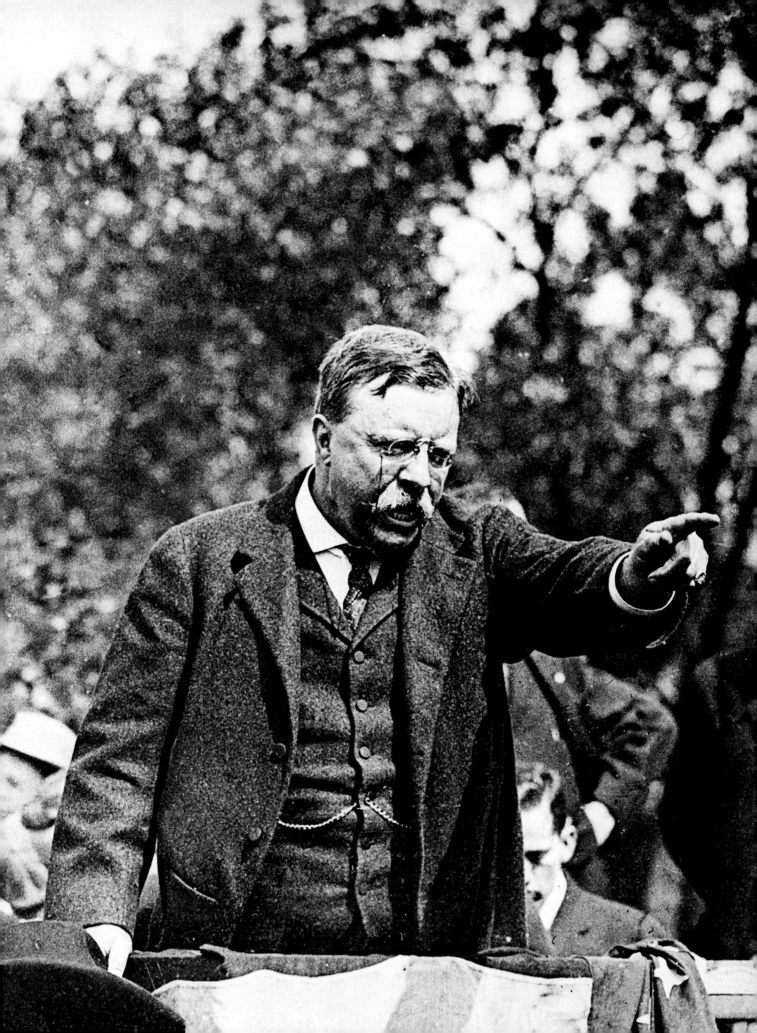

1908

William Howard Taft (wearing dark coat) at a rally: Reluctant at first, he became a powerful campaigner in the TR mold.

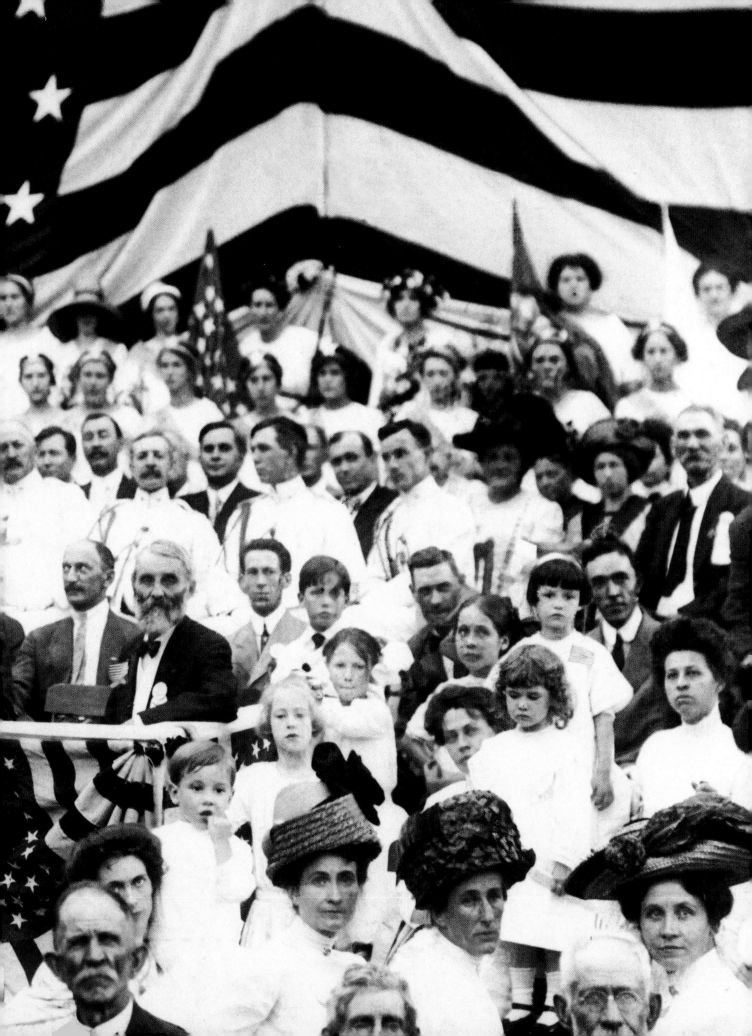

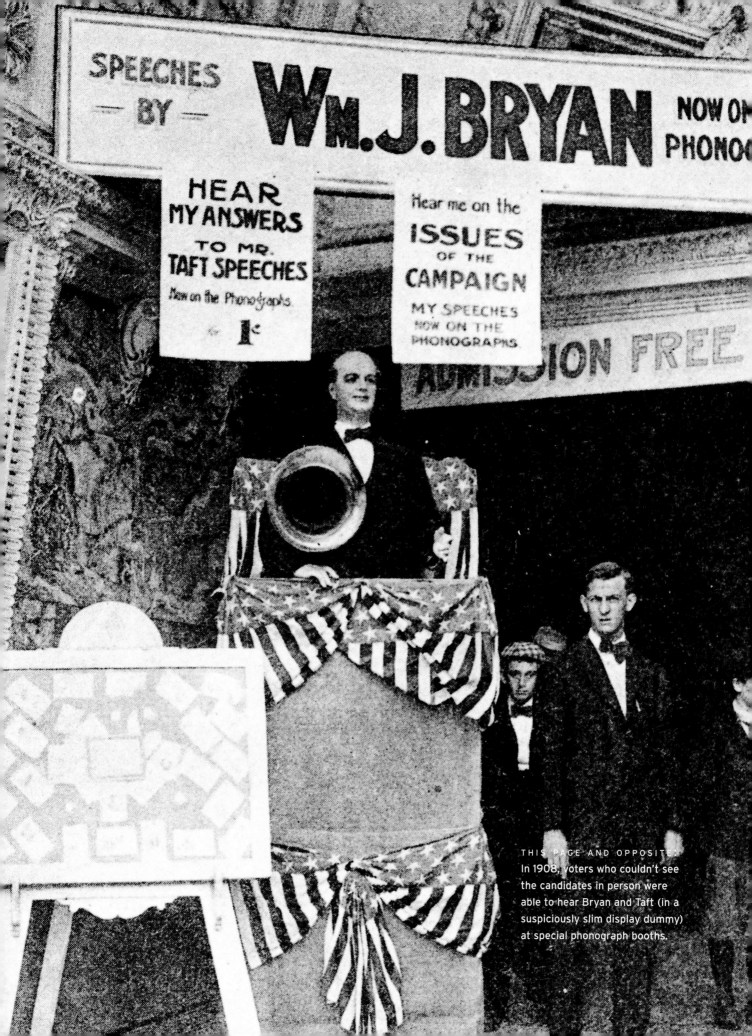

SPEECHES —BY— **Wm.J.BRYAN** NOW ON PHONOG

HEAR MY ANSWERS TO MR. TAFT SPEECHES Now on the Phonographs. for 1¢

Hear me on the ISSUES OF THE CAMPAIGN MY SPEECHES NOW ON THE PHONOGRAPHS.

ADMISSION FREE

THIS PAGE AND OPPOSITE: In 1908, voters who couldn't see the candidates in person were able to hear Bryan and Taft (in a suspiciously slim display dummy) at special phonograph booths.

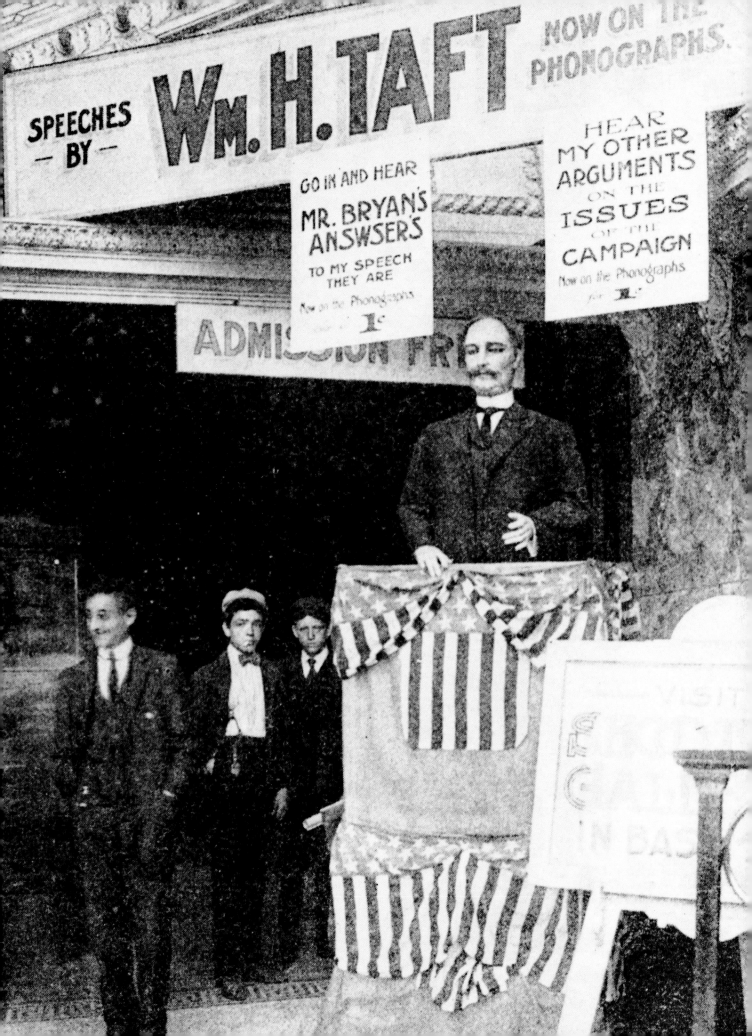

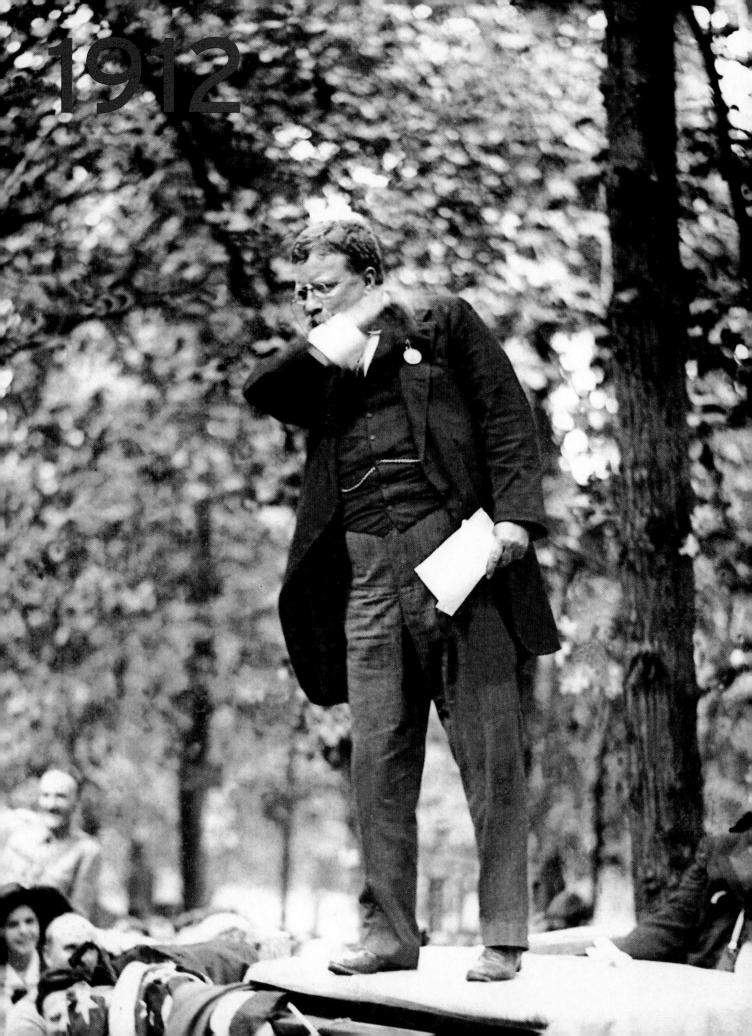

1912

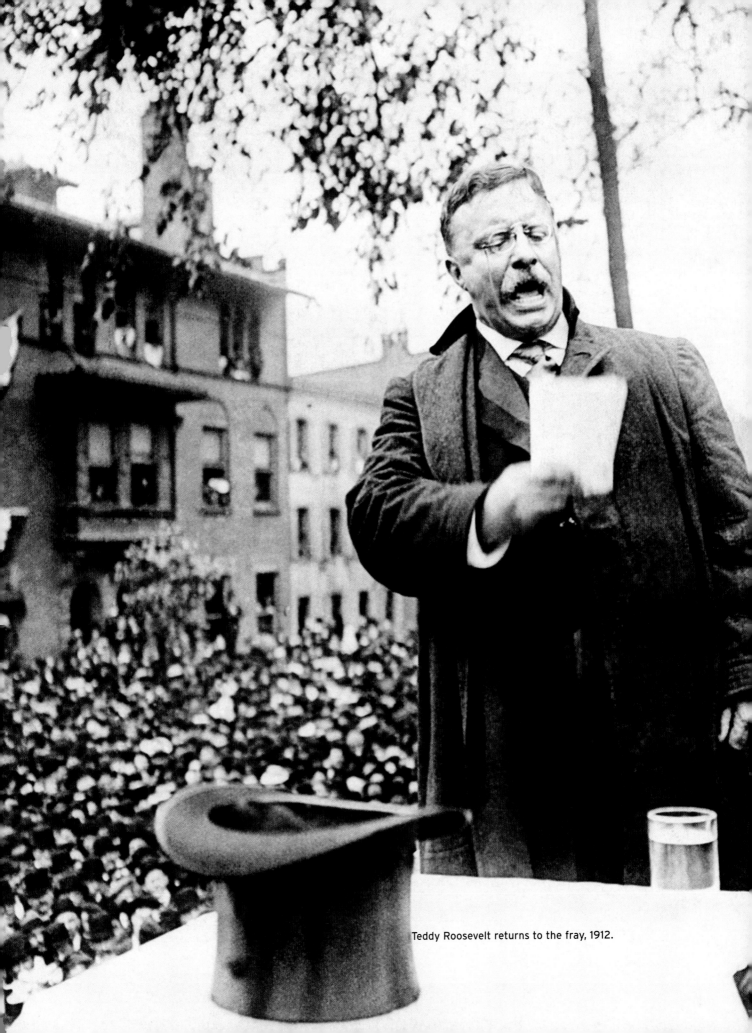

Teddy Roosevelt returns to the fray, 1912.

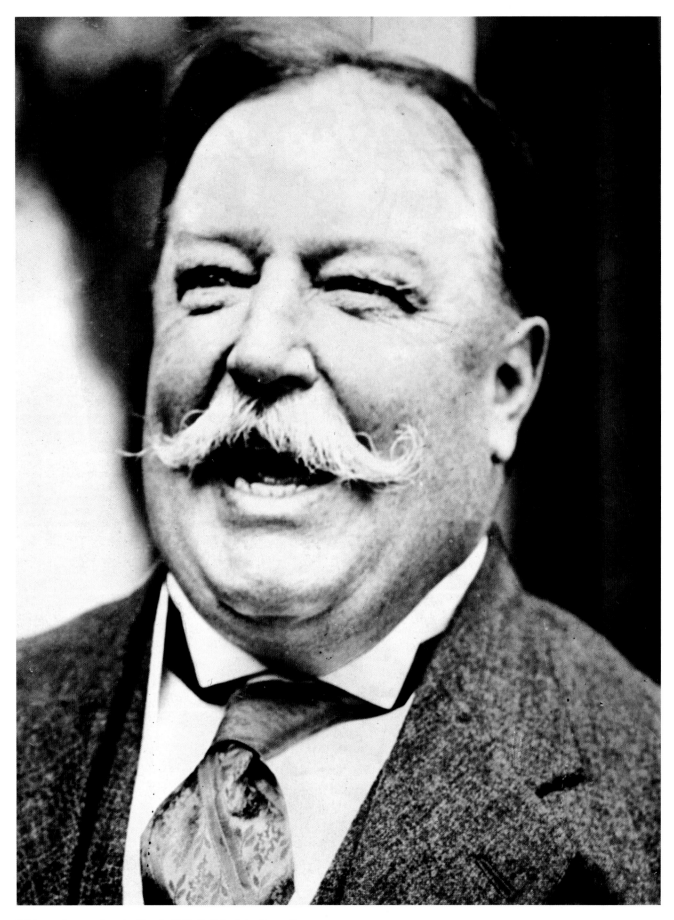

With no chance of reelection in 1912, Taft took to the golf course.

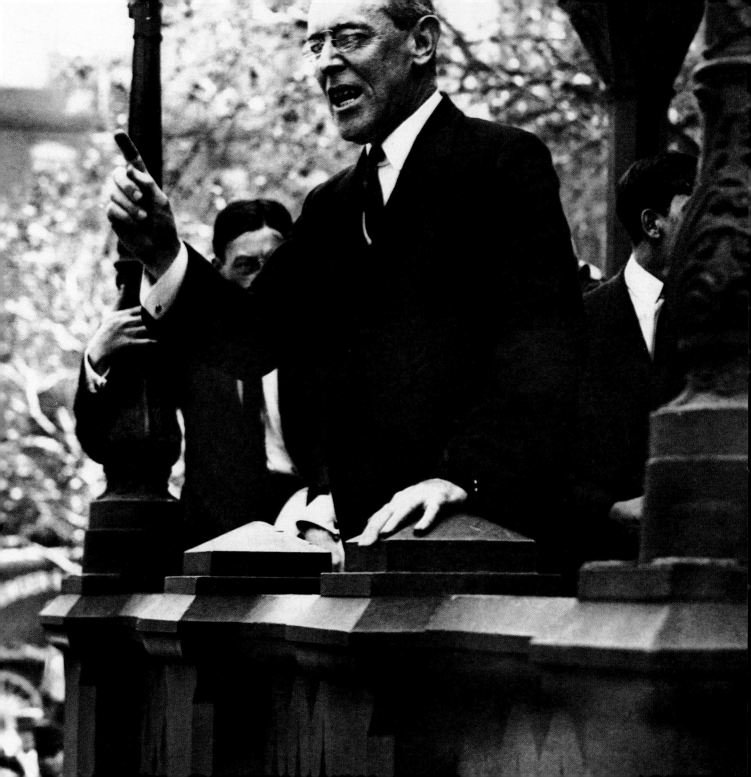

CAMPAIGNS &
WHISTLE-STOPS

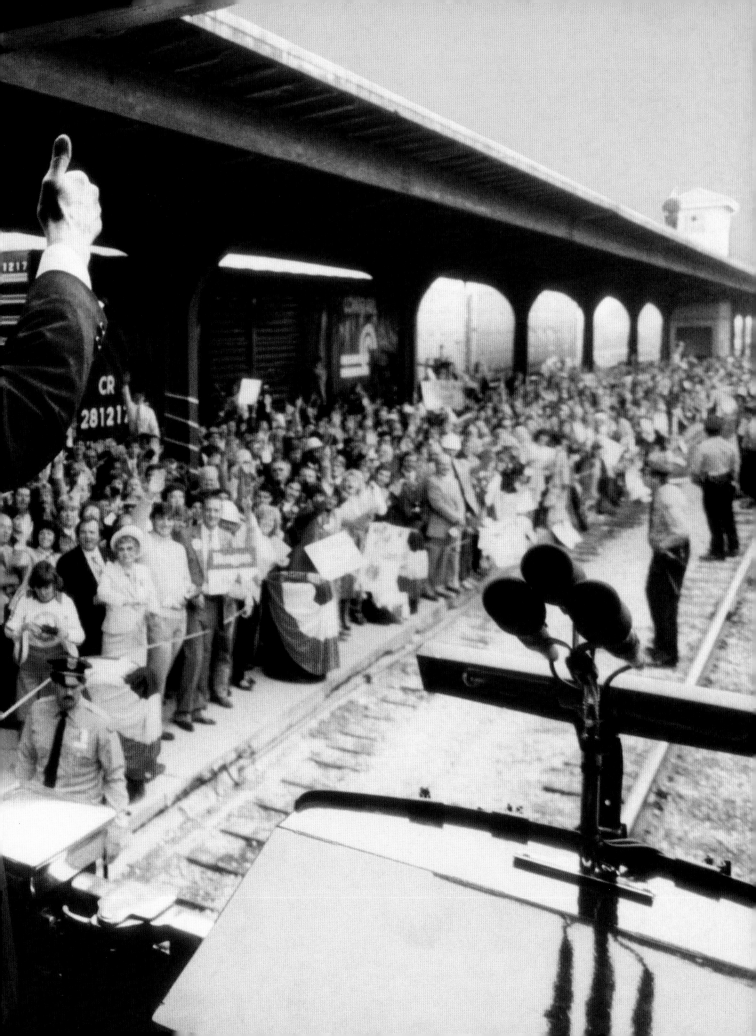

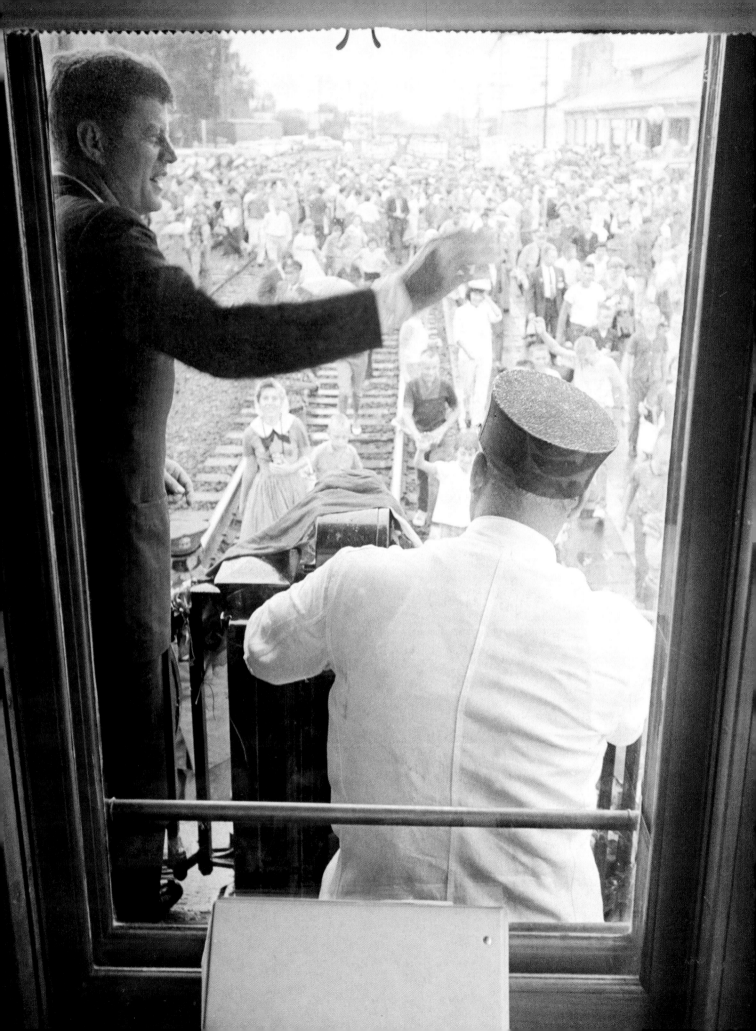

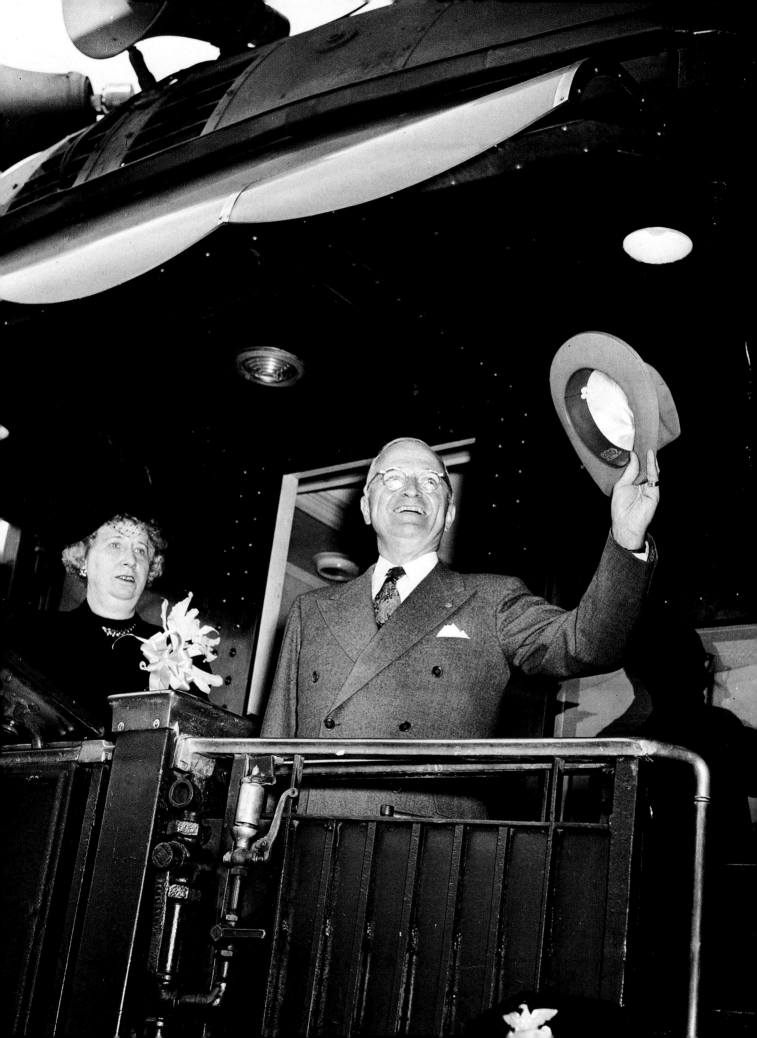

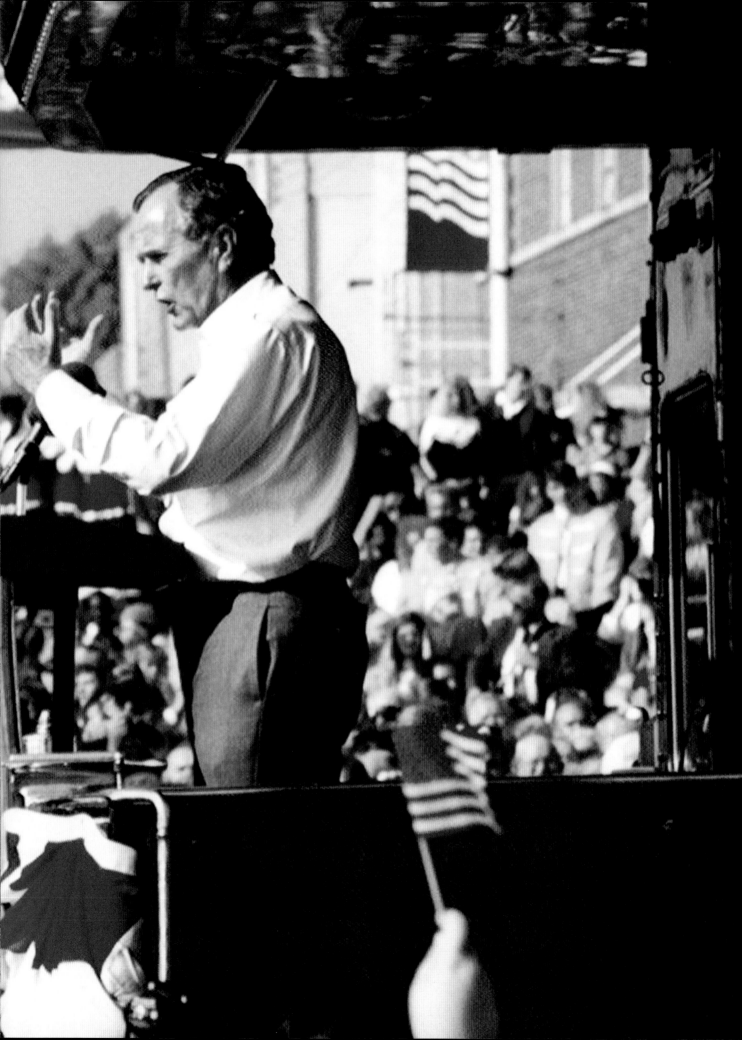

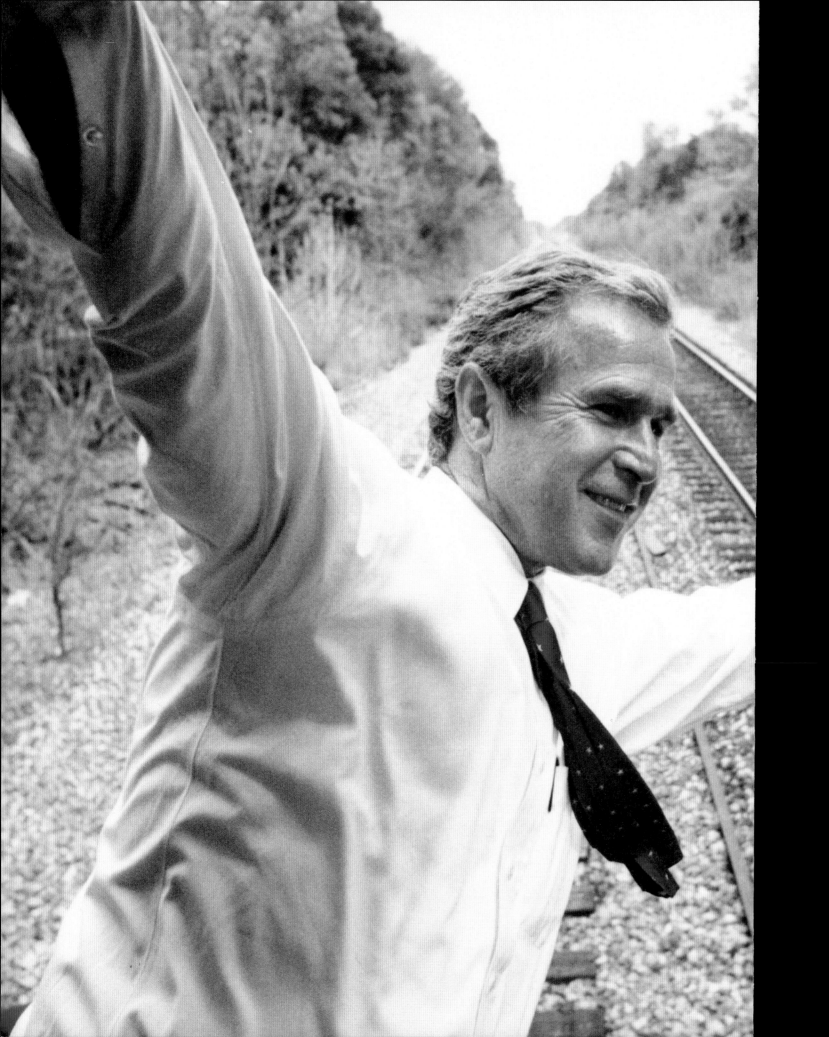

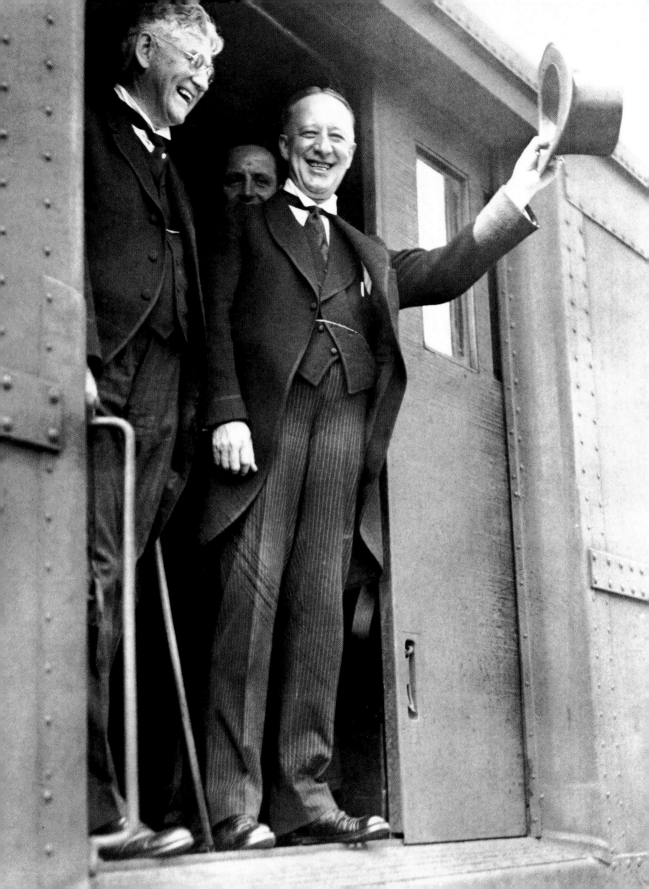

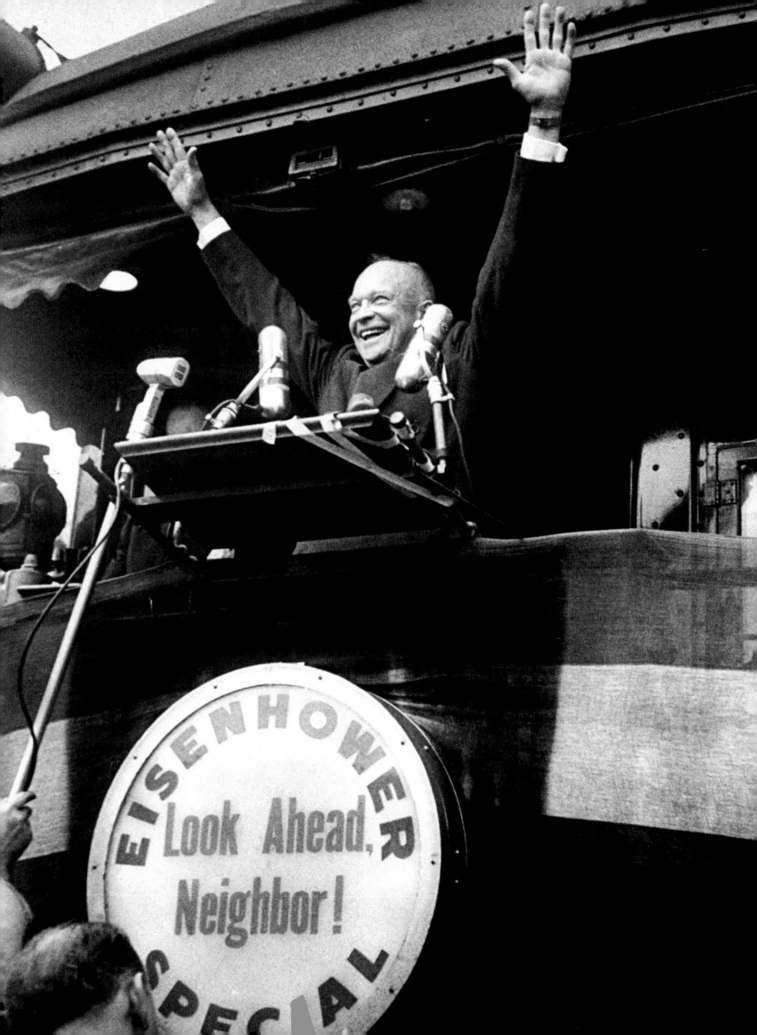

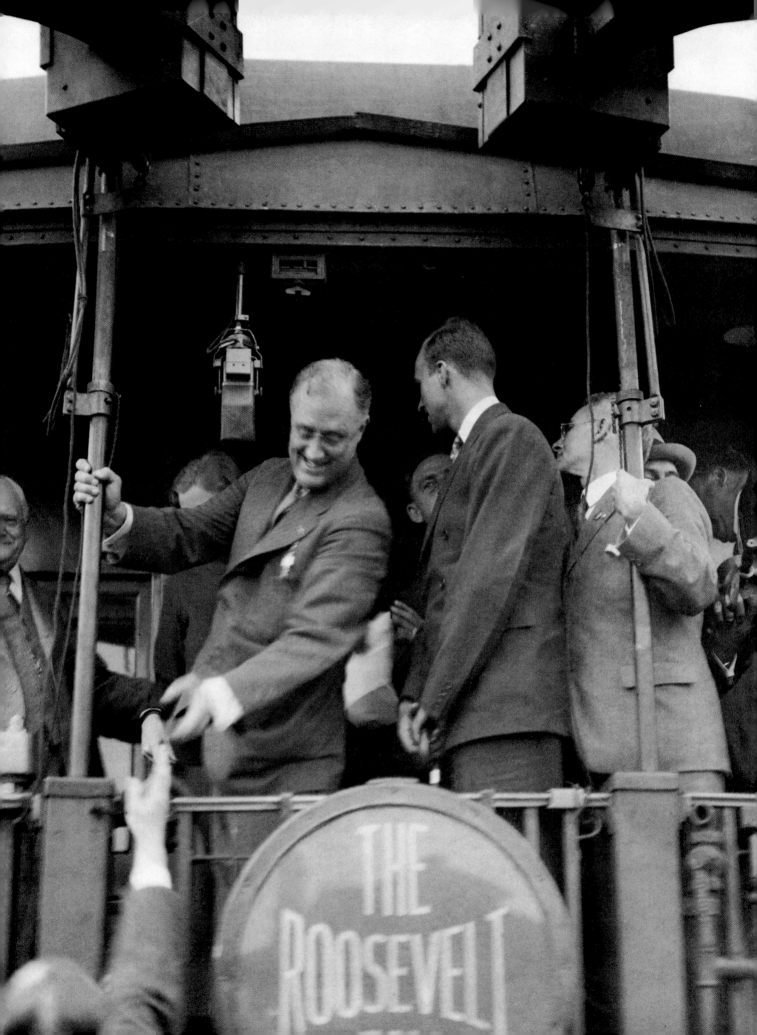

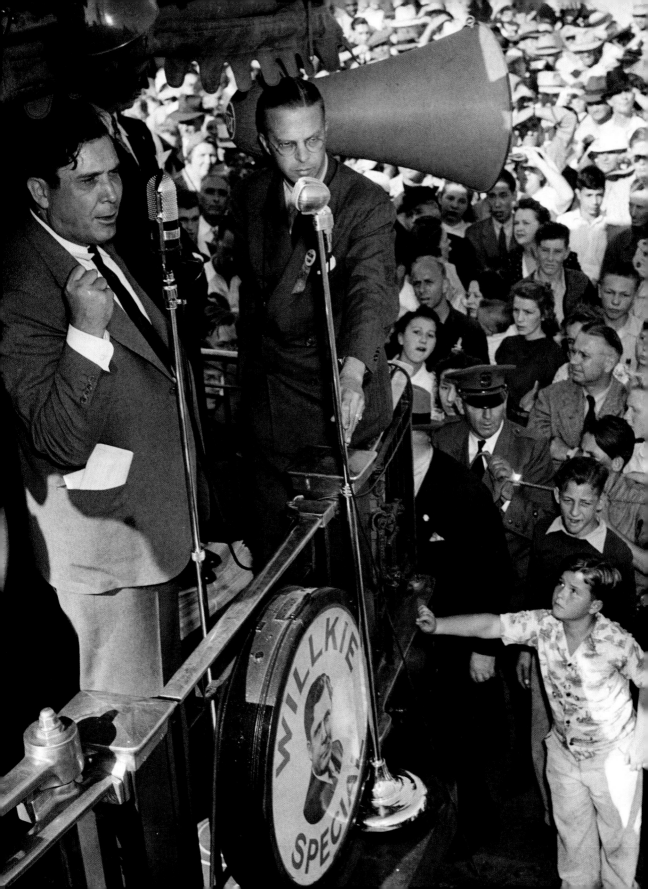

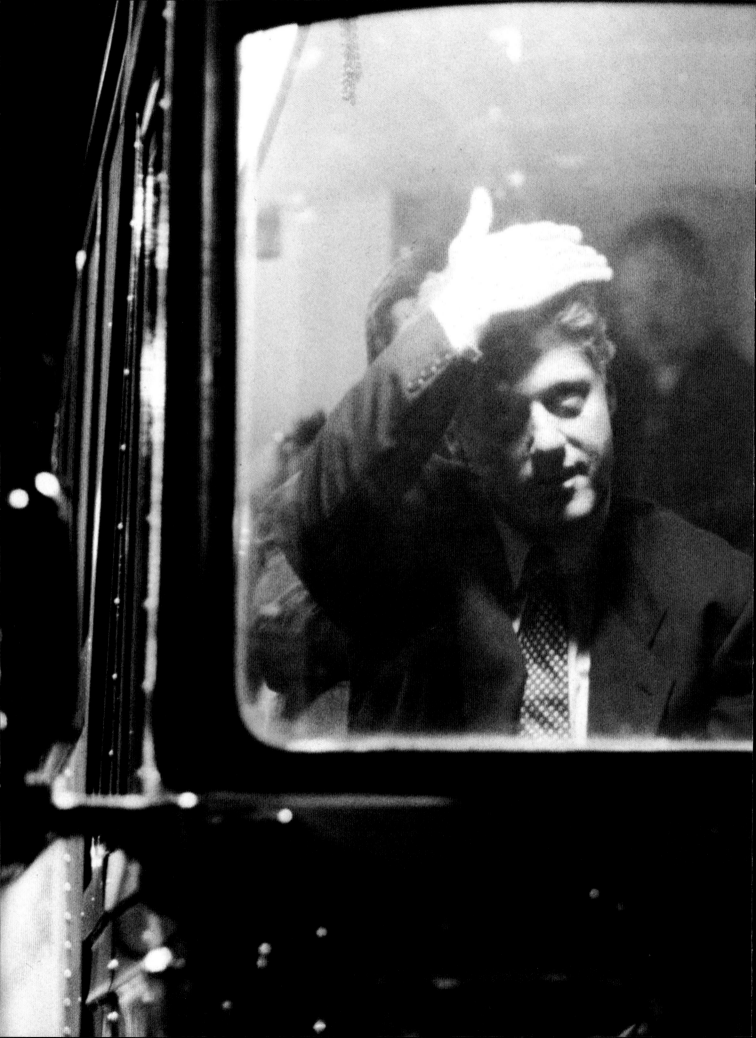

1916-

1928

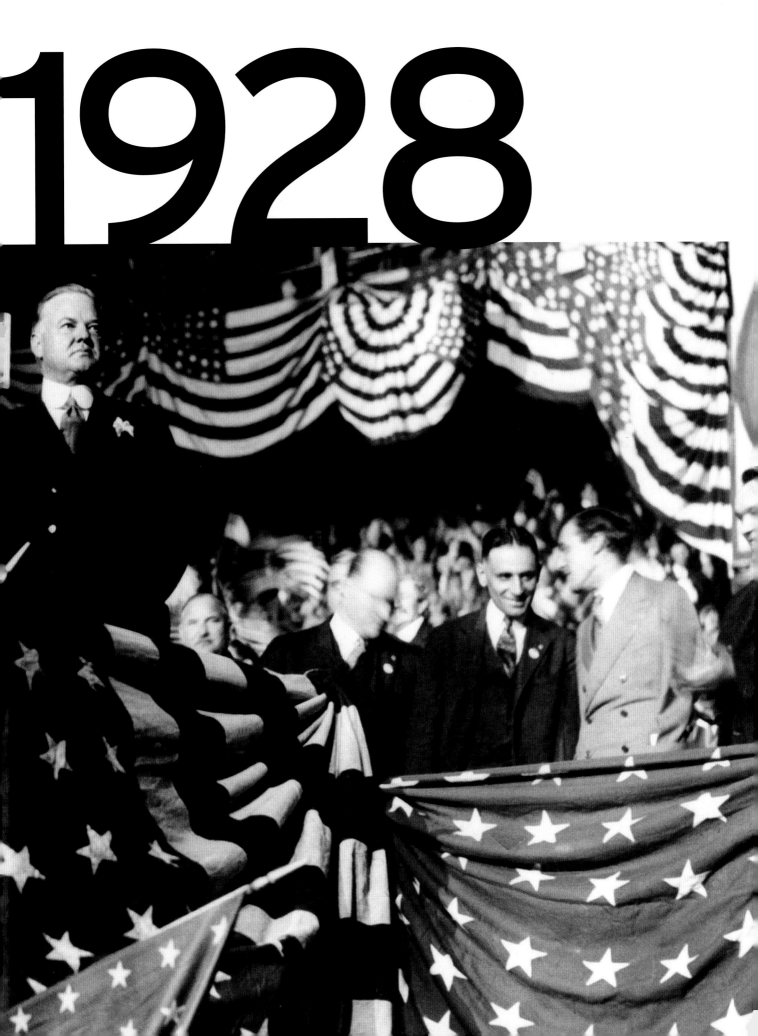

A Return to Normalcy

Normalcy over nostrums; healing over heroics. These were the words that defined Warren Harding's campaign for president in 1920, and a more apt description of American politics from 1916 to 1928 is difficult to imagine. By the 1920s, the country was exhausted from the great battles of Progressivism. Retrenchment was under way, and the country was in a conservative, isolationist mood. The result was the election of some of the most colorless and detached leaders in American history. By the end of the decade the country would soon find itself on the cusp of a new and defining era, but first came the calm before the storm.

The era began with an election campaign that was defined as much by what *didn't* happen as by what did: One candidate refused to take the nation to war, and his opponent neglected to shake a governor's hand.

When Wilson began his reelection campaign in **1916,** he could have run on an impressive record of progressive accomplishment. Instead, Wilson chose to remind Americans that "He Kept Us Out Of War." The slogan became the rallying cry of Democrats and one of the most effective campaign messages in American history.

Wilson faced off against Supreme Court Justice Charles Evans Hughes. While Teddy Roosevelt briefly flirted with the idea of running again, he reluctantly supported Hughes, whom he dubbed "a bearded iceberg." An aloof and listless campaigner, Hughes had trouble developing a coherent theme of attack against Wilson. Worse, he upset Progressives during an August trip by failing to meet with one of their national leaders, California governor Hiram Johnson (Roosevelt's 1912 running mate). Dubbed the "forgotten handshake" by journalists, the slight would prove crucial for Wilson, who enjoyed strong Progressive support. In addition, TR's increasingly bellicose calls for war hurt Hughes by association. Wilson was able to use Roosevelt's warmongering to his advantage. The first incumbent president to

campaign actively, Wilson hammered away on his pacifist theme, warning of war if Hughes won.

Nonetheless, the reunified Republican Party posed grave challenges to Wilson. When the returns began trickling in on election night, it appeared that Hughes would be victorious. But his snub of Johnson came back to haunt him; Hughes lost California, and thus the presidency. With his message of peace and prosperity, Wilson became the first Democrat in eighty-four years to be reelected for consecutive terms. Less than six months later, the man who pledged to keep the nation out of conflict was seeking a declaration of war from a joint session of Congress.

By **1920,** however, the political landscape was again dramatically transformed. In the wake of World War I, Progressivism had lost much of its appeal for most Americans. The country was in the grips of the anti-Communist "Red Scare," and the electorate was angry with Wilson's failed foreign crusade for peace and growing economic problems at home. Moreover, Wilson himself, who had suffered a stroke in 1919, was in no position to run for reelection.

The Republicans were so confident of victory that they didn't even bother to nominate their strongest contender; they instead broke a convention deadlock by choosing Senator Warren G. Harding.

Looking back today, it's difficult to imagine a weaker presidential candidate than Warren Harding. He was prone to gaffes, drank heavily, and was plagued by rumors of extramarital affairs (true), an illegitimate child (true), and Negro ancestry (false). Harding also had a weak heart, a fact that would make the selection of Calvin Coolidge as his running mate particularly crucial. Yet when party leaders asked whether anything in his past might hurt his chances, Harding amazingly answered no. However, Harding was not without advantages: Some aides thought his good looks would work in his favor for the first election in which all women cast a ballot.

Moreover, Harding's revival of front-porch campaigning was an effective antidote for the nation's anxiety. Supporters traveled to Harding's Marion, Ohio, home

to hear his soothing message that "America's need is not heroics, but healing; not nostrums, but normalcy; not surgery, but serenity." After eight years of high-minded rhetoric from Wilson, the American people were anxious for a return to quieter, less ambitious times.

The demoralized Democrats selected Ohio governor James Cox as their nominee, but Wilson's unpopular shadow hovered over the party, and few believed Cox could win. The Democrats did generate some excitement by selecting the young assistant secretary of the navy, Franklin Delano Roosevelt, as the vice presidential nominee. Roosevelt and Cox campaigned hard, but to no avail; with more than 60 percent of the popular vote, Harding won one of the great landslides in American history. (The perennial socialist candidate Eugene Debs won nearly a million votes while imprisoned in a federal penitentiary for antiwar activities).

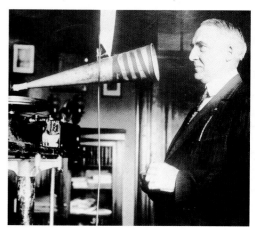

Warren Harding records a campaign message.

Today, Harding's presidency is synonymous with scandal, corruption, and mediocrity. The man himself once conceded, "I am not fit for this office and should never have been here." Two years into his term he died of a heart attack, thrusting Calvin Coolidge into the White House.

Though little remembered today, "Silent Cal" was one of America's most popular presidents. With the country experiencing unparalleled prosperity, and conservatism on the rise, Coolidge reflected the American people's desire for less, not more, from Washington. As he pointed out, "the business of America is

business," and in the 1920s business was booming. Content with their lot, Americans spent little time worrying about overseas affairs. While Coolidge's tempered guidance stood in sharp contrast to the otherwise "Roaring Twenties," it was exactly what Americans wanted from their leader.

The Democrats, for their part, found themselves in an uproar. For decades, the party had been mired in a simmering dispute between its rural South and growing urban Eastern blocs. At the **1924** Democratic Convention, things finally came to a boil in the most raucous and discordant convention yet.

The twin catalysts were Prohibition and the Ku Klux Klan. The Eastern Democrats' standard-bearer, the Catholic New York governor Al Smith, wanted the convention to support an end to Prohibition—and to condemn the racist, anti-Catholic, and anti-immigrant KKK, which was becoming an increasingly violent and disturbing voice in American society. Smith was opposed by Wilson's former treasury secretary and son-in-law, William McAdoo, who sought to reawaken the turn-of-the-century Bryan coalition by trumpeting "dry" Western values. Though he never endorsed the KKK, McAdoo was happy to look the other way. After days of debate, an anti-Klan resolution was finally defeated by a single vote. And the divisive debate, broadcast

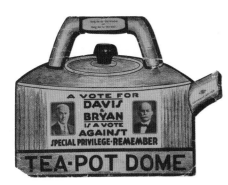

A Democratic reminder of Harding's Teapot Dome corruption scandal

through the new technology of radio, was heard by most of the nation.

Ultimately, neither McAdoo nor Smith was able to garner a two-thirds

The Progressive Party's Robert LaFollette

majority of the delegates. In a sweltering Madison Square Garden, fights broke out among the delegates; ballot after ballot was cast with no winner in sight. Will Rogers joked that New York City had invited the delegates to visit, not to live. Finally, after nine days and an extraordinary 103 ballots, a compromise candidate emerged: John W. Davis from West Virginia. He was doomed from the beginning.

Progressives, who remained a political force in the country, cast their lot with Wisconsin senator Robert LaFollette under the banner of their party. The combination of Coolidge's popularity, the Democrats' debacle in New York, and LaFollette's strong third-party showing contributed to the most sobering defeat in Democratic history. Though Coolidge gave only one speech during the campaign, he won a clear majority. Davis mustered a mere 29 percent of the vote. Only four years after controlling the White House, the Democrats were again in disarray.

What the 1920 and 1924 elections lacked in excitement was more than made up for in 1928, with an election that was truly a study in personal and political contrasts. On one side was the dour Herbert Hoover, on the other the cigar-smoking, back-slapping Al Smith. Yet what might have been a high-minded campaign of differing principles was marked by some of the most vicious attacks in presidential campaign history.

Today, Herbert Hoover is generally remembered for presiding over the Great Depression. Yet when he ran for president in **1928,** Hoover had as impressive

a resume as any man who sought the job. A wealthy businessman, Hoover had helped provide food aid for millions in war-torn Europe. As Coolidge's commerce secretary, he cultivated a strong, progressive image. When Coolidge chose not to run again, Hoover easily won the Republican nomination.

His Democratic rival, Al Smith, was an energetic and vigorous campaigner. With his thick Lower East Side accent, he brought an unceremonious, down-to-earth approach to the campaign trail. But Smith's campaign was bedeviled by attacks on his character. From murmurs about his Tammany Hall roots to allegations of alcoholism, every imaginable charge was raised against the Democrat. Hoover's surrogates alleged that Smith supported intermarriage between whites and blacks. Religious leaders were particularly harsh, speculating that a Catholic president would annul Protestant marriages or bring the Pope to live in Washington. Some even alleged that eternal damnation awaited those who voted for Smith. While it's doubtful that any Democrat could have won in 1928, Protestant-dominated America was clearly not ready to put a Catholic in the Oval Office.

If the 1928 race carved a lasting impression on the American campaign tradition, it was in the emergence of radio as a mass-media tool by both candidates. Though Smith was the far livelier speaker, radio helped Hoover, who sounded statesman-like when compared to his raspy-voiced rival. With the country enjoying prosperity, most Americans saw little reason to cast the Republicans out of office. Hoover's pledge to put "a chicken in every pot and a car in every garage" resounded with voters; he won 444 electoral votes—including those of Smith's native New York. Yet there were foreboding signs on the horizon, as the country was only a year away from its worst economic downturn in history. What in 1928 seemed like a runaway train of GOP electoral success was about to come to a screeching and lasting halt. ❏

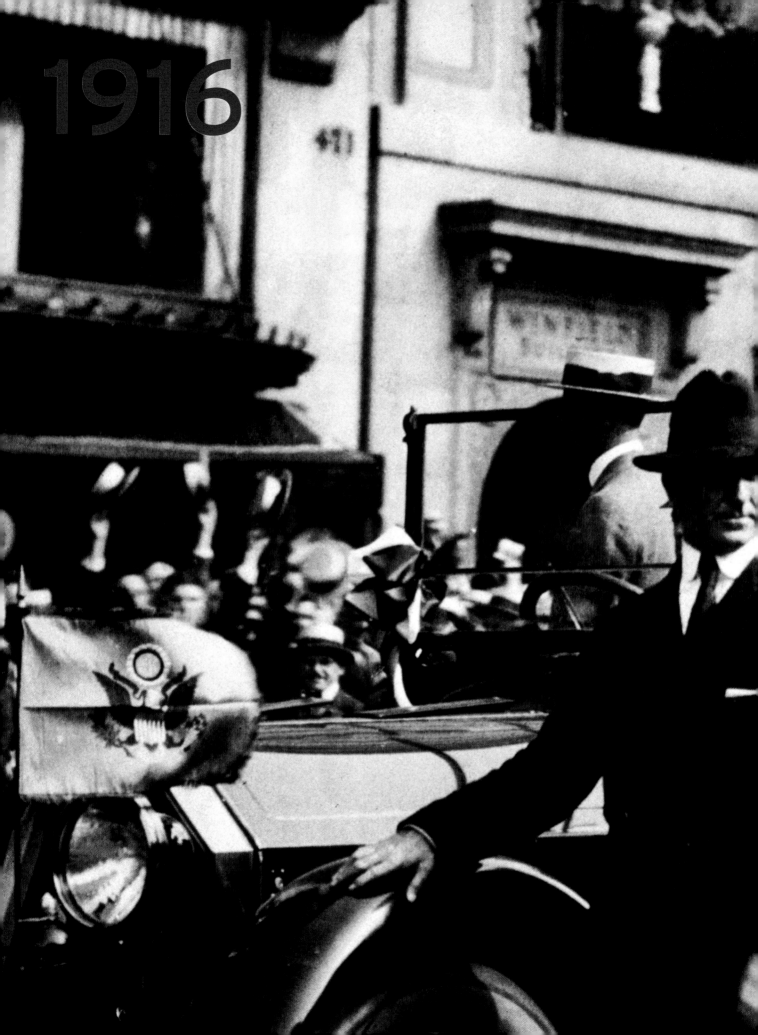

1916

Wilson was the first president to campaign actively for his own reelection.

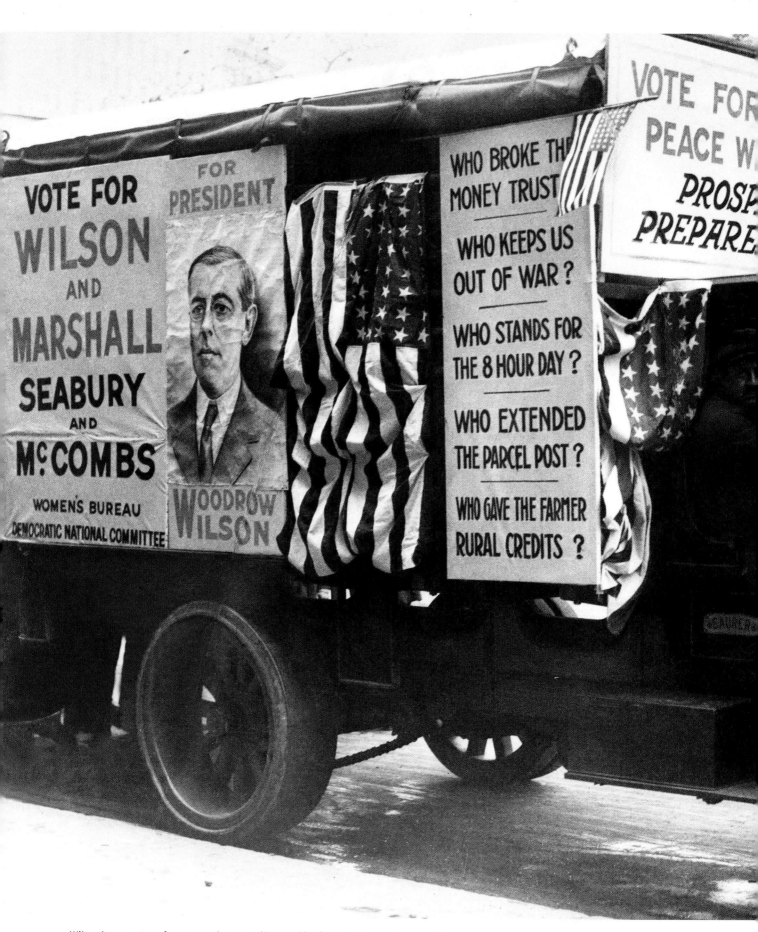

Wilson's message of peace and prosperity won him four more years in the White House.

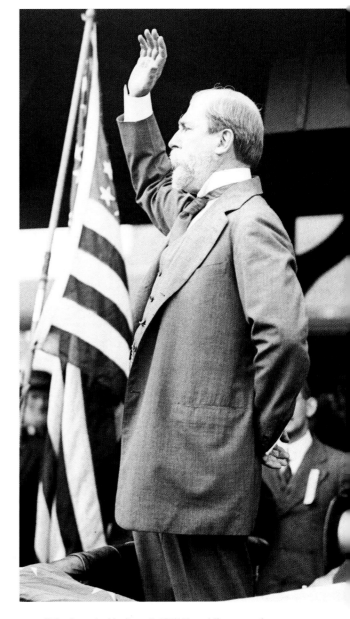

"The bearded iceberg": 1916 Republican nominee
Charles Evans Hughes.

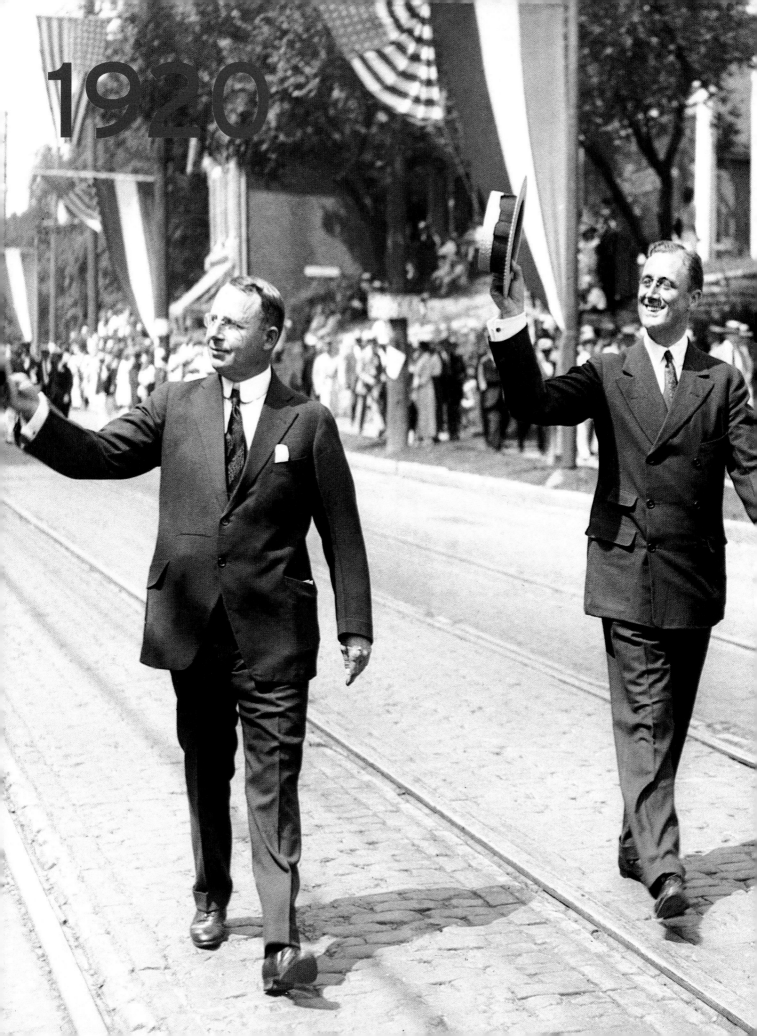

1920

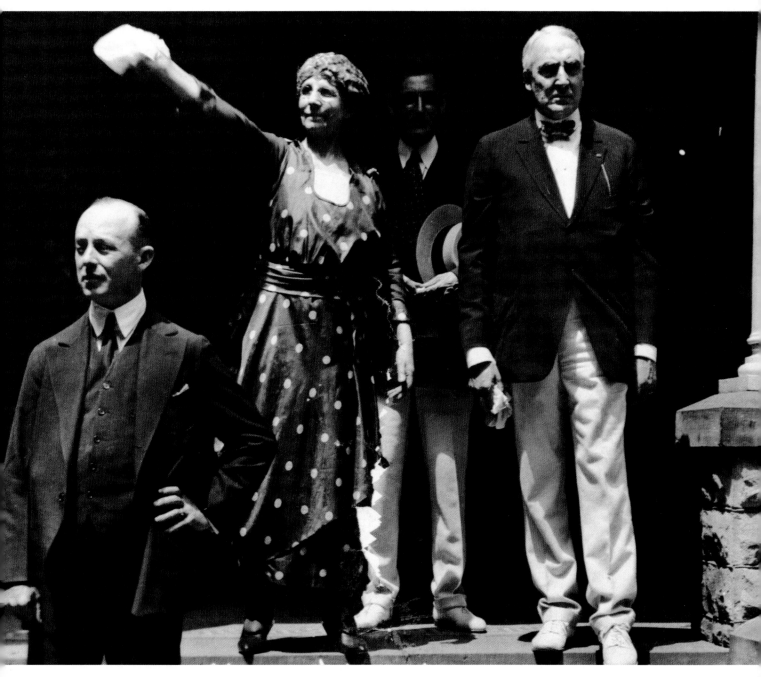

Warren Harding ran for president in 1920 from the front porch of his Marion, Ohio, home.

OPPOSITE: Democratic nominee James Cox with his running mate, the young Franklin Delano Roosevelt.

1924

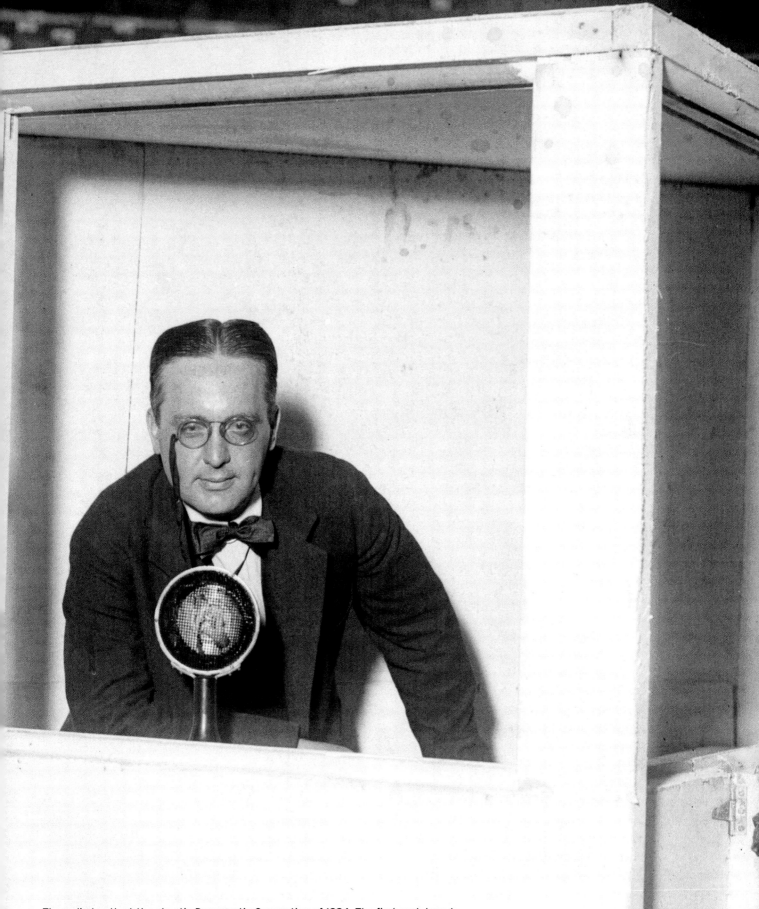

The radio booth at the chaotic Democratic Convention of 1924. The first such broadcast, it proved an inauspicious beginning for national convention coverage.

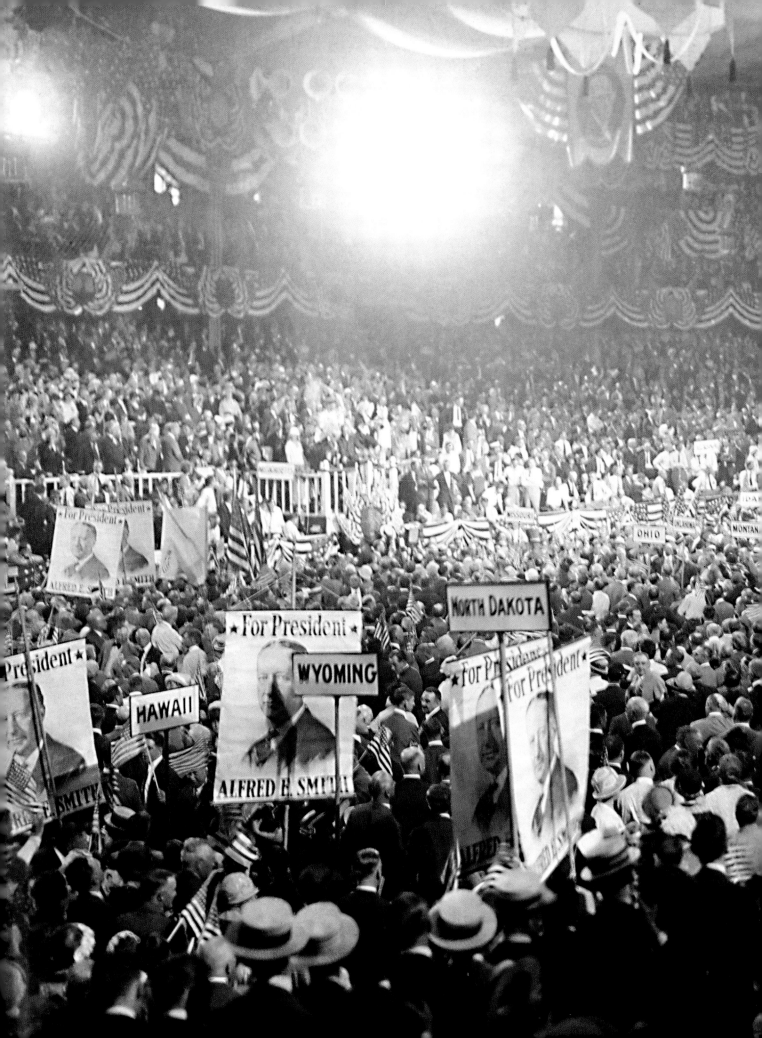

The convention lasted nearly two weeks, with delegates casting 103 ballots before settling on a nominee.

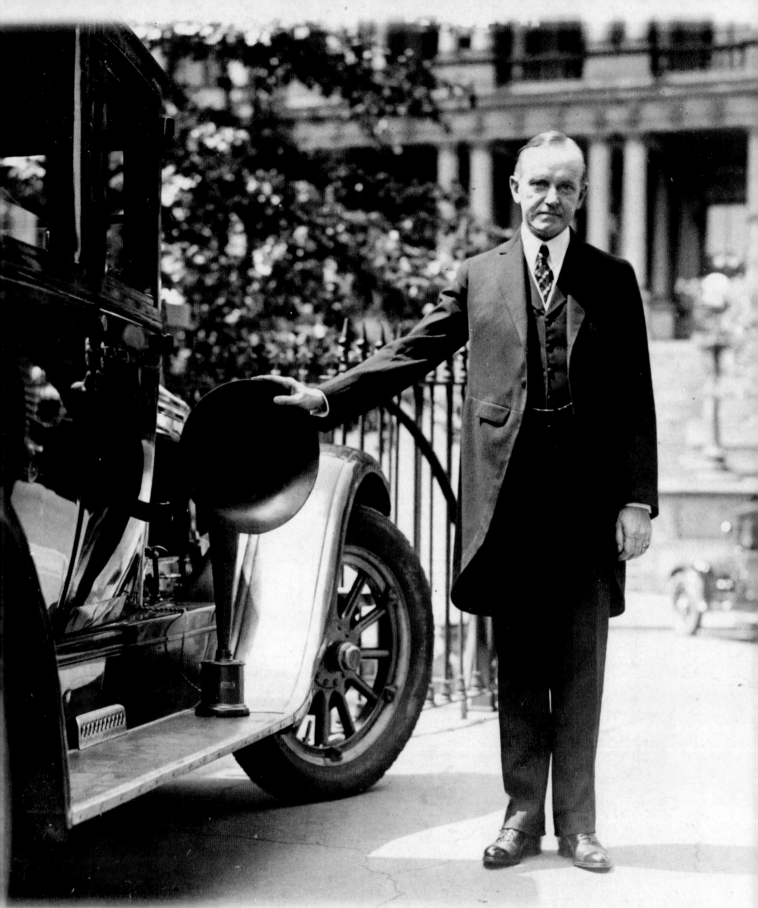

Even "Silent Cal" got into the broadcasting act, posing with his truck-mounted radio facilities.

OPPOSITE: Coolidge accepts the Republican nomination.

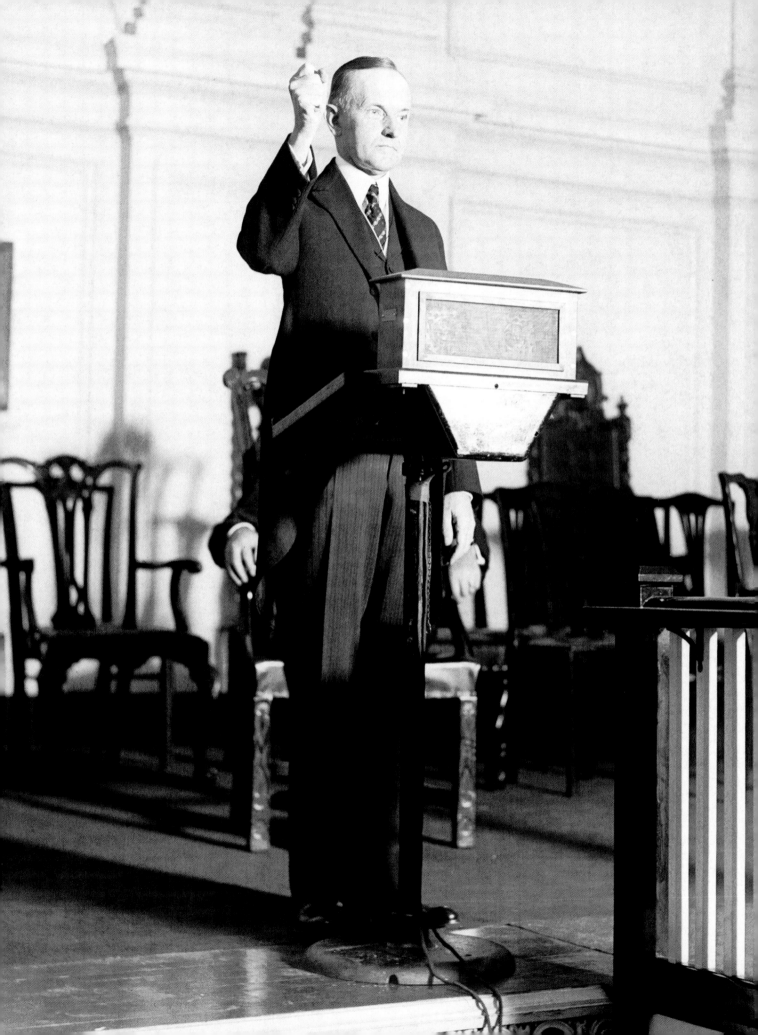

1928

"Talking pictures" made their first appearance in the 1928 campaign.

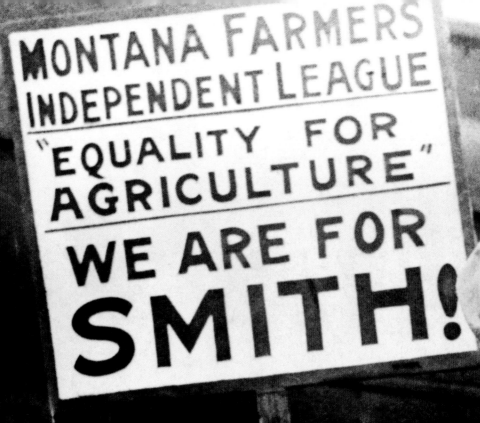

ABOVE: Herbert Hoover campaigning in Tennessee. His impressive showing in the traditionally Democratic South was bolstered by his supporters' racist attacks on Al Smith.

The ebullient Al Smith brings a taste of New York to Montana voters.

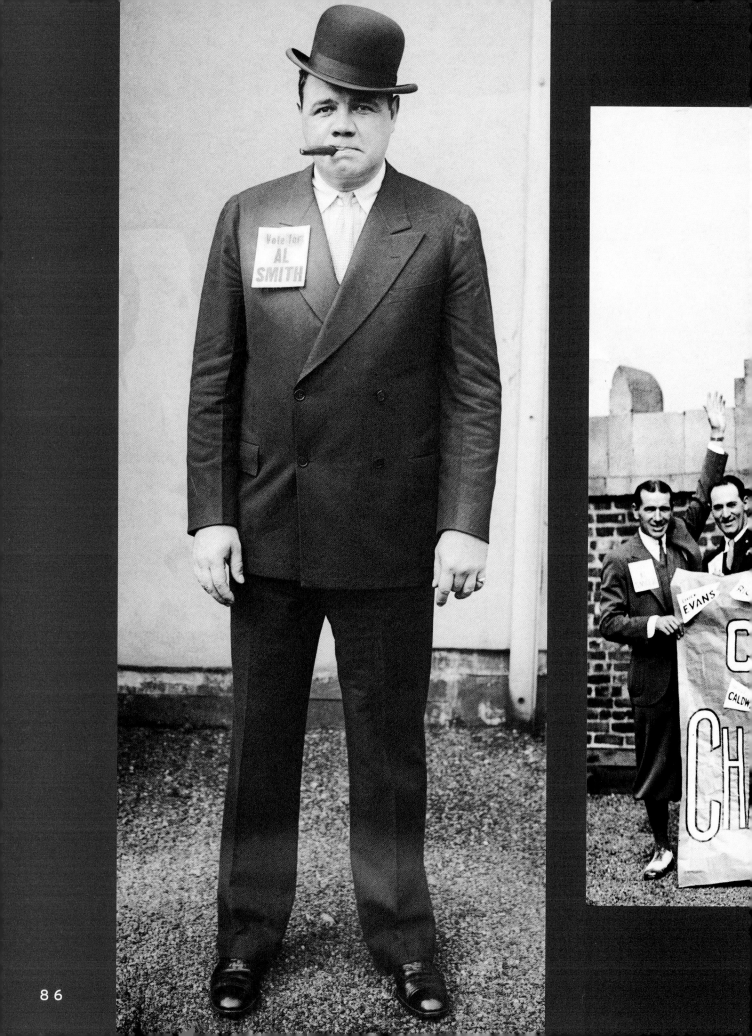

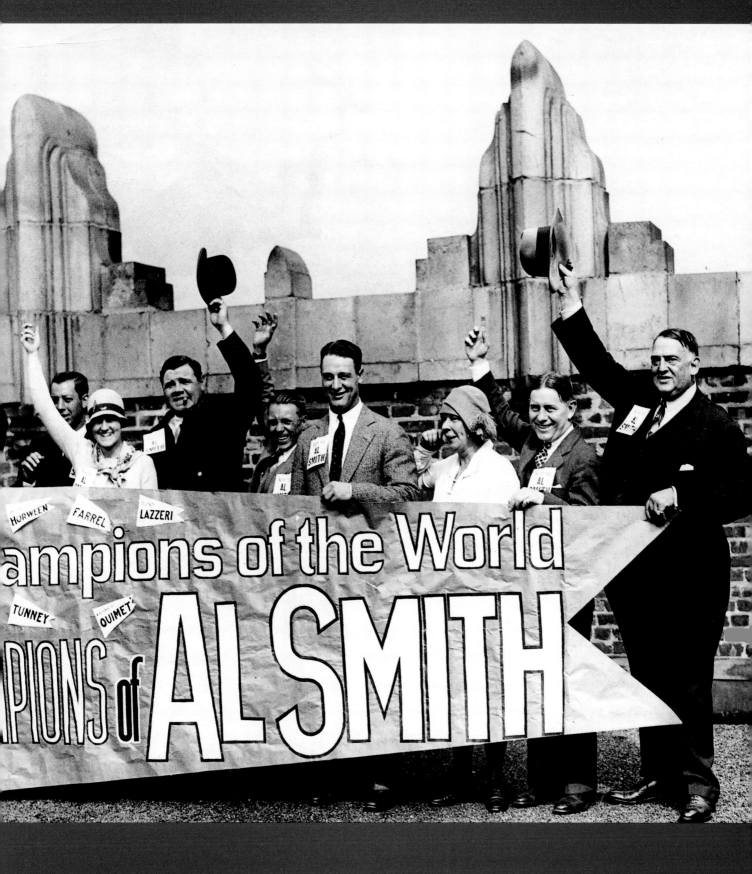

Al Smith may have been trounced by Hoover In 1928, but at least he had the support of Babe Ruth and the world champion New York Yankees.

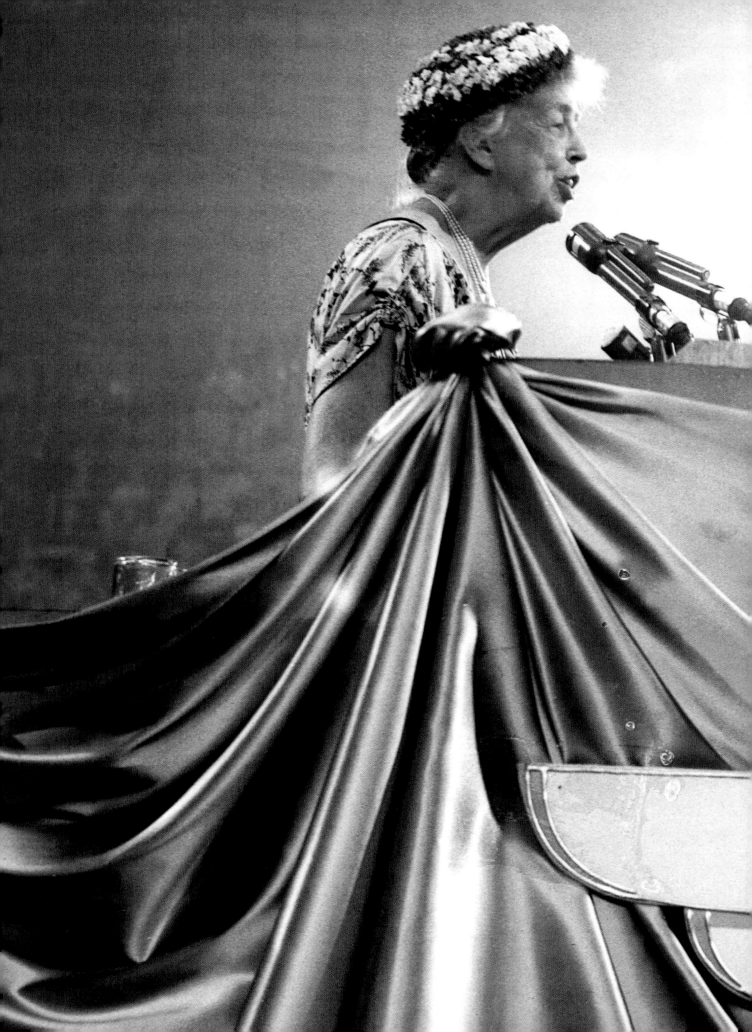

CAMPAIGNS &
WOMEN

1956
DEMOCRATIC

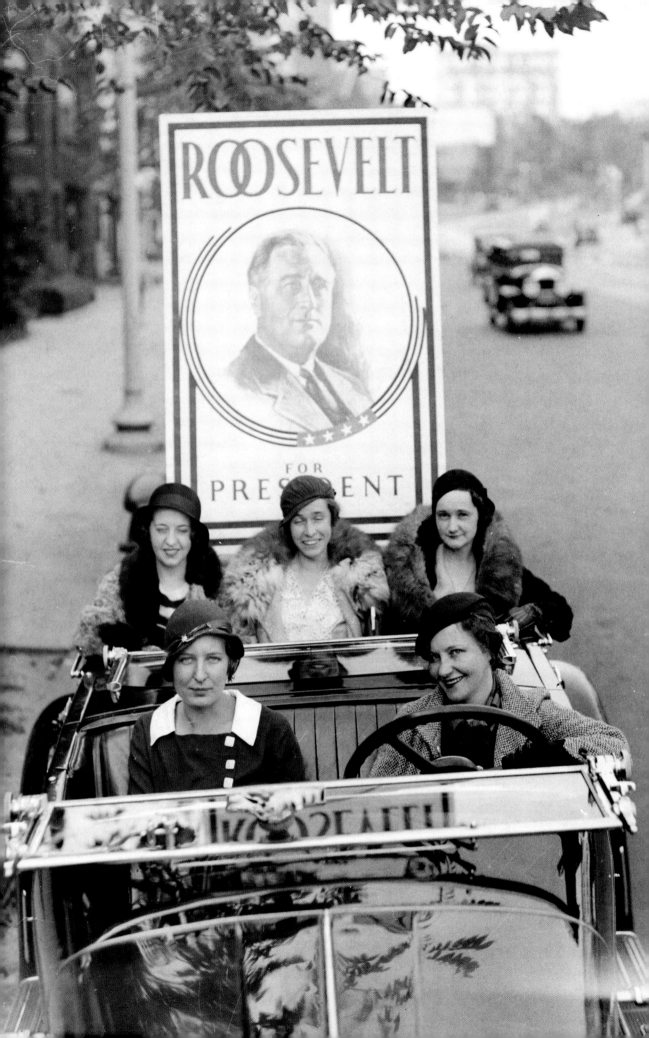

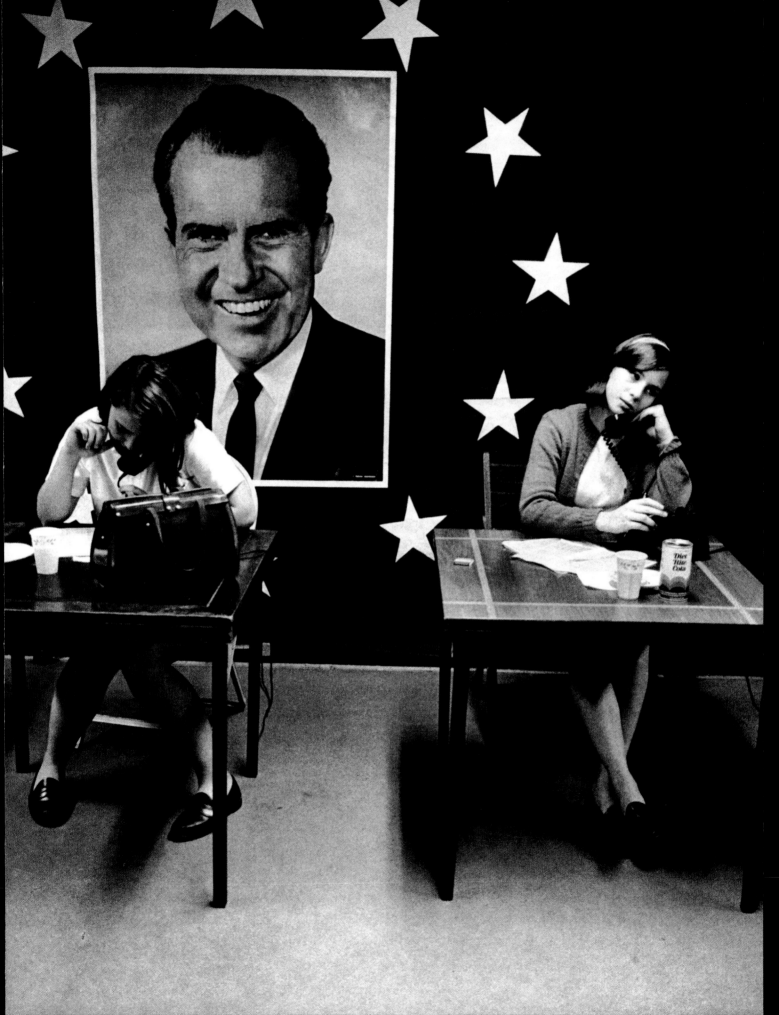

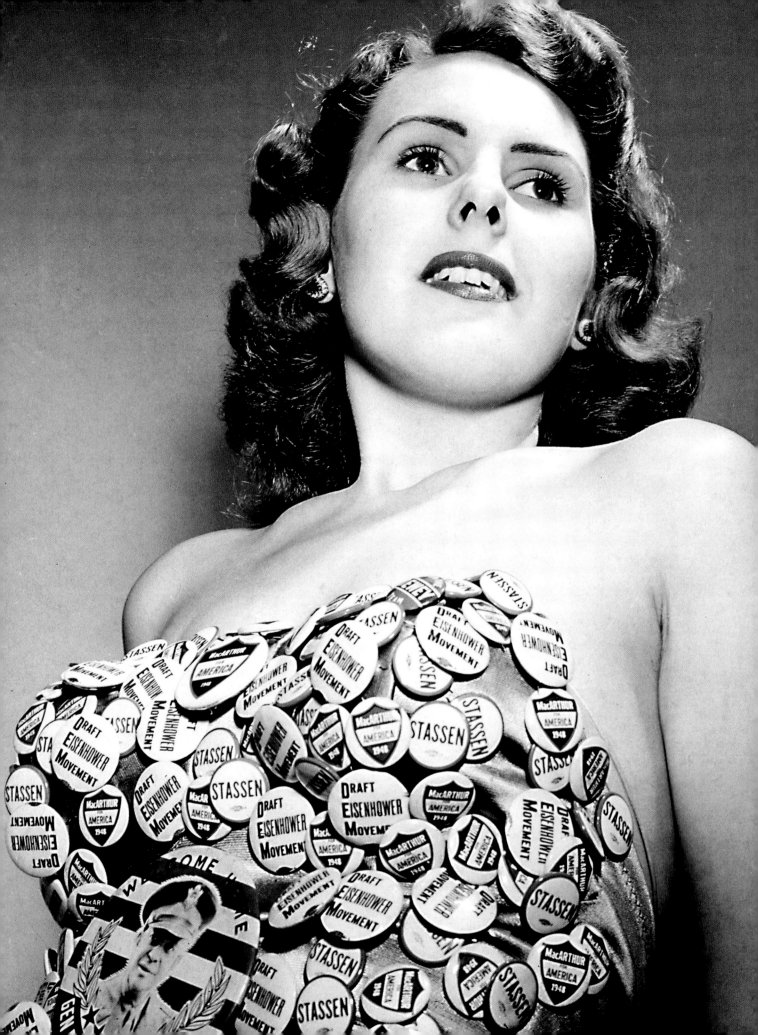

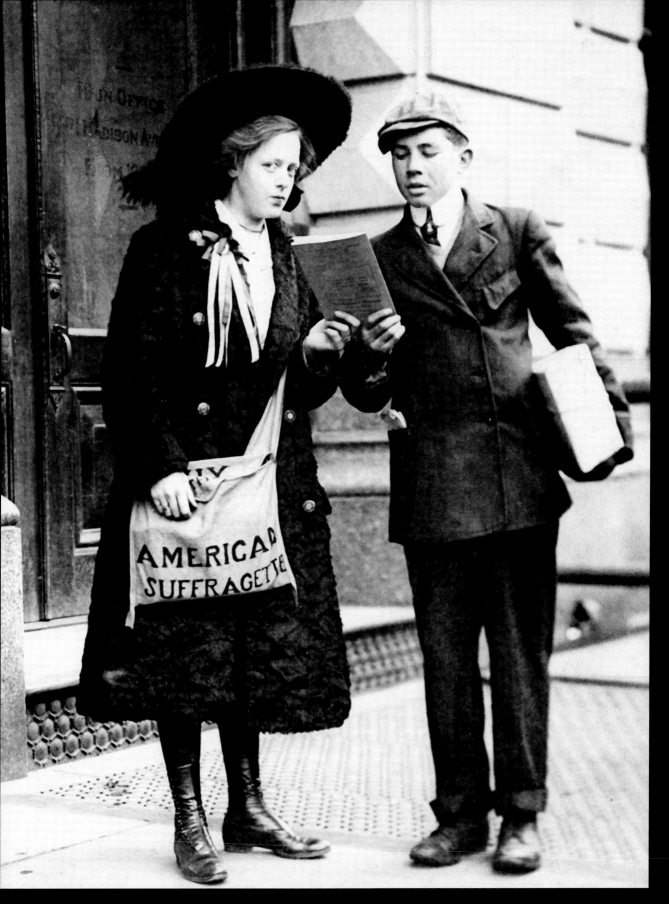

Throughout the late nineteenth and early twentieth century,
suffragettes actively campaigned for the rights of women.

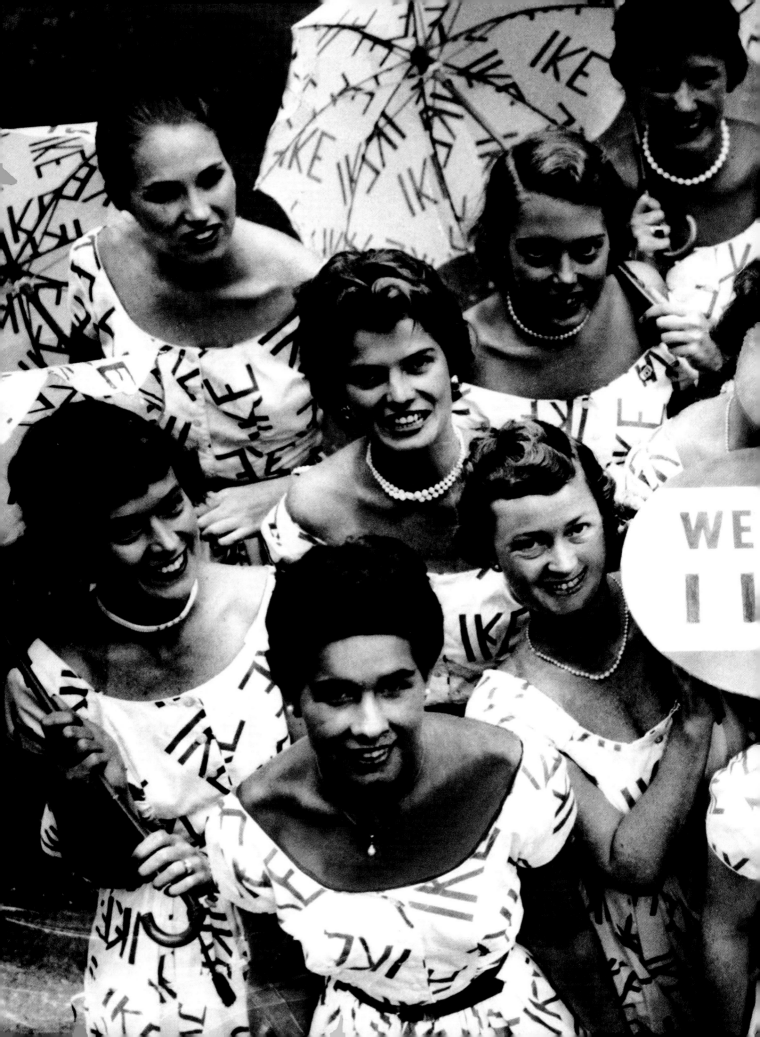

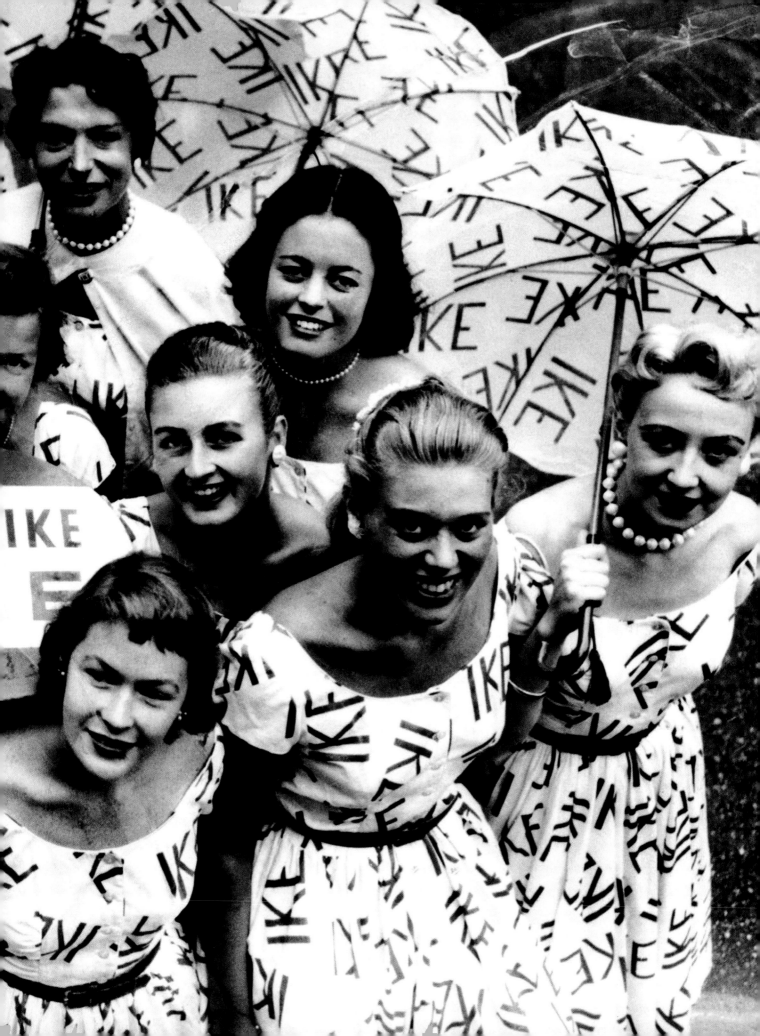

Though the fight for national women's suffrage would continue until 1920, by the time of this 1908 cartoon several states already were allowing women to vote.

VOTES for WOMEN

JAN 21 1903

Copyright 1909 E.W. Gustin

Election Day!

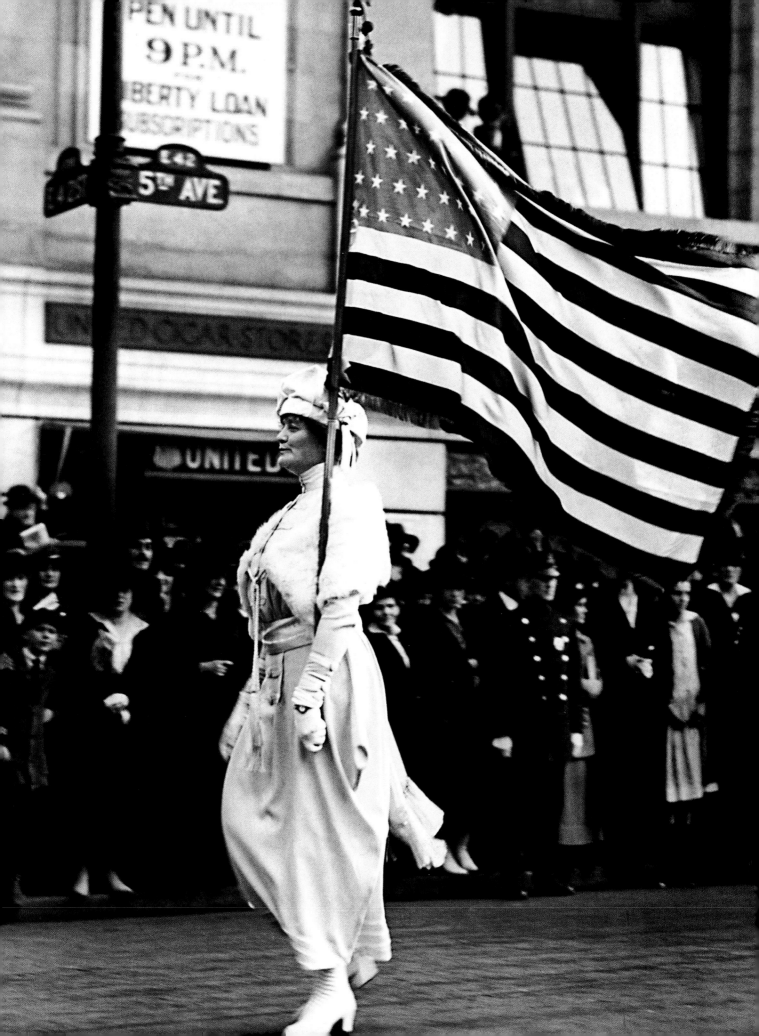

Pat Nixon, the epitome of the long-suffering political wife

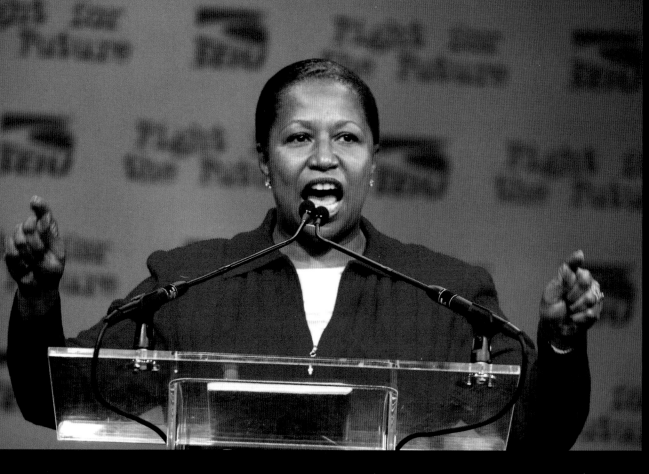

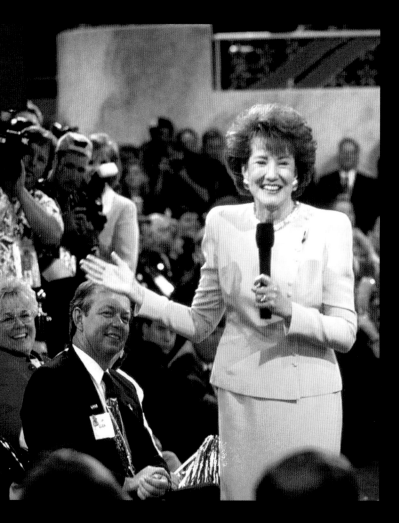

Former Senator Carol Moseley Braun, the first African-American woman to serve in the U.S. Senate, waged a long-shot campaign for the presidency in 2004.

Elizabeth Dole, who stumped impressively for her husband at the 1996 convention, launched her own short-lived bid four years later.

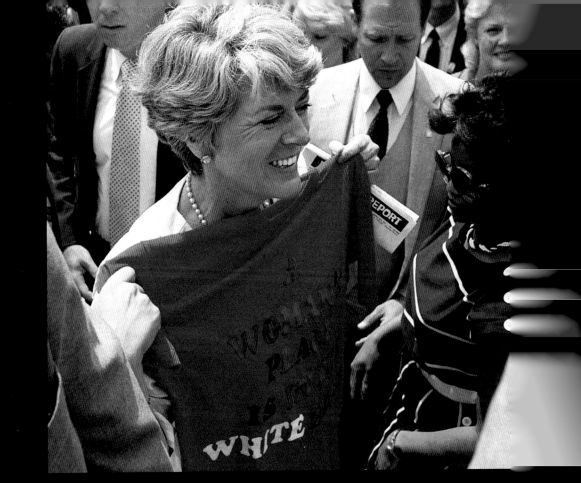

Geraldine Ferraro became the first woman to appear on a presidential ticket when she was selected as Walter Mondale's running mate in 1984.

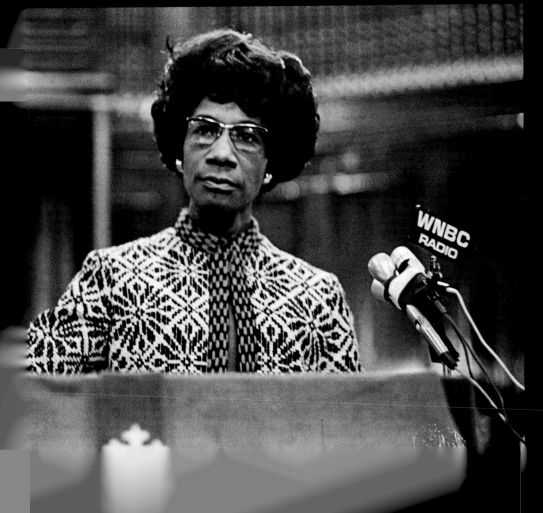

Shirley Chisholm: In 1972, she became the first African American to seek a major party nomination.

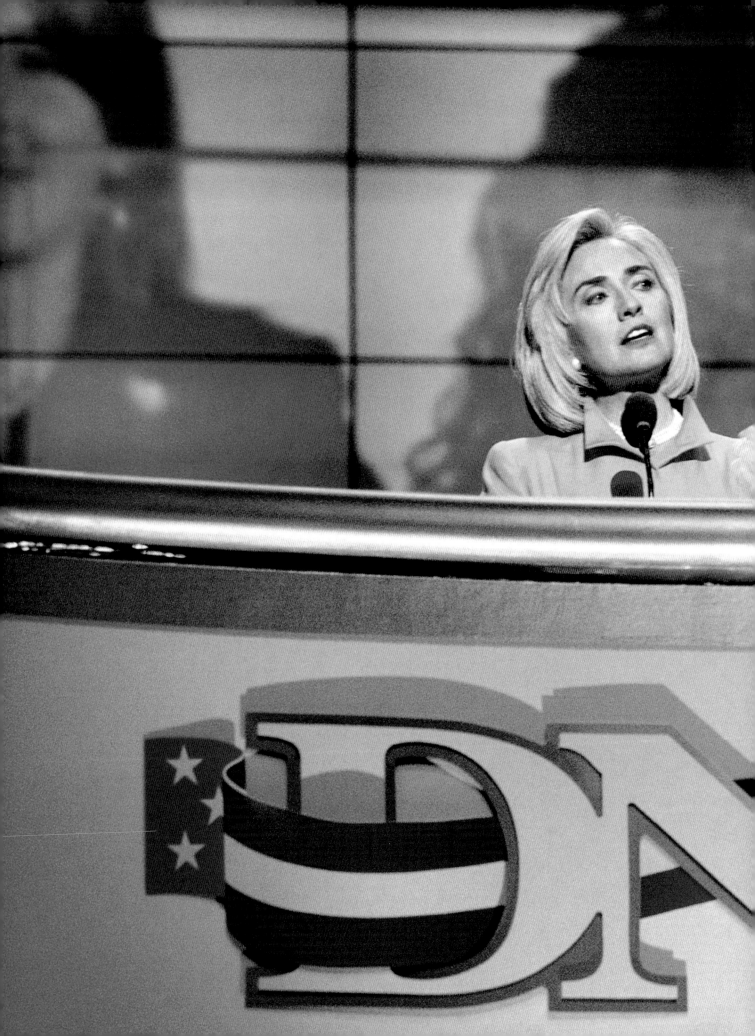

Throughout the 1990s, Hillary Clinton
was both lightning rod and inspiration.

1932-

1948

The Great Depression: the age of bread lines, Hoovervilles—and Franklin Roosevelt's New Deal.

n the fall of **1932,** America found itself mired in the worst economic depression in the nation's history. Unemployment was at record levels, bank failures and farm foreclosures were on the rise, bread lines snaked around street corners, and ramshackle "Hoovervilles" sprang up to house the homeless and indigent around the nation. The country was desperate for new leadership and new ideas. Into the breach stepped Franklin Delano Roosevelt, who brought to the White House a vitality and daring experimentation rarely seen before.

In a fitting show of boldness, Roosevelt flew from the governor's mansion in Albany to the Democratic Party convention in Chicago to accept his nomination in person—becoming the first presidential candidate in history to make such an appearance. There Roosevelt pledged a "New Deal for the American people," creating in the public mind a sharp contrast to four years of President Herbert Hoover's inattention toward the nation's economic crisis. After twelve years in the political wilderness, Democrats sensed that their time had come. Conversely, Republicans were so despondent about Hoover's chances of reelection that they didn't bother to display any pictures of their nominee at the party convention.

Though he was crippled by polio, Roosevelt cultivated an aura of vigor and activity on the campaign trail. Roosevelt kept his infirmities secret by tightly gripping his son James's arm or the railing of his train car to allow him to stand; as a result, many Americans had little idea of his true physical state.

Though his background was that of a New York patrician, Roosevelt's common touch resonated across class lines. FDR was a hero to the working class, ethnic voters, farmers, and African-Americans, who would come to form much of the so-called "New Deal coalition," which dominated Democratic politics for the next thirty years. Conversely, for many wealthy Americans, Roosevelt was seen as nothing less than a traitor to his privileged, aristocratic background.

Not surprisingly, Roosevelt's message captivated a nation desperate for change. He crushed Hoover, winning 57 percent of the popular vote. It was a feat he would repeat in **1936** when challenged by Kansas governor Alf Landon, who sounded a conventional Republican message of laissez-faire economics, while warning of an erosion of civil liberties under the New Deal. Landon had no chance against FDR, who brilliantly used the emerging medium of radio (by now the dominant political communication tool) as a new and powerful bully pulpit—providing him with unvarnished access to the American people through his legendary "fireside chats." In the throes of economic calamity, Roosevelt's upbeat message gave Americans hope in even the darkest days of the Great Depression.

Roosevelt bested Landon in another overwhelming victory, winning nearly 61 percent of the vote and all but two states. In the Senate, Democrats increased their de facto majority to an extraordinary 80–16 advantage. Many wondered if the GOP could survive such a crushing defeat.

In **1940,** however, Roosevelt would face his first serious challenge—from Wendell Willkie, a political unknown who may have been the most unlikely presidential nominee in the Republican Party's history. An industrialist with no political background, Willkie had been a registered Democrat only a year before seeking the Republican nomination. But what he lacked in political experience Willkie more than made up for with a fiery speaking style and a pledge to bring an internationalist agenda to the GOP. Willkie's supporters organized an aggressive grassroots campaign that gave him a burst of momentum going into the Republican convention. He quickly emerged as the favorite among the assembled delegates, horrifying the old-guard party establishment. With chants of "We Want Willkie" reverberating throughout the hall, Willkie won the nomination. At

the Democratic convention in Chicago, Roosevelt allies organized a "spontaneous" draft—as the president was reluctant to be seen actively spoiling for an unprecedented third term.

During the campaign Willkie hammered away at Roosevelt's bid for another term, warning of "dictatorship" if Roosevelt was given another four years. "Better a third-termer, than a third rater," the Democrats responded, and most Americans seemed to agree. With Willkie's campaign foundering, he began to attack FDR as a warmonger who would plunge the country into conflict overseas.

As Willkie's antiwar stance began gaining traction, the president responded with a famous speech at Madison Square Garden that linked his opponent to three prominent Republican isolationists in Congress—"Martin, Barton and Fish." The triumvirate became a mocking chant in subsequent FDR's speeches, and an albatross around Willkie's neck. After eight years in the White House, Roosevelt still knew the right buttons to push. With the world in crisis, Americans were not inclined to change horses in midstream; though his margin of victory was narrower than in 1936, FDR grabbed 55 percent of the popular vote.

By **1944,** with the nation mired in war, the real drama centered on whom Roosevelt would choose as his running mate. Conservatives had never liked Henry Wallace, FDR's vice president since 1940, and the president's failing health had many of his own advisers genuinely alarmed at the prospect of a President Wallace.

On the eve of the Democratic convention, South Carolina's James Byrnes emerged as the frontrunner. But Roosevelt insisted on running the choice by Sidney Hillman, a key ally in organized labor. "Clear it with Sidney,"

the president ordered. "Sidney" made it clear that Byrnes was an unacceptable pick. The labor movement preferred Harry S Truman, a relatively low-profile senator from Missouri. Truman wasn't particularly interested in the job—even his own mother publicly declared that he should stay in the Senate. After much arm-twisting, though, Truman finally relented.

Roosevelt faced off against Thomas E. Dewey, a former prosecutor and (like Roosevelt) New York governor. Once famously likened to the little man perched on top of a wedding cake, Dewey was running against a president whose unflagging spirit—and popularity—masked his increasing physical deterioration. Washington journalists concealed their suspicion that the president was unlikely to survive another term, although some begged Dewey to raise the issue. Fearing a backlash, Dewey contented himself with references to the "tired, old men" running the government.

Even in failing health, though, Roosevelt still knew how to work his old campaign magic. In a memorable speech that September, he reminded the country of the Republican failures that had led to the Great Depression. He also cleverly responded to a GOP charge that he had sent a battle destroyer to pick up his Scottish terrier, Fala, expressing mock indignation over the accusation.

On Election Day, voters overwhelmingly granted FDR a record fourth term. Just as many of his advisers had feared, however, Roosevelt did not survive his final term. On April 12, 1945, he died from a cerebral hemorrhage—and the compromise choice from Missouri was now in charge.

A few months later World War II finally ended, and with the 1946 Employment Act Truman began his expansion of FDR's New Deal into his own "Fair Deal." Yet these triumphs brought little political gain for the new president. By **1948** Truman was hugely unpopular, and most political observers were convinced that GOP standard-bearer Thomas Dewey would easily win the White House. Republicans had taken control of Congress in 1946, and with Dewey and California governor Earl Warren running

against Truman, the Republicans had the governors of the country's two most populous states on the ticket.

Making matters worse for Truman was the growing dissension in his own ranks. His secretary of commerce, former Vice President Henry Wallace, left the cabinet, and challenged Truman as a candidate of the Progressive Party. At the Democratic convention, a contentious platform debate over civil rights split the party again. Upon passage of a plank supporting civil rights, many Southern delegates walked out and launched their own third-party bid as "Dixiecrats," rallying behind South Carolina's young firebrand governor, Strom Thurmond.

Facing opposition on all sides, Truman appeared bound for a shattering defeat. But that hardly stopped him as Truman used his convention acceptance speech to launch a blistering attack on the Republican-led 80th Congress.

In an unusual approach for an incumbent president, Truman undertook an ambitious whistle-stop campaign. In a foreshadowing of the modern era of campaigning, he traversed the nation railing against the "do-nothing" Republican Congress and warning that a vote for Dewey was a return to the economics of Hoover. Americans responded to his populist, "Give 'Em Hell" tone; the Friday before the election, Truman was welcomed by more than a million well-wishers in New York City. Still, nobody thought Truman would win. Journalists were already speculating on Dewey's agenda as president, and the candidate himself was reported to be planning his inauguration. Even Truman's hometown of Independence, Missouri, failed to plan a victory party.

But it was not to be. By a margin of 2 million votes, Truman scored the single most dramatic upset in American political history, confounding every political observer in the country—including the *Chicago Tribune*, whose famous headline "Dewey Defeats Truman" the president jubilantly held aloft the next morning. The *New York Times* called his victory a "miracle of electioneering."

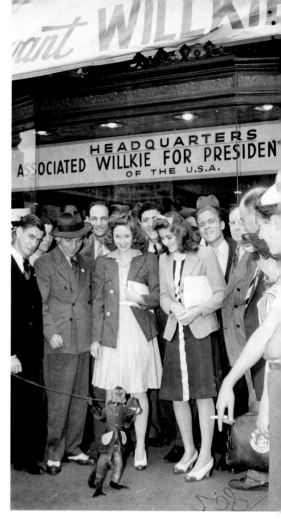

Though Roosevelt prevailed in 1940, Willkie carried the dancing-monkey vote.

It was a moment of classic political hubris: Overconfident, Dewey had "snatched defeat out of the jaws of victory" by barely campaigning—and his Republican supporters stayed home, certain there was no way their man could lose. It certainly didn't help that Dewey was an uninspiring speaker and a detached and cold campaigner who enjoyed support among Republicans but little genuine affection. On the other hand, in a year in which the nation was cresting toward the Republicans, Truman adopted the only campaign style that would garner him reelection: a no-holds-barred partisan approach that would remind Americans of their fears of GOP victory. Truman captivated the American people, helping him to preserve the New Deal voting bloc—giving the Democrats four more years in the White House. ❑

1932

Three years of economic depression doomed Herbert Hoover's chances of reelection.

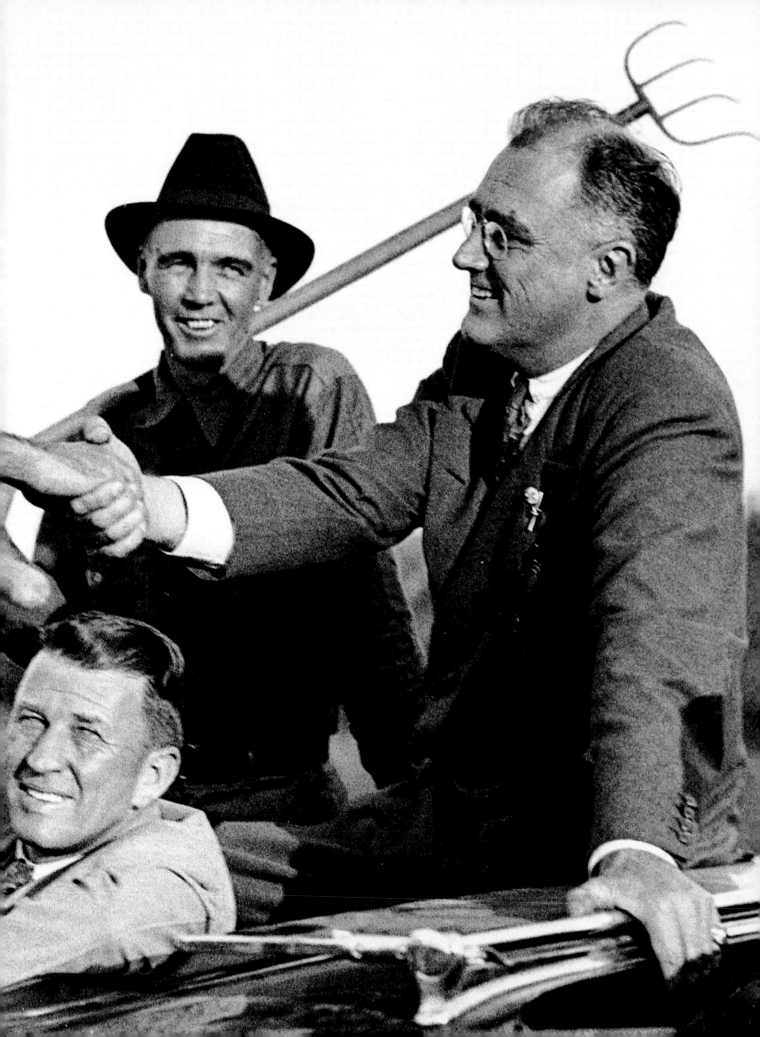

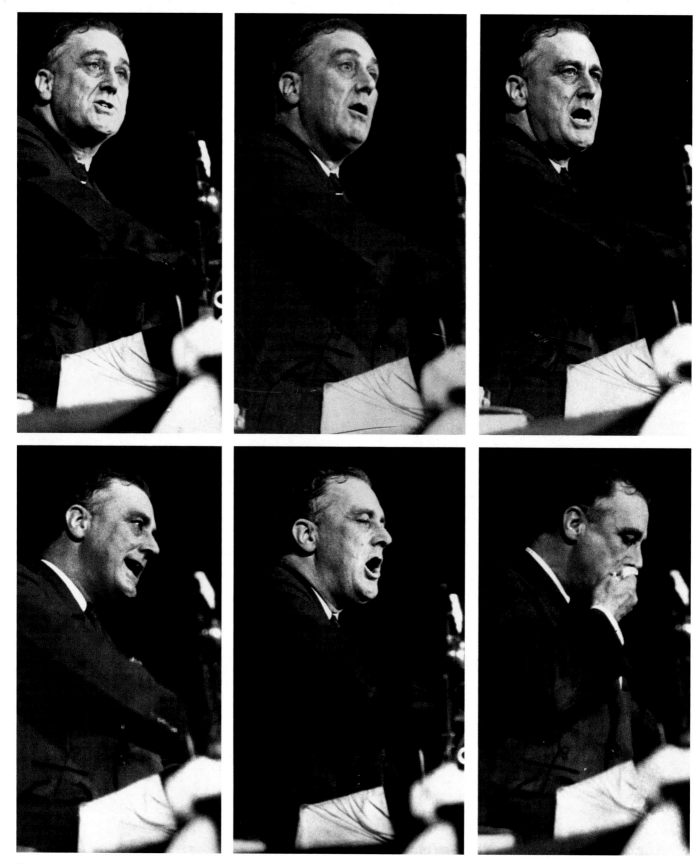

The peerless orator

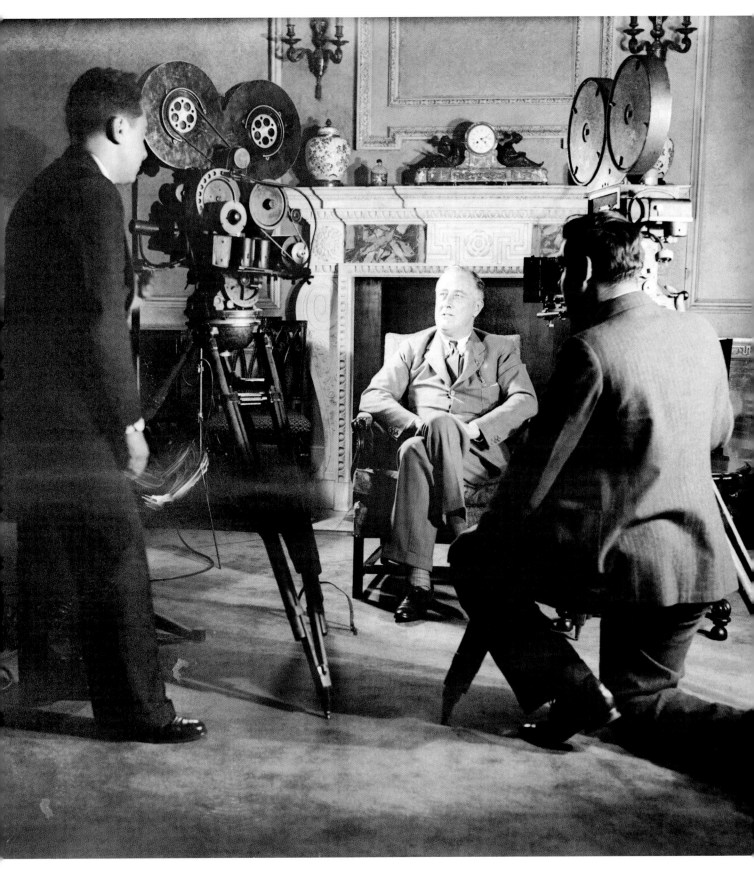

Roosevelt, the media master of his time, making sound newsreels.

1936

Despite his patrician background, FDR's empathy with America's working class propelled him to office a record four times.

A lackluster campaign rally for 1936
Republican nominee Alf Landon

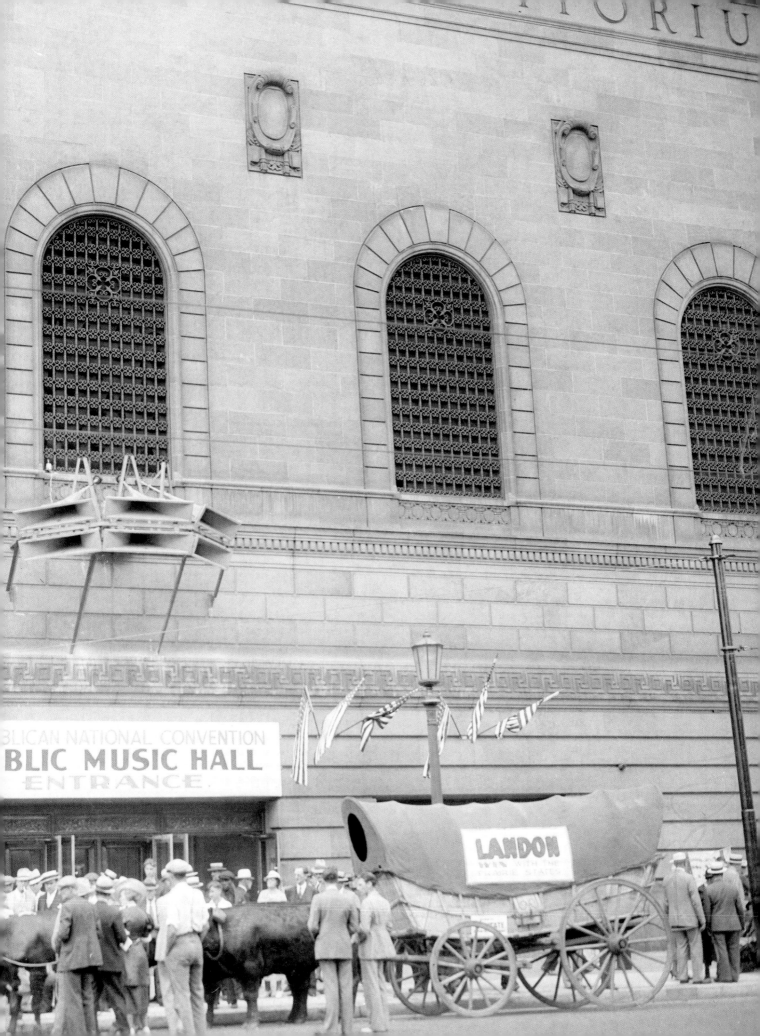

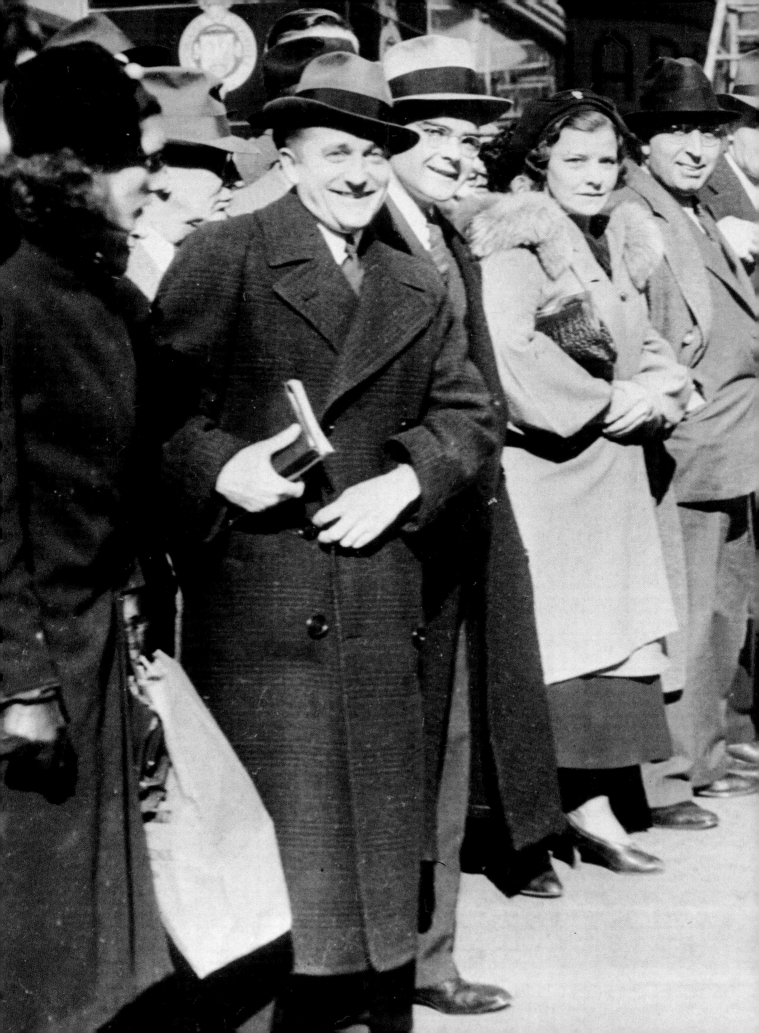

A Chicago waitress who wagered that Landon would win the White House pays off her bet on a cold November afternoon.

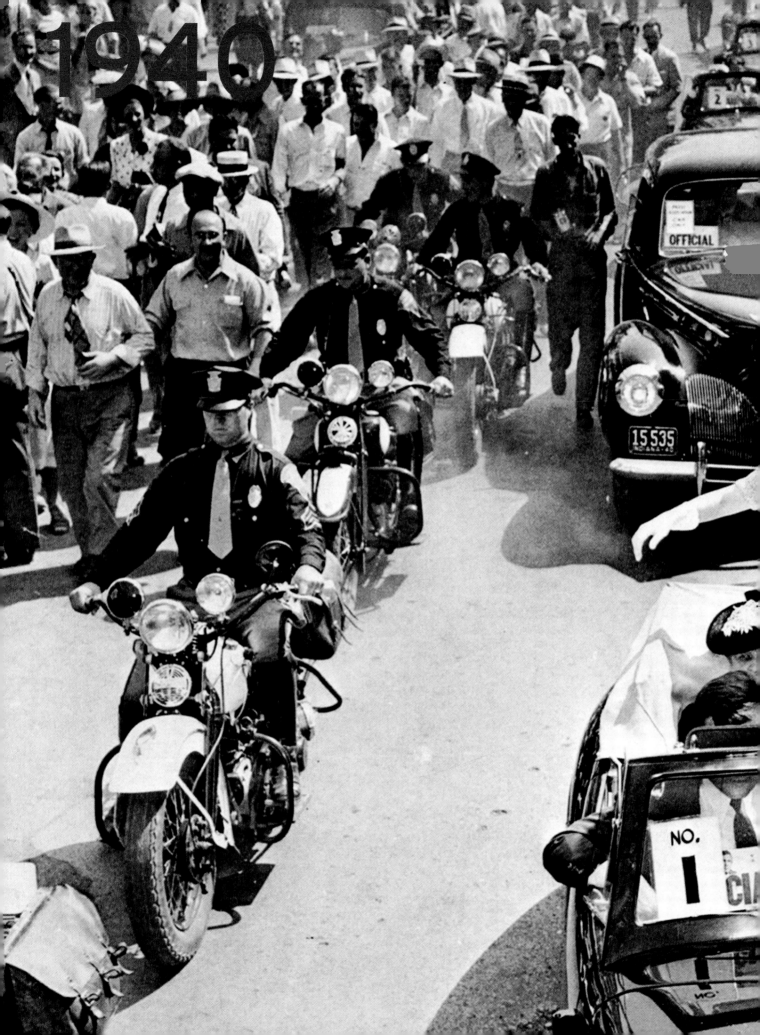

1940

Former Democrat and
political neophyte Wendell Willkie in
his hometown of Elwood, Indiana

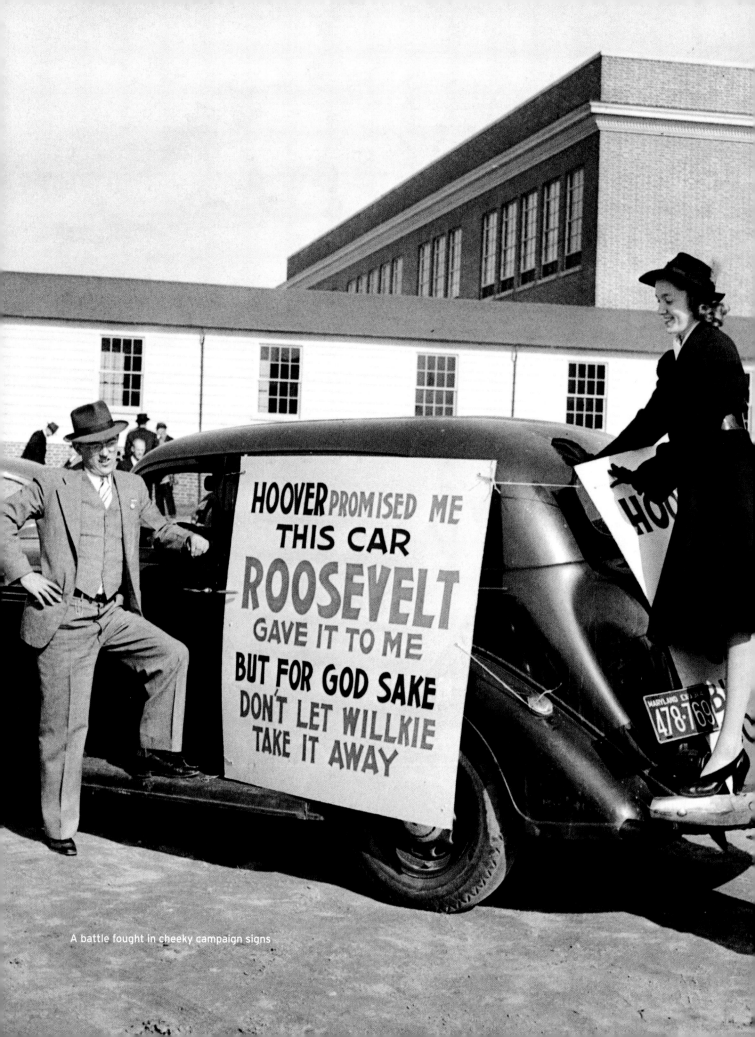

A battle fought in cheeky campaign signs

F.D.R. SALARY $75,000.⁰⁰
8 YEARS
$600,000.⁰⁰
WITH BOARD & ROOM
WHAT DOES HE WANT-
A MILLION ???

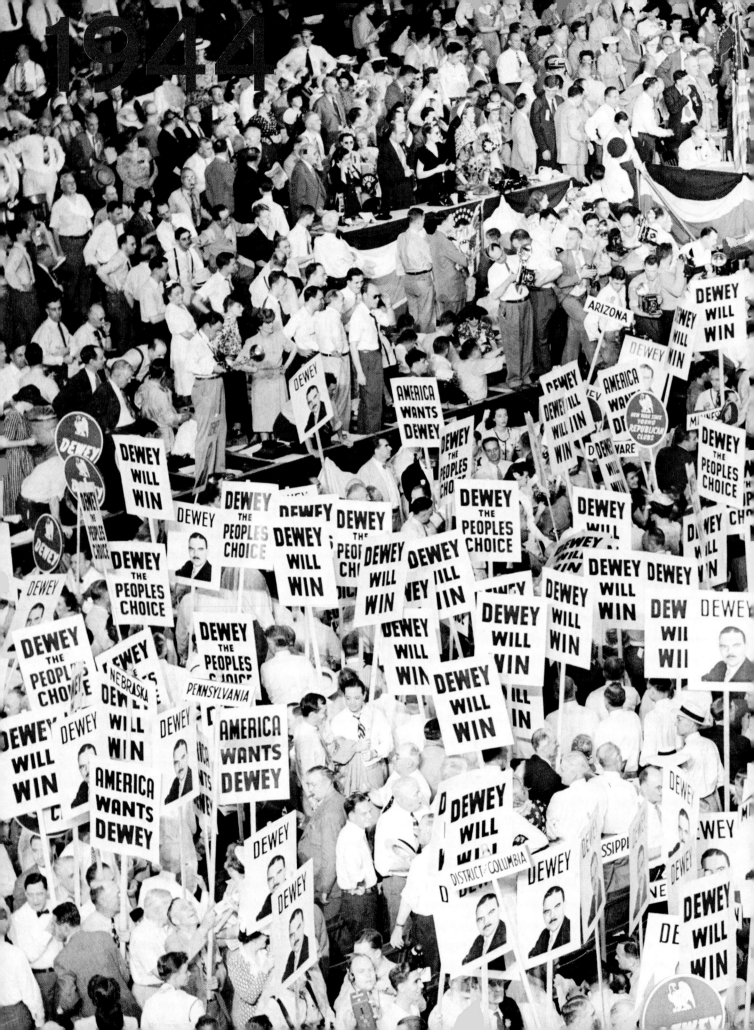

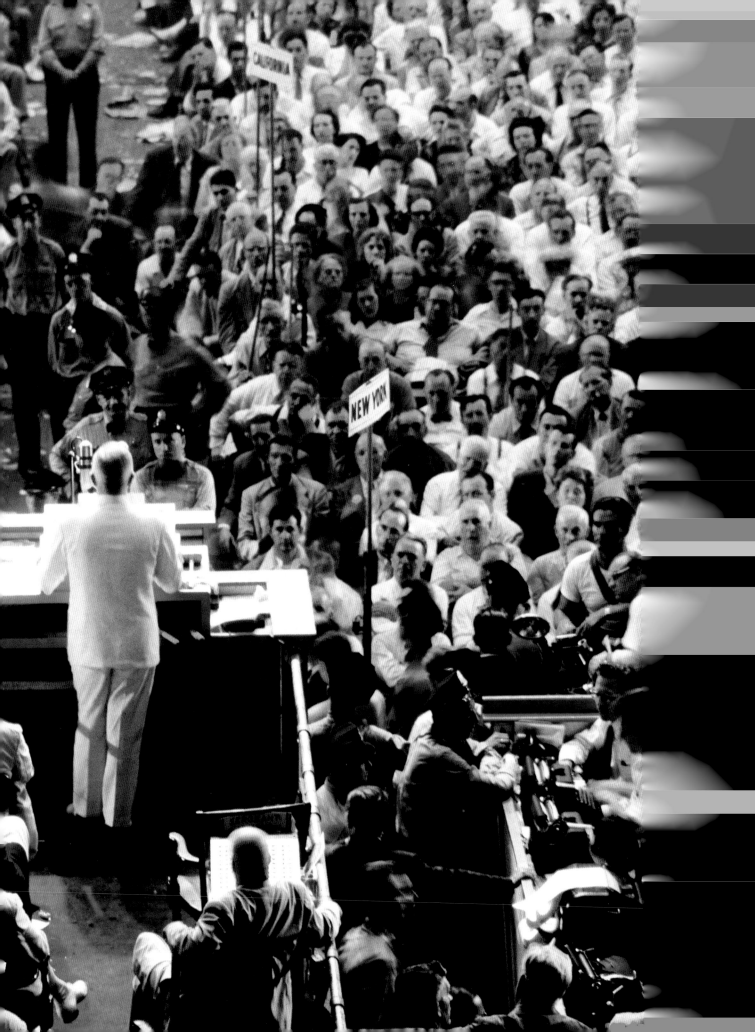

Running on the States' Rights Democratic ("Dixiecrat") ticket in 1948, Strom Thurmond won four states and 39 electoral votes.

Progressive Party nominee Henry Wallace *(right)*, at a campaign rally
with the celebrated actor, singer, and political activist Paul Robeson.

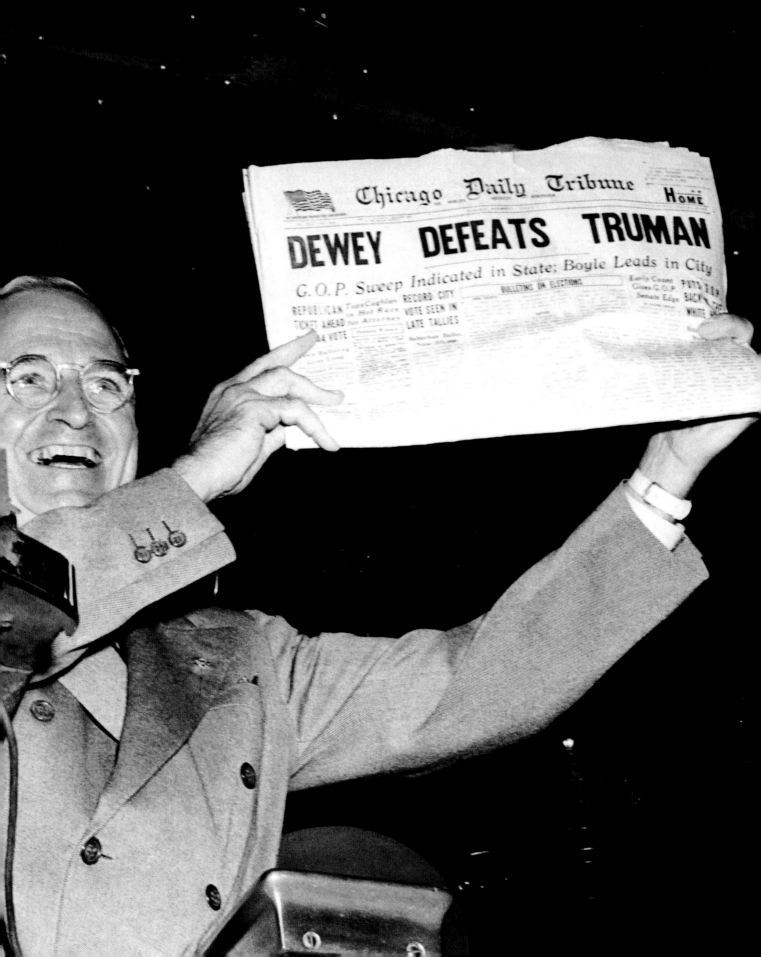

"The greatest upset" and one of the most memorable images in American campaign history

Tom Dewey, viewed by many (including himself) as a virtual lock for the presidency in 1948.

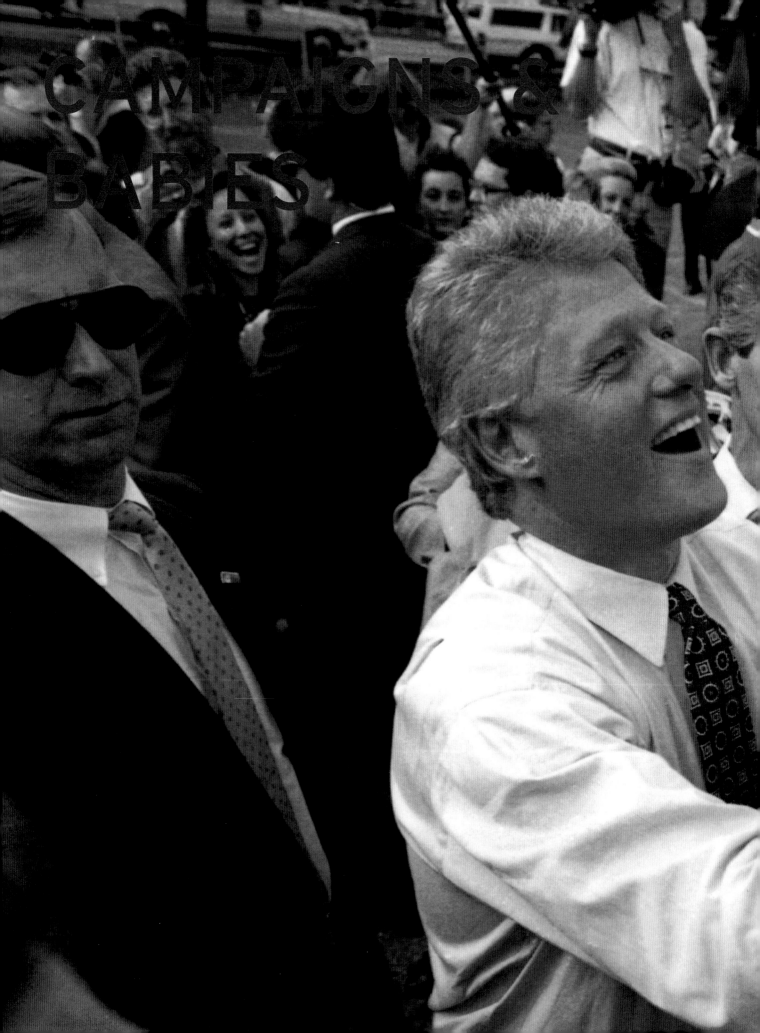

CAMPAIGNS &
BABIES

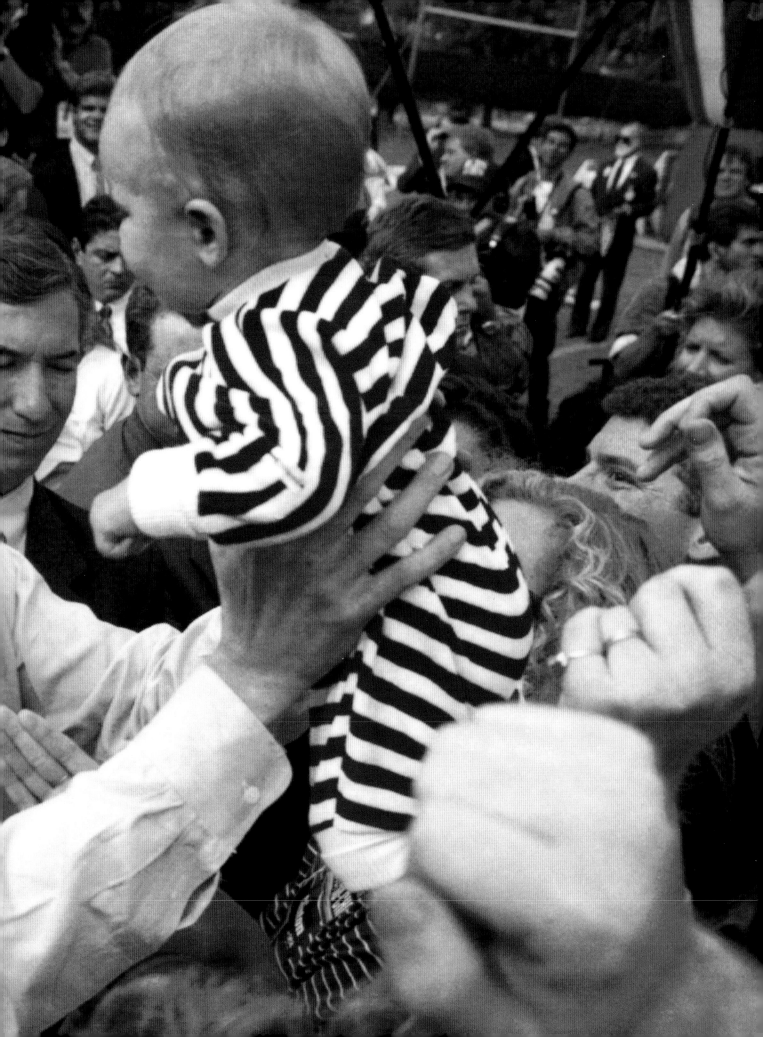

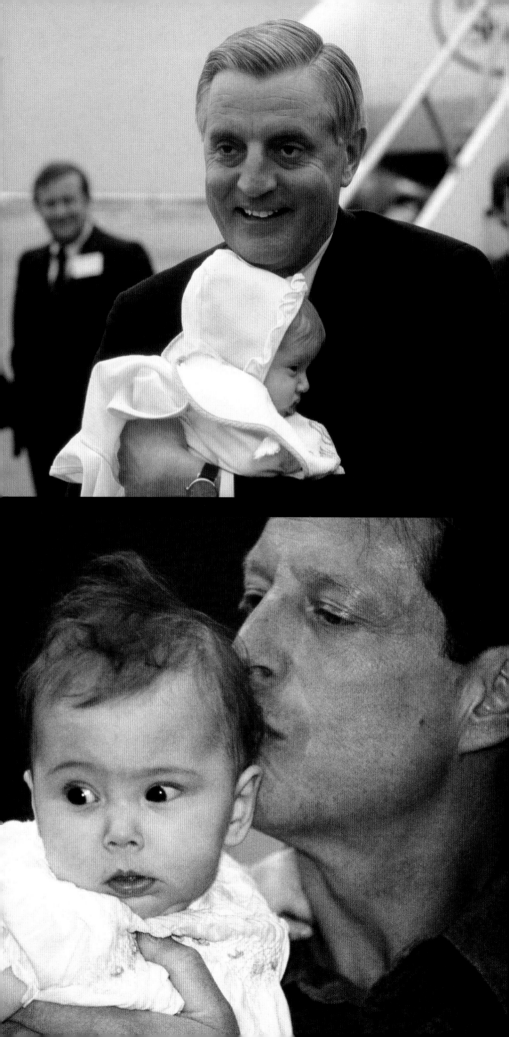

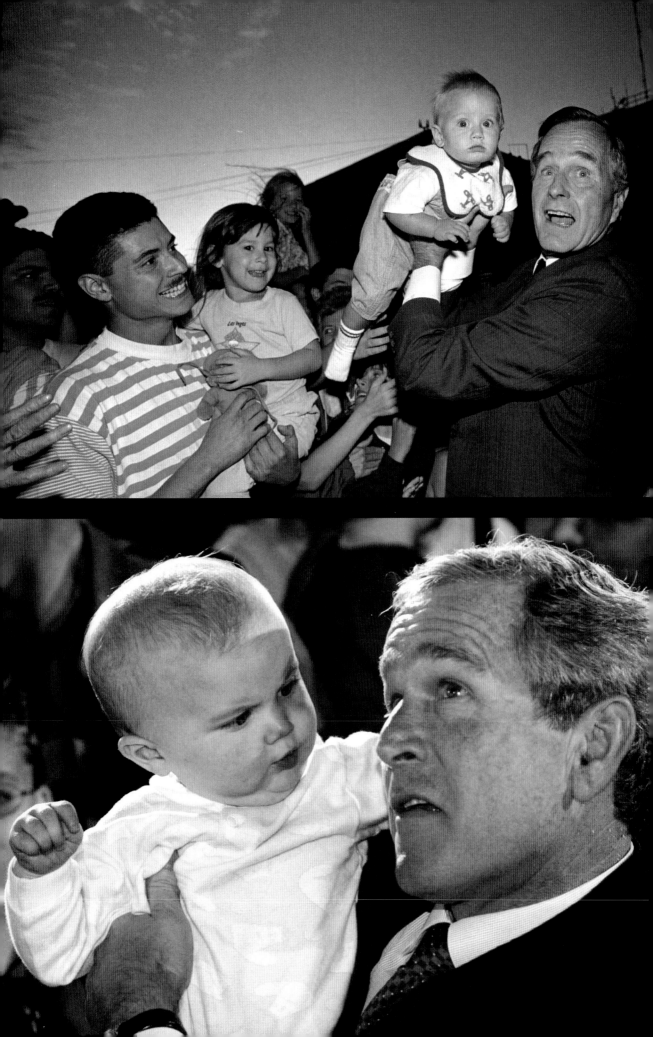

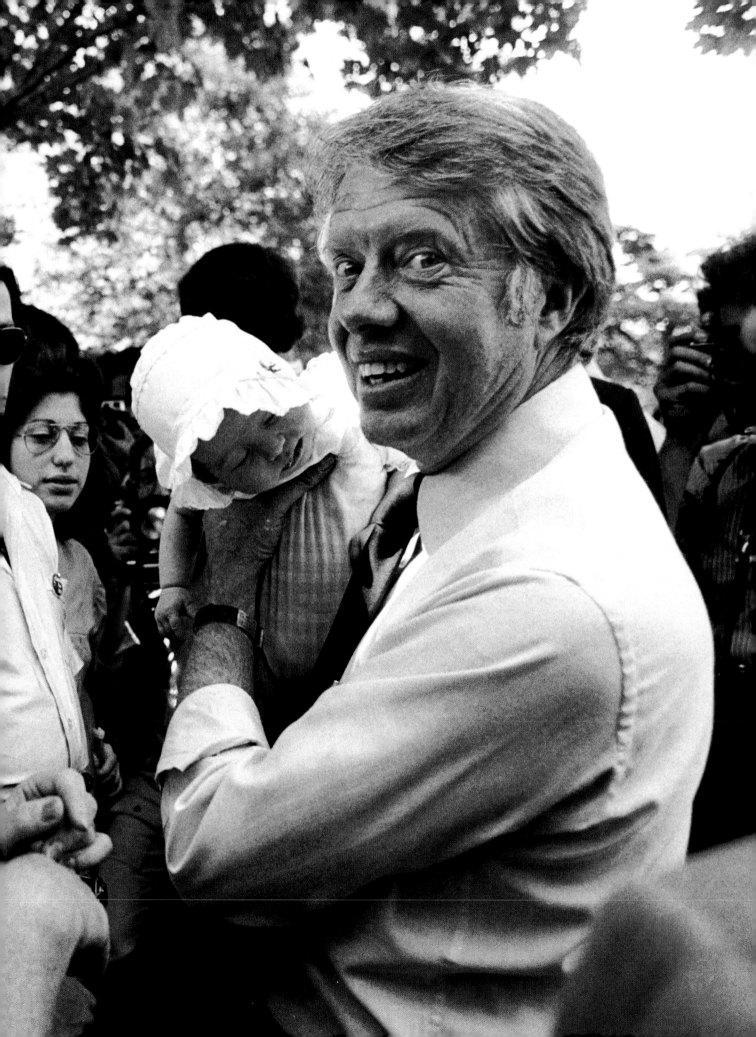

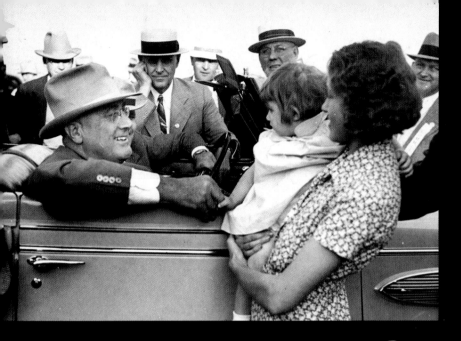

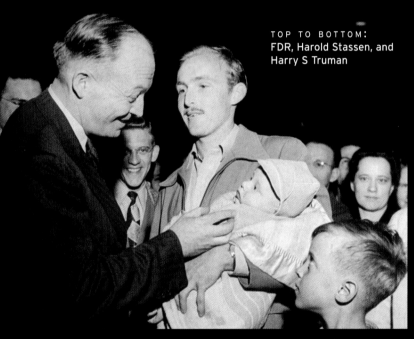

TOP TO BOTTOM:
FDR, Harold Stassen, and
Harry S Truman

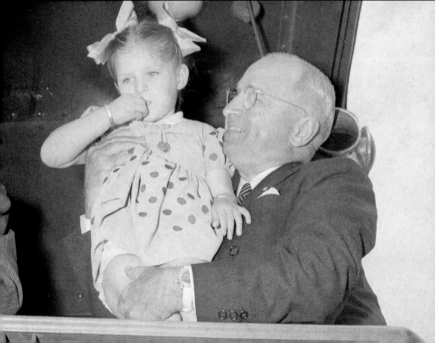

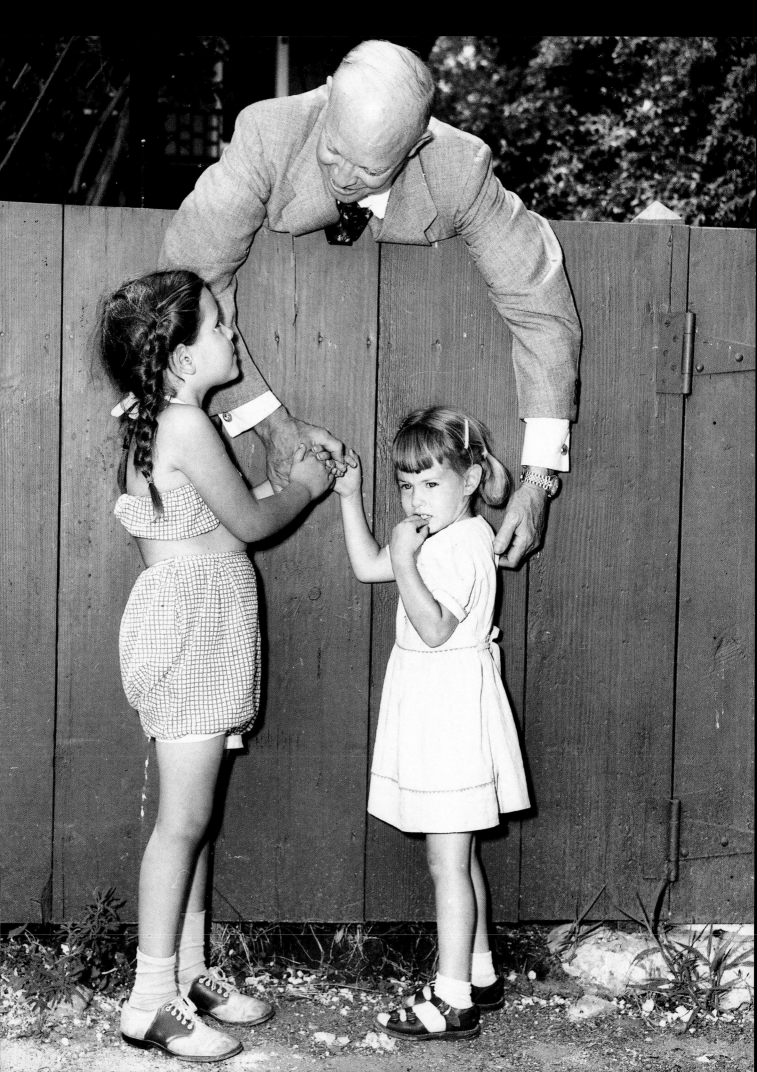

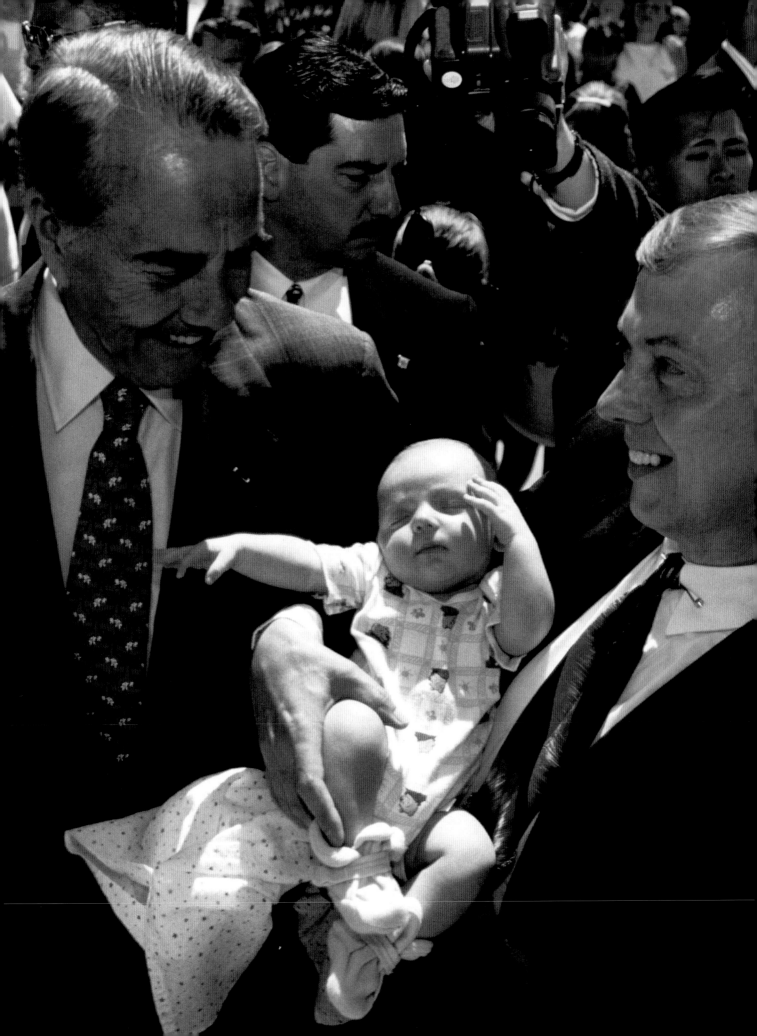

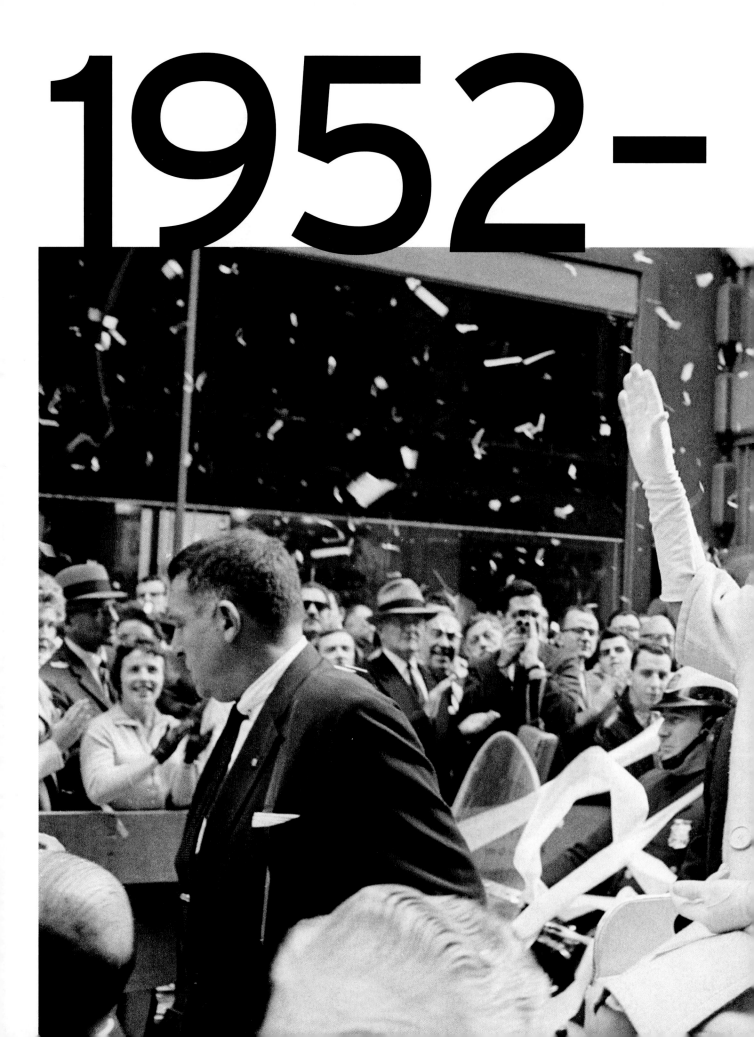

1972

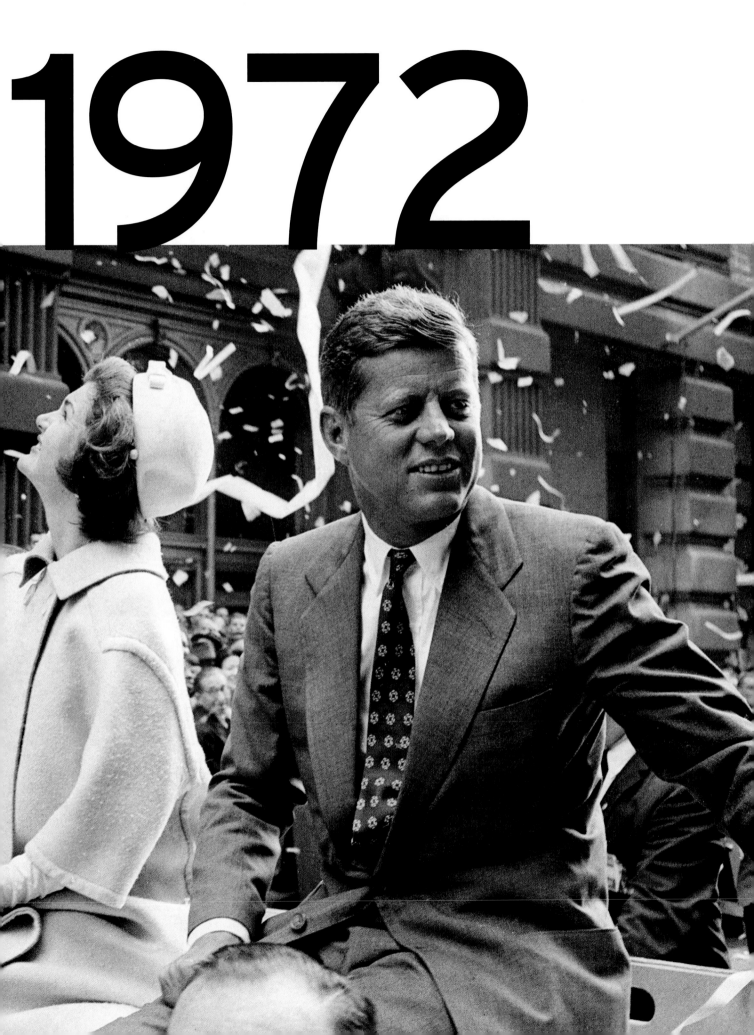

On an otherwise unexceptional afternoon in September **1952,** General Dwight D. Eisenhower took a day off from the campaign trail and stopped into a television studio in New York City to make the first presidential television advertisements. Little did he know, but the old war hero was about to give birth to the television age in American politics.

Few inventions have transformed the process of presidential campaigns as thoroughly as television. From 1952 onward, candidates would now have direct, immediate access to the electorate. Instead of relying on the party apparatus or the press, politicians could sell their messages directly to the American people. The highlights and lowlights of this period—from Richard Nixon's Checkers speech and the 1960 Kennedy-Nixon debates to the "Daisy ad" and the terrifying pictures of chaos in Chicago 1968—are lessons in the extraordinary power of television images to transform the national political process. Campaigning has never been the same.

As he entered the 1952 race, Ike was understandably skeptical of a technology available in less than twenty million homes. But he had been reluctantly convinced by Rosser Reeves, head of the country's most prominent advertising agency, that there might be something to TV advertising.

As David Halberstam recounts in *The Fifties*, Eisenhower's ads were simple, effective—and revolutionary. "Eisenhower answers America," said an announcer, followed by a woman on the street complaining about higher prices. Eisenhower read his response from cue cards: "Yes, my Mamie gets after me about the high cost of living. It's another reason why I say it's time for a change." Off-camera, Ike shook his head with dismay, lamenting, "To think that an old soldier should come to this." But his advisers used the ads to build support in states where the race was closest. It was one of the first examples of targeted advertising: Ike's simple yet powerful

message of change helped him appeal to the very swing voters who would decide the election.

But the most dramatic demonstration of television's new power came courtesy of Eisenhower's running mate, Senator Richard Nixon. Accused of having a secret slush fund, Nixon took to the airwaves to refute the charges. On September 23, with his wife, Pat, by his side, Nixon appeared on prime-time TV to review his family's meager finances in great detail. In the speech's most memorable and maudlin moment, Nixon pleaded guilty to accepting one gift: a dog named Checkers. "And you know, the kids, like all kids, love the dog," Nixon said, "and I just want to say this right now: that regardless of what they say about it, we're gonna keep it." The Republican National Committee was flooded with telegrams of support. Television, through the vehicle of the so-called "Checkers speech," had saved Nixon's political career.

The Democratic nominee, Illinois governor Adlai Stevenson, had no time for the new medium. Amazed that Eisenhower would package himself "like cereal," he later called political advertising "the ultimate indignity to the democratic process." It was little wonder that newspaper columnists Joseph and Stewart Alsop dubbed him an "egghead."

Stevenson pledged that he would "talk sense" to the American people, but he lacked the personal popularity of Eisenhower. After two decades of Democratic rule—and continuing military stalemate in Korea—the stars were finally aligned in the Republicans' favor. On October 24, in Detroit, Eisenhower dra-

matically pledged, "I shall go to Korea." His reward was a landslide victory.

In **1956,** Ike and Stevenson faced off in a largely lackluster rematch. In a time of peace and prosperity, not even Ike's 1955 heart attack failed to weaken his hold on the White House. The biggest sensation of the 1956 race was the emergence of the junior senator from Massachusetts as a national political voice. John F. Kennedy came within forty votes of becoming Stevenson's running mate at the Democratic convention. The nomination ultimately went to Tennessee senator Estes Kefauver, but the charismatic young son of Joseph P. Kennedy would return to fight another day.

Four years later, television would again make the difference. In September

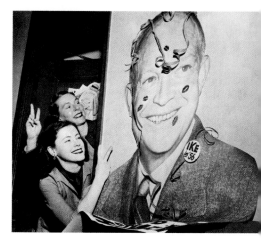

1960, when Richard Nixon arrived in Chicago for the nation's first televised presidential debate he was tired and haggard from almost constant campaigning. Nixon had pledged to visit all fifty states, and the constant travel left him exhausted. Worse, his resume as an experienced adviser to the president had been undermined by Eisenhower. When asked what decisions Nixon had weighed in on as vice president, Ike replied, "If you give me a week, I might think of one." Still, as an incumbent VP and seasoned debater, Nixon arrived at the CBS studio in Chicago a presumptive favorite.

His opponent, John F. Kennedy, had had troubles of his own on the campaign trail. Dogged by questions about his

Catholicism, he had been called an "unacceptable" candidate by one Protestant clergy group. Forced to respond, Kennedy traveled to Houston to tell a group of ministers: "I am not the Catholic candidate for president. I am the Democratic Party's candidate for president, who happens also to be a Catholic." The speech largely helped to defuse the religion issue, but in order to win the general election Kennedy knew that he must do well in the upcoming debates.

The Chicago debate—the first of four—heralded a new type of political skill: the ability to communicate on television. It was a talent Kennedy seemed to come by naturally. Nixon was another story. Streaked with perspiration and showing a five o'clock shadow, the vice president spent much of his time stealing shifty glances at Kennedy; JFK looked right into the camera, addressing the 70 million viewers directly. Nixon, who had banged his recently injured knee on a car door upon entering the studio, leaned on his one good leg, mopping his brow and smiling nervously; Kennedy stood ramrod straight. Television had been Nixon's savior in 1952, but it was his downfall in 1960.

Radio listeners thought Nixon had performed at least as well as Kennedy— but the TV audience saw Kennedy as the clear winner. Still, the outcome would be one of the closest in American history, with JFK winning by just under 120,000 votes. Kennedy knew why. After his victory, he commented, "It was TV more than anything else that turned the tide."

The power of television, and its ability to captivate the nation, was never on greater display than in the terrible days of late November 1963. From Walter Cronkite's emotional announcement of the president's passing to JFK Jr.'s poignant salute to his slain father, to Lee Harvey Oswald's shocking assassination on live television, the images of that time still reverberate today.

Kennedy's tragic assassination put Lyndon Johnson in the White House and gave the new president a relatively easy path to his own electoral victory. But what

the national race lacked in drama, the Republicans more than made up for during their convention at San Francisco's Cow Palace. The **1964** election marked the first great political triumph of the party's ascendant conservative wing, embodied by Arizona senator Barry Goldwater. The moderate governor of New York, Nelson Rockefeller, was literally booed from the convention floor—and Goldwater's fiery rhetoric left little room for conciliation. In the kind of language seldom heard in a presidential campaign, Goldwater told the convention, "I would remind you that extremism in the defense of liberty is no vice. And let me remind you that moderation in the pursuit of justice is no virtue." Even conservative stalwarts saw that Goldwater had gone overboard. Pat Buchanan muttered afterwards, "He's finished."

Once again advertising would play a prominent role, as the Democrats used Goldwater's arch-conservative and trigger-happy image to great effect. To the GOP slogan "In Your Heart, You Know He's Right," they added, "Yes—Extreme Right." More pointedly, Johnson's campaign targeted Goldwater with one of the most controversial TV ads in American political history. The so-called "Daisy spot" opened with a little girl counting

daisy petals. Suddenly her voice was replaced by the sound of a nuclear countdown, and then the sight of a mushroom cloud—followed by Johnson's voice, intoning: "These are the stakes." Though it ran only once, the spot became a sensation, and signaled the emergence of negative television advertising on the political scene.

While certainly effective, the Daisy ad was hardly necessary. Americans were in an optimistic mood in 1964, and Goldwater's extreme rhetoric frightened more listeners than it attracted. As Johnson barnstormed the nation trumpeting his idealistic vision of a Great Society, Americans overwhelmingly responded, giving him the largest percentage of the popular vote in U.S. history.

Even more dramatic was the regional shift that transpired in 1964. When Lyndon Johnson pushed civil rights legislation through a recalcitrant Congress, he remarked that he had just cost Democrats the South. History would prove him correct. In addition, when a former actor and budding politician named Ronald Reagan went on television only days before the election and called on Americans to embrace Goldwater and conservatism, a new political star was born. The Democrats had won the battle,

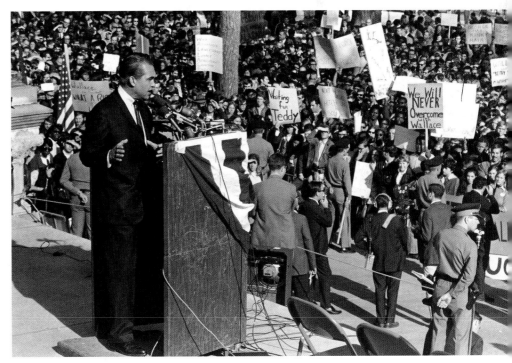

but it was the conservative wing of the Republican Party that would win the war.

By **1968,** things were beginning to turn in the GOP's favor. The deepening escalation in Vietnam, combined with racial unrest at home, undermined Johnson's promise of a Great Society; the cynicism and mistrust of government born in the 1960s still roils within American politics today. As the year began, LBJ was in a perilous political position. On March 12, he was blindsided by Senator Eugene McCarthy's strong showing in the New Hampshire primary, where McCarthy won 42 percent of the vote. (While some viewed McCarthy's "victory" as a sign of antiwar discontent, many in New Hampshire were concerned that Johnson was not doing enough to win the war.) Even Johnson's own staff, though, was caught off guard by the bombshell he dropped nineteen days later. Broken by four years of war in Vietnam—and the chants of young protestors demanding "Hey, hey, LBJ! How many boys did you kill today?"—Johnson declared: "I shall not seek, and I will not accept, the nomination of my party for another term as your pres-

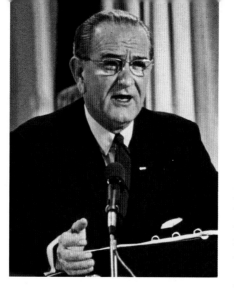

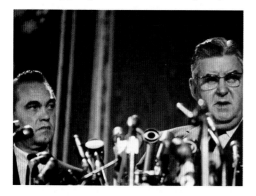

Alabama governor George Wallace looks on in horror as running mate Curtis LeMay celebrates the softer side of nuclear warfare.

ident." Already staggering, the nation was further stunned when Reverend Martin Luther King Jr. was gunned down four days later at a Memphis motel, sparking deadly riots in many American cities.

The Democratic primary battle that followed reflected the nation's growing political disorder. McCarthy was joined in

the nomination race by LBJ's longtime nemesis, Robert F. Kennedy. Vice President Hubert Humphrey was quietly working to line up party support behind the scenes. And Alabama's Democratic governor, George Wallace, had launched an independent bid for the White House on an anti–civil rights platform.

In a heated primary battle, RFK prevailed in Indiana. But McCarthy defeated him in Oregon, in the first-ever election defeat for a Kennedy. In June's all-important California primary, Kennedy's whirlwind campaign topped McCarthy—but tragedy struck again. After declaring victory at Los Angeles's Ambassador Hotel, Kennedy slipped out through the hotel's kitchen—where he was shot by a young Palestinian named Sirhan Sirhan. Fatally wounded, Kennedy died the next day.

The mantle of leadership fell to Humphrey, who managed to secure a majority of the delegates without ever directly entering a primary. But the Democratic convention that followed would leave the entire country in shock. Gathered by the thousands outside the Chicago convention hall, antiwar protestors (and innocent bystanders) were viciously attacked by Mayor Richard Daley's police in what was later termed a "police riot." Connecticut senator Abraham Ribicoff came to the convention floor to decry the "Gestapo tactics" in the streets of Chicago. Conventions were now prime-time television, and the entire sordid spectacle played out in living rooms across America, fatally undermining the Democrats' chances of victory in November.

The Republicans, meanwhile, had turned once again to Richard Nixon. Six years earlier, after losing the California governor's race, Nixon told reporters "you won't have Nixon to kick around anymore." Now older, wiser, and determined to avenge his 1960 presidential defeat, Nixon hired a media-savvy campaign team to sell the "New Nixon" as a defender of law and order who spoke for America's "forgotten majority." It was a message that was more than enhanced by the mayhem in Chicago.

The **1968** election also gave birth to Nixon's so-called "Southern strategy," aimed to appeal to white Southerners outraged by civil rights legislation. It was a cynical approach that helped to drive a wedge in the Democratic Party and propel a generation of Republicans to elected office. With the segregationist George Wallace on the ballot, Nixon didn't need to talk about race himself—he could let the Alabama governor do that for him. As the race moved forward, though, both sides became concerned that a strong showing by Wallace could throw the election into the House of Representatives.

Things dramatically changed, however, when Wallace introduced his running mate, former Air Force Chief of Staff Curtis LeMay, who asserted that Americans needed to get over their "phobia" of nuclear conflict. As Wallace stood by, ashen-faced, LeMay described the positive effects of nuclear testing at the Bikini

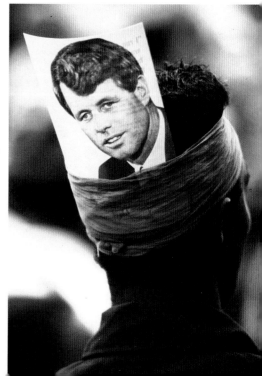

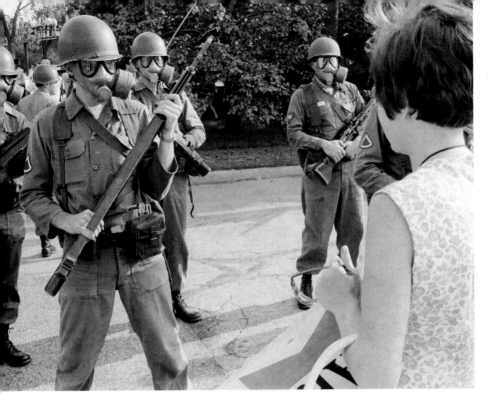

Atoll ("the rats out there are bigger, fatter, and better"). As traditional Democrats returned to the fold, and attacks on the Alabama governor's labor record mounted, Wallace's campaign was weakened. He ultimately won only five southern states.

The general election was one of the most dispiriting in American history. With a big post-convention lead, Nixon avoided the press, appearing instead in carefully staged events. Humphrey, who had secured the nomination with little money, organization, or popular support, was heckled so mercilessly by Vietnam War demonstrators that he was once reduced to tears. He vacillated for weeks on what to say about the war. In late September the tide began to turn, after Humphrey finally called for a bombing halt in Vietnam and Paris peace talks began to show signs of progress. But the administration's chances for an election-eve deal were scuttled after a backchannel communiqué from Nixon's camp promised the South Vietnamese a better deal once Nixon was elected; Richard Nixon squeaked to victory by less than one percent of the popular vote.

By **1972,** the two political parties were again moving in very different directions. With a campaign war chest unmatched in presidential history, Nixon

was intent on winning a decisive political victory. On the Democratic side, things were going from bad to worse.

After its repudiation in 1968, the Democratic Party was in dire straits. Edmund Muskie, Humphrey's running mate, was the party's early front-runner, but he soon fell victim to a series of Nixon-inspired dirty tricks and faded from contention. Other formidable candidates—including Humphrey and Senator Ted Kennedy—either didn't win or didn't run. George Wallace narrowly survived an assassination attempt outside a Maryland shopping center in May; days later, he shocked the nation by winning the Maryland and Michigan primaries from his hospital bed.

The polarization among the Democrats left South Dakota senator George McGovern, who had been running since 1971 on the strong base of McCarthy and Kennedy's antiwar coalition. McGovern had taken advantage of changes in the delegate selection process to build a strong grassroots organization that overwhelmed his opponents in the party primaries. But McGovern was well to the left of most Americans.

The raucous Democratic convention in Miami featured all the excesses of the

party's liberal wing, from abortion and gay rights activists to strident antiwar voices; though McGovern secured the nomination, interminable platform negotiations pushed his acceptance speech to well after 3 A.M.—by which time most Americans had long gone to bed.

Soon after the convention, it was revealed that McGovern's running mate, Missouri senator Thomas Eagleton, had undergone electroshock therapy for depression. McGovern pledged his "1000 percent" support, but dropped him from the ticket only days later. After almost half a dozen prominent Democrats turned down the spot, McGovern selected Kennedy relative Sargent Shriver.

The elections of 1968 and 1972 set the direction of the two parties for decades to come. As the Republicans built a lasting conservative coalition on the foundation of Nixon's "silent majority," the Democrats finally watched their New Deal coalition shatter. Abandoned by unions, Catholics, and other traditional Democratic constituencies, McGovern lost to Nixon by 18 million votes—and left his party on life support. Conversely, Nixon believed he was on the way to constructing a "New Republican Majority."

Less than two years later, however, a little-noticed break-in at the Democratic campaign headquarters in July 1972 would prove to be Nixon's downfall, as the Watergate scandal made him the first American president to resign from office. ❑

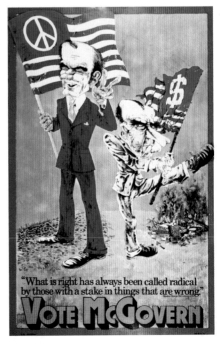

"What is right has always been called radical by those with a stake in things that are wrong."
VOTE McGOVERN

1952

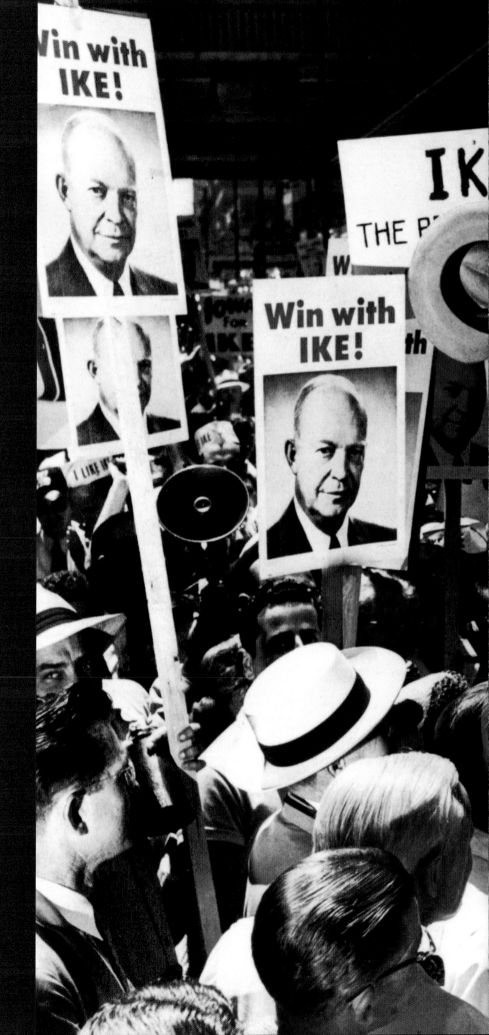

When a photographer captured Adlai Stevenson with a hole in his shoe, the image won a Pulitzer Prize—and became a lasting symbol for the two-time Democratic nominee.

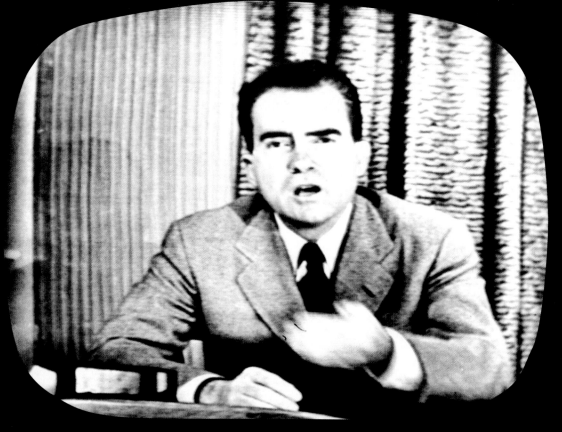

Richard Nixon "set the record straight" with his famous Checkers speech; a few days later, he relaxed with his family—and the dog in question *(below)*.

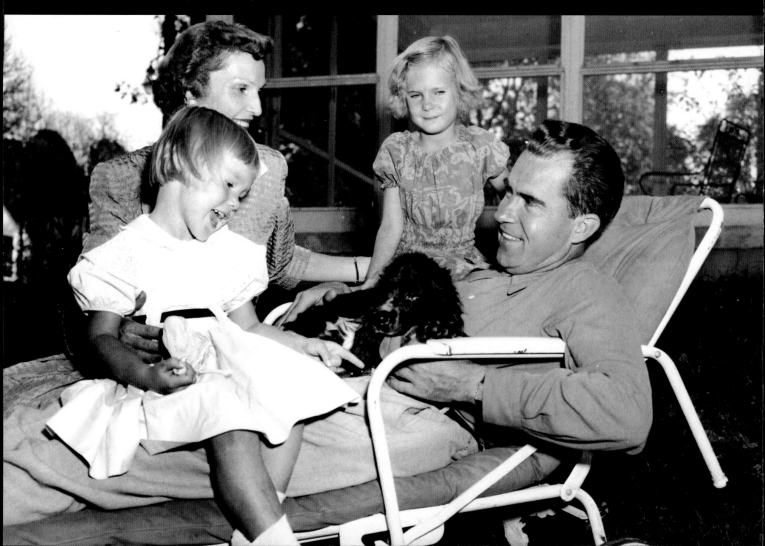

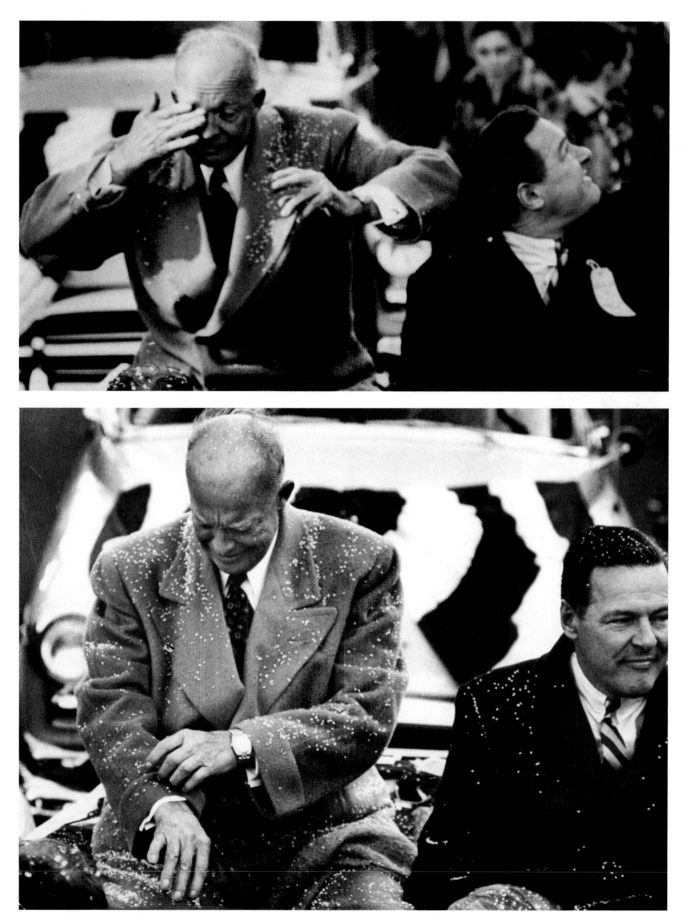

The perils of the campaign trail

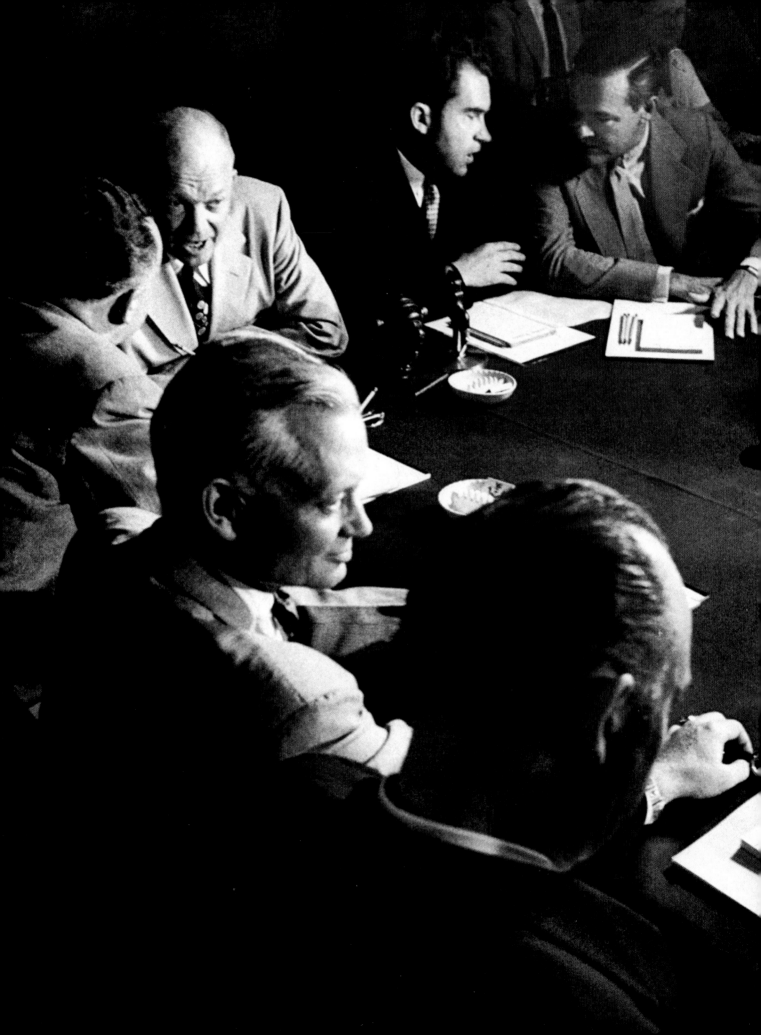

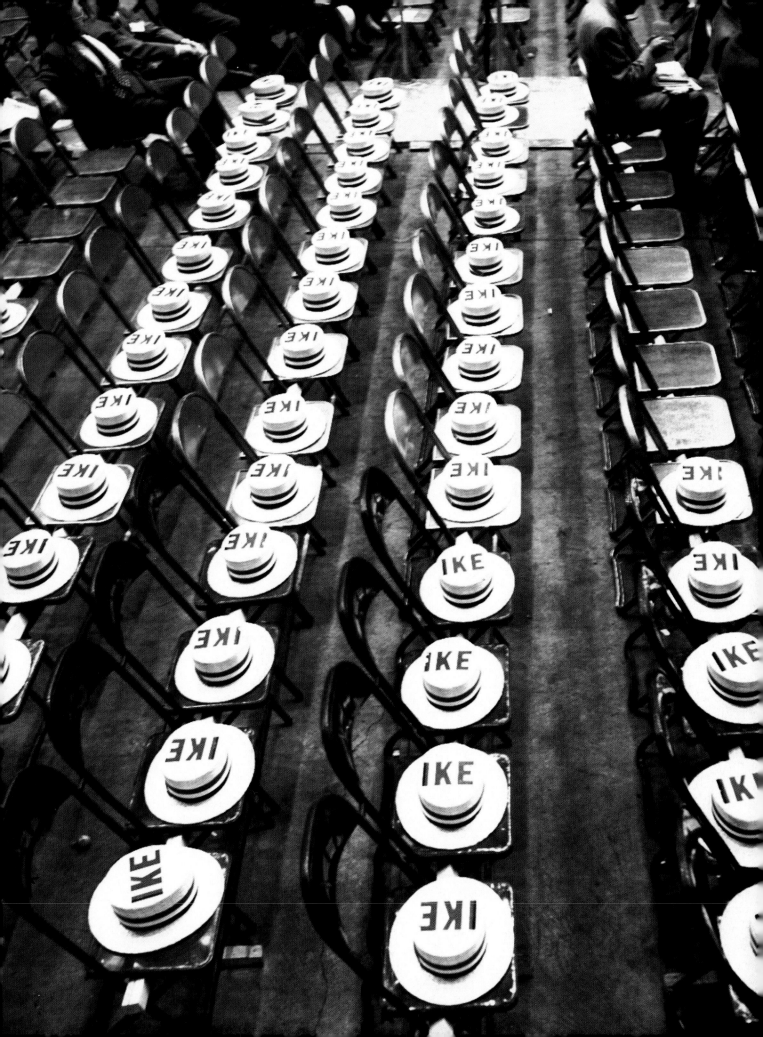

Though he resisted the idea, Ike starred in some of the first television advertisements in American presidential politics.

1956
DEMOCRATIC
NATIONAL
CONVENTION

Twice pitted against Eisenhower, Adlai Stevenson could never compete with Ike's enormous popularity and charisma.

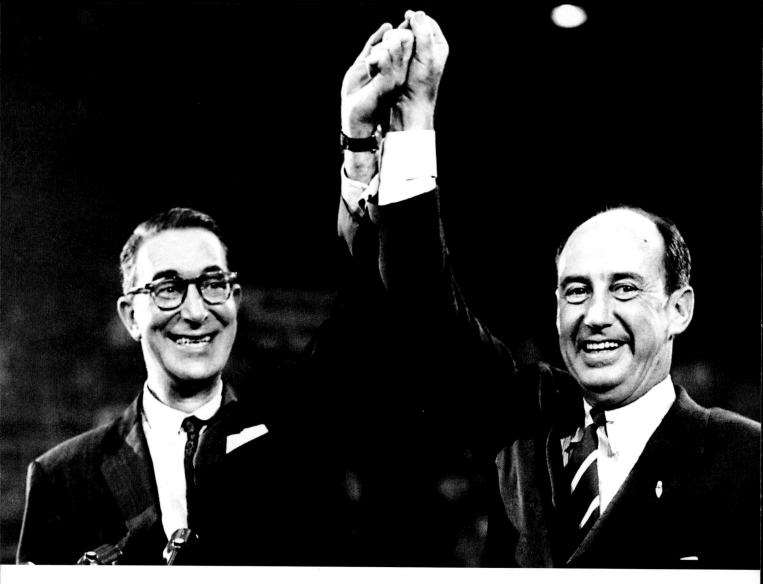

When the dust settled, Tennessee senator Estes Kefauver *(left)* emerged as Stevenson's running mate.

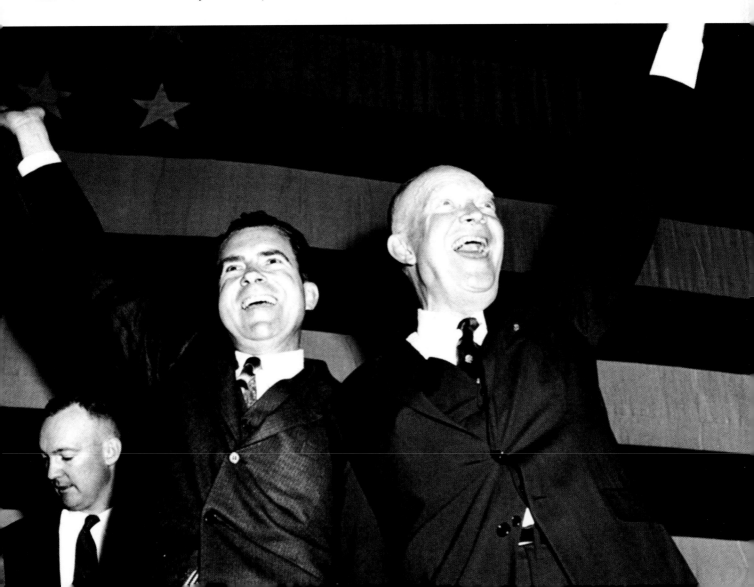

Eisenhower and Nixon celebrating their victory in 1956 after Stevenson's concession.

1960

Narrowly defeated for the vice presidency in 1956, John F. Kennedy returned in 1960 to wage a hotly contested race against former vice president Richard Nixon.

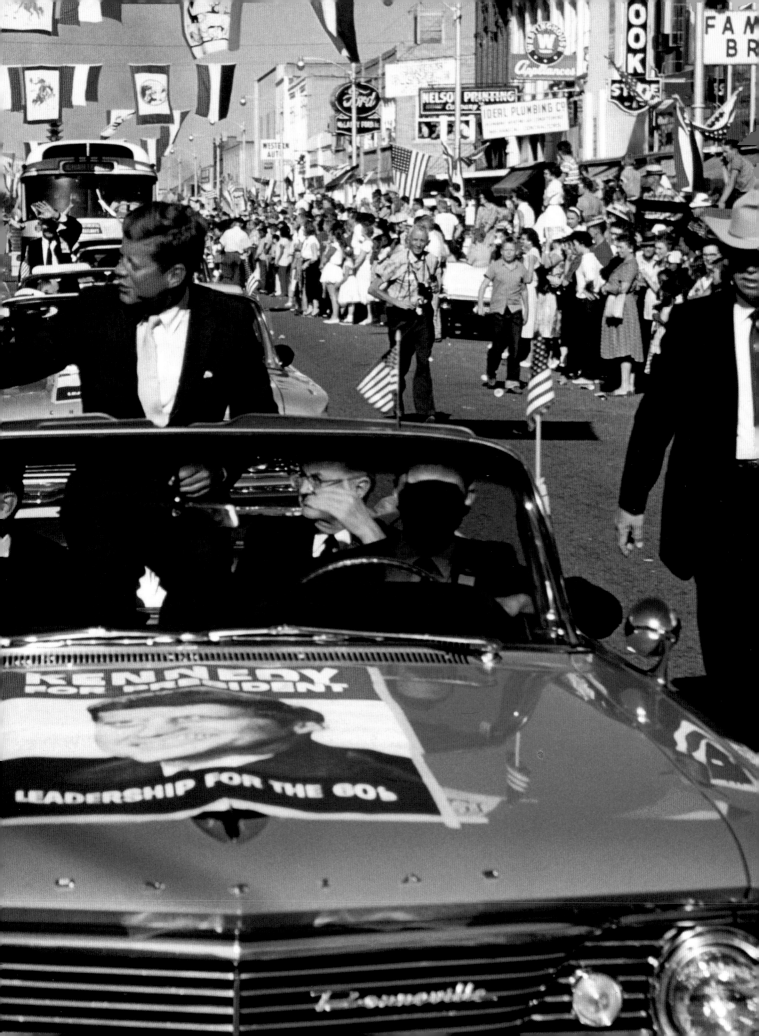

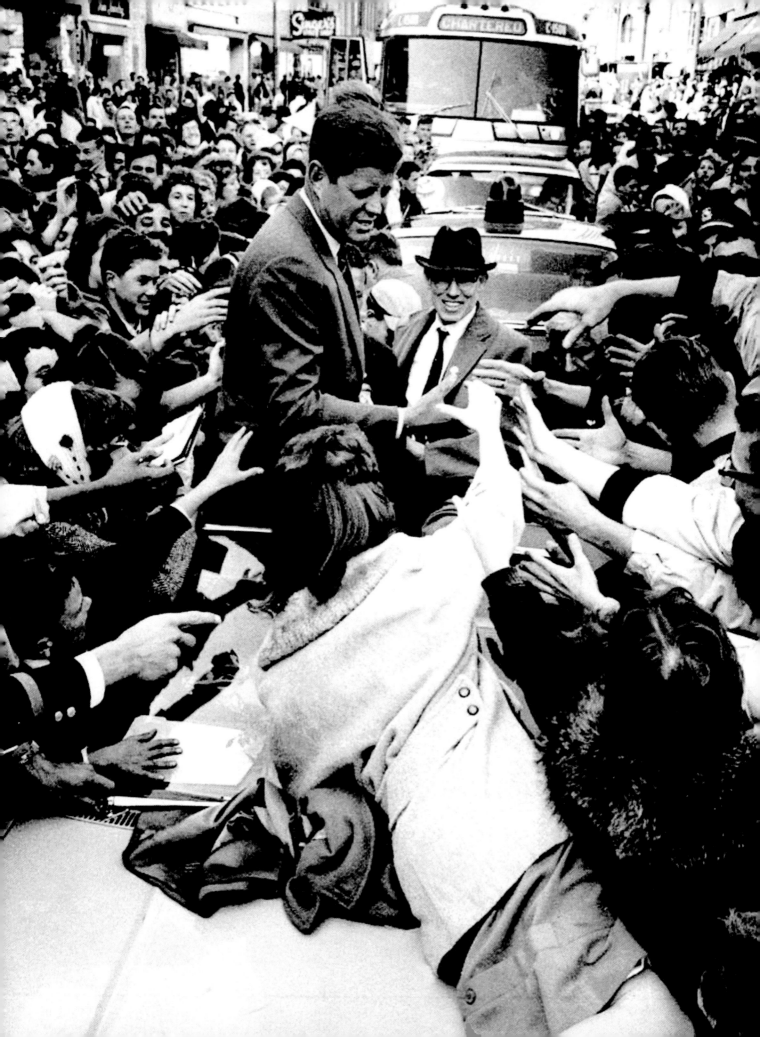

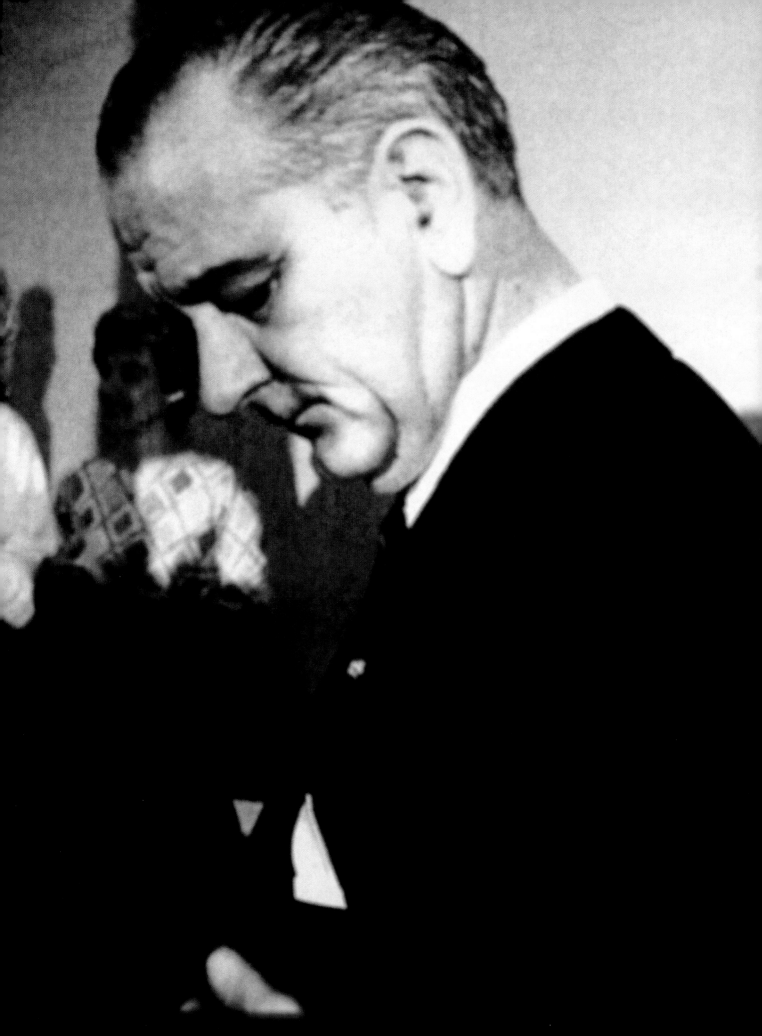

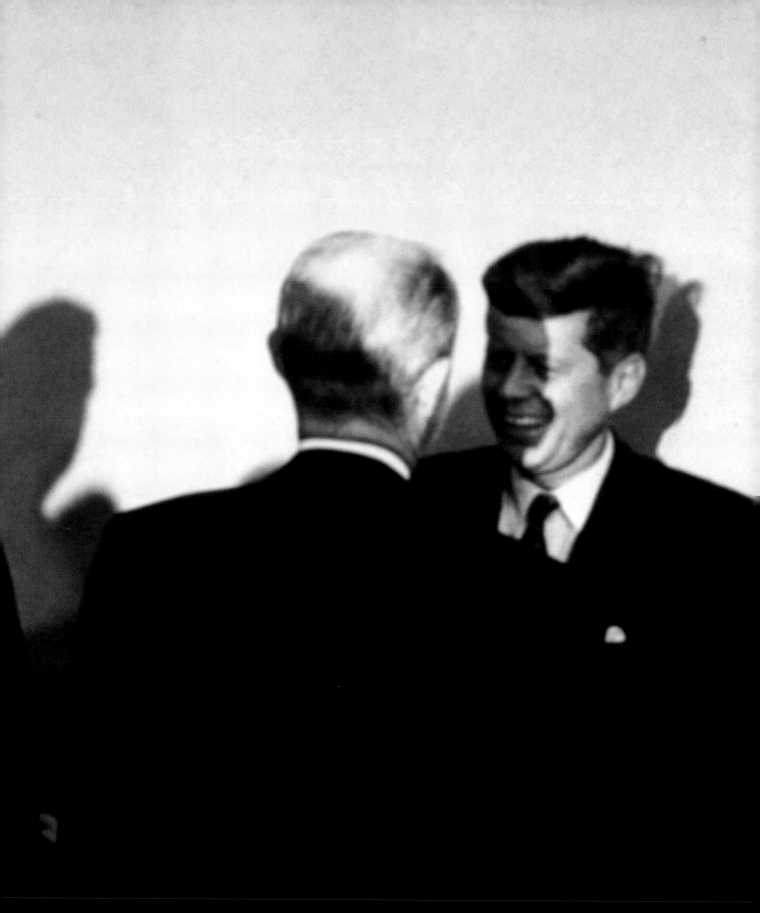

Kennedy chose as his running mate Lyndon Johnson of Texas; LBJ's strained relationship with the Kennedys would continue long after JFK's death.

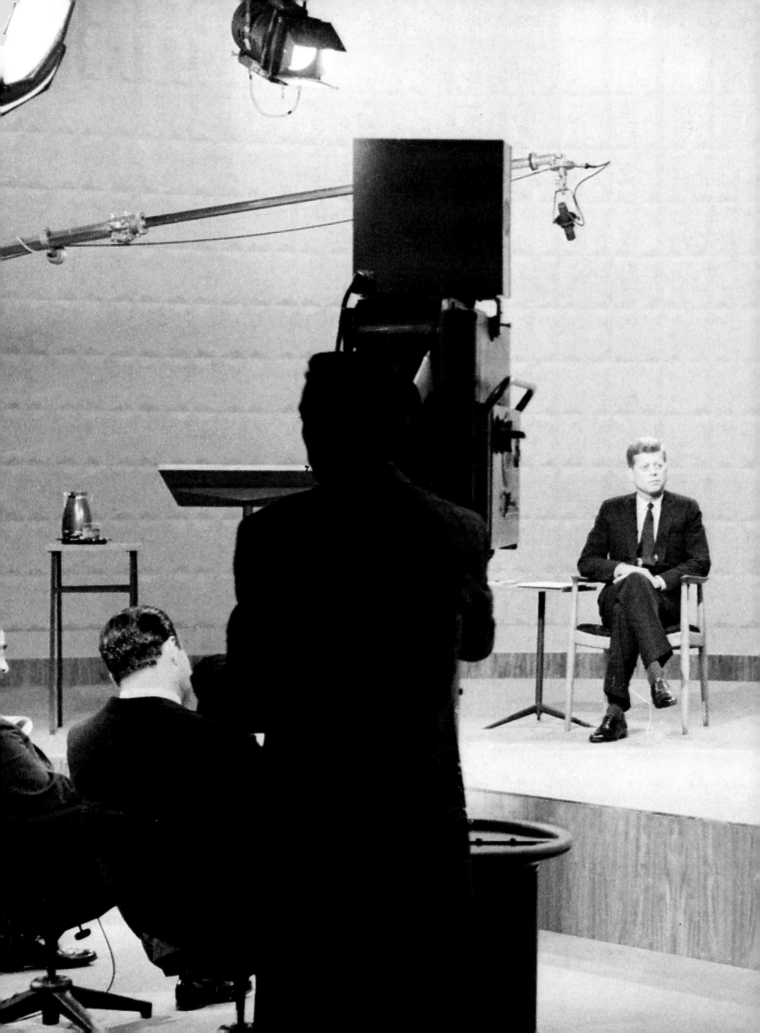

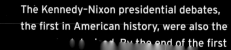

The Kennedy-Nixon presidential debates,
the first in American history, were also the
 ... By the end of the first

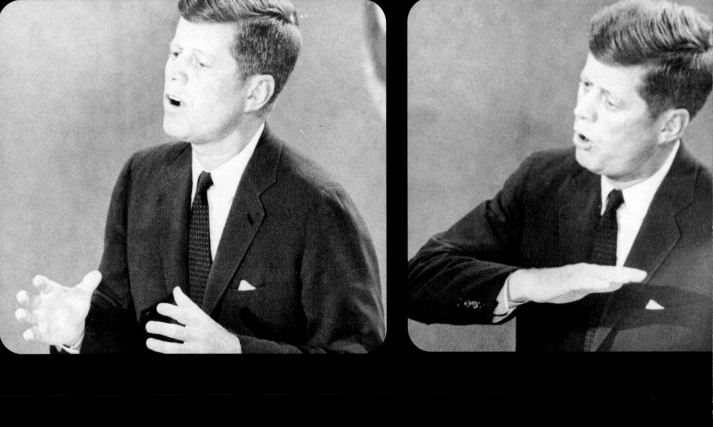

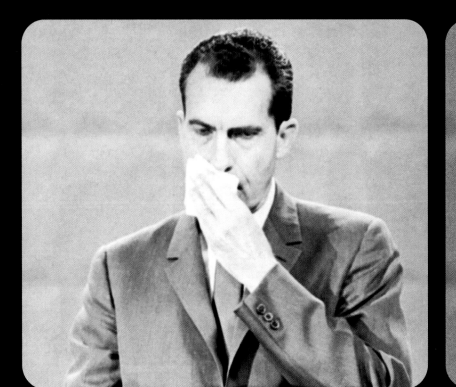

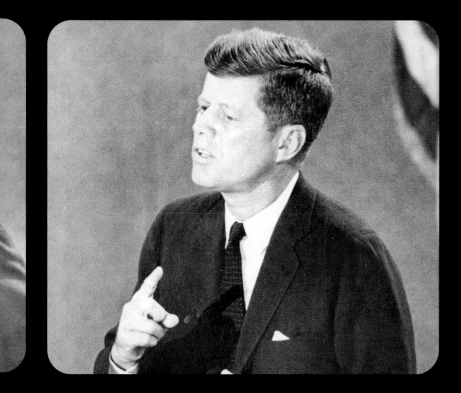
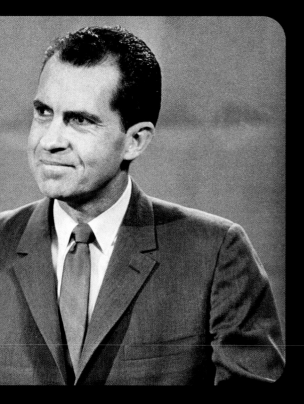
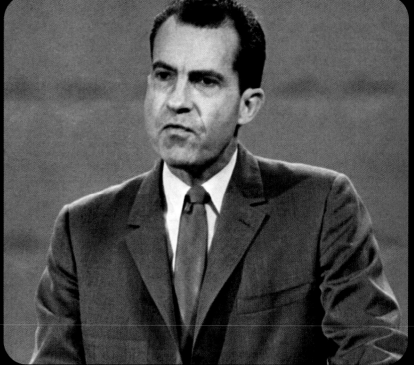

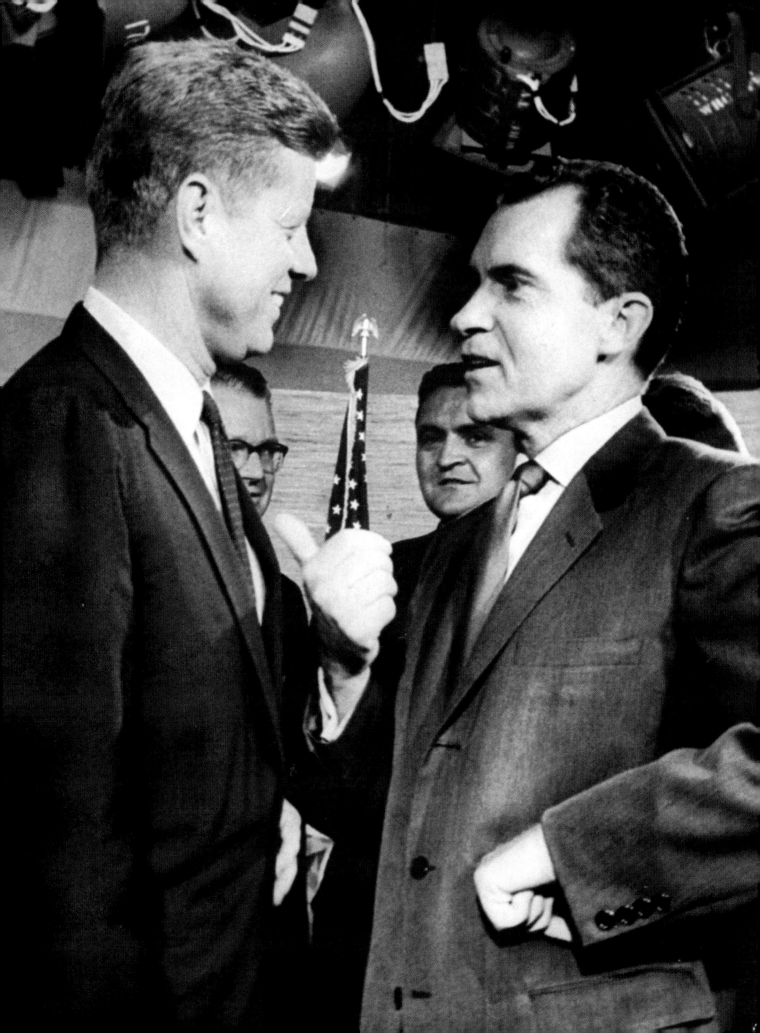

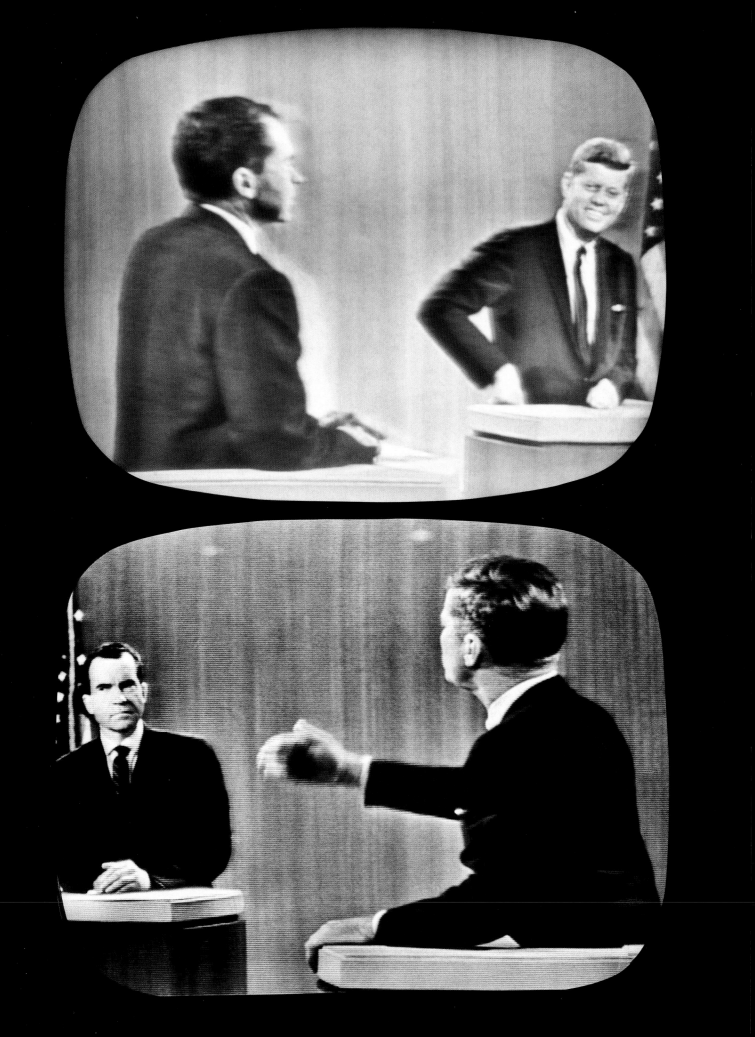

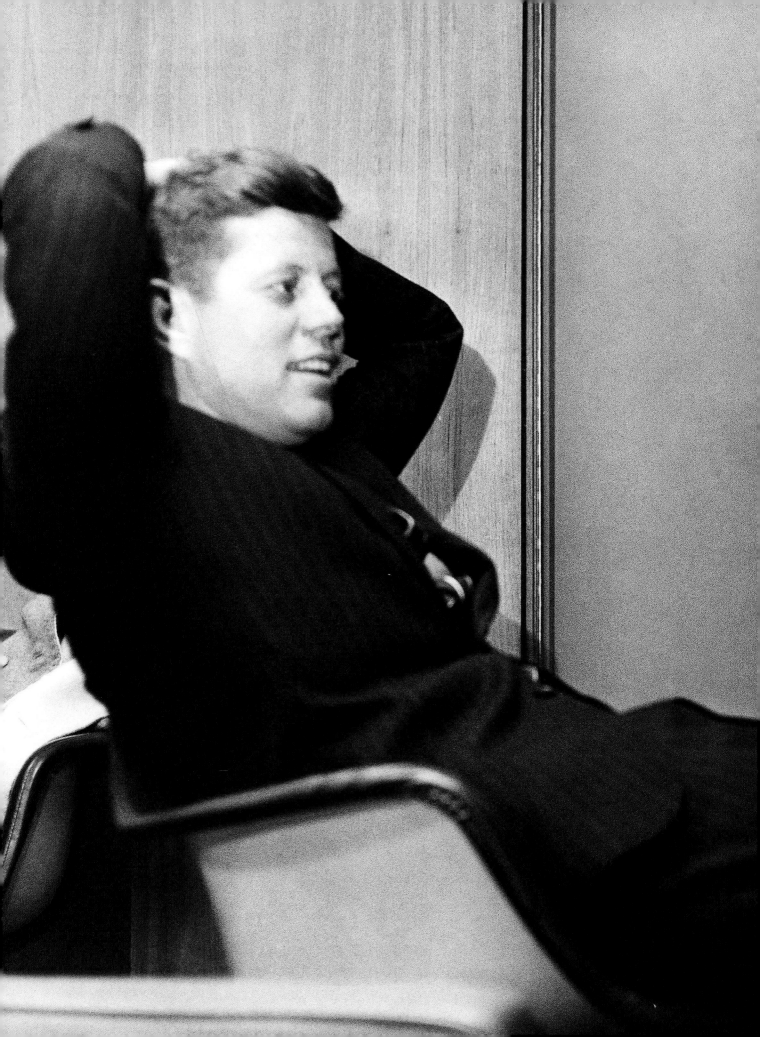

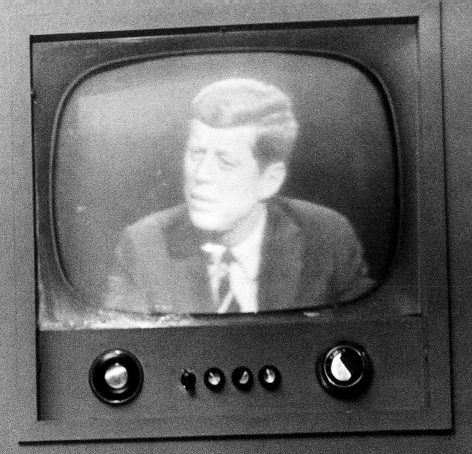

Though Ike had pioneered TV advertising, JFK was truly America's first television president.

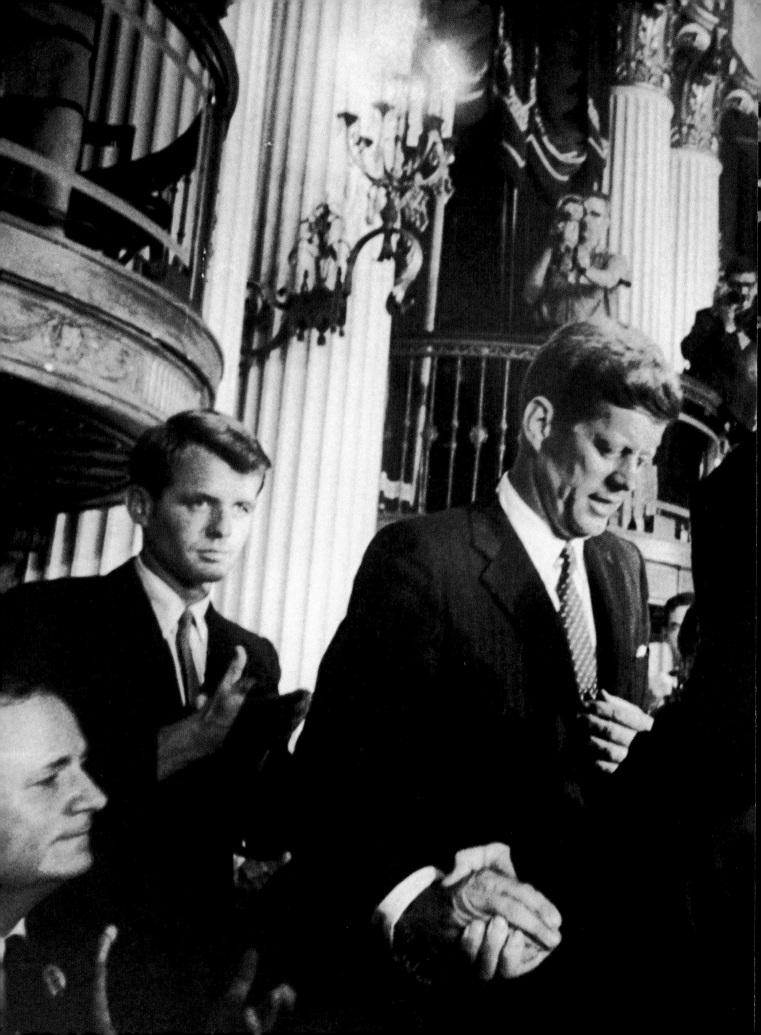

Bobby, Jack, and LBJ: Their politics and personalities would help shape the 1960s.

LBJ with his daughter Lynda Bird at the 1964 convention

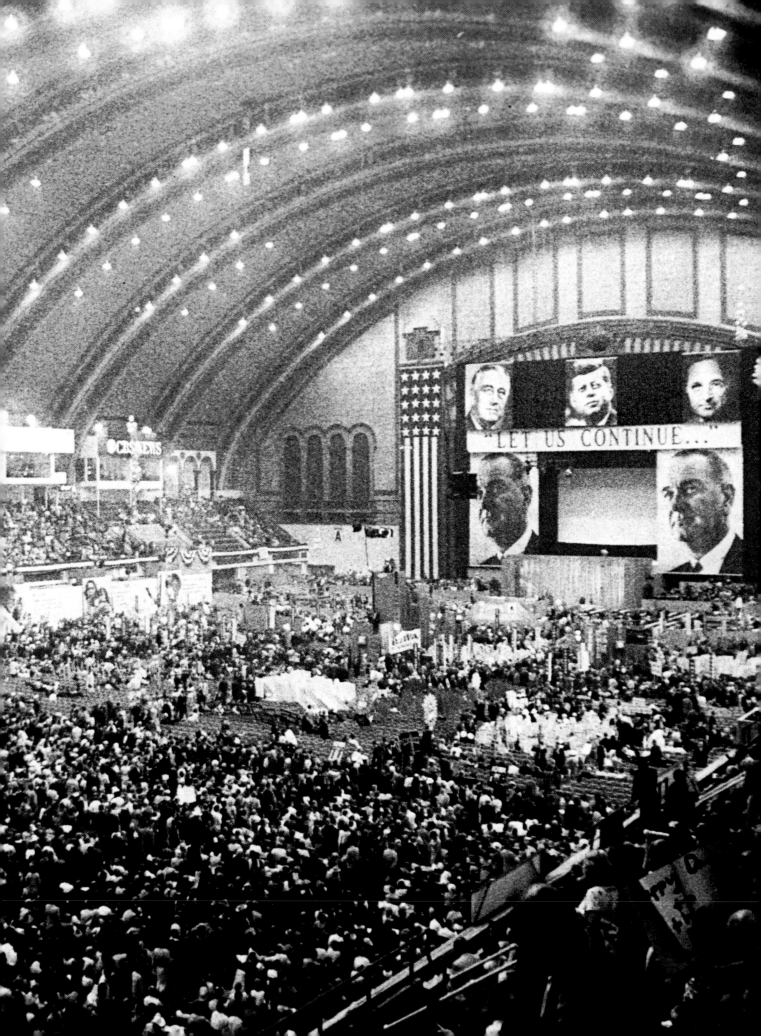

188

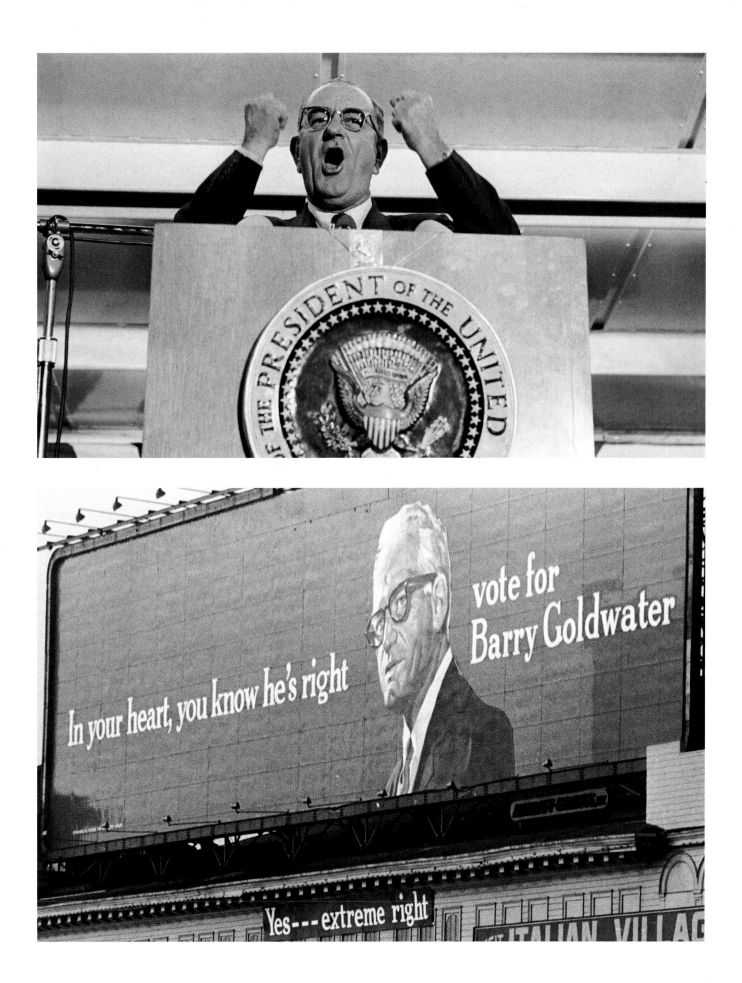

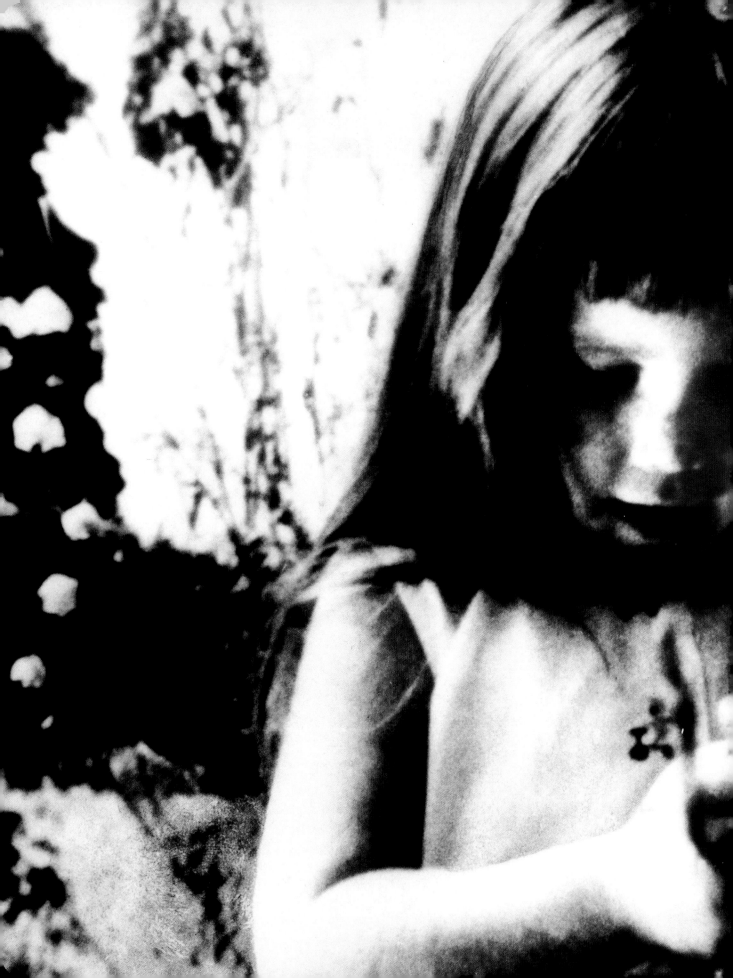

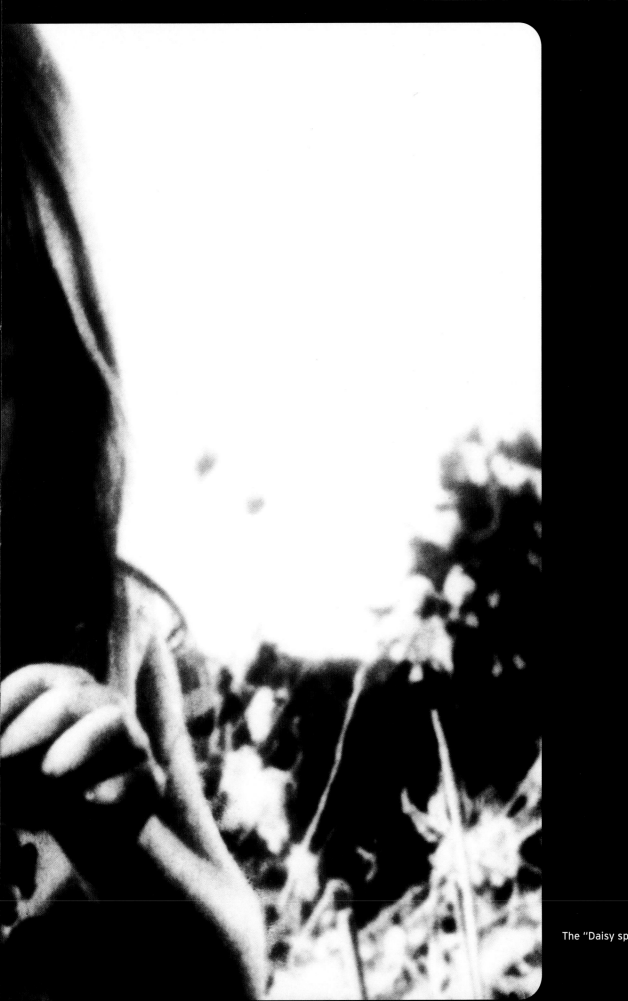

The "Daisy sp

1964 saw the emergence of former Hollywood star (and anti-Communist crusader) Ronald Reagan as a powerful Republican campaigner—here, stumping for Goldwater.

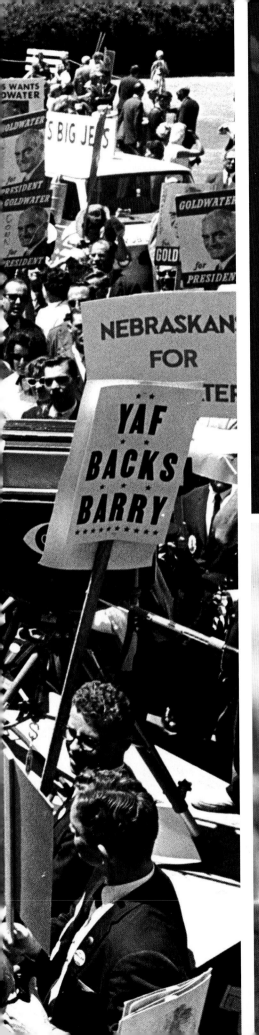

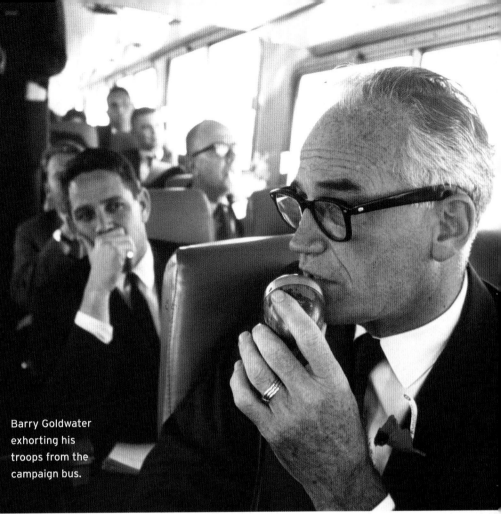

Barry Goldwater exhorting his troops from the campaign bus.

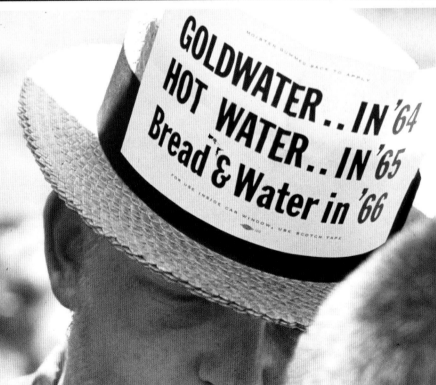

1968

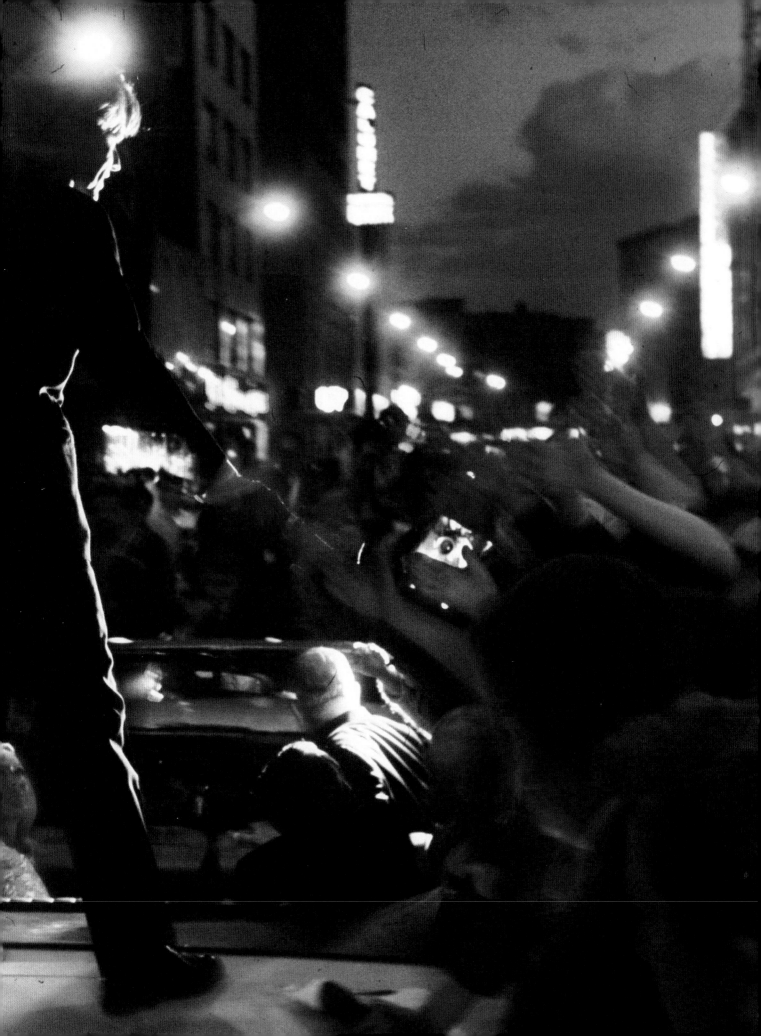

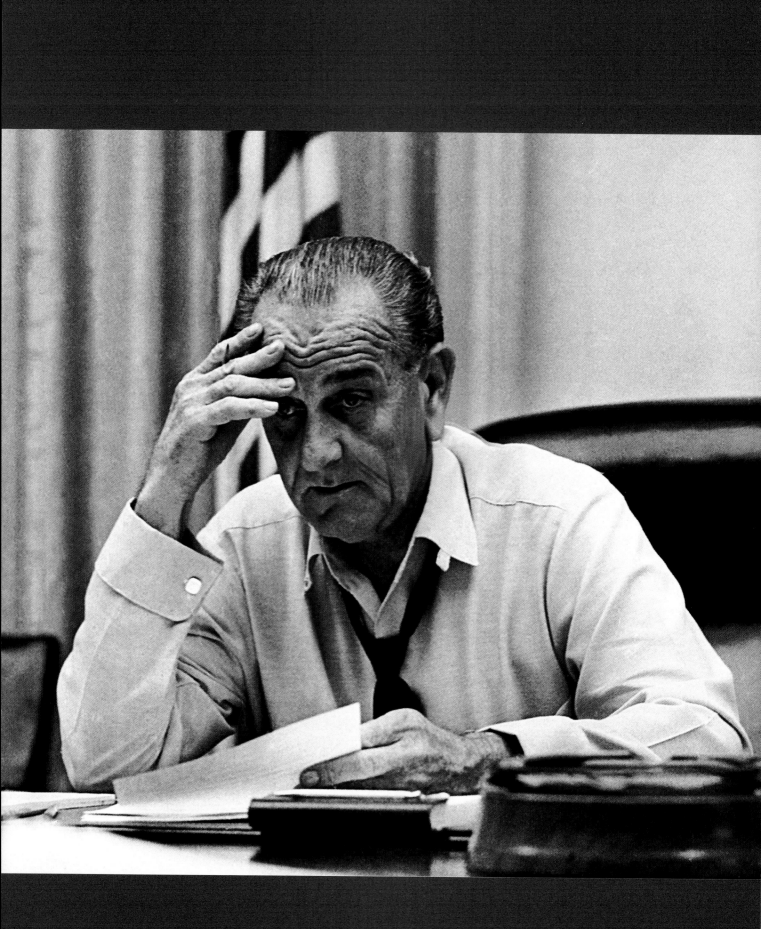

By 1968 the turmoil of Vietnam had taken its toll on LBJ, who watched helplessly as Eugene McCarthy *(opposite)* launched a campaign to challenge his nomination for a second term.

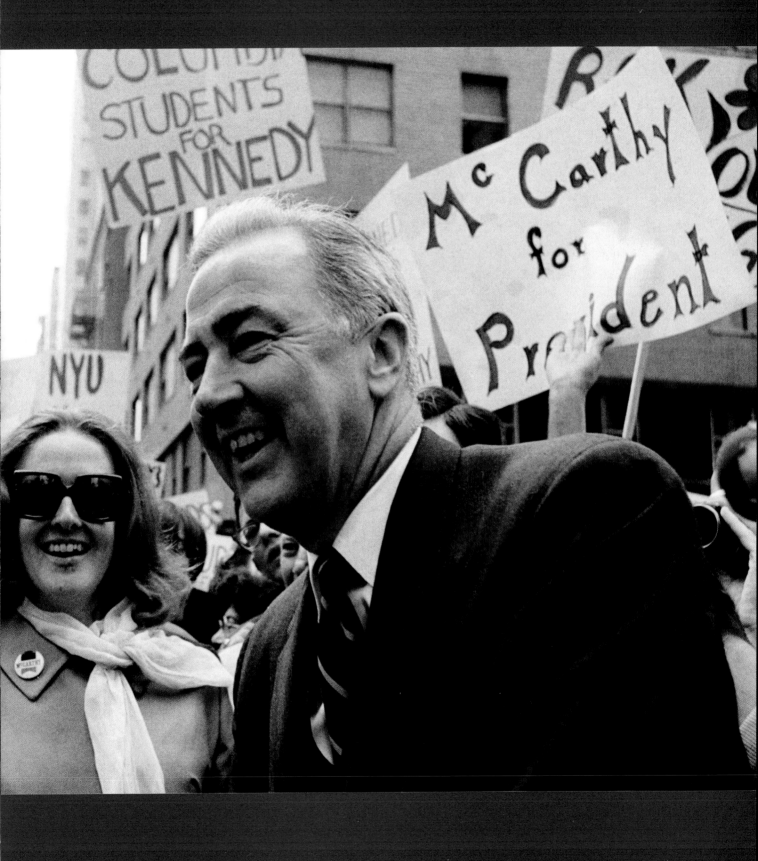

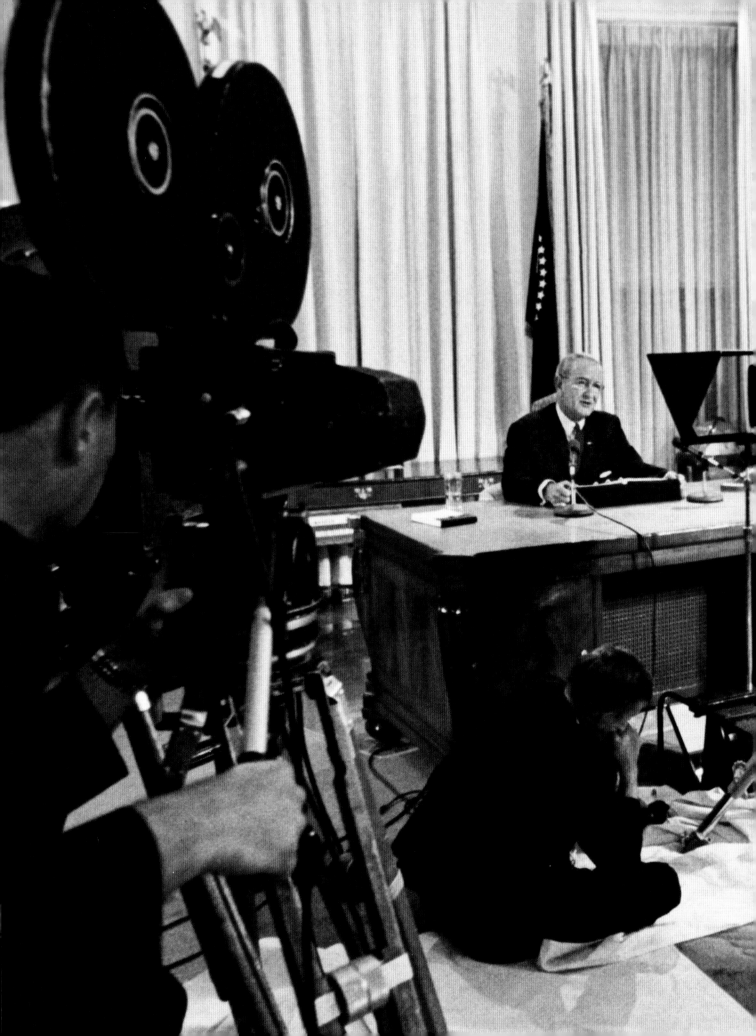

LBJ withdraws from the
1968 race for the White House.

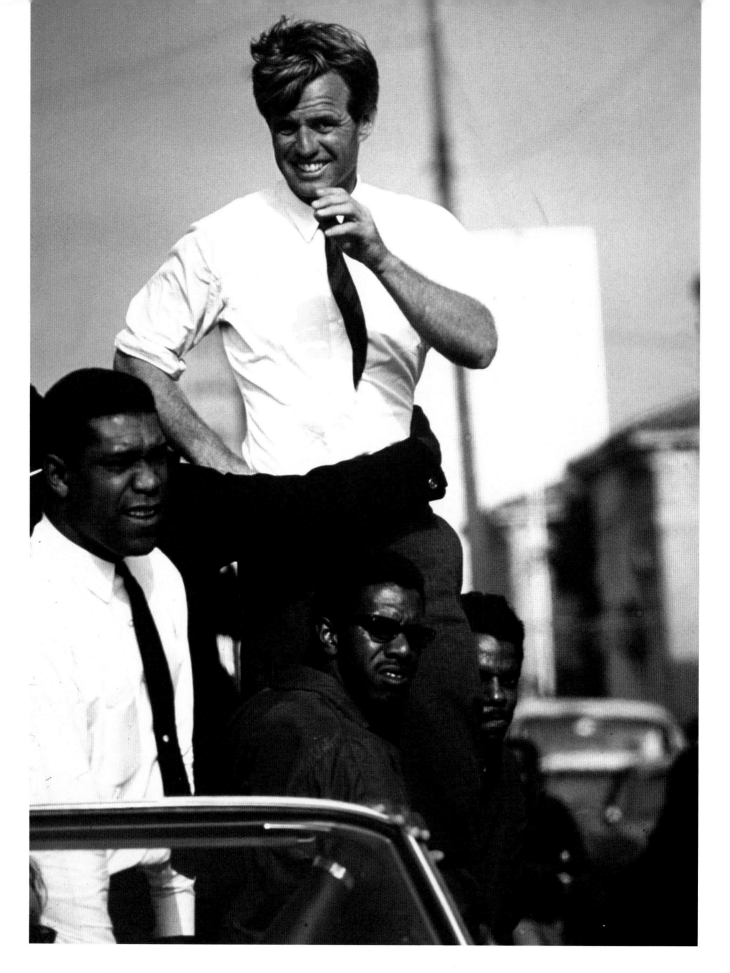

RFK at a rally in Watts, the Los Angeles ghetto racked by riots in 1965.
Kennedy developed a special rapport with African-American voters.

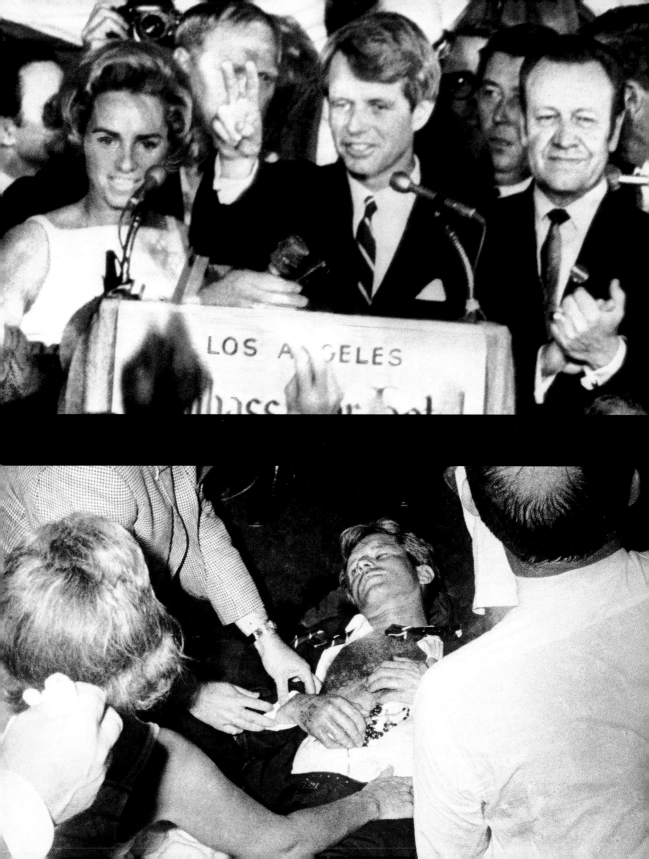

LOS ANGELES

Vice President Hubert Humphrey, the Democrats' establishment candidate and eventual nominee; the sun rarely shone so brightly.

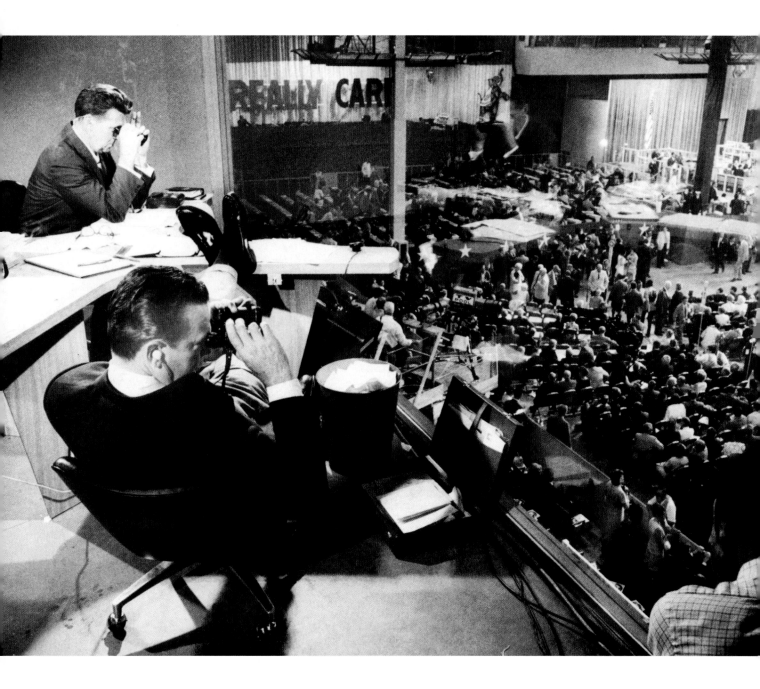

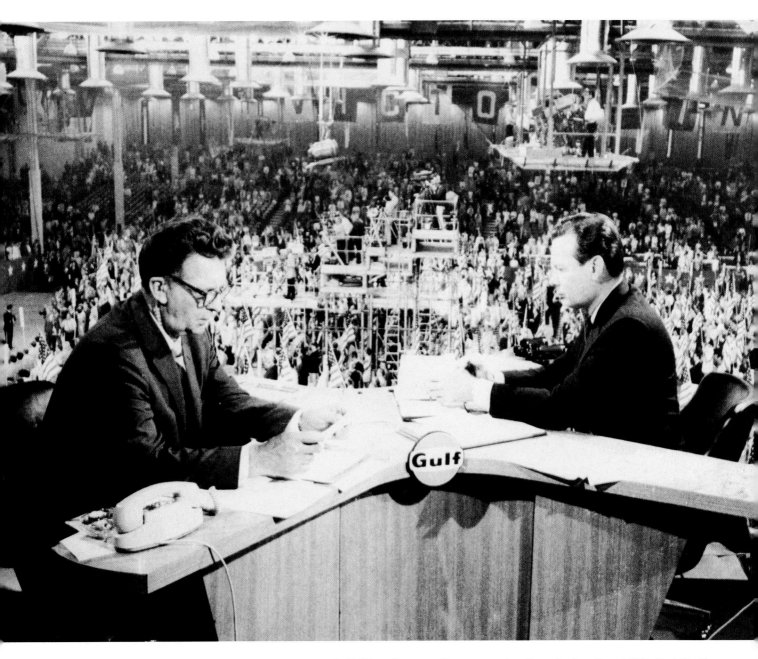

In 1968, party conventions were prime-time viewing. Here, NBC's Chet Huntley and David Brinkley report from the relatively peaceful Republican convention.

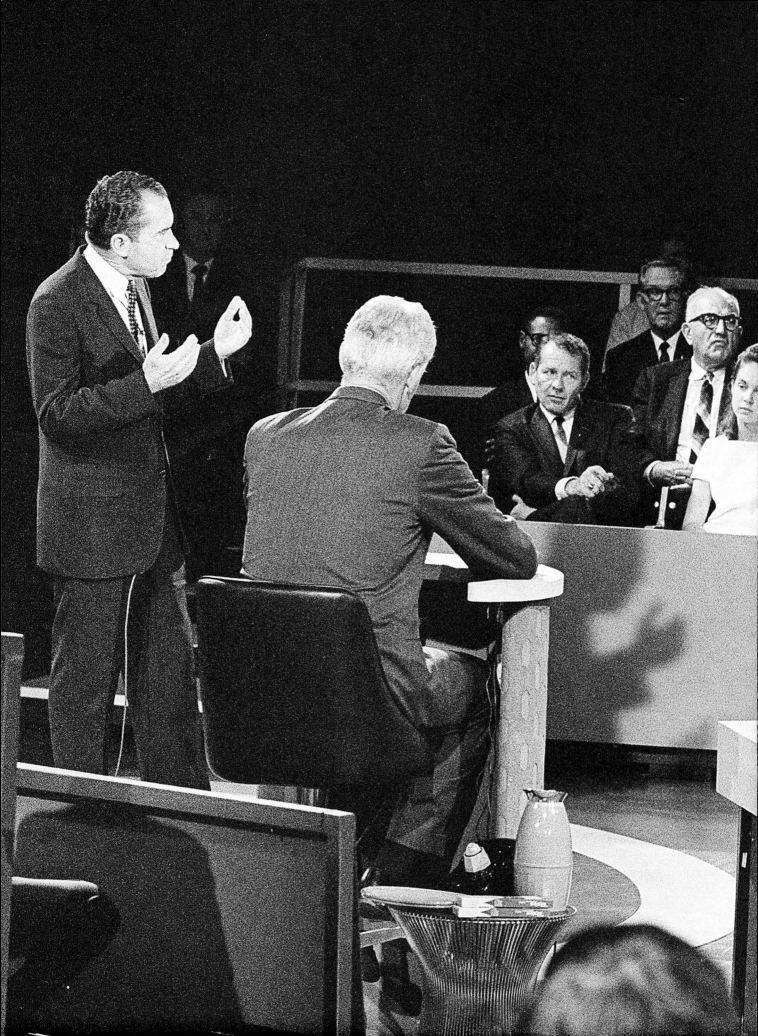

Richard Nixon's 1968 race gave birth to the modern political campaign, sidestepping the press in favor of carefully choreographed "town hall" broadcasts.

KEN REYNOLDS
CALIFORNIA

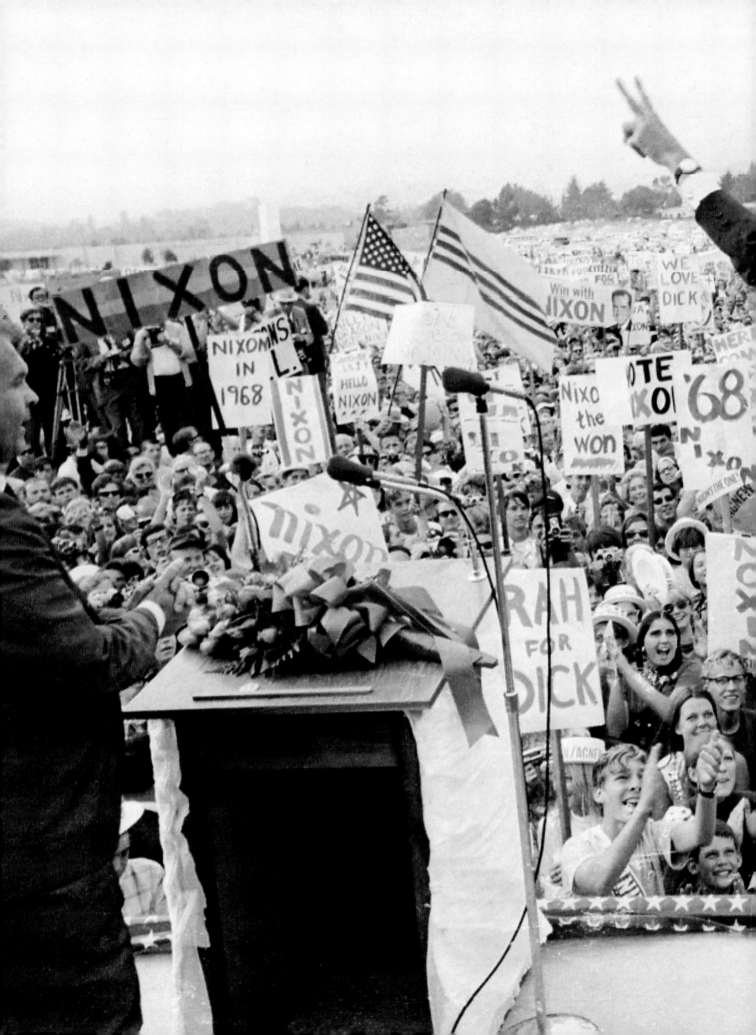

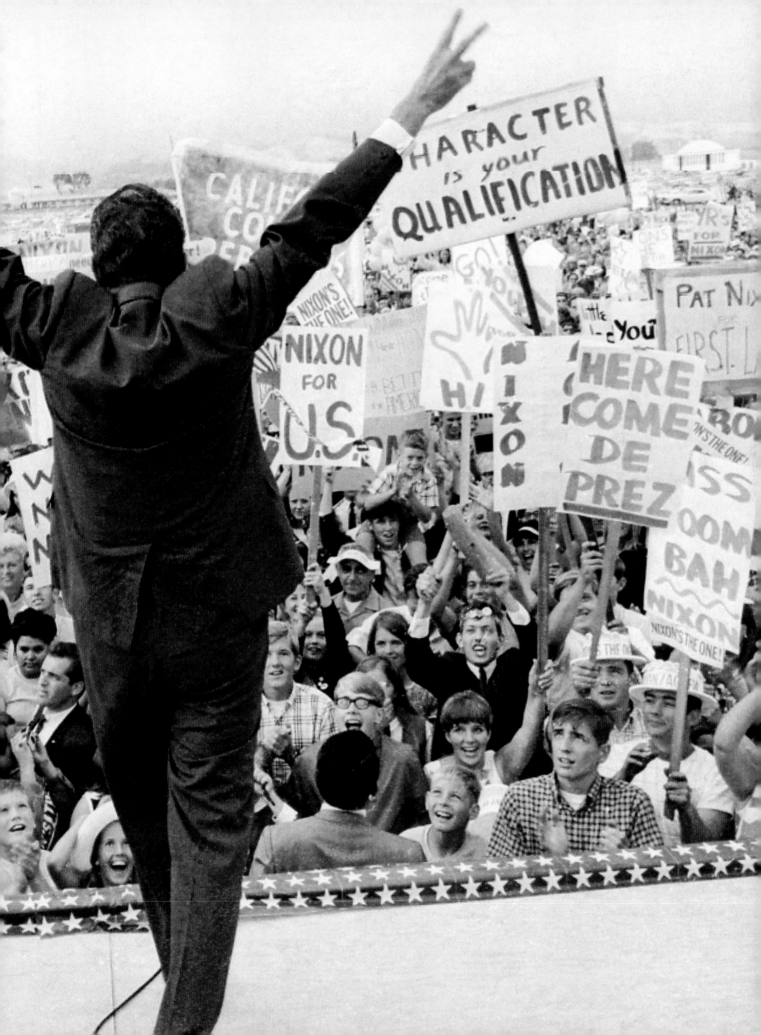

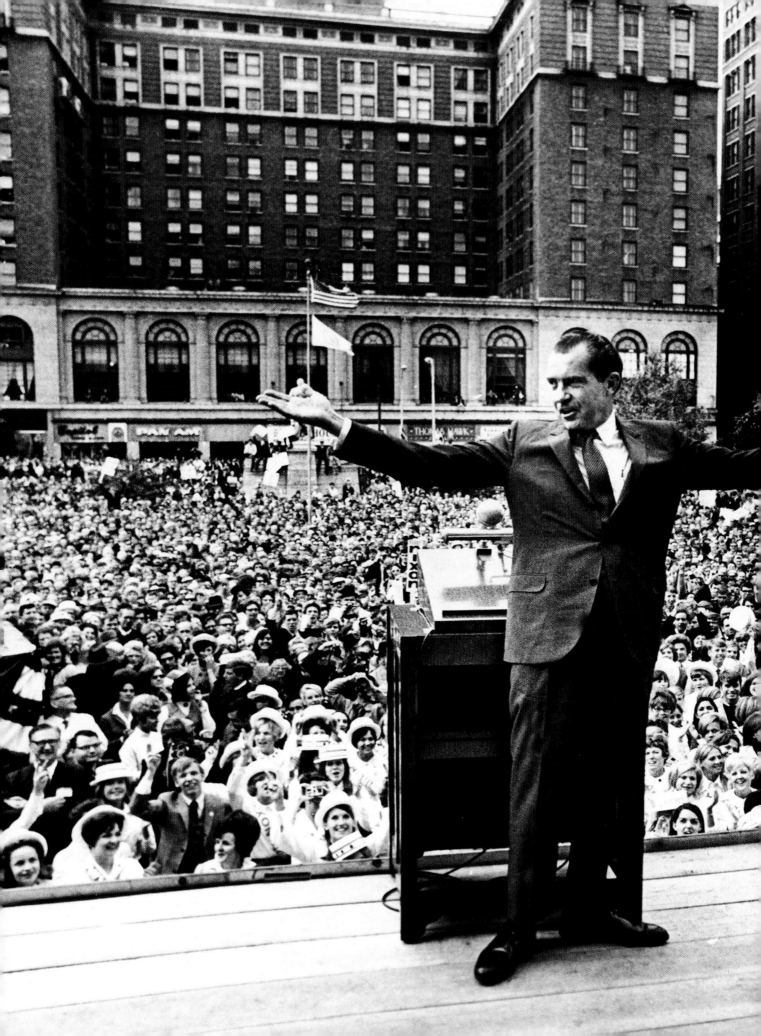

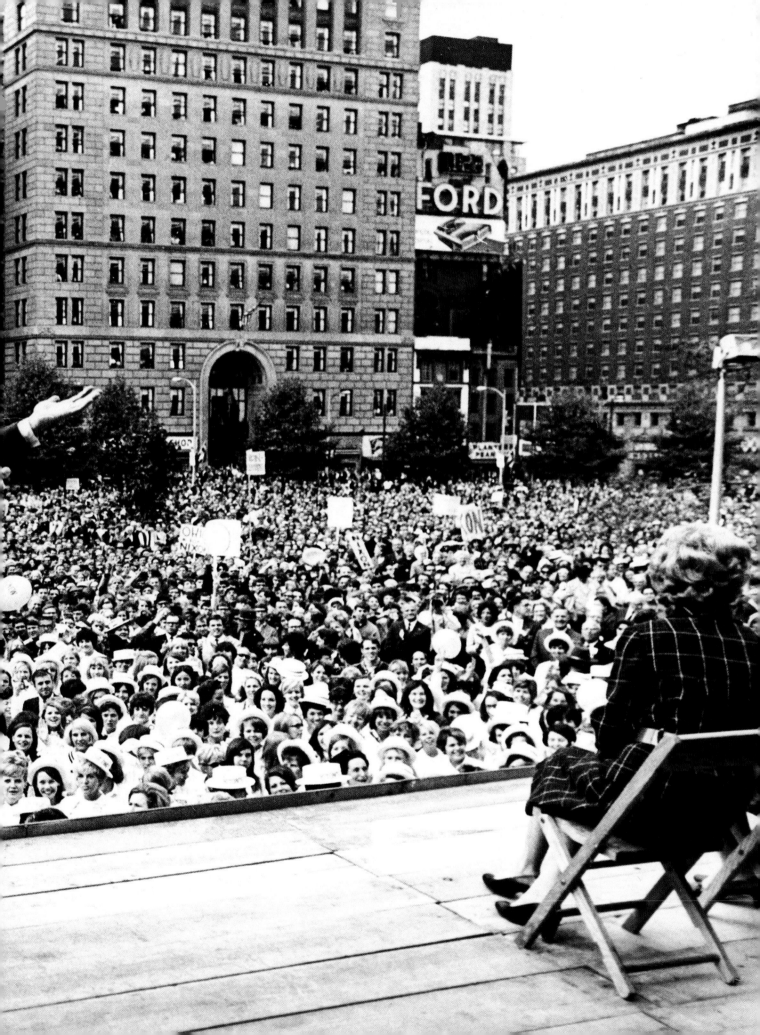

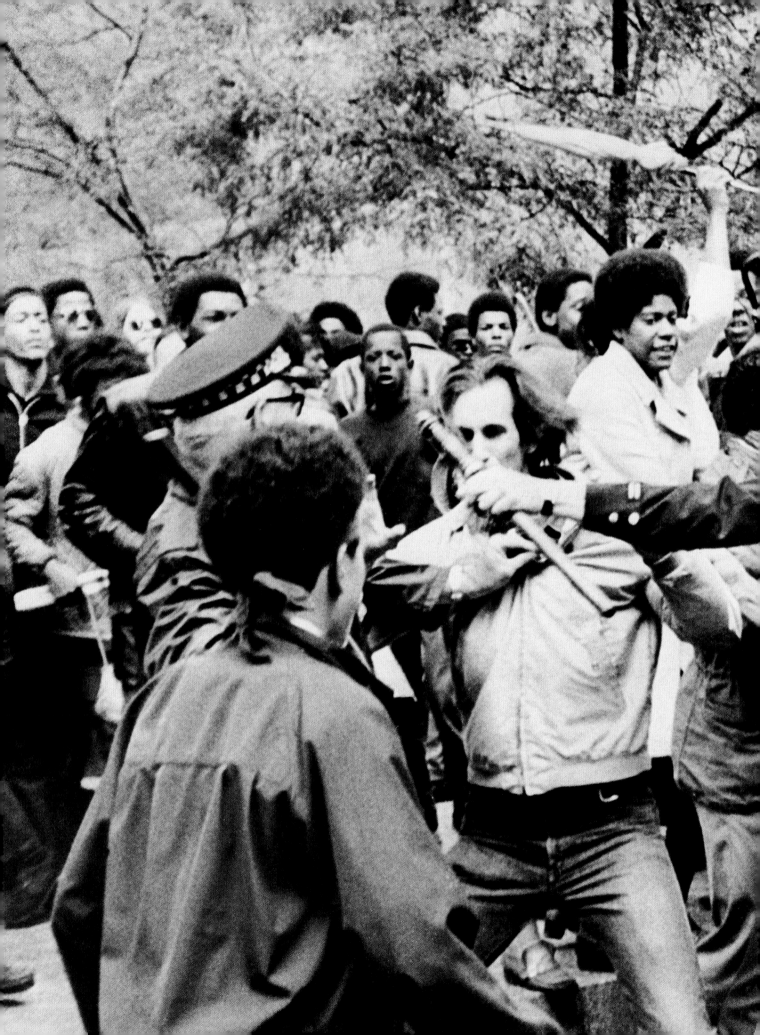

FOLLOWING PAGES: The 1968 Democratic National Convention in Chicago. It was a week of infamy, as antiwar demonstrators were routed by Chicago police and National Guard troops. An investigation later termed the violence a "police riot."

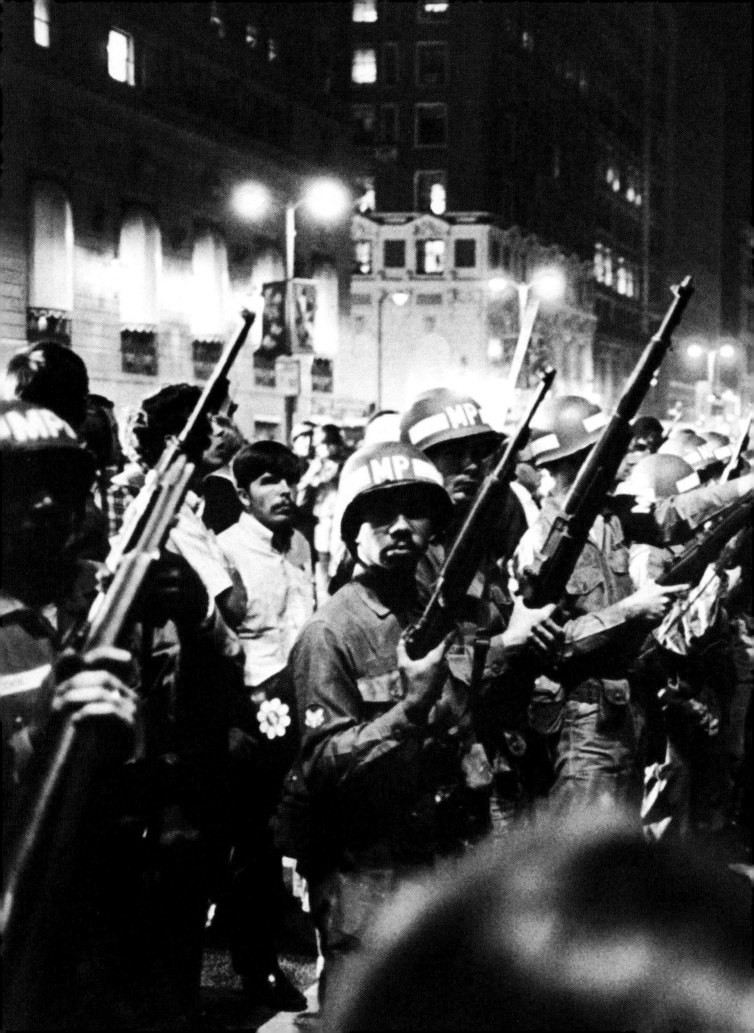

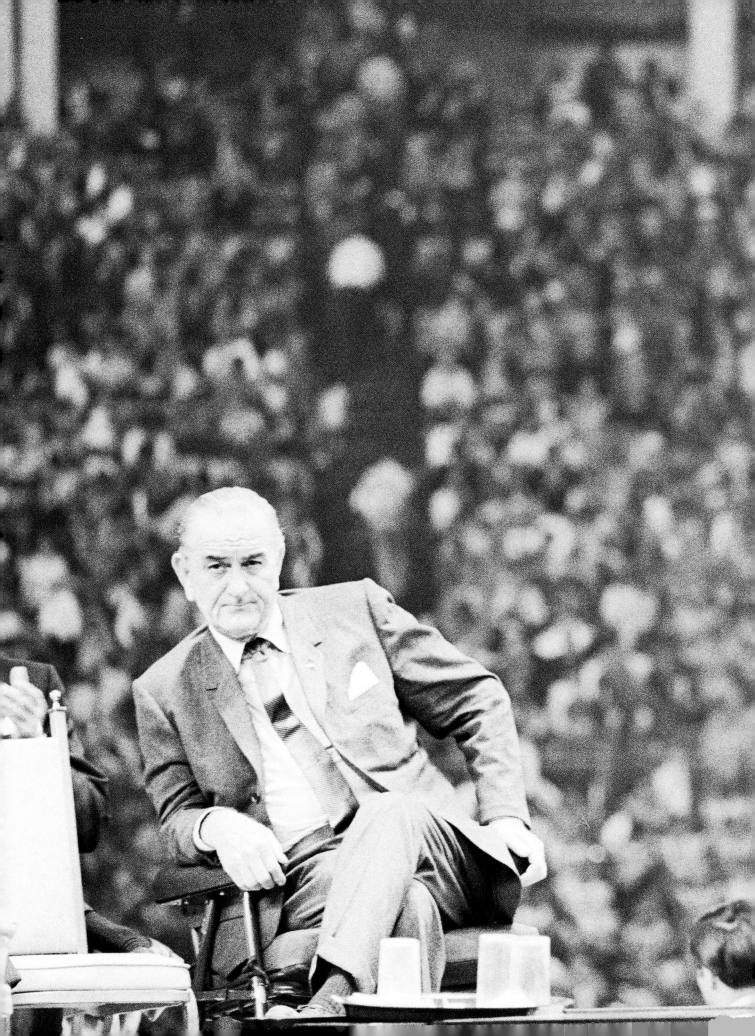

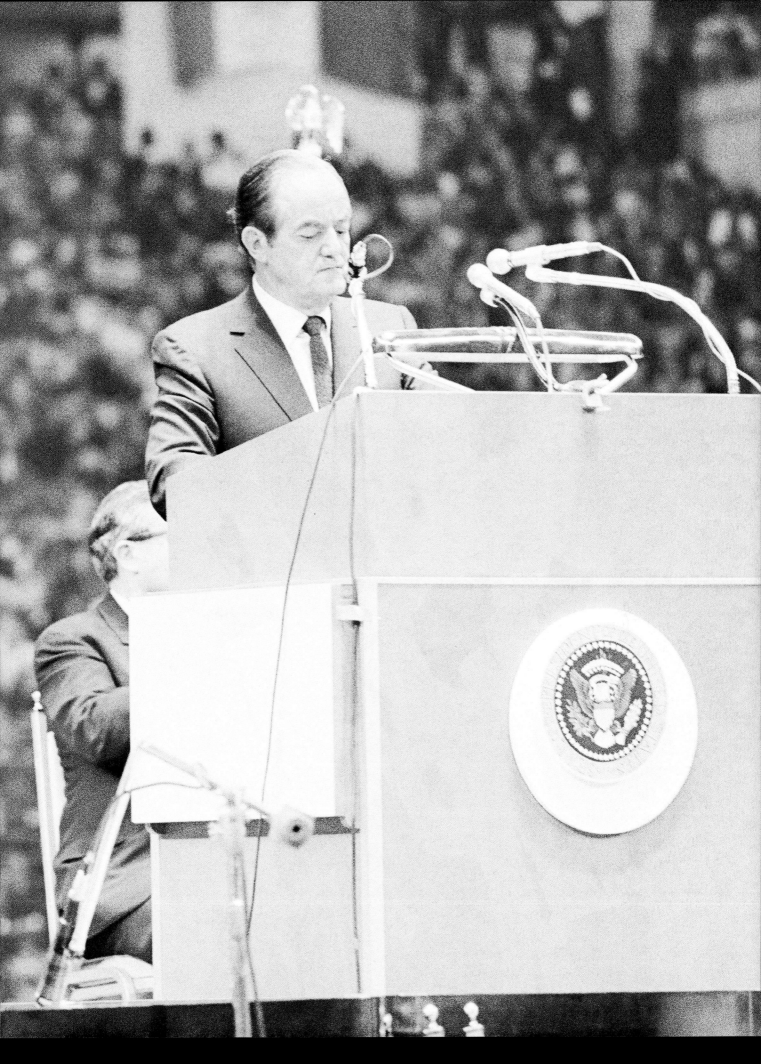

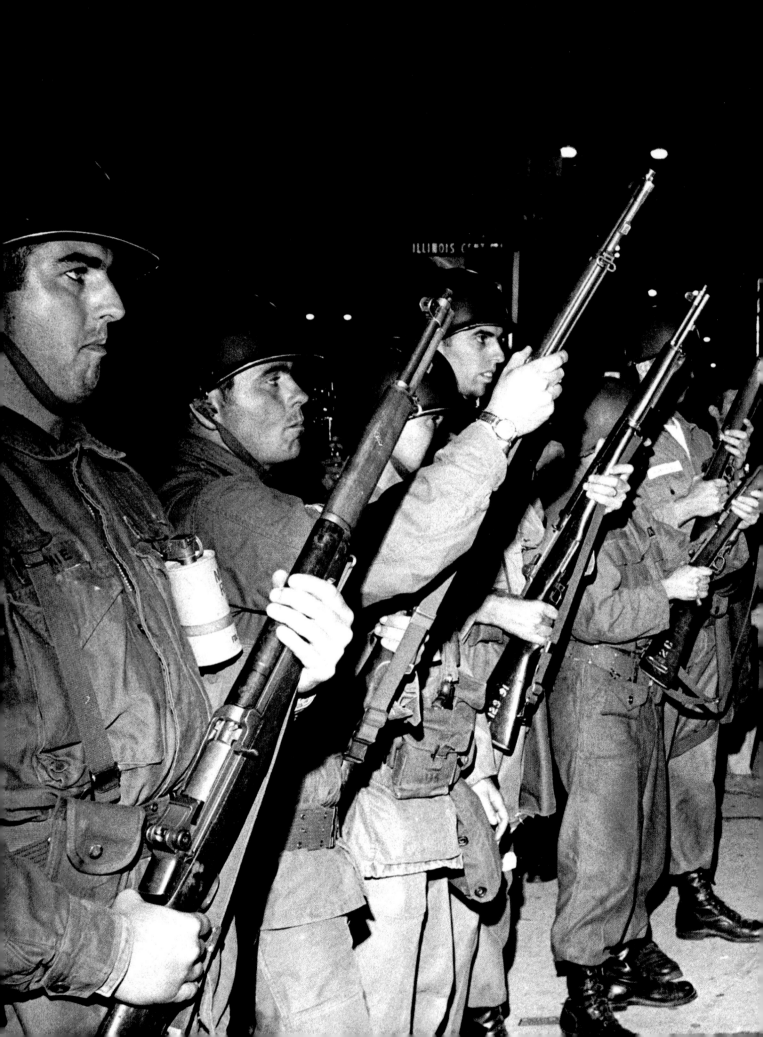

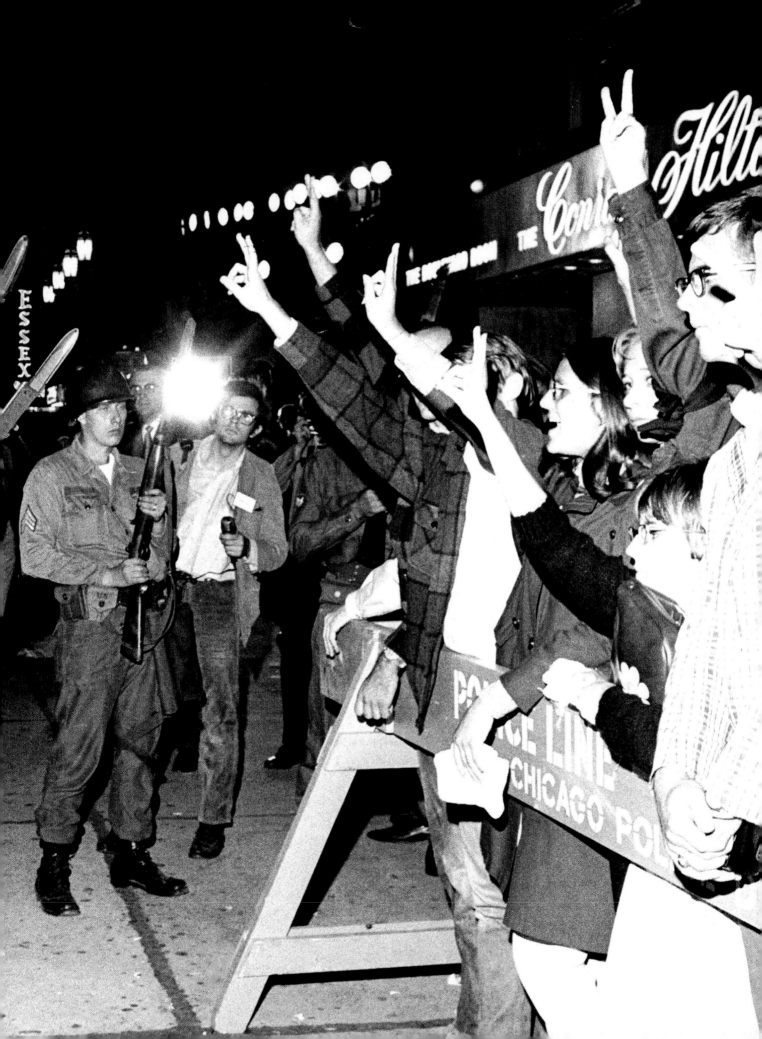

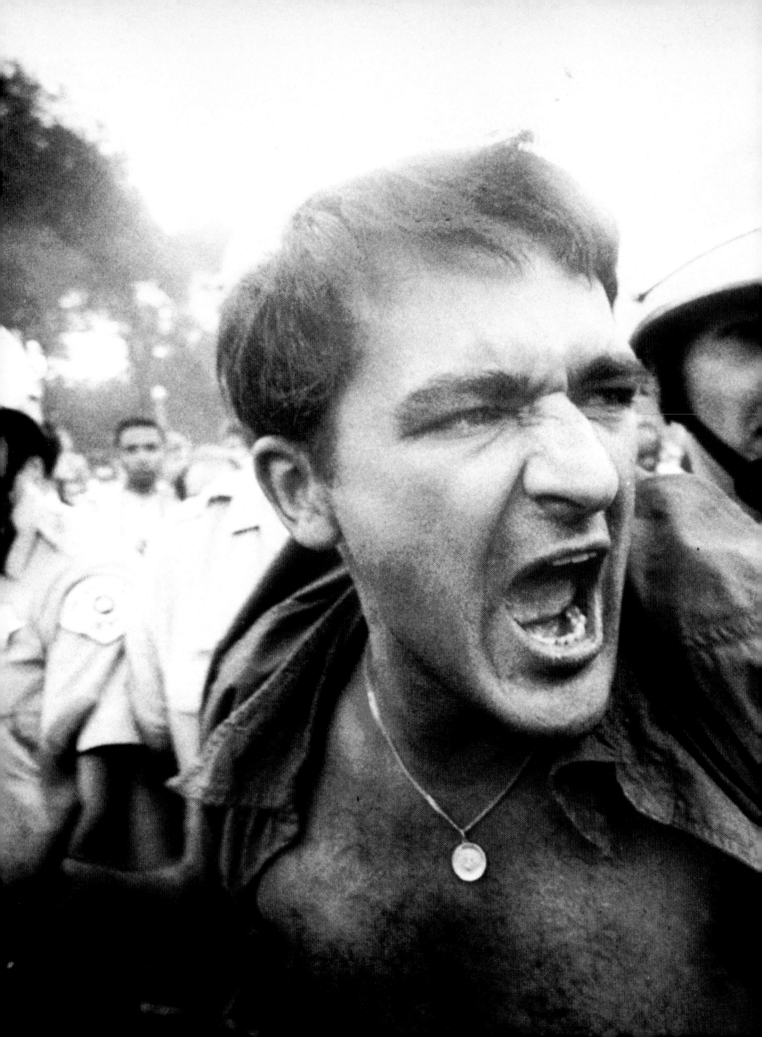

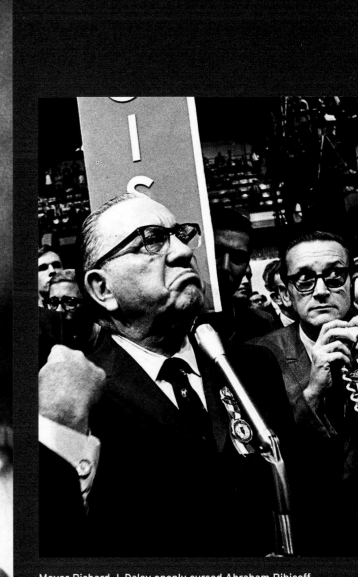

Mayor Richard J. Daley openly cursed Abraham Ribicoff
from the convention floor after the Connecticut senator
condemned the "Gestapo tactics" of Daley's
Chicago police.

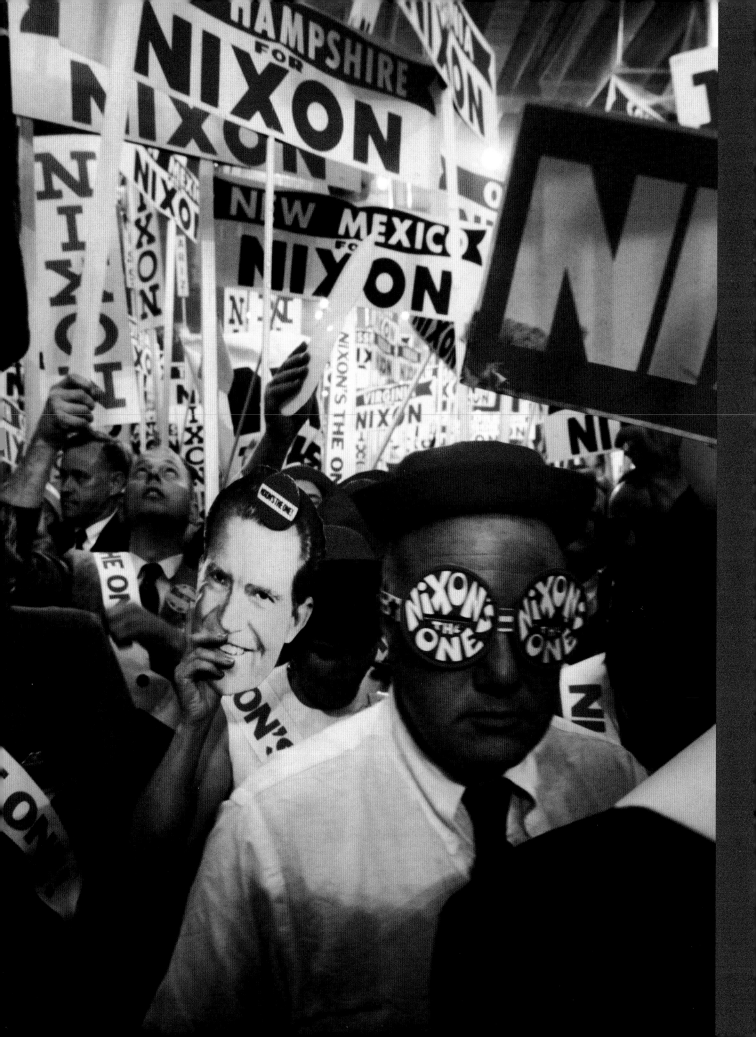

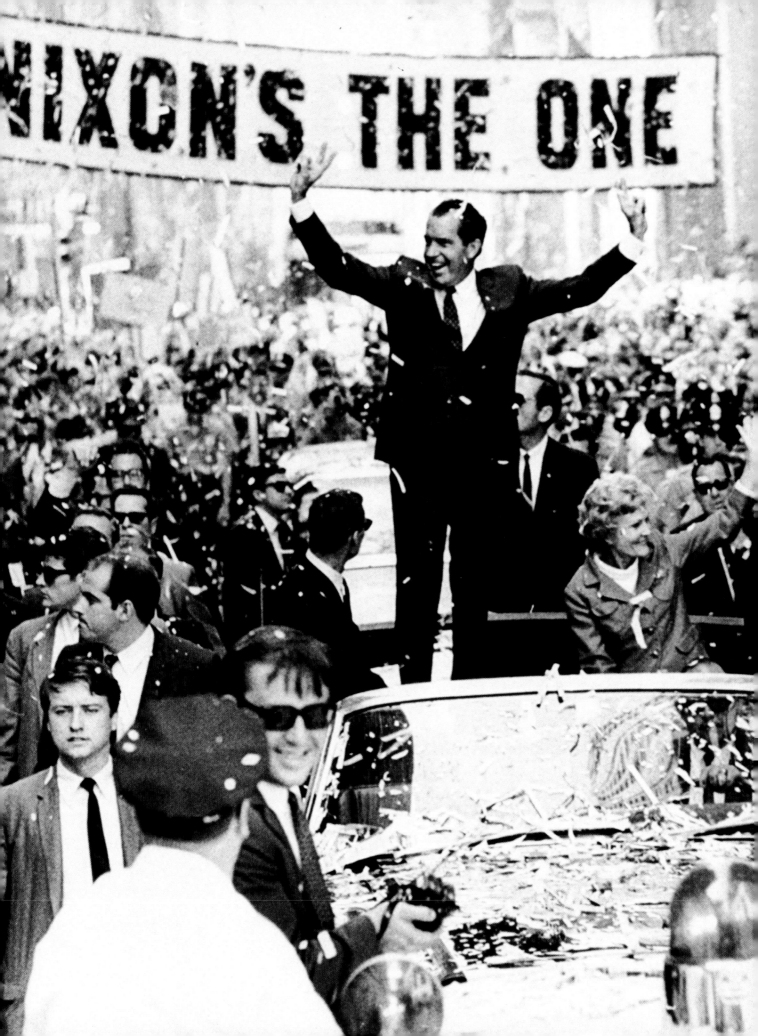

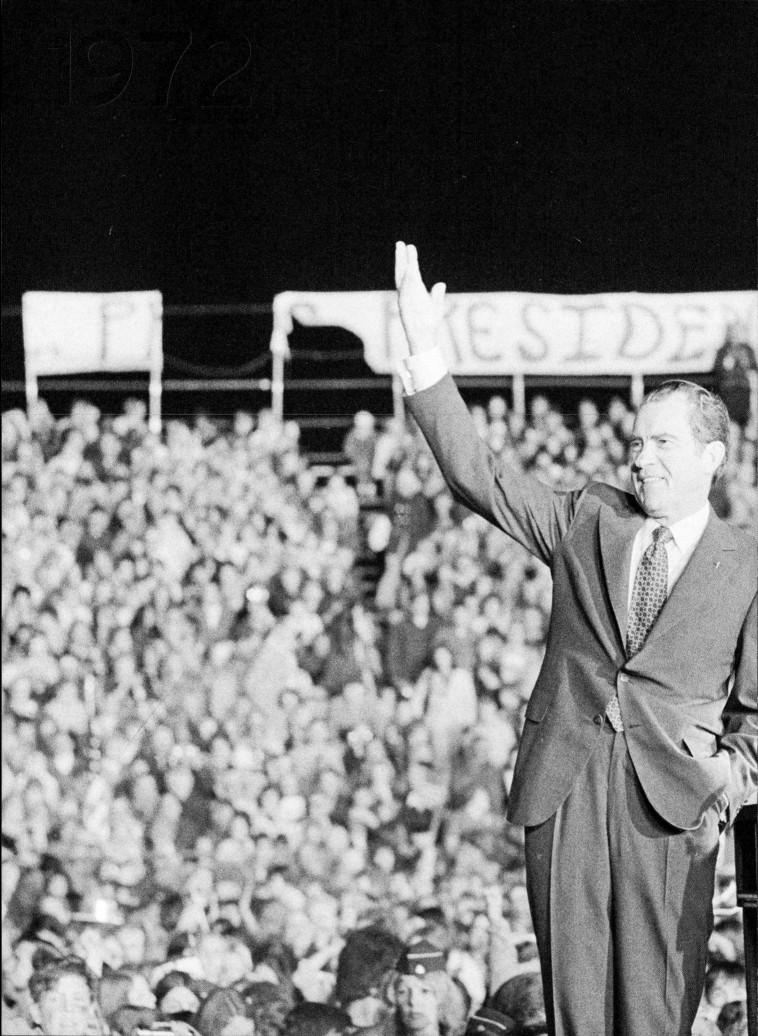

Nixon barnstormed the nation in 1972; though he won the race in a 49-state landslide, the disgrace of Watergate would drive him from office in less than two years.

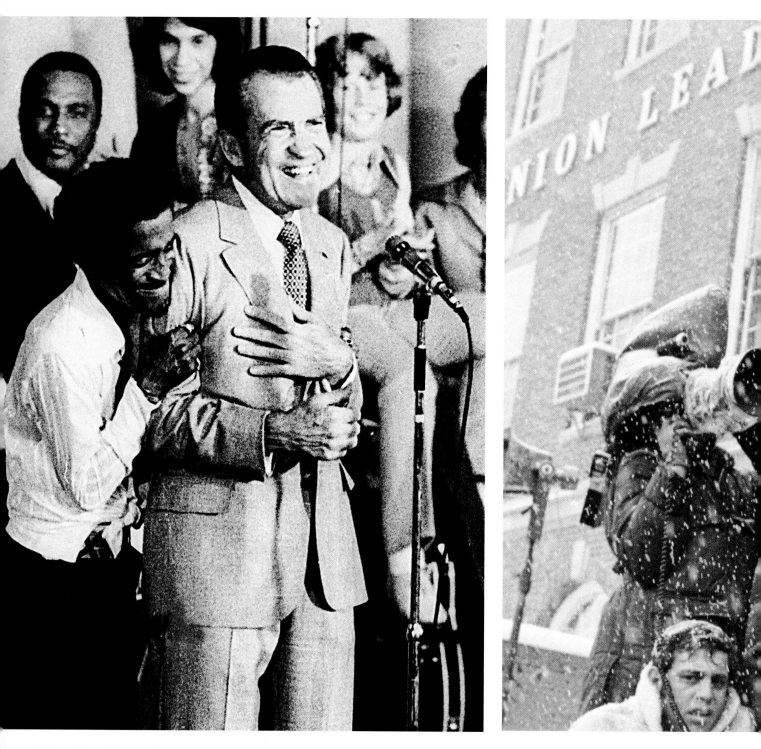

Strange bedfellows: President Nixon embraced by Sammy Davis, Jr.

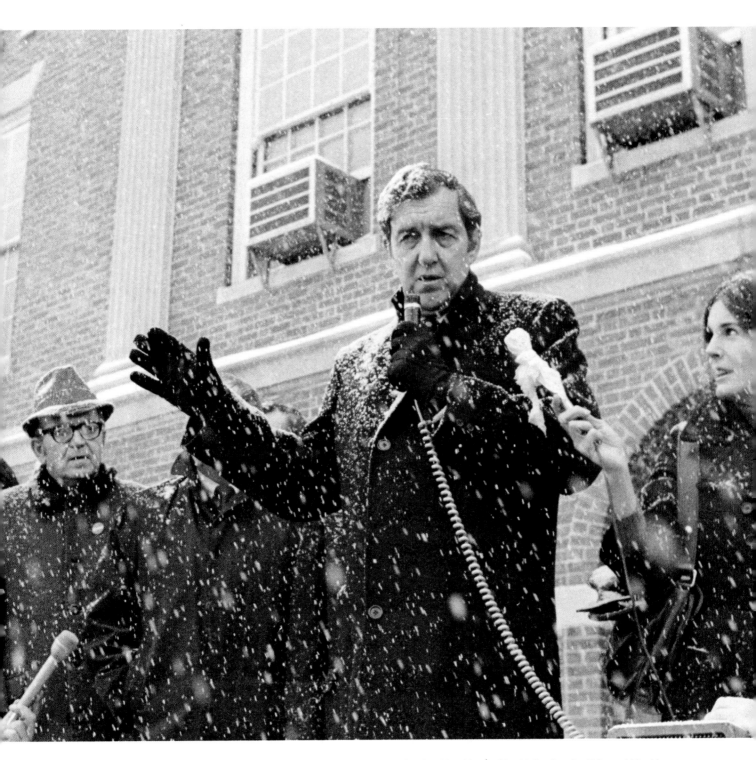

After a scurrilous attack on his wife appeared in the Manchester, New Hampshire *Union Leader,* Edmund Muskie defended his wife's honor in front of the paper's offices. Photographs and news footage made it appear that Muskie shed tears during the appearance; others blamed the impression on snowfall, but Muskie's candidacy was mortally wounded.

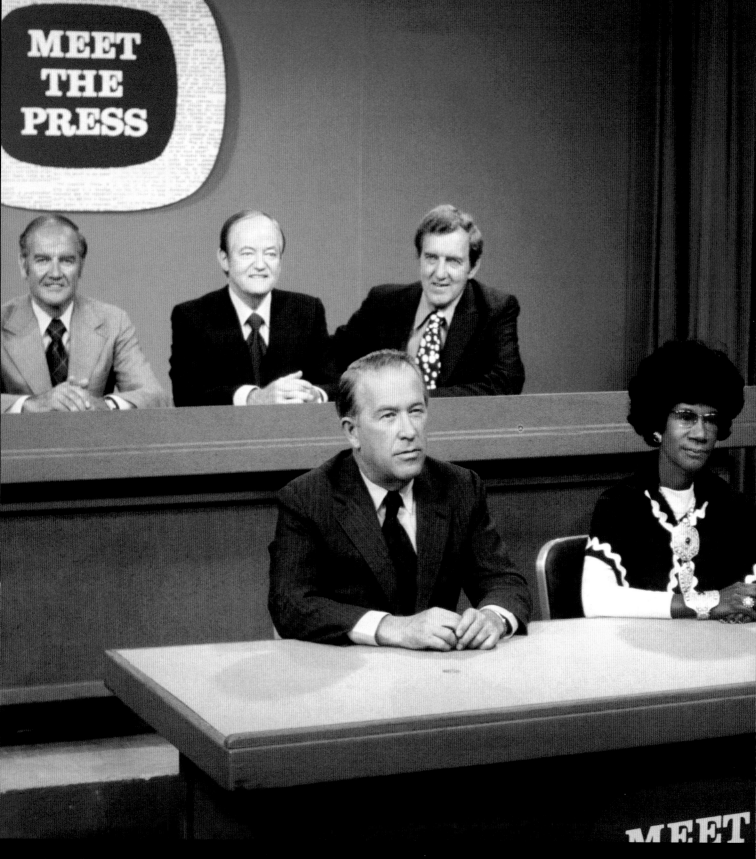

The candidates for the 1972 Democratic nomination: *(back row)* George McGovern, Hubert Humphrey, Edmund Muskie, and *(front row)* Henry "Scoop" Jackson and Shirley Chisholm, in a joint appearance on *Meet the Press*.

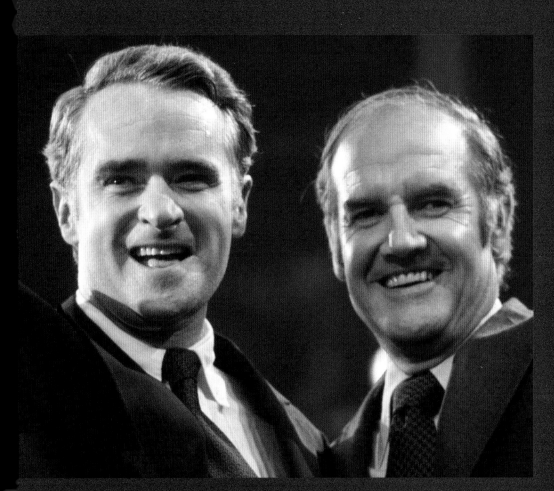

George McGovern selected Thomas Eagleton (*above*, with McGovern) as his running mate; when it was revealed that Eagleton had been treated for depression, McGovern replaced him with Sargent Shriver (*below*).

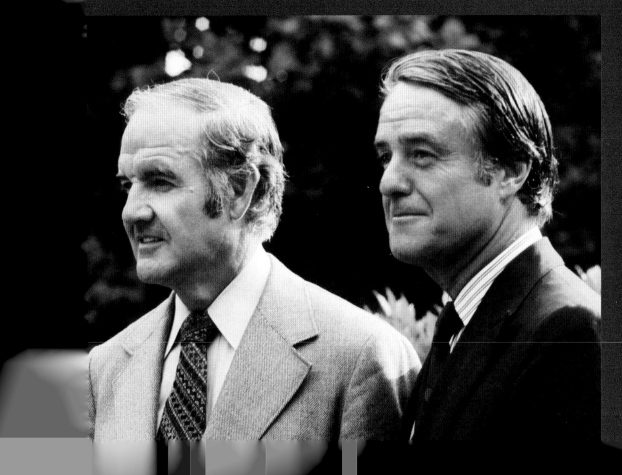

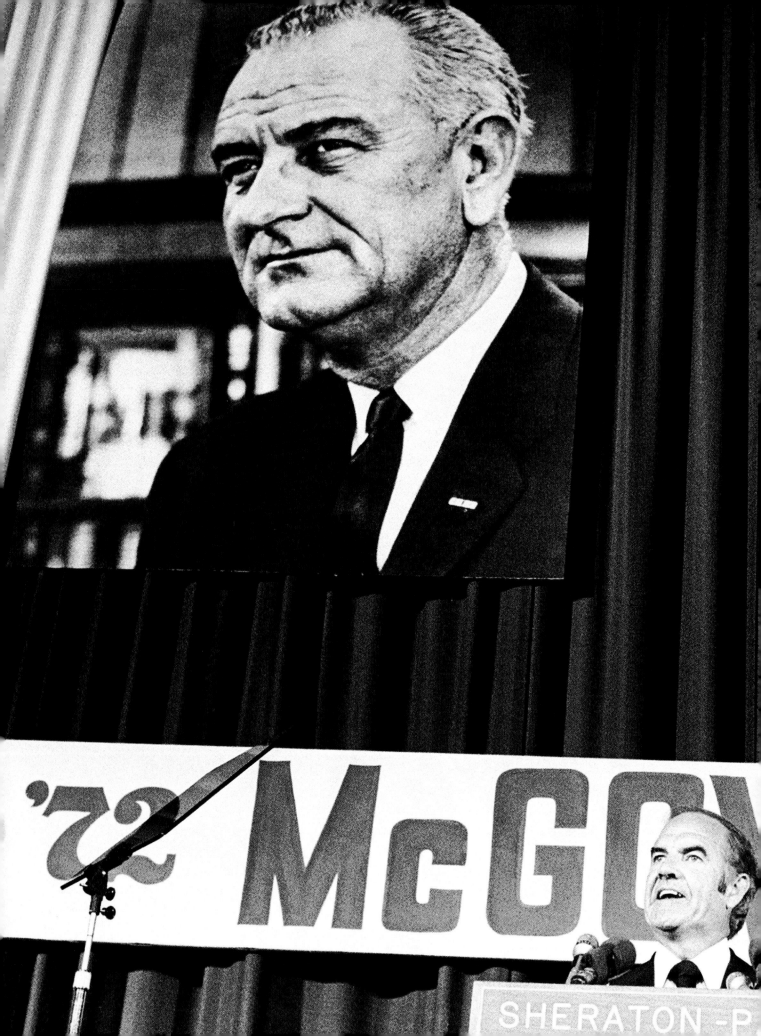

'72 McGOV

SHERATON-P

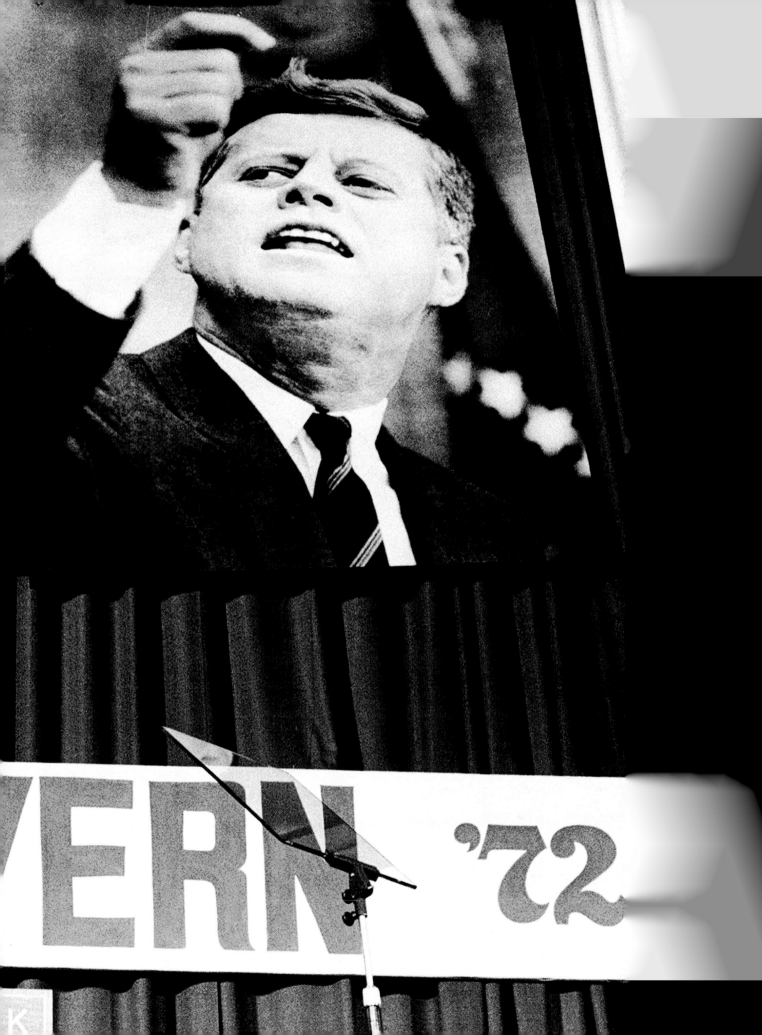

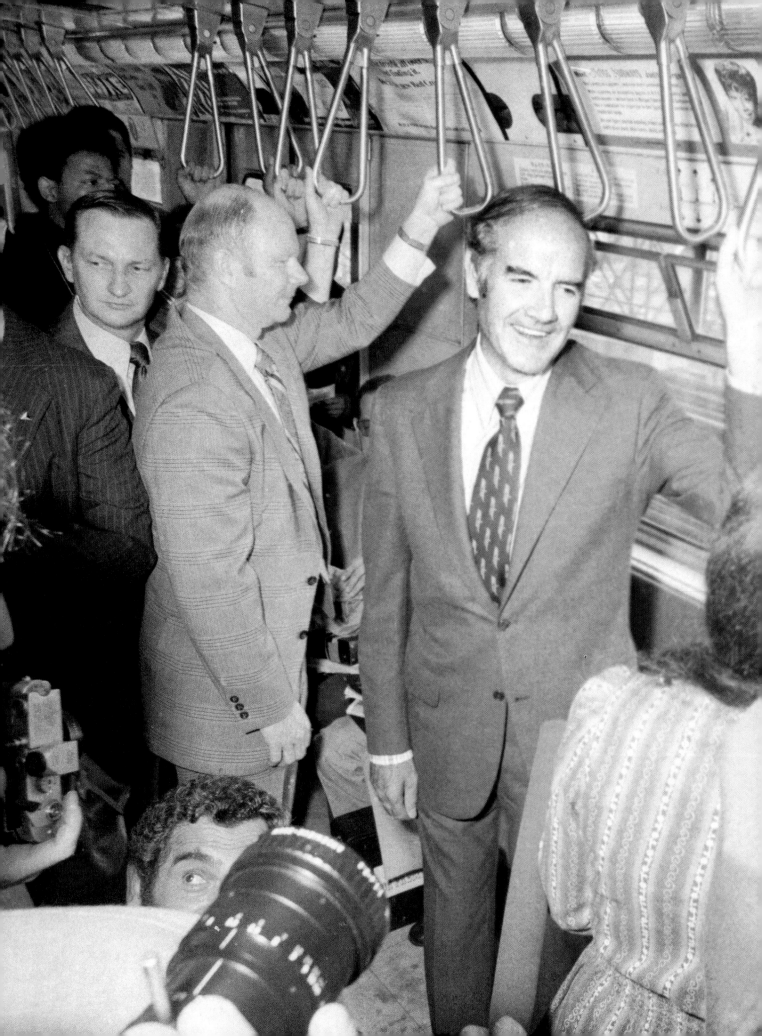

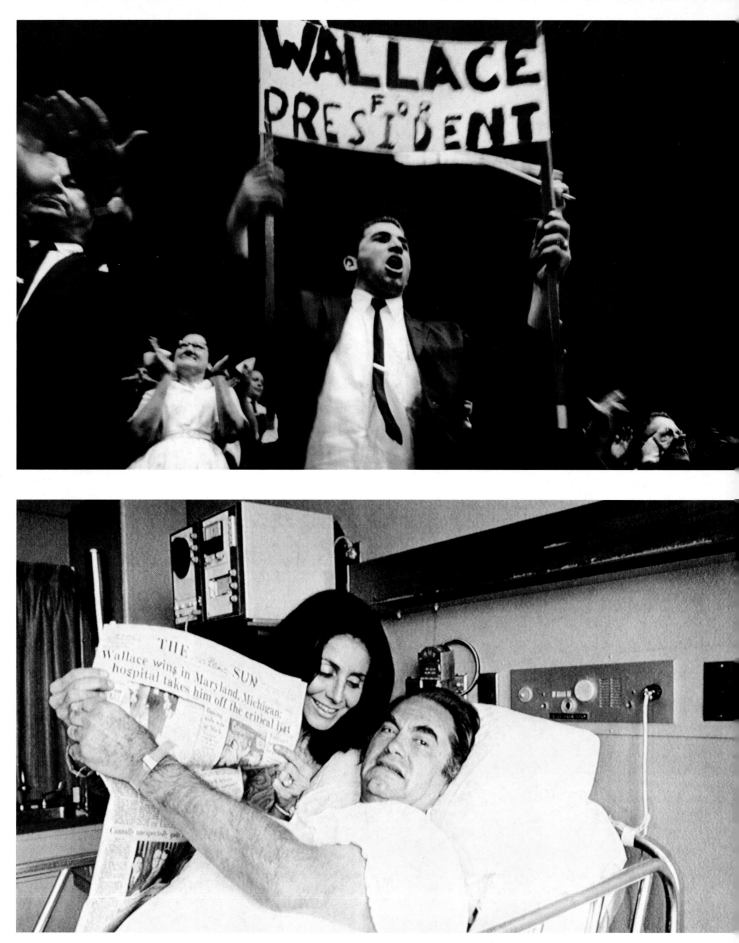

After his strong independent bid in 1968, George Wallace returned to the Democratic fold in 1972. Even after an assassination attempt left him paralyzed, Wallace won Democratic primaries in the northern states of Maryland and Michigan.

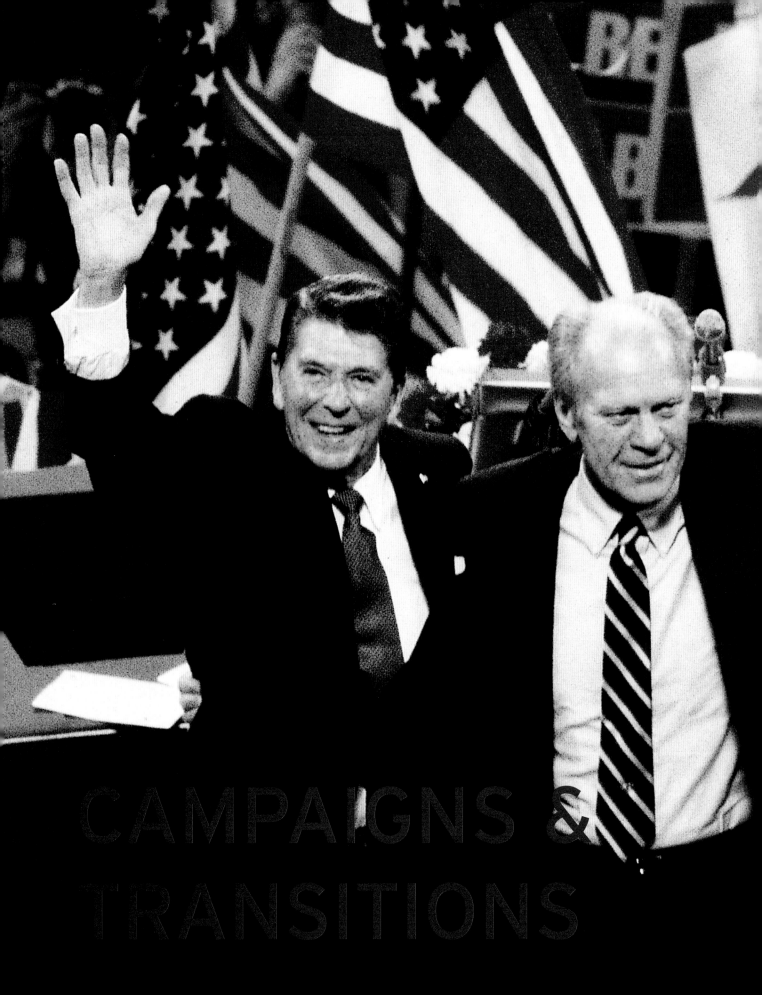

CAMPAIGNS &
TRANSITIONS

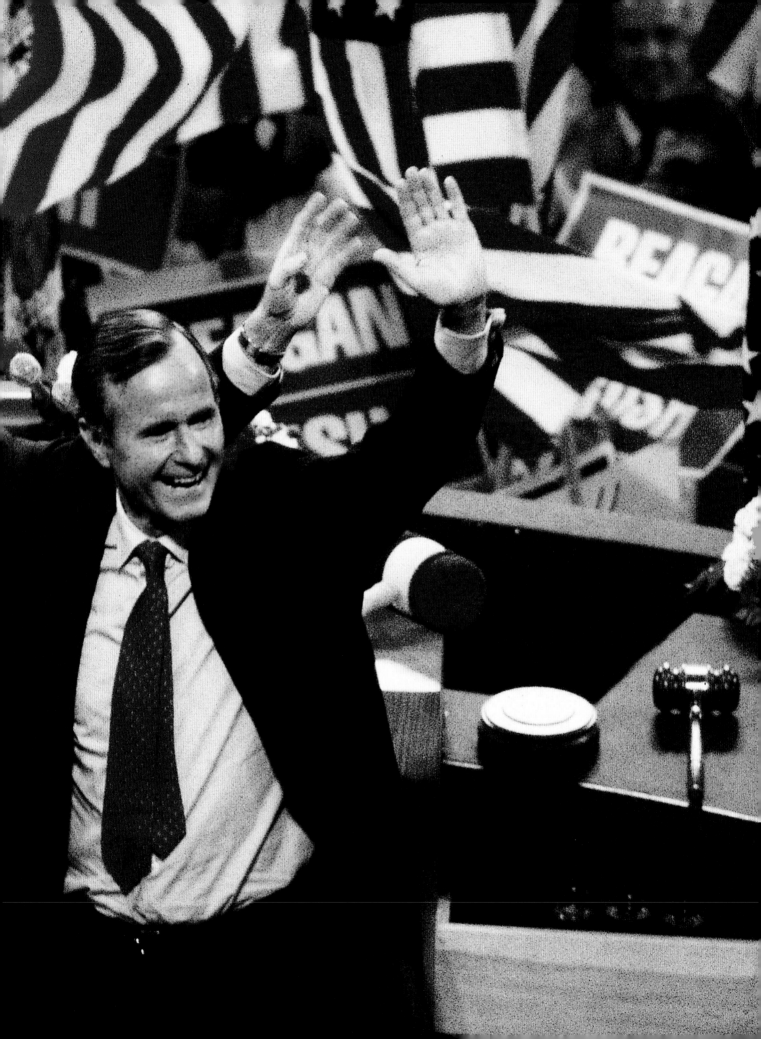

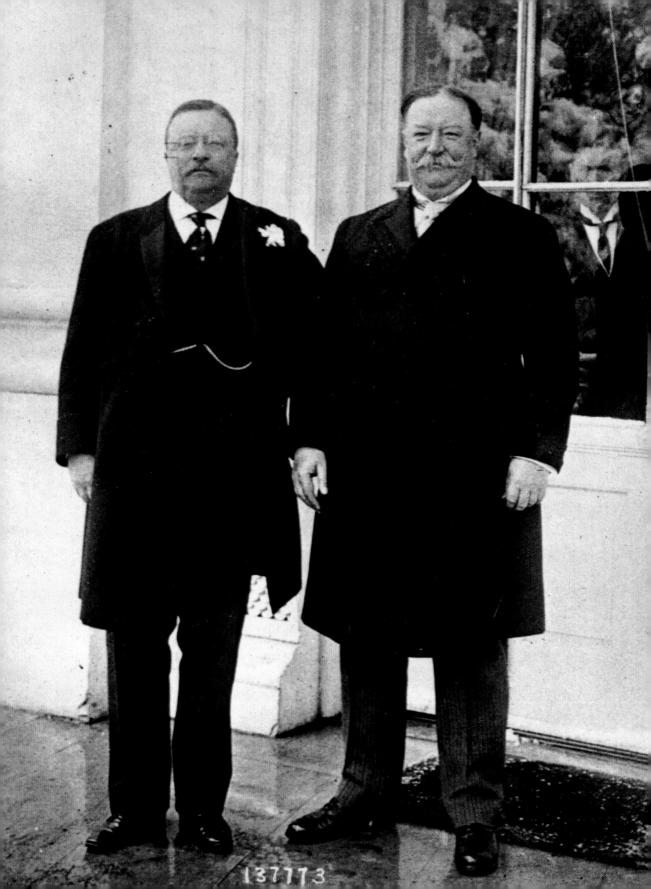

137773

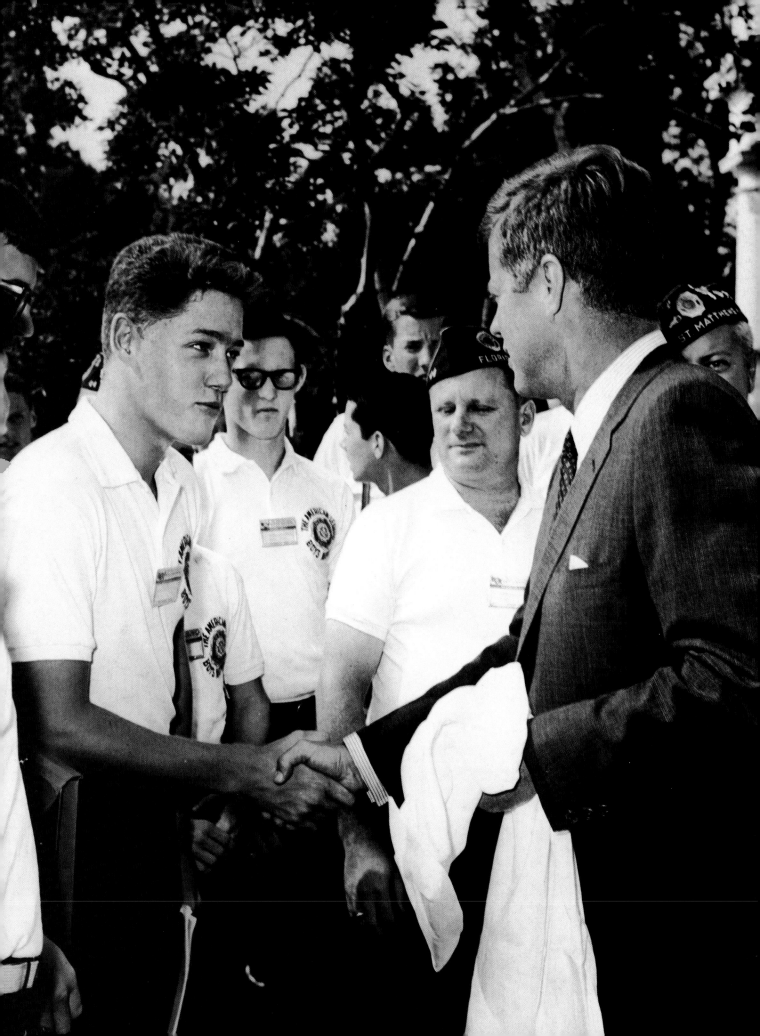

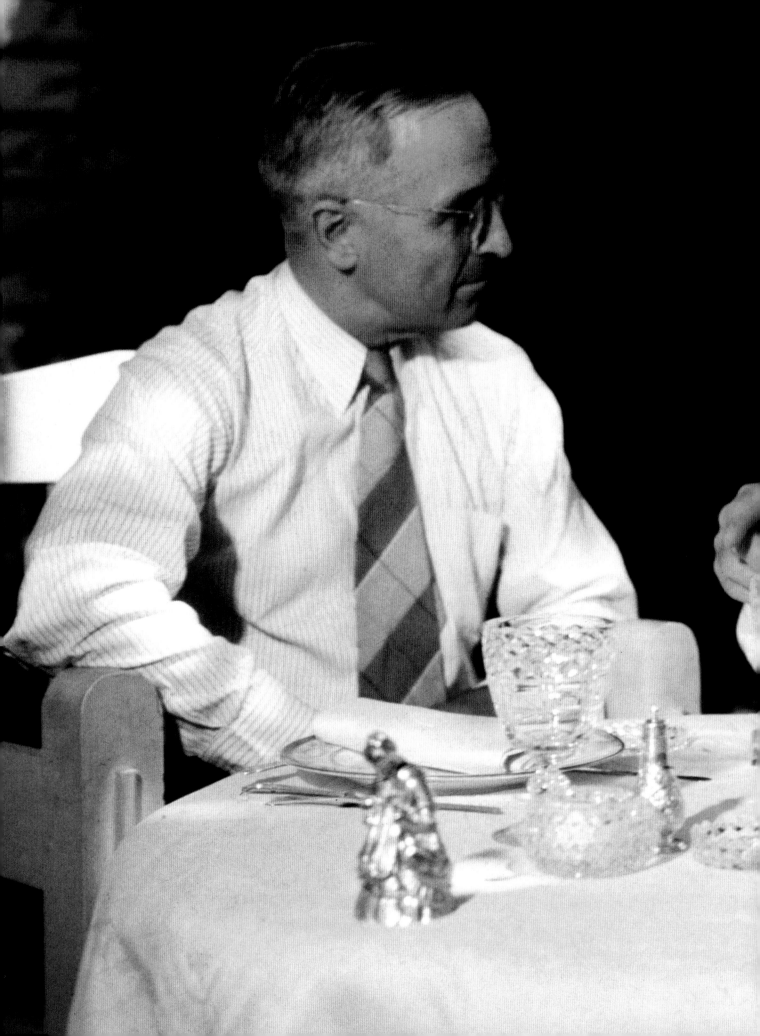

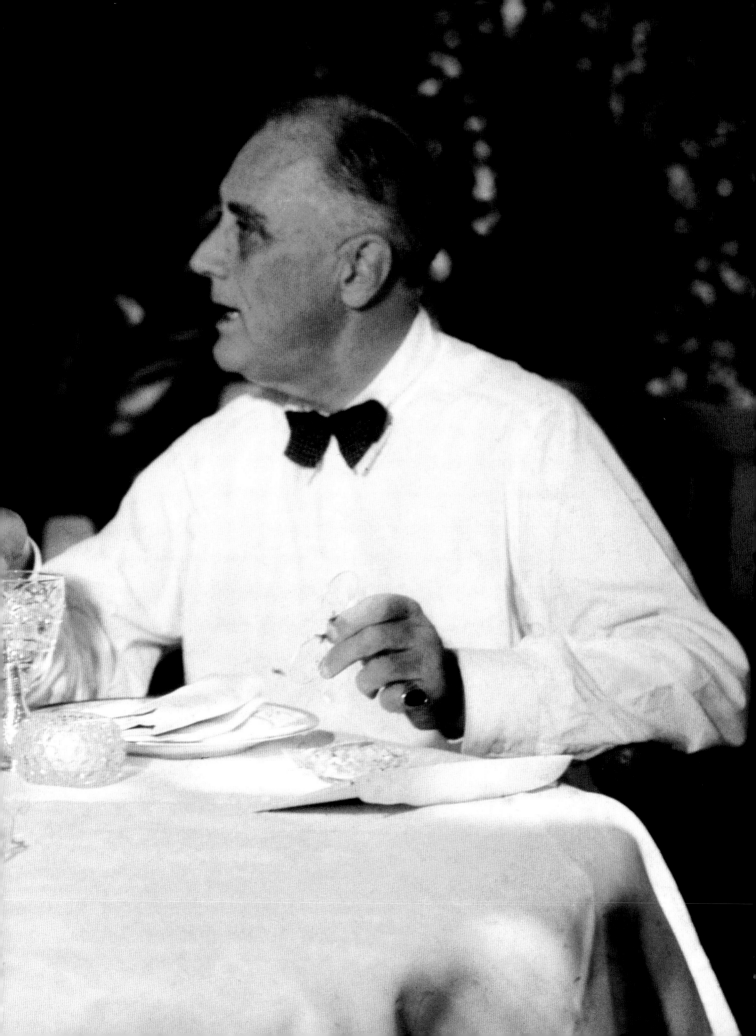

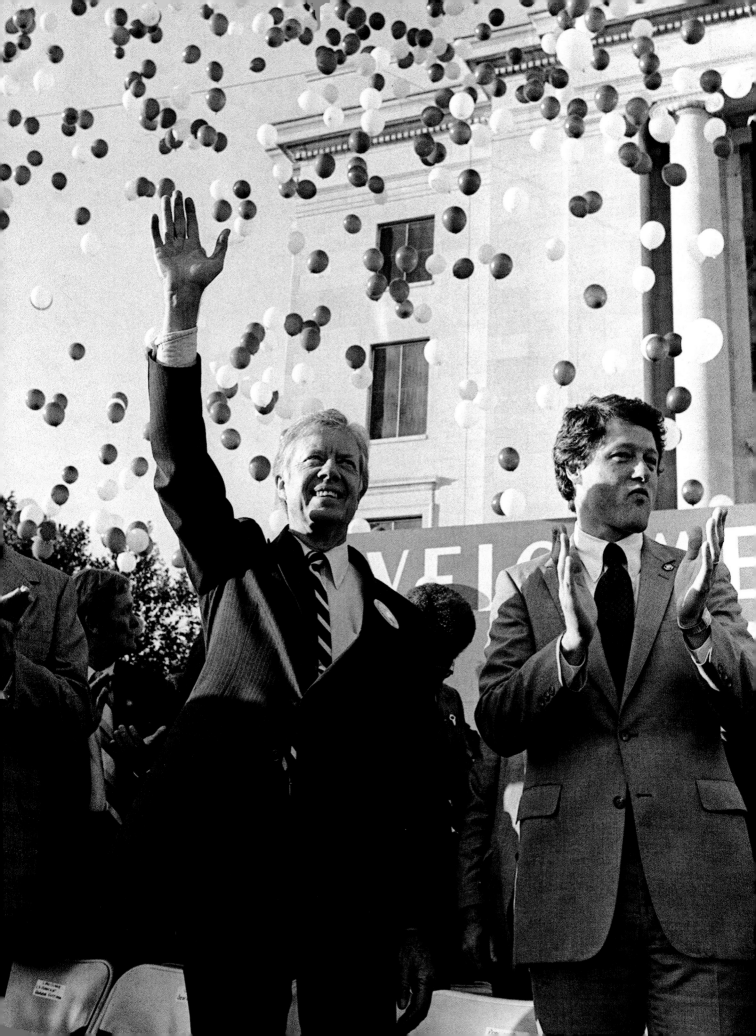

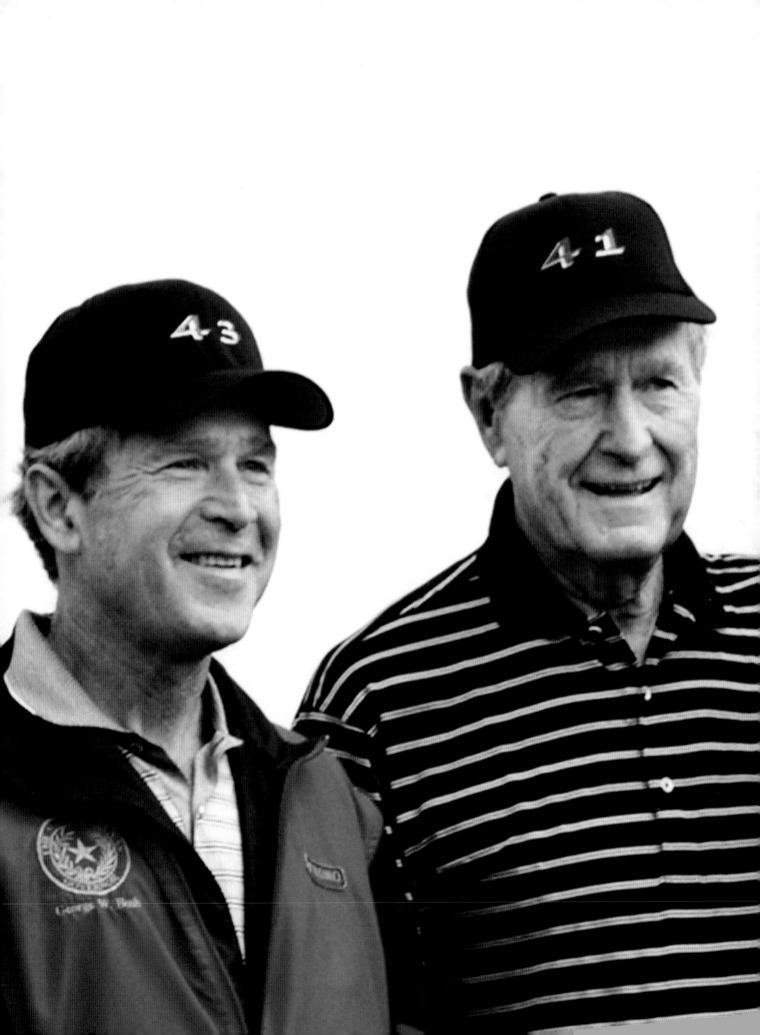

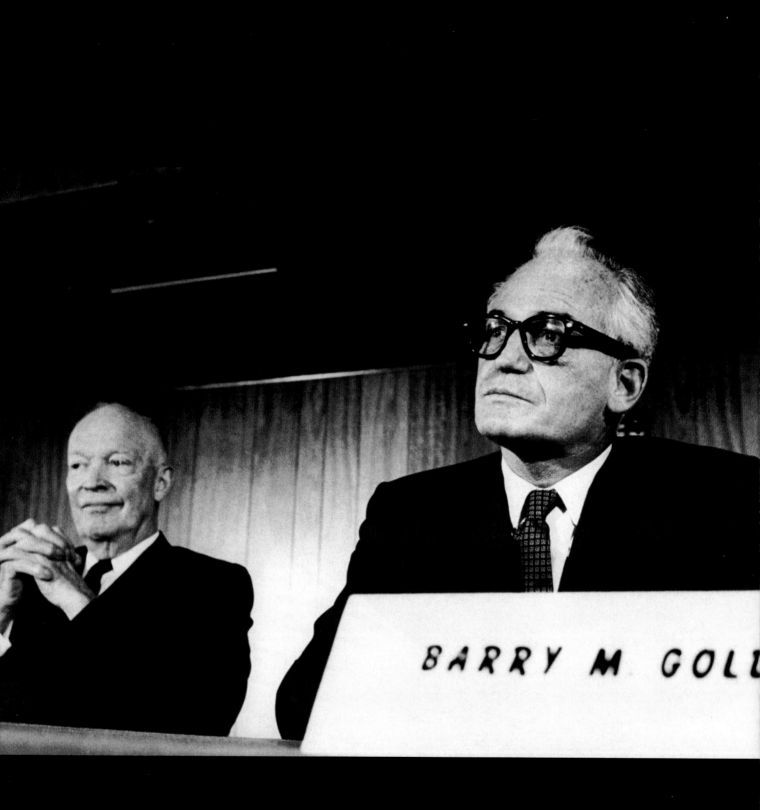

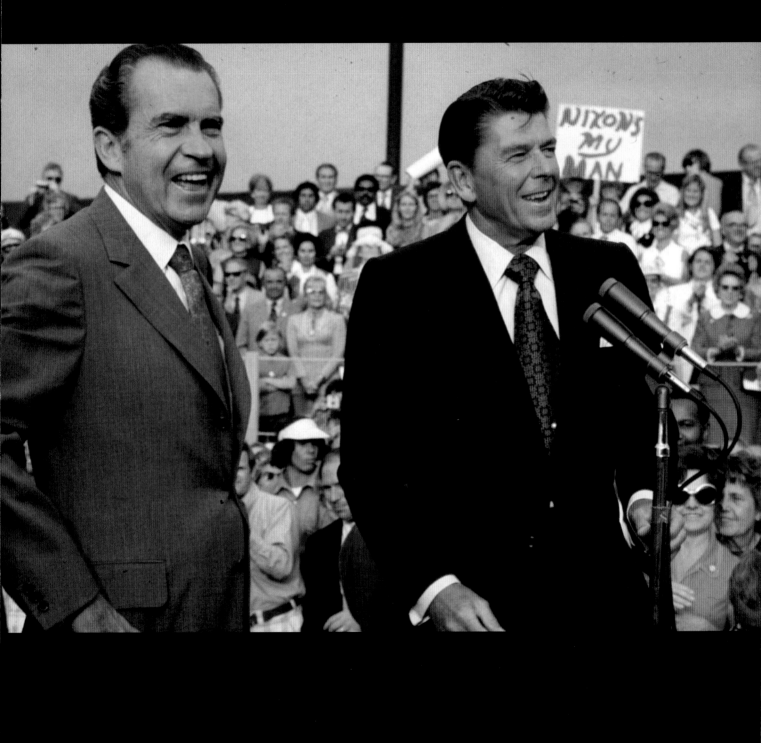

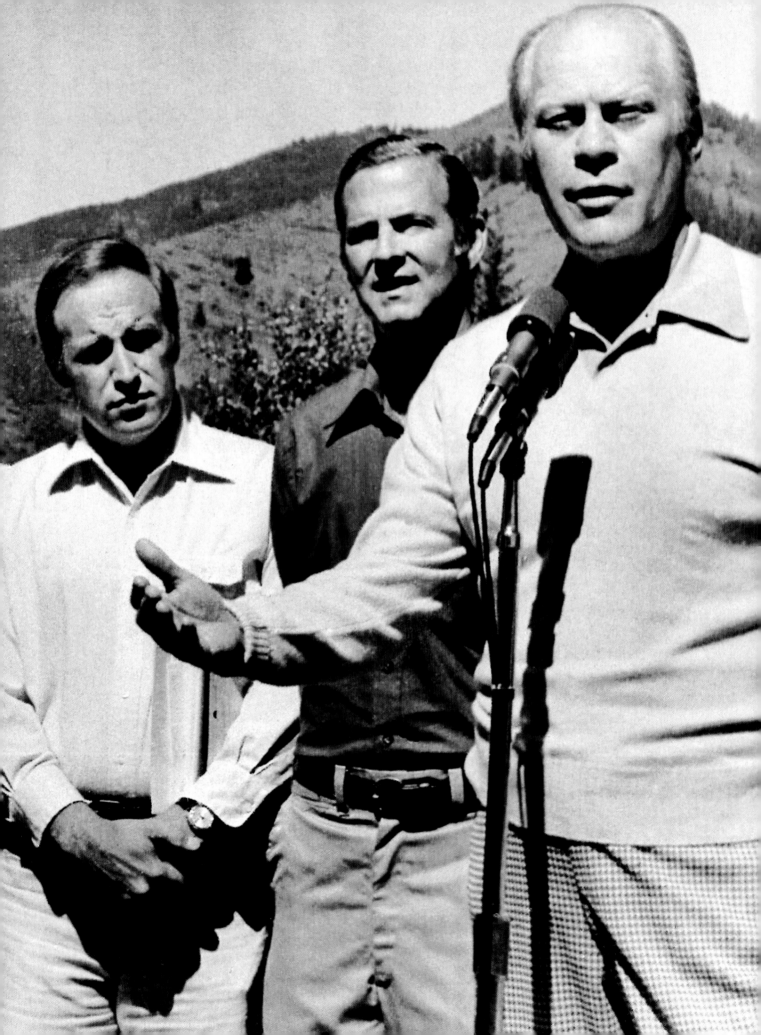

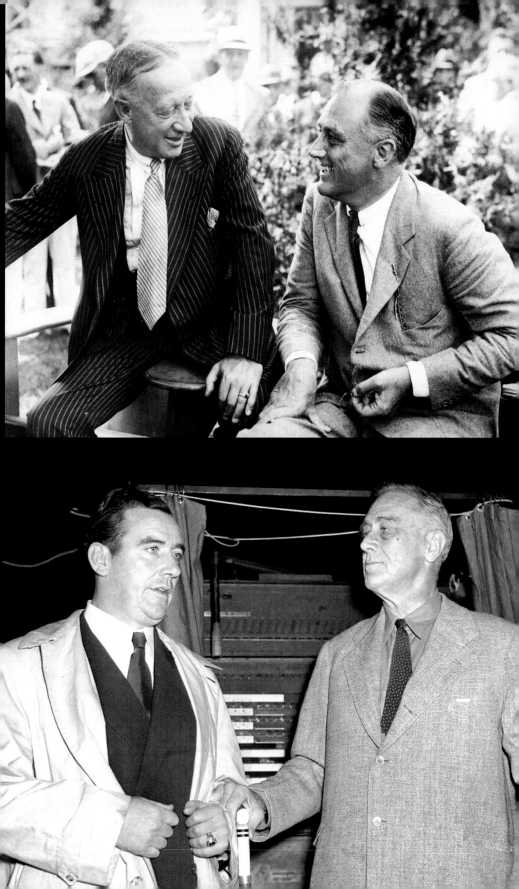

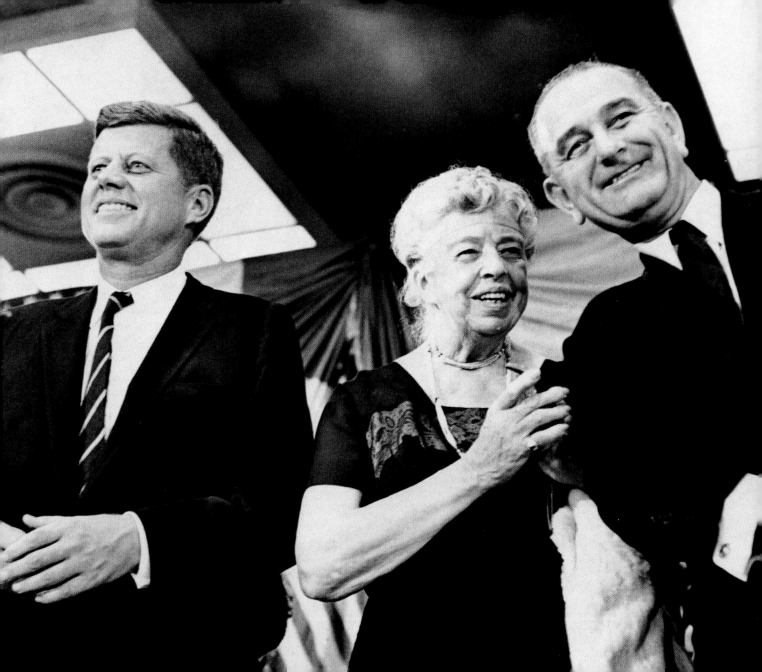

1976–

1988

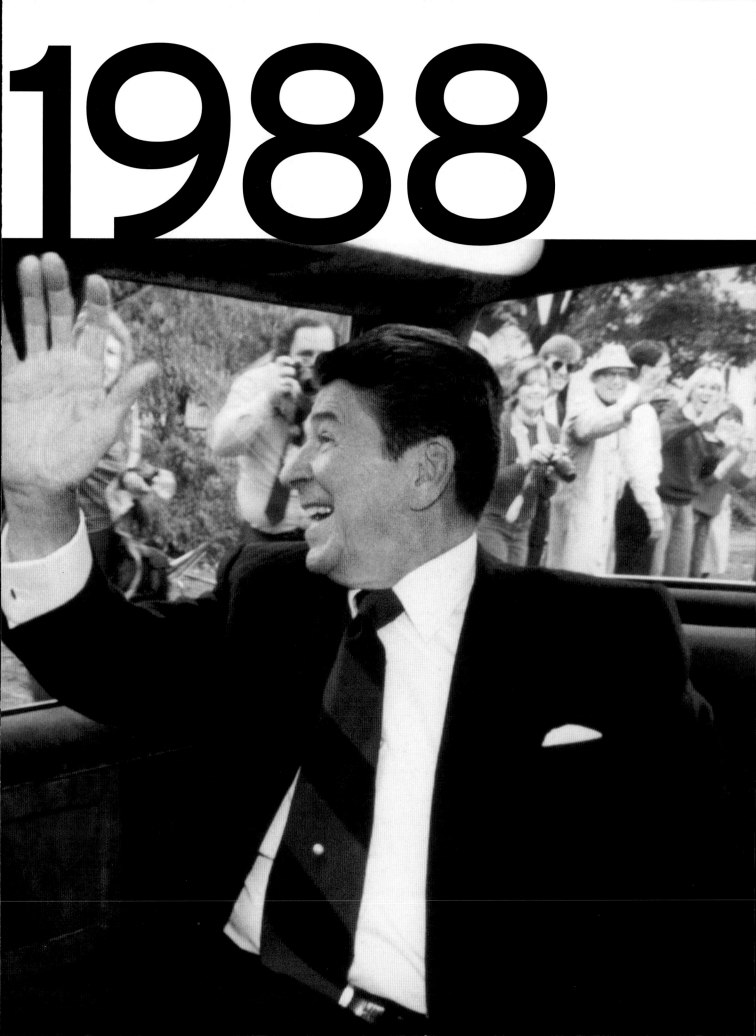

When Jimmy Carter began his presidential campaign in **1976,** few voters outside of his home state of Georgia would have recognized him walking down the street. With five simple words, though, Carter found a way to make sure his voice was heard: "I'll never lie to you." After Watergate and Vietnam, it was a message that resonated with millions of disaffected Americans. Unfortunately for the Democrats, however, Carter's ascendancy was short-lived; four years later he would be defeated by a man and a message that would reshape American politics: Ronald Reagan and his conservative revolution.

A peanut farmer from Plains, Georgia, Governor Carter shocked the political establishment with a strong showing in the Iowa caucuses, where he trounced his better-known opponents—while still finishing second, behind "uncommitted"! Carter's early victories helped to increase the importance of caucus and primary voting, and in the process American elections became more democratic—as well as longer and more expensive.

Things were a bit more challenging for Gerald Ford, America's first unelected president. In a sketch on NBC's new late-night show *Saturday Night Live,* Ford was haunted by the ghost of Richard Nixon. It was a telling image: Ford's decision to pardon Nixon plagued him throughout his presidency. Barely staving off a primary challenge from former California governor Ronald Reagan, Ford went into the general election a 33-point underdog to Carter.

Ford adopted a Rose Garden strategy, trying to cultivate a presidential aura while attacking Carter as too inexperienced to lead the country. As he hammered away at Carter's record in Georgia, the challenger's lead slowly began to erode. Just when the momentum was shifting, however, Ford's reputation as a bumbler reemerged. In the second presidential debate, he stunned viewers by declaring that "there is no Soviet domination of Eastern Europe, and there never will be under a Ford Administra-

tion"—and then refused for several days to admit he'd misspoken.

The verbal miscues did not end there. In the vice presidential debate, GOP vice presidential nominee Bob Dole cavalierly referred to World War I, World War II, Korea, and Vietnam as "Democratic wars," an outrageous remark that became fodder for a campaign commercial. But Carter also made his own blunder, telling *Playboy* magazine "I've committed adultery in my heart many times"—a comment that did little to help his puritan image.

In the end, however, Americans responded to Carter's outsider status, and his promise to return honesty and integrity to public life. A late surge by Ford fell two points short, and Carter eked out a narrow victory.

In **1980,** however, rising inflation, endless gasoline lines, and signs of weakness abroad had put Carter in a feeble political position. The president himself lamented the nation's "crisis of confidence"; to many, the president seemed to be blaming the American people for the nation's problems. Unfortunately for him, Americans were more inclined to blame Jimmy Carter. When Iranian radicals seized sixty-six American hostages in Tehran—and eight U.S. soldiers were killed in a failed rescue attempt—the spectacle of a helpless Carter administration and powerless United States cast a shadow over the entire election year.

Americans were looking for change, and Ronald Reagan eagerly stepped forward with a message combining aggressive foreign policy goals and a smaller government at home. Reagan staked out his position squarely on the right flank of American politics. In 1964 a similar message had led Republicans to a crushing defeat, but after sixteen years of attacks against "tax-and-spend liberals," conservative political views were now part of the political mainstream.

Carter was also facing political problems within his own party. Massachusetts senator Ted Kennedy posed an aggressive challenge to Carter, but quickly tripped himself up when he struggled to answer the rather straightforward question of why he wanted to be president. Nonethe-

less, the Kennedy insurgency damaged Carter; in one of the campaign's more comical moments, the president appeared to follow Kennedy around the dais at the Democratic convention for a unifying handshake.

The general election was marked by heated rhetoric on both sides. Carter attacked Reagan as a warmonger and racist who would divide the country and put America's security at risk; Reagan pilloried Carter's economic record and pledged to rein in the size and scope of government.

The race remained tight until the last few weeks. But in the campaign's only debate Reagan's talents as the "Great Communicator" won the day. At one point, Carter mentioned that he'd sought his young daughter Amy's counsel on the risk of nuclear war, while Reagan dismissed Carter's negative attacks with the memorable line "There you go again." In his closing remarks, Reagan asked viewers, "Are you better off than you were four years ago?" For most Americans, the answer was clearly no. The momentum from his strong debate performance propelled Reagan to a landslide victory.

In **1984,** in the words of the Reagan campaign, it was "Morning Again in America." The country was coming out of economic recession and was well on the path to recovery. And Reagan and his image-conscious campaign advisers—who never missed an opportunity to wrap the president in the American flag—made sure voters knew who should get the credit.

The only real excitement in the campaign came from the Democratic

side, where the nomination battle pitted former Vice President Walter Mondale against Senator Gary Hart and the civil rights activist Reverend Jesse Jackson. Mondale was the early front-runner, but he was put on the defensive by Hart's strong showing in the New Hampshire primary. Mondale began attacking the relatively inexperienced Hart, asking "Where's the beef?" a catchphrase lifted from a popular ad for the Wendy's fast-food chain. Jackson brought his impassioned oratory to the campaign, but his own words betrayed him after he was overheard referring to New York City as "Hymietown."

Mondale eventually won the nomination, and then made American political history by picking New York congresswoman Geraldine Ferraro as his running mate—the first woman to appear on a presidential ticket. But the choice of Ferraro did little to help the Democrats. The party's liberal orientation still contrasted sharply with the country's rising conservatism—buffeted by Mondale's ill-advised assertion at the Democratic convention that he would raise taxes if elected.

The Reagan-Mondale race was a listless affair, enlivened only by two televised debates. In the first, Reagan looked all of his seventy-three years, and delivered a rambling and incoherent closing statement that gave Mondale much-needed momentum. At the next debate, though, Reagan recaptured his Great Communicator crown, defusing the age issue by joking that he would not take

advantage of his opponent's "youth and inexperience." The outcome was no surprise: Reagan went on to a landslide victory, winning forty-nine states.

By 1987, Senator Gary Hart quickly emerged as a strong front-runner for the Democratic nomination. Plagued with rumors of philandering, Hart invited journalists to follow him. They'd be very bored, he joked. But when reporters from the *Miami Herald* took up the challenge, they discovered that a young woman named Donna Rice had spent the night at Hart's Washington townhouse. When a *Washington Post* reporter confronted him with the question, "Have you ever committed adultery?" Hart sputtered, then refused to answer. It was an appropriate beginning to one of the nastier presidential races in modern American politics.

Vice President George Bush was the clear favorite among Republicans, but he was fighting what became known in the press as the "wimp factor." A tussle on live television with CBS anchorman Dan Rather gave him a huge boost, but in the Iowa caucuses he stumbled badly, finishing third behind Senator Bob Dole and televangelist Pat Robertson. Bush immediately went on the attack, accusing Dole of supporting tax increases. In tax-obsessed New Hampshire the charges stuck, and Bush won. Asked if he had any message for the vice president, an angry Dole responded "Stop lying about my record." With his new momentum Bush went on to win the GOP nomination.

On the Democratic side, Hart's departure left the field wide open. After a bruising primary battle and a strong performance by Jesse Jackson—whose victory in the Michigan primary was the first ever by an African-American— Massachusetts governor Michael Dukakis bested his rivals, nicknamed the "seven dwarfs" by political reporters.

At the Democratic convention in Atlanta, Dukakis declared that the choice in **1988** was about competence, not ideology. Under the guidance of campaign manager Lee Atwater, Bush set a different tone. While he spoke of the need for a "kindler, gentler nation," Bush tarred Dukakis with the "L" word—liberal. He

Rubbing Lincoln's nose for good luck: Springfield, Illinois, 1980.

attacked Dukakis for opposing the death penalty, vetoing a state law mandating Massachusetts children to recite the Pledge of Allegiance, and supporting a state furlough program that allowed the infamous Willie Horton to flee the state and rape a Maryland woman. The charge was trumpeted by interest groups supporting Bush—a new feature in presidential campaigns. Paralyzed by the attacks, Dukakis failed to defend himself. Worse, when asked in a presidential debate whether he would favor the death penalty if his wife, Kitty, were raped and murdered, Dukakis offered a detached, legalistic answer that only seemed to confirm his cold and unemotional image.

But Bush's path to the White House was not error-free. His choice of a running mate, the unproven and gaffe-prone Dan Quayle, provoked howls of derision from Democrats and comedians alike. Quayle's presence also provided one of the more memorable political moments of the late 1980s: During the vice presidential debate with Democratic nominee Senator Lloyd Bentsen, Quayle compared his career with that of John F. Kennedy. Bentsen pounced: "I served with Jack Kennedy. I knew Jack Kennedy. Jack Kennedy was a friend of mine. Senator, you are no Jack Kennedy." But Bentsen's gibe wasn't enough to carry the day. Bush went on to defeat the overmatched Democrats, and the GOP dominance of the White House continued for another four years. ❏

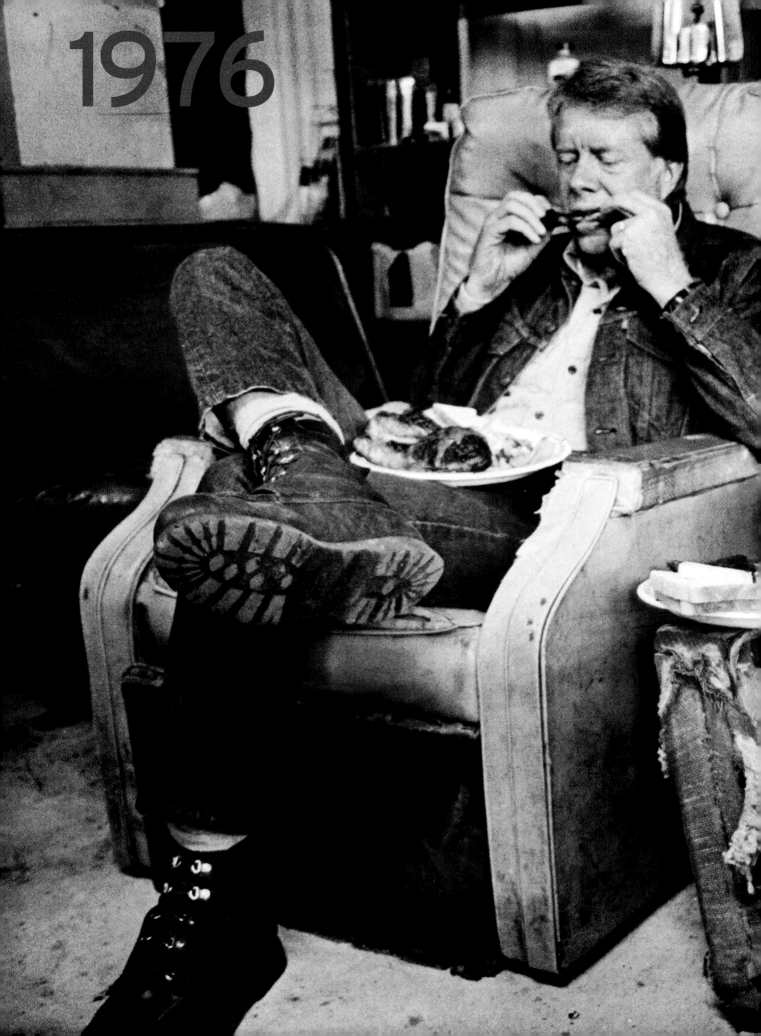

1976

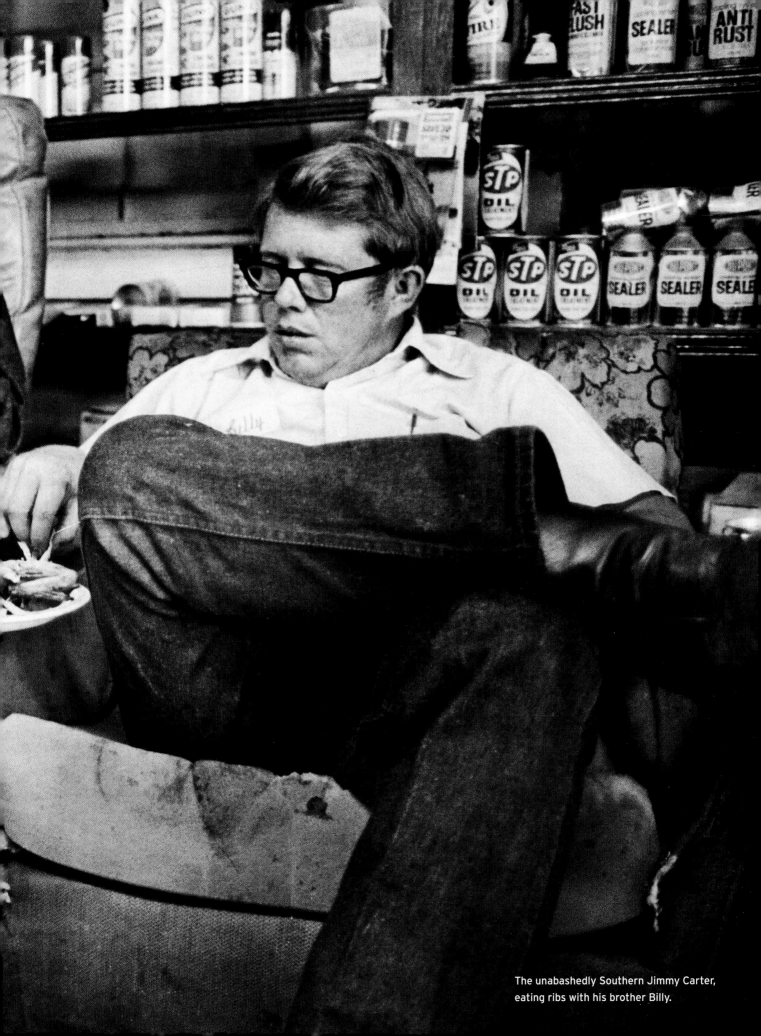

The unabashedly Southern Jimmy Carter, eating ribs with his brother Billy.

Ford's nomination was challenged from the right by Ronald Reagan. The former California governor was narrowly defeated; he would return to fight another day.

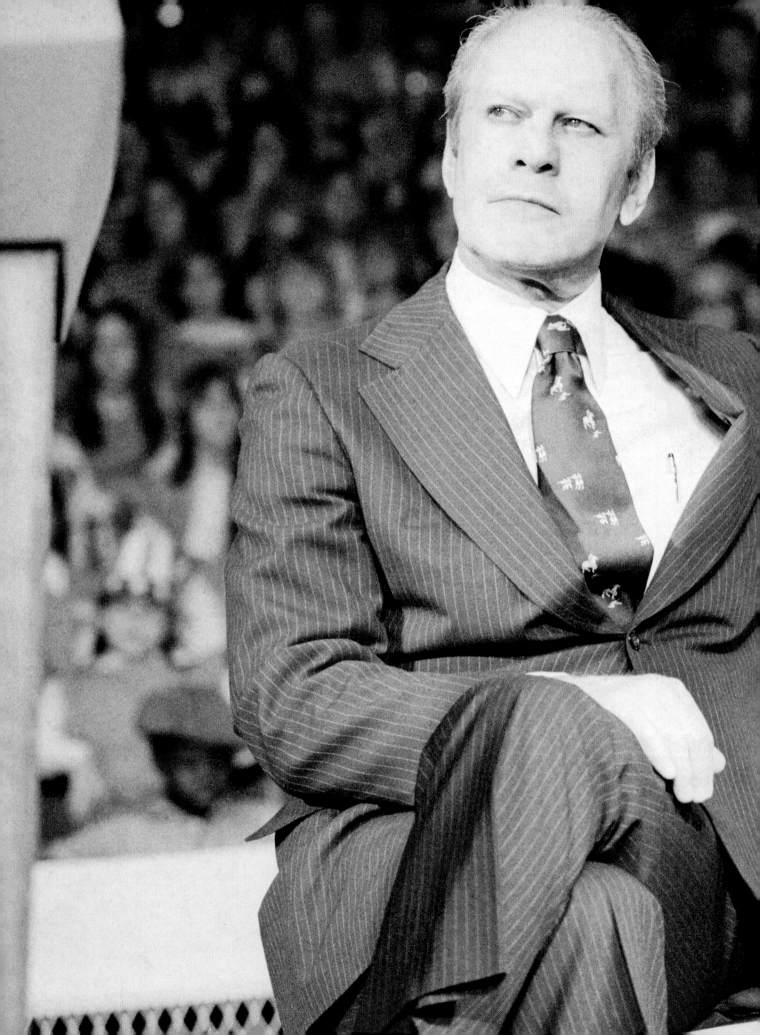

A campaign on uncertain footing: Ford appears with John Wayne.

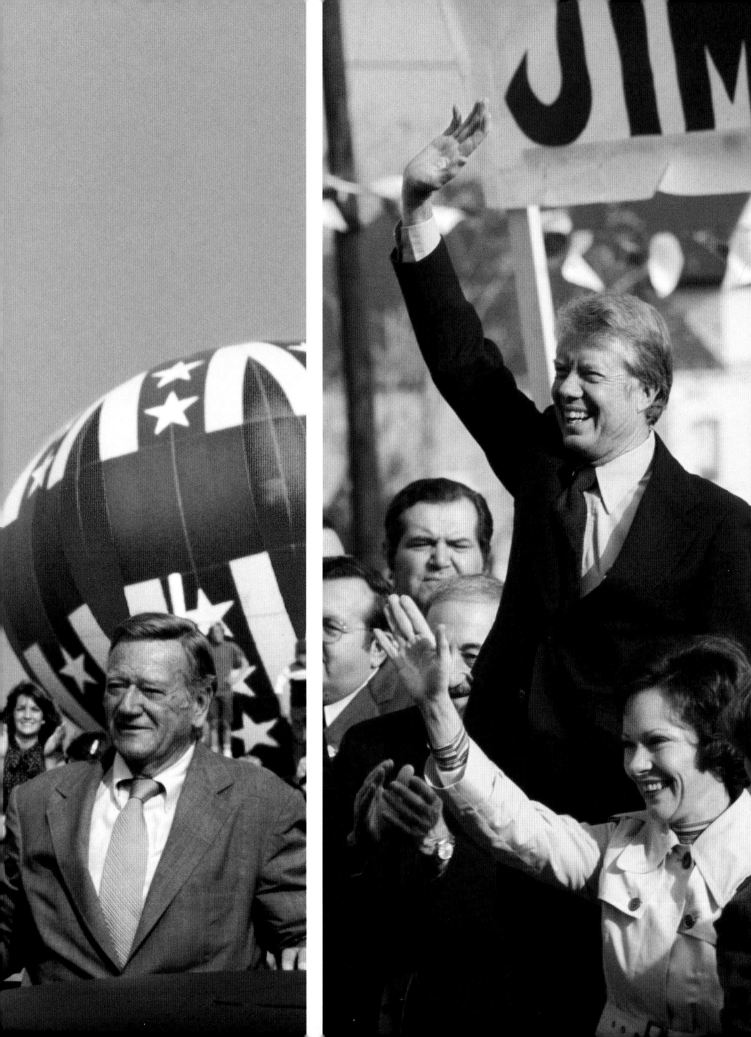

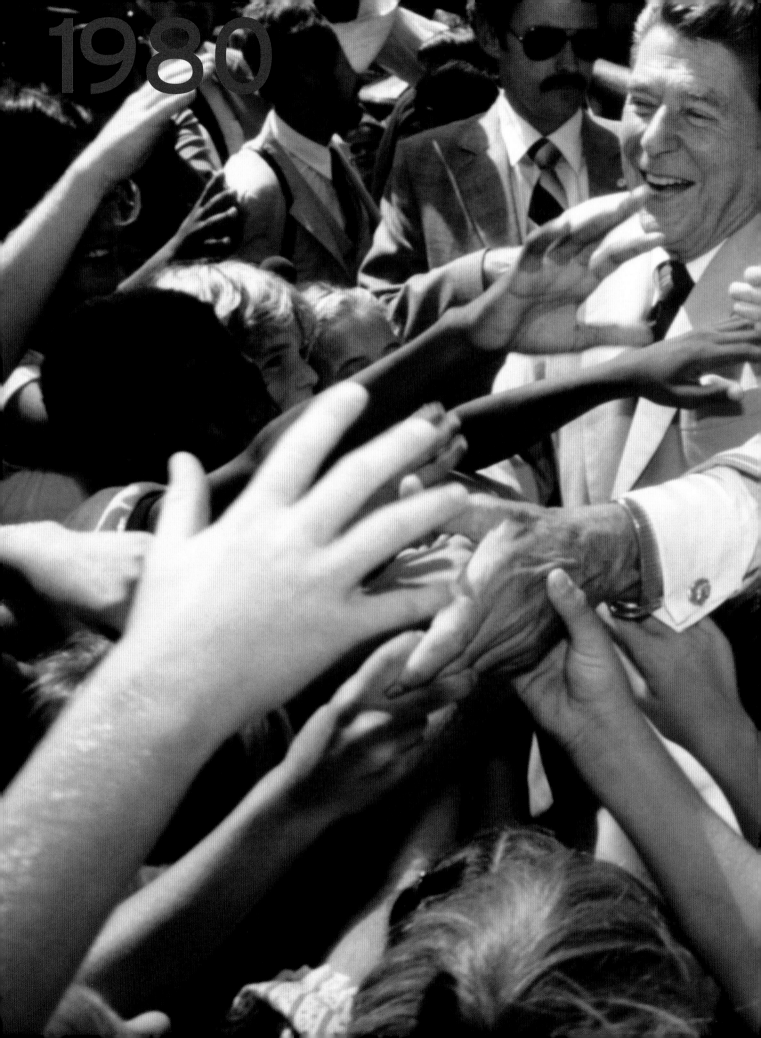

1980

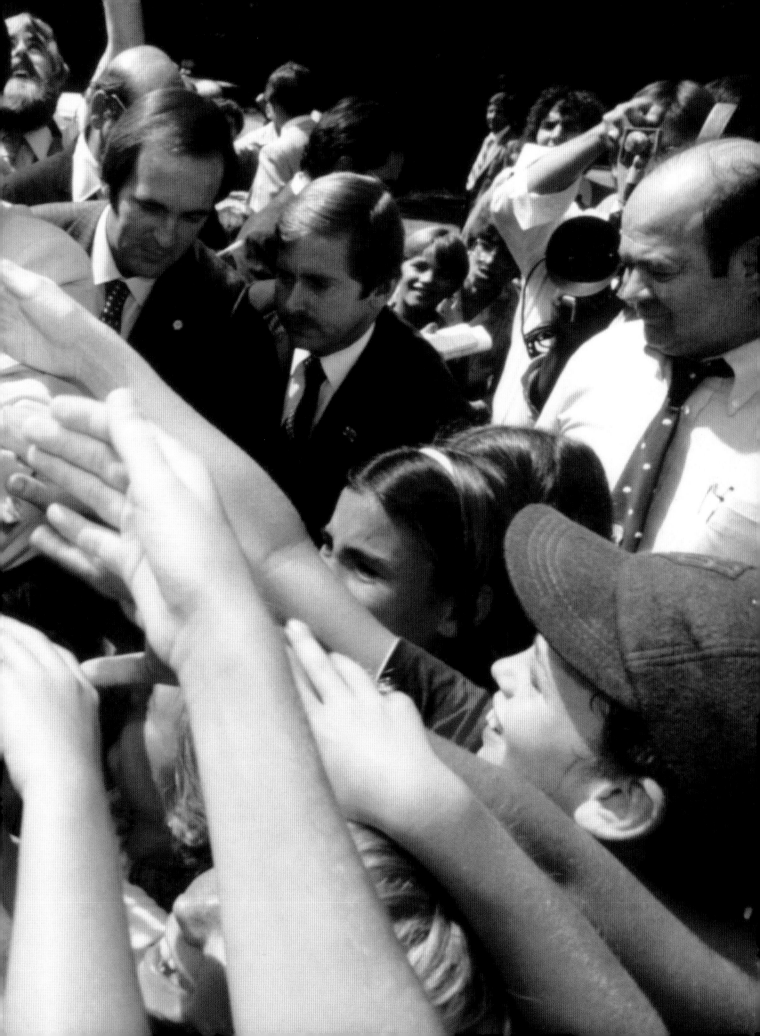

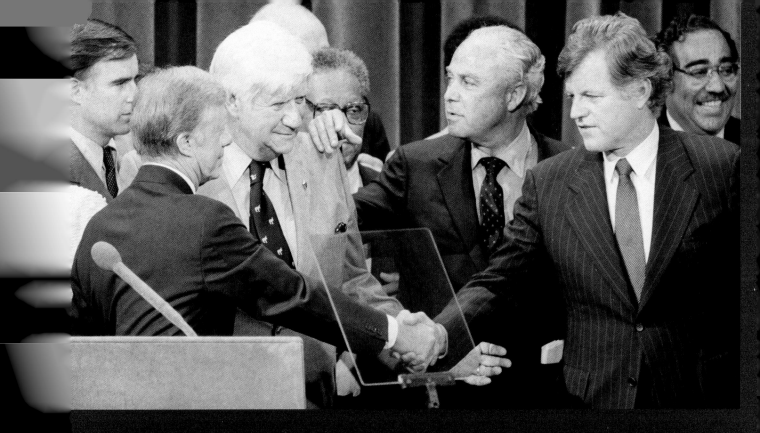

ABOVE: By the time of the Democratic convention, Jimmy Carter had managed to fend off the insurgent Ted Kennedy—but was still reduced to chasing him around the dais for a handshake.

BELOW: Republican Congressman John Anderson, a long-shot third-party contender in 1980.

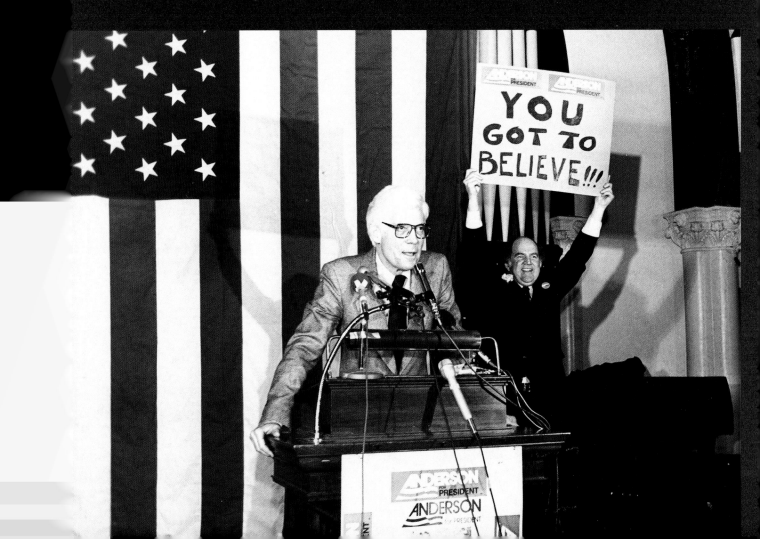

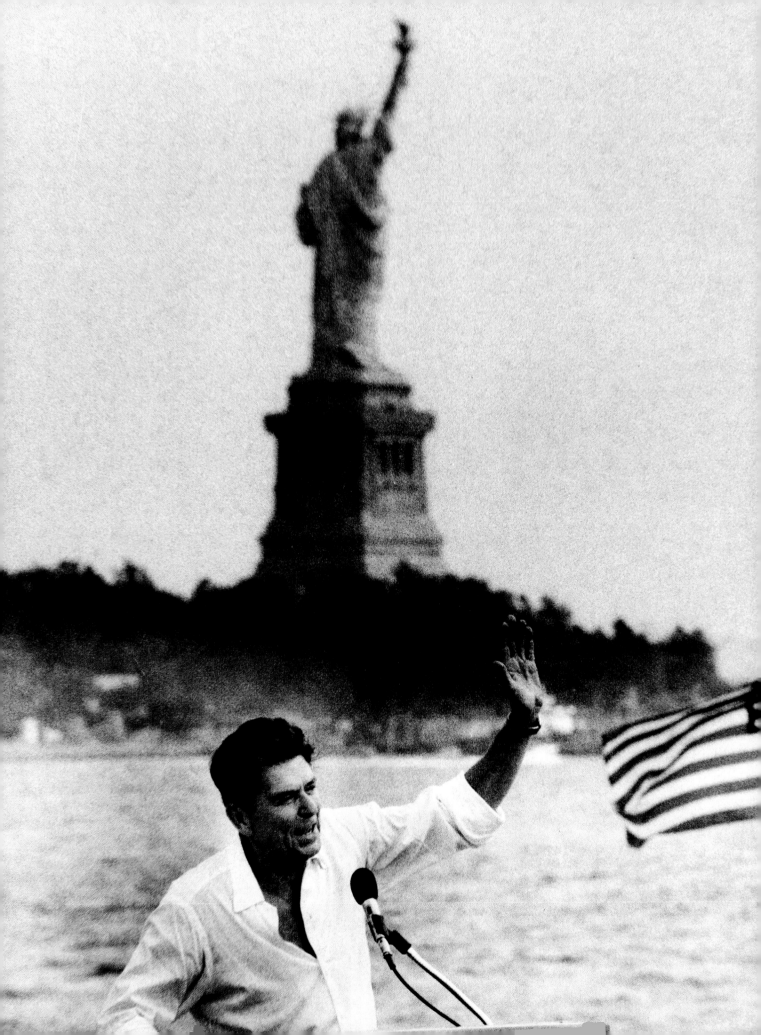

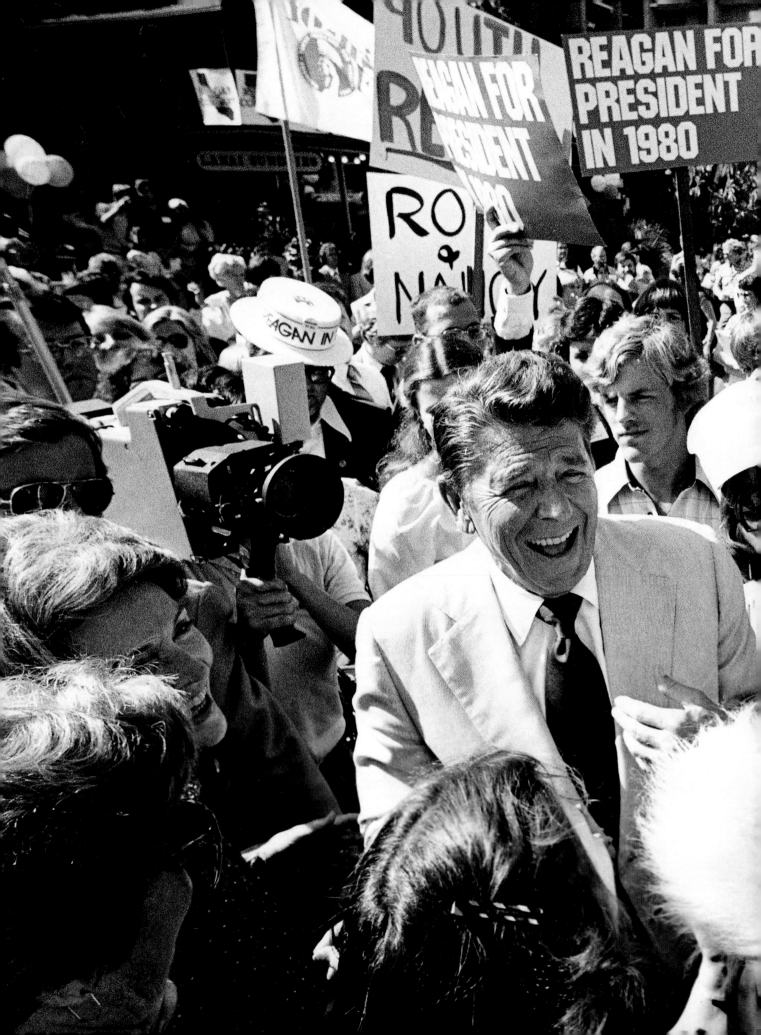

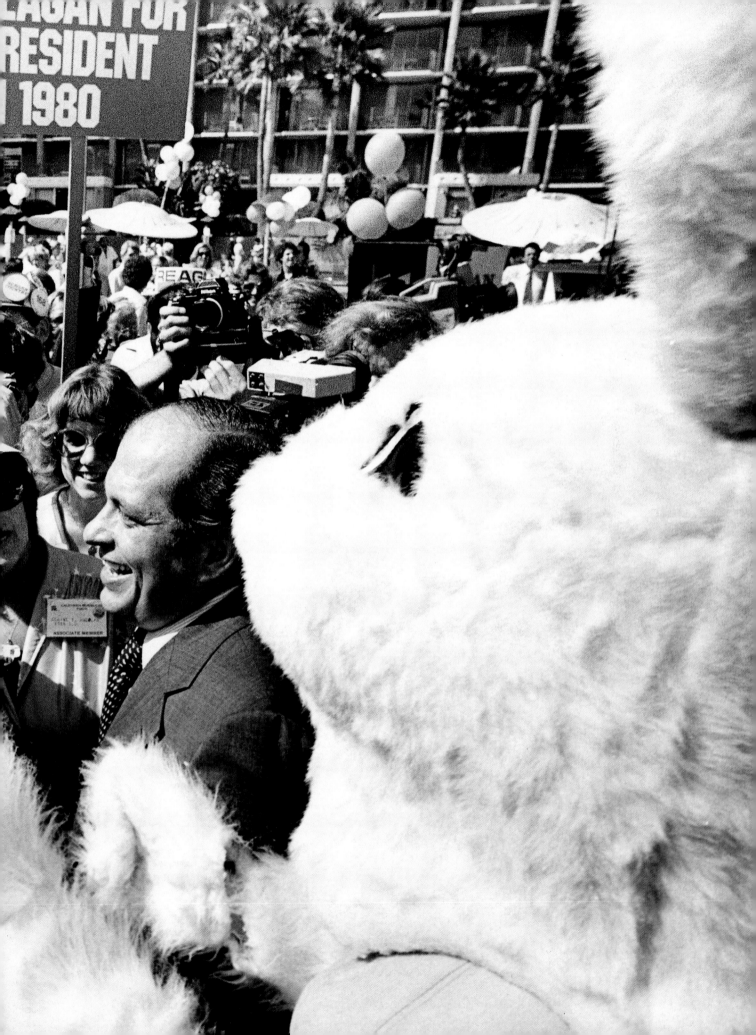

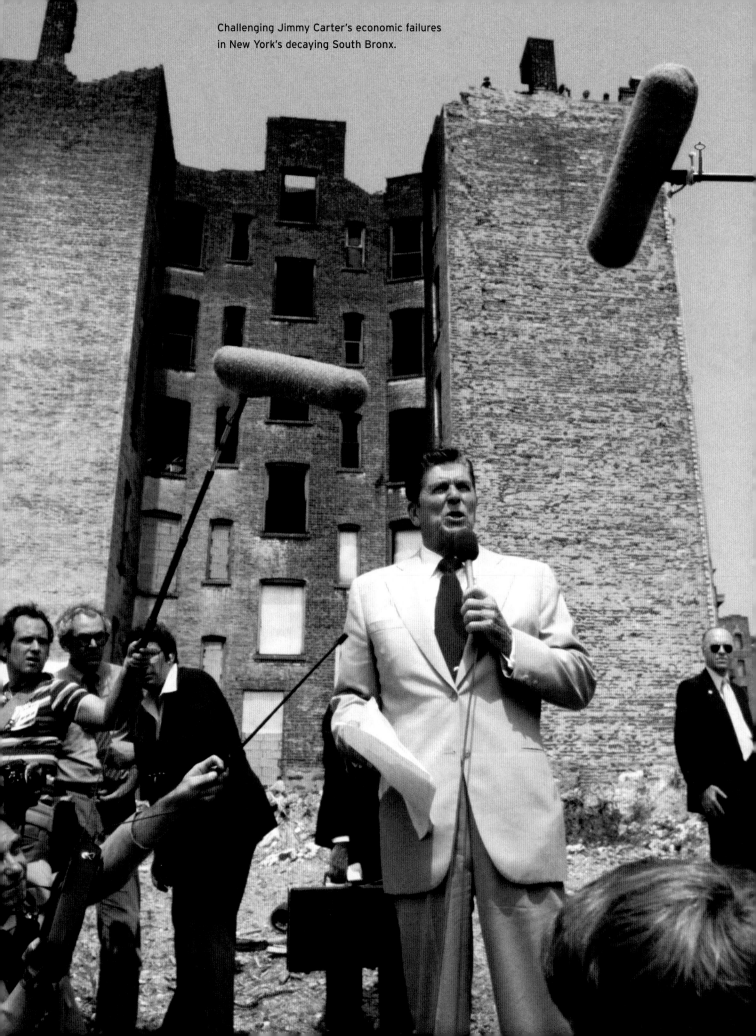

Challenging Jimmy Carter's economic failures
in New York's decaying South Bronx.

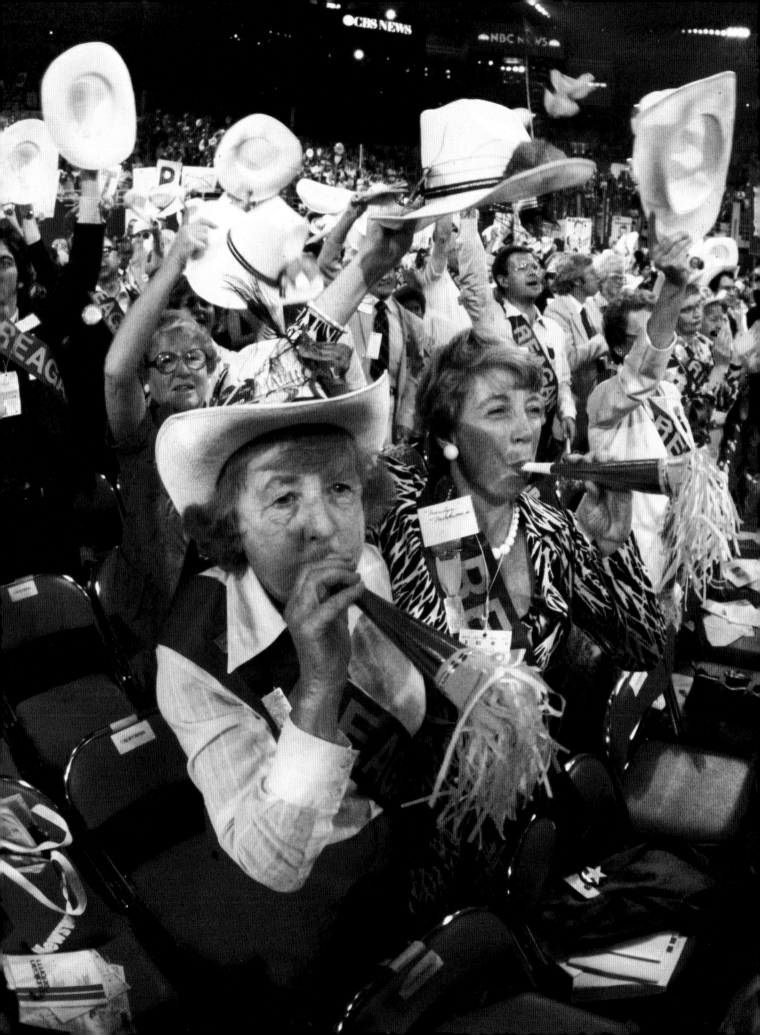

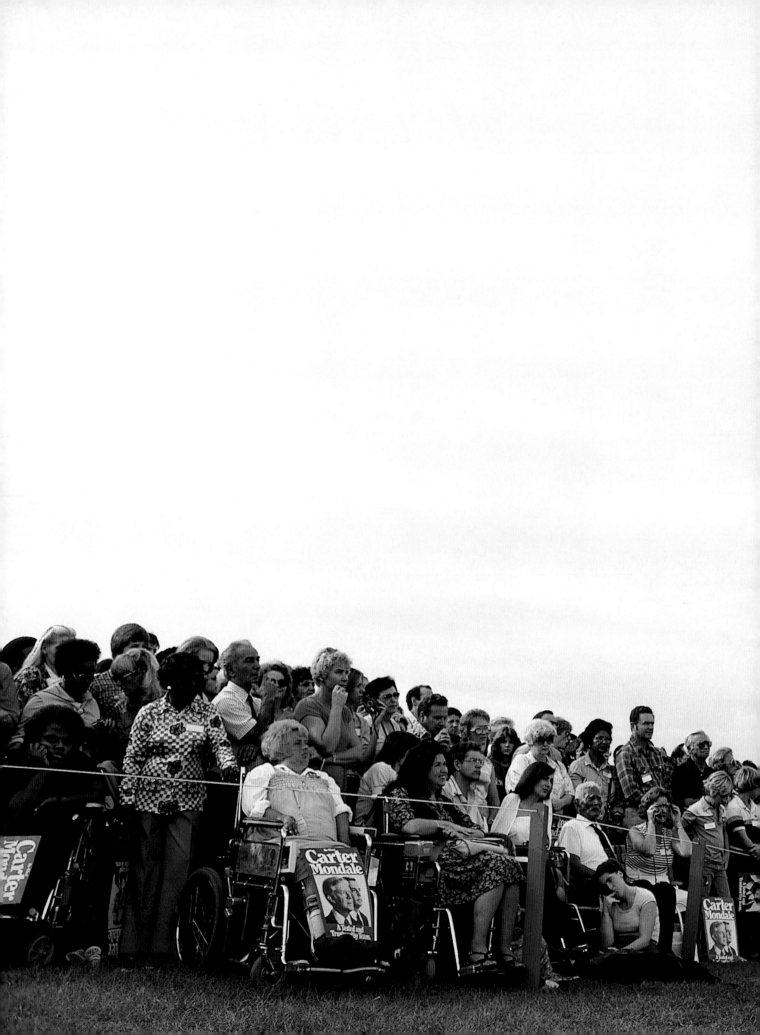

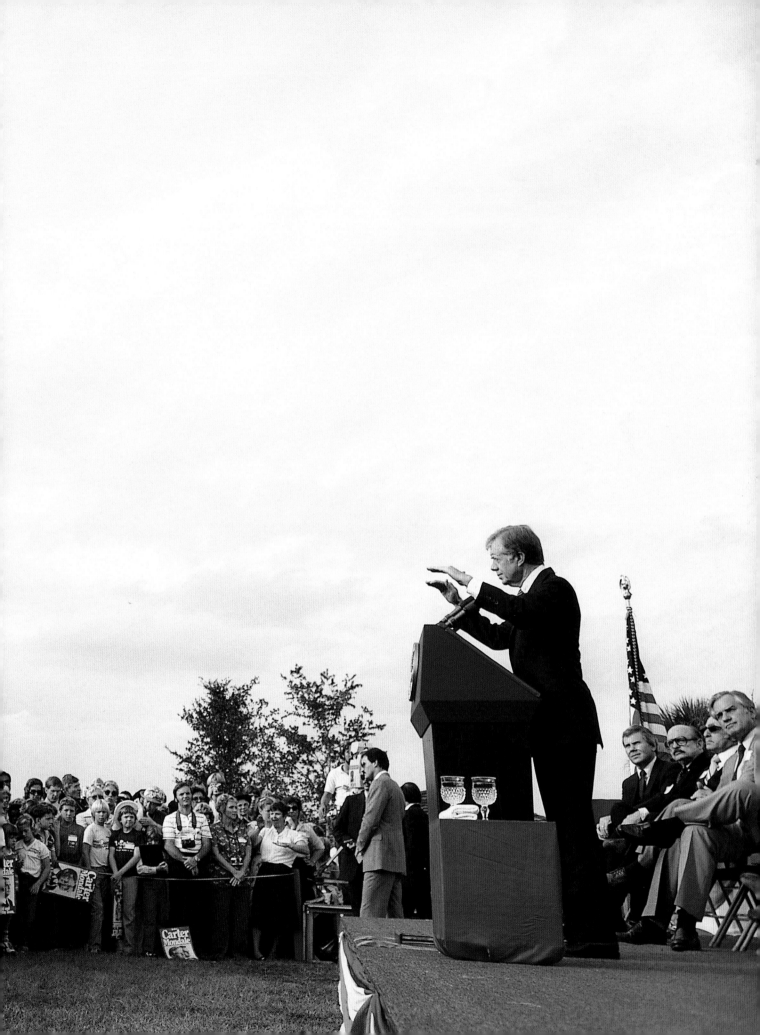

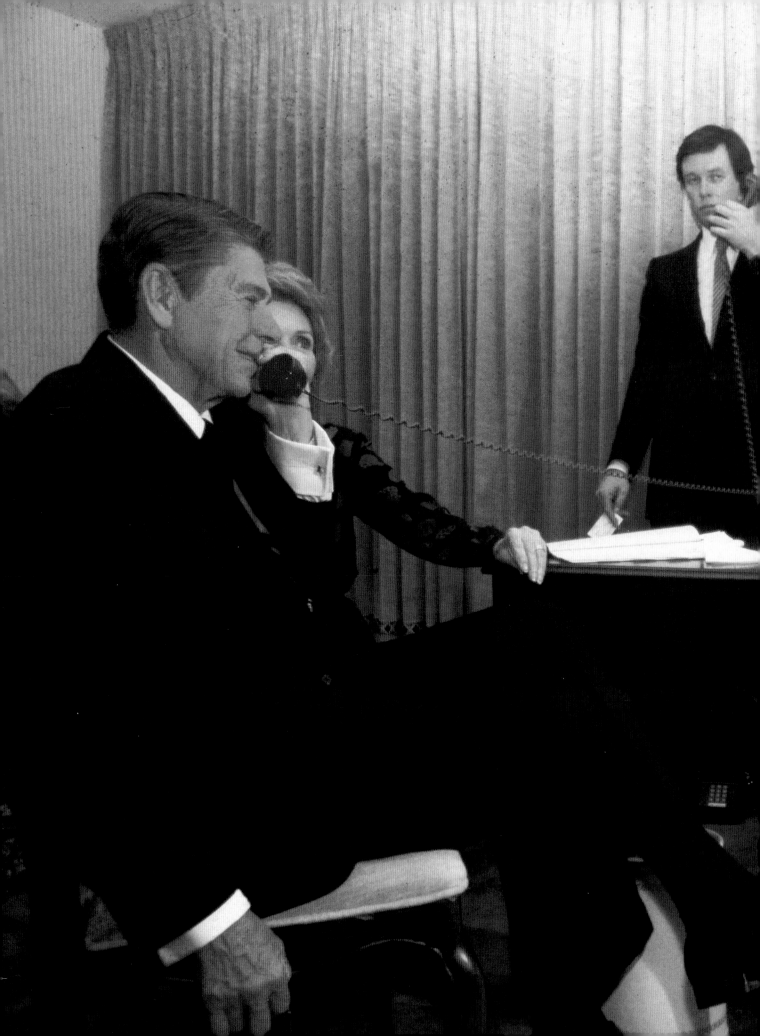

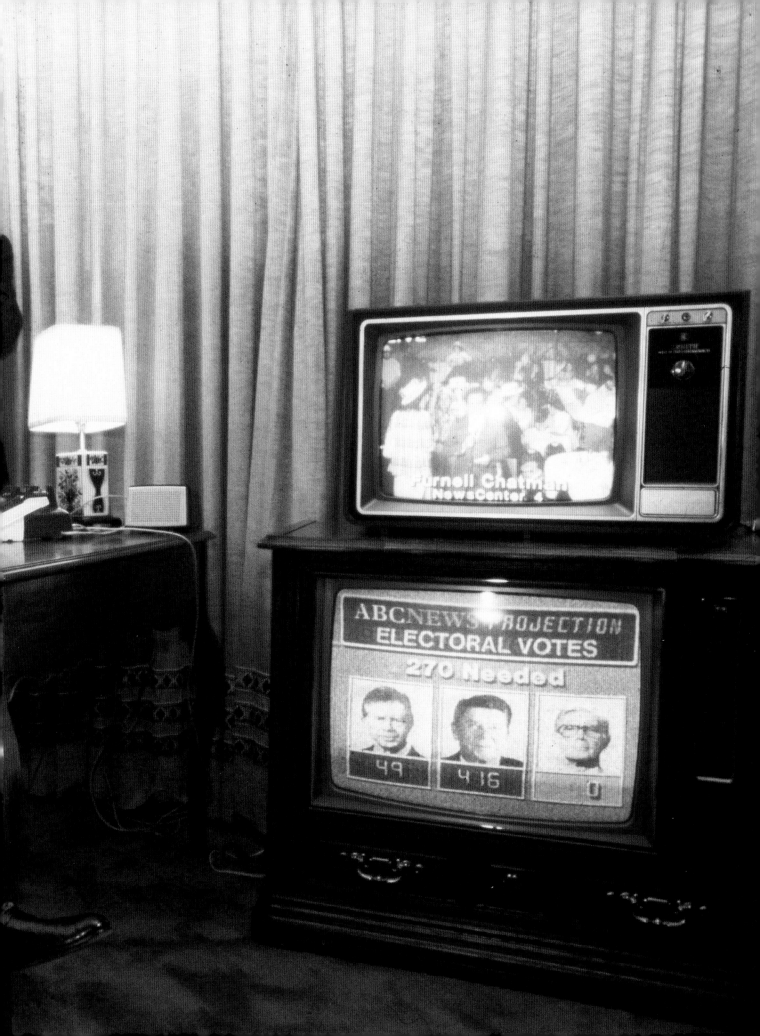

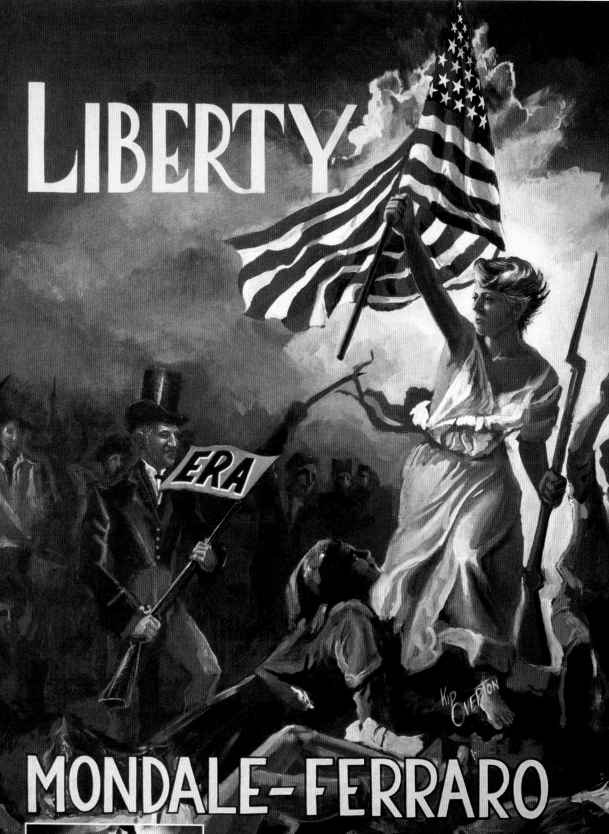

Echoing Eugene Delacroix's *Liberty Leading the People,* a poster celebrating Geraldine Ferraro's selection as the first woman to appear on a major party ticket.

LIBERTY LEADING THE PEOPLE — 1984

This 'Liberty' reprint was inspired by the 1830 masterpiece by Delacroix "Liberty Leading the People".

The three main contenders for the 1984 Democratic nomination: former vice president Walter Mondale, the Reverend Jesse Jackson, and Colorado senator Gary Hart

Echoes of Adlai: Gary Hart, 1984

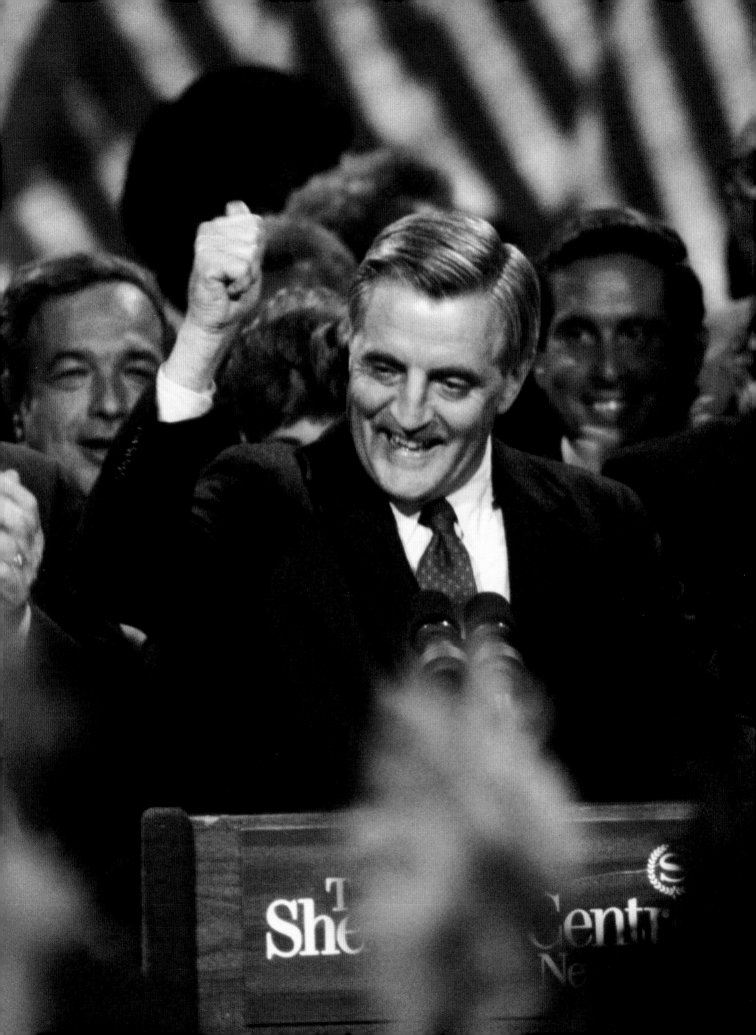

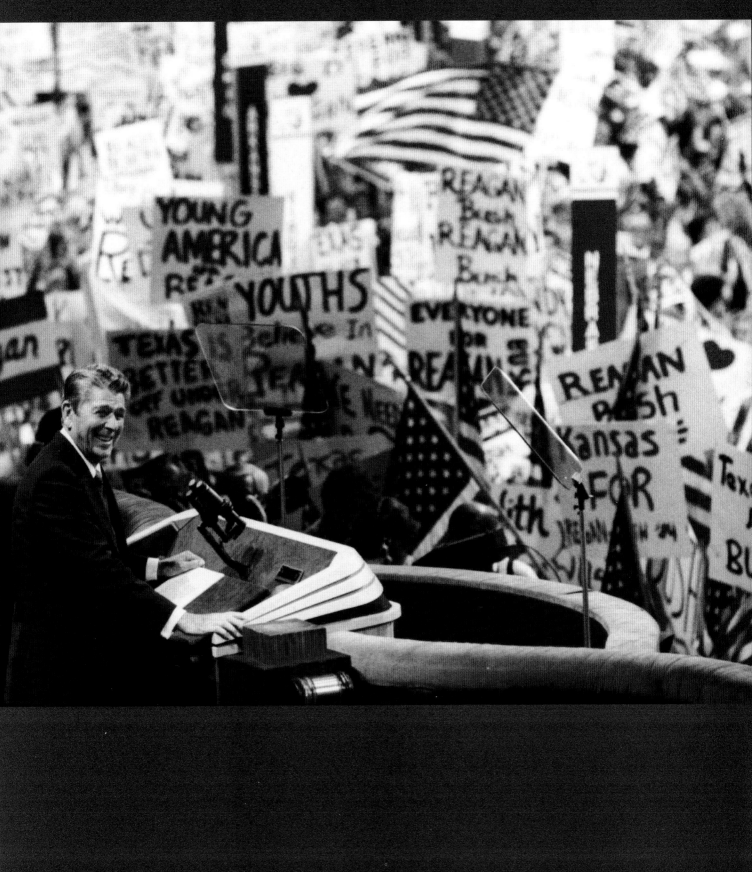

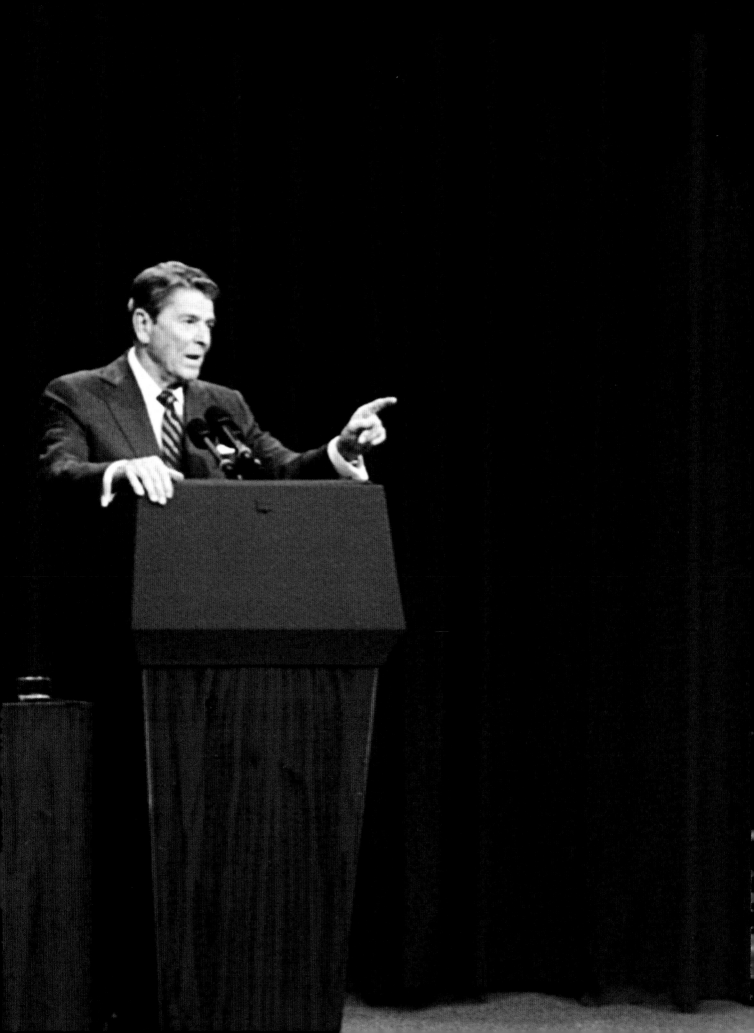

Bringing America Back.
Prouder, Stronger and Bette

Morning Again in America: President Reagan in 1984

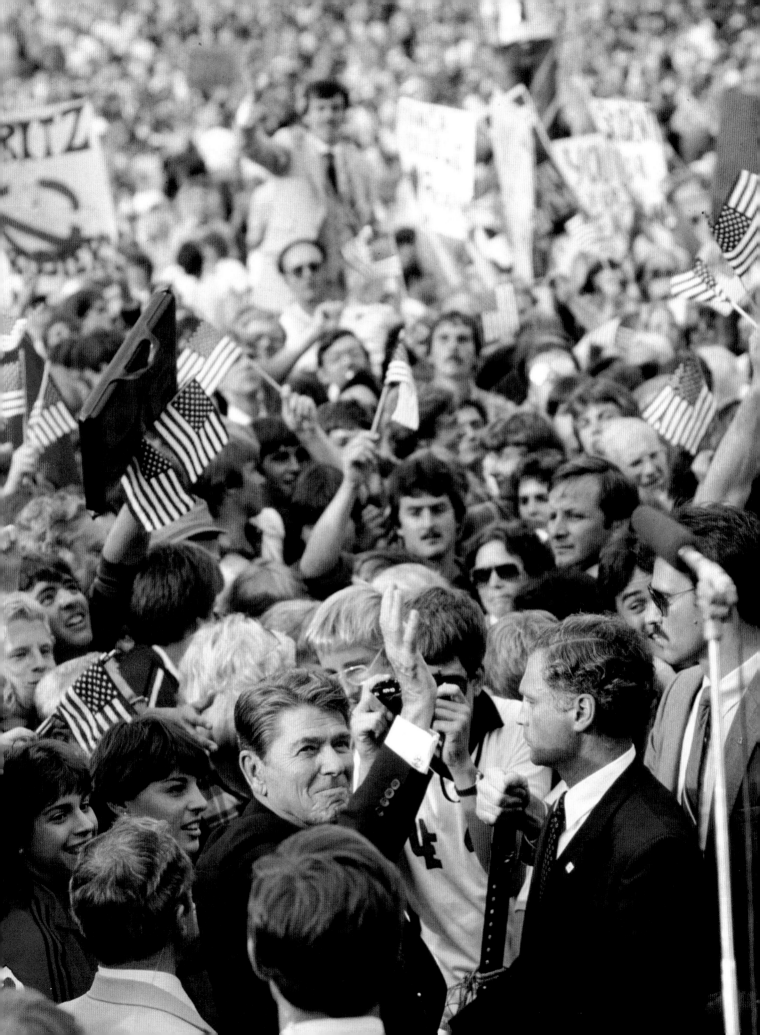

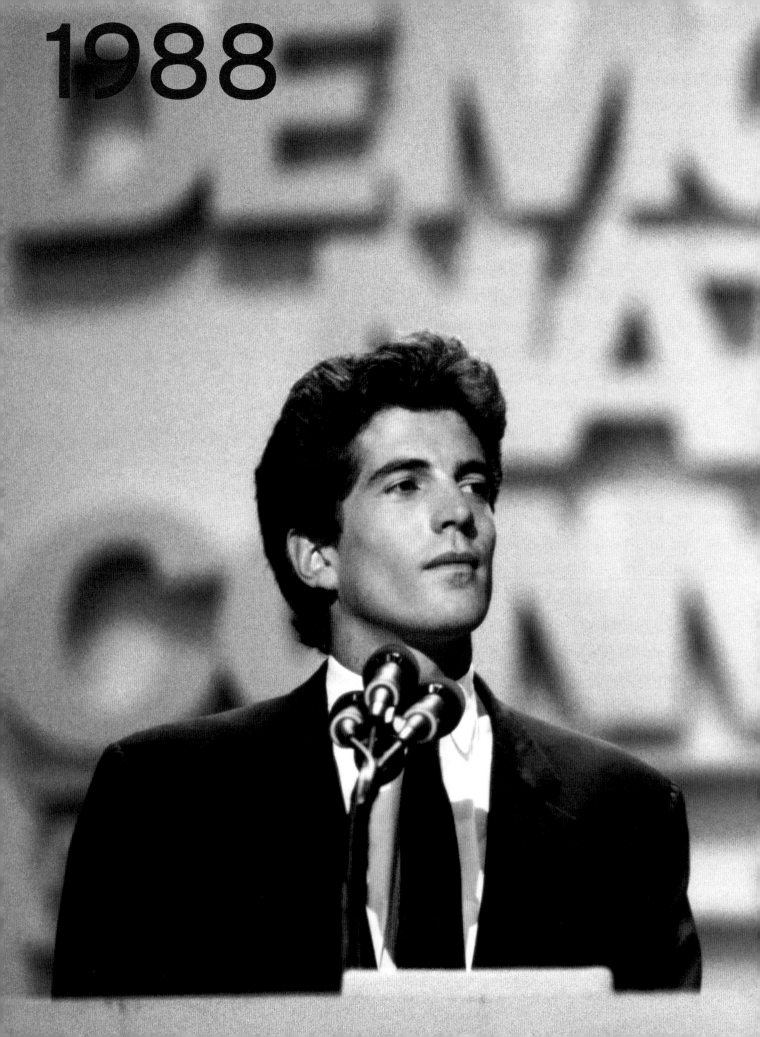

1988

A parting glance at Camelot: JFK Jr. at the 1988 Democratic National Convention.

The photo that sank Gary Hart's political career: with Donna Rice about to board the *Monkey Business (above)*. He left the race soon thereafter (with wife Lee, *right*).

Jesse Jackson back in action, 1988

The 1988 debates: Dukakis stumbled against Bush *(above)*, but Bentsen got the better of Quayle *(below)*.

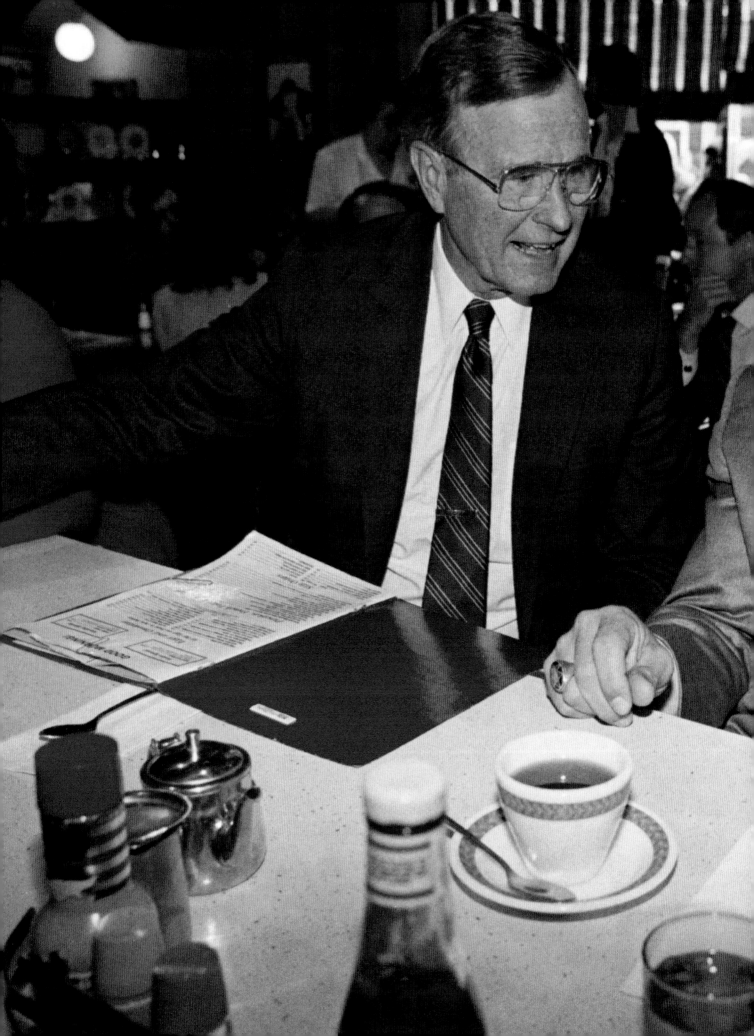

Bush with Arnold Schwarzenegger.

A photo op gone wrong: Mike Dukakis in the tank.

Boston Herald, August 1988

Gov 'gave pardons to 21 drug dealers'

Will Dukakis Turn Gun Owners Into Criminals... While Murderers Go Free?

The Most Soft-on-Crime Governor in Massachusetts History Is a Leading Advocate of Gun Control

Gun Owner Magazine quotes Dukakis as saying in 1986, **"I don't believe in people owning guns, only the police and military. And I'm going to do everything I can to disarm this state."** In 1976 Dukakis supported a (losing) statewide referendum which would have done just that. Dukakis has called for **federal registration** of all concealable handguns and has written, "... the solution to the problem of gun-inflicted violence must come at the national level."

Michael Dukakis talks about fighting crime, but there is a big gap between the *rhetoric* and the *record*. Maybe that's why the **Boston Police Patrolman's Association unanimously endorsed George Bush for President.**

While trying to deny the citizens of Massachusetts the right to defend themselves, Dukakis has put more convicted criminals on the streets than any governor in his state's history.

- He has used his gubernatorial pardoning power to commute the sentences of *44 convicted murderers*—a record for the state of Massachusetts.

- He has vetoed and continues to oppose the death penalty *under any circumstances*, even for cop-killers, drug kingpins and traitors.

- He *opposes* mandatory sentences for hardcore criminals but *supports* mandatory sentences for anyone caught with an unregistered gun *of any kind*.

Dukakis has also presided over and actively endorsed the *most liberal prisoner furlough program in America*, the **only one in the nation** releasing prisoners sentenced to life without parole.

- On average, in the state of Massachusetts, one convicted first degree murderer was released *every day* over the last seven years.

- Since the beginning of Dukakis' second term as Governor, 1,905 furloughs have been granted to first degree murderers and at least 4,459 furloughs to second degree murderers. He has given 2,565 furloughs to drug offenders.

- In 1986 alone, Dukakis gave 1,229 furloughs to sex crime offenders, including 220 to persons charged with *six or more* sex offenses.

- Today 85 violent felons from Massachusetts are on the loose in America— set free on furloughs, they never bothered to come back.

Meet Willie Horton.

Willie Horton was convicted in 1975 and sentenced to life in prison without parole for stabbing a 17-year-old to death during a robbery. In 1986, on his tenth release under the Dukakis-supported furlough program, he escaped to Maryland where he stabbed and beat a man and then repeatedly raped his fiancee.

Horton was captured, but Maryland Judge Vincent Femia refused to send him back to Massachusetts saying, "I am not prepared to take the chance that Mr. Horton might be furloughed or otherwise released ...

I would strongly urge the people of Massachusetts not to wait up for Mr. Horton ... not to bother to put out a light for him because he won't be coming home." Judge Femia recommended that Horton, "should never draw a breath of free air again ... and should die in prison." Michael Dukakis *refused to even meet* with the parents of the couple Horton attacked, saying, "I don't see any particular value in meeting with people ... I'm satisfied ... we have the kind of furlough policy we should have."

Paid for by Victory '88, New Jersey

Bush adviser Lee Atwater joked that he would turn Willie Horton—a convicted felon who raped a woman while on furlough from a Massachusetts prison—into "Dukakis's running mate."

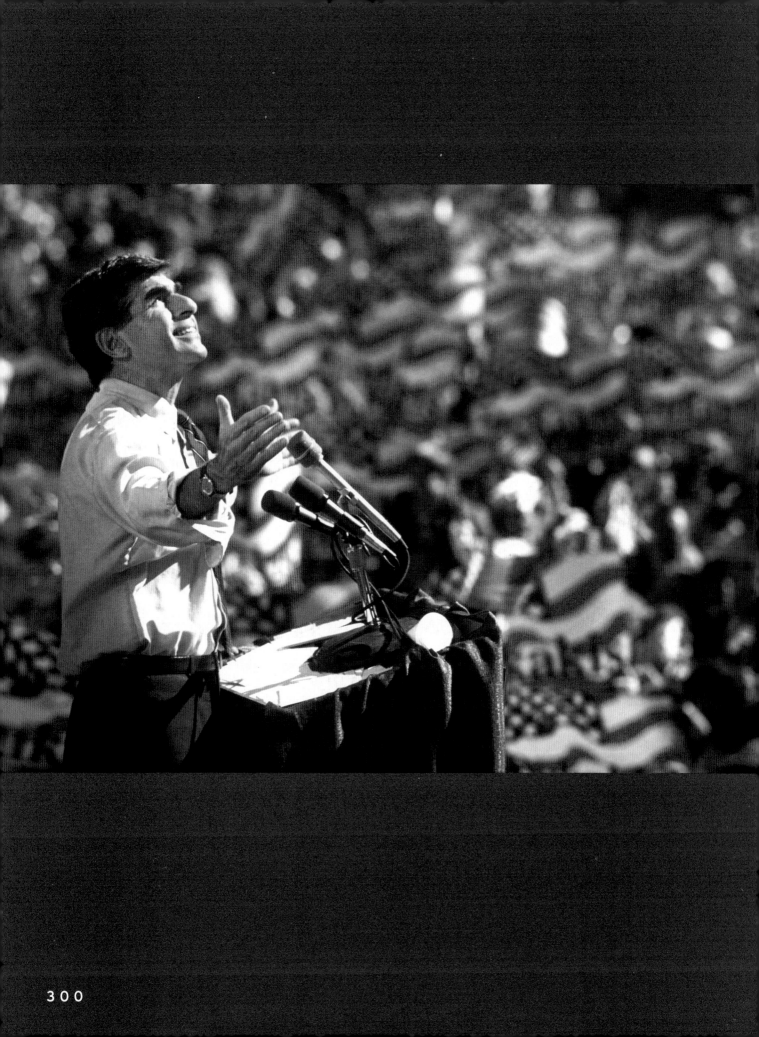

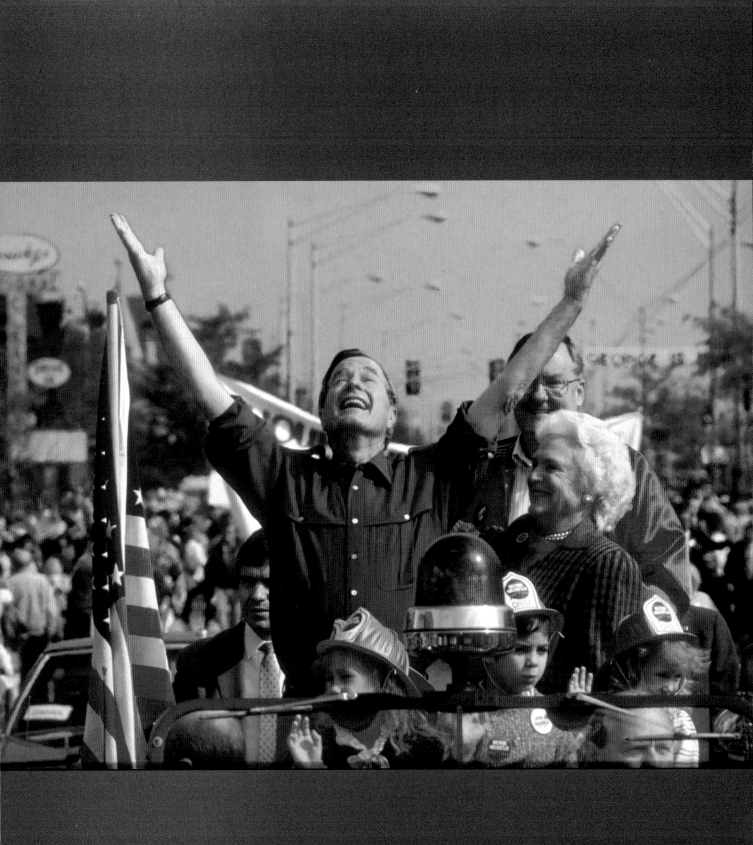

CAMPAIGNS &
SPORTS

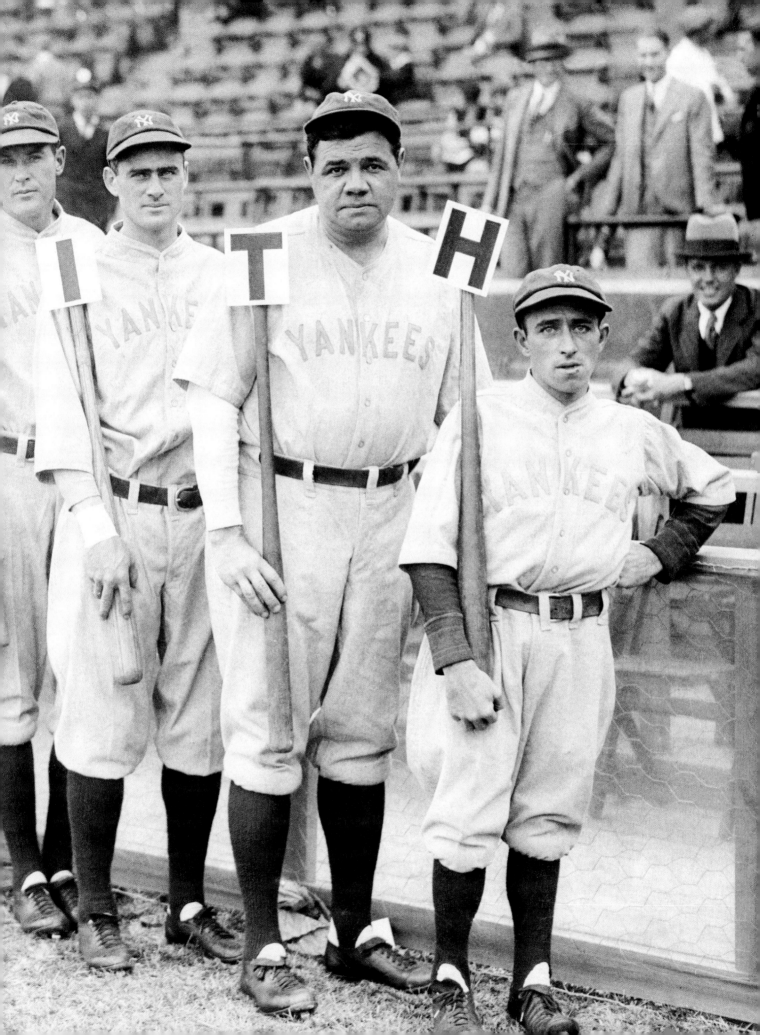

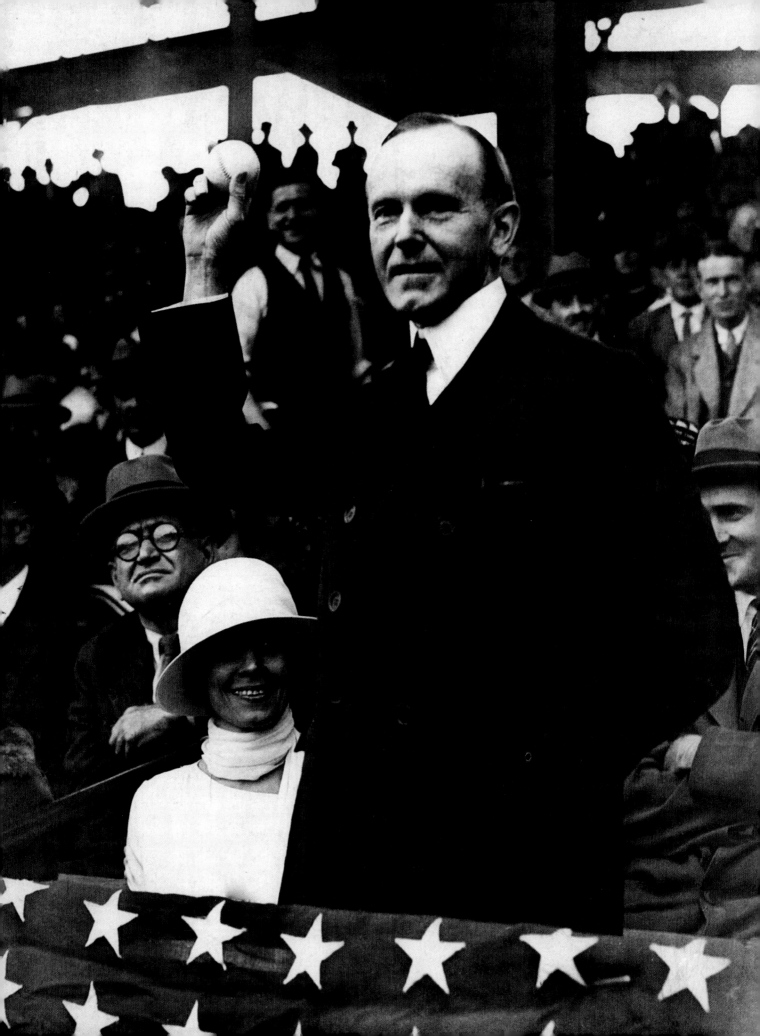

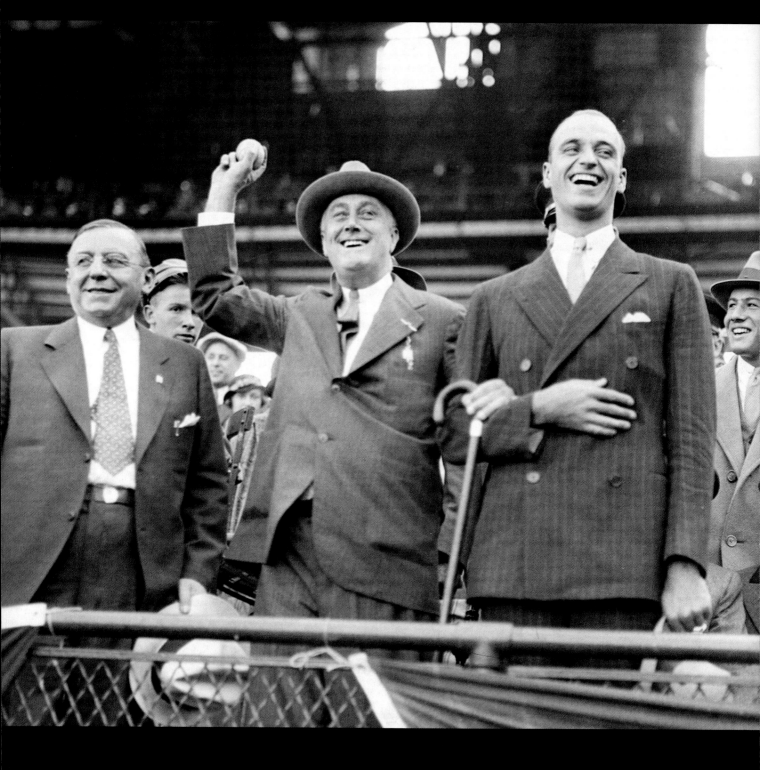

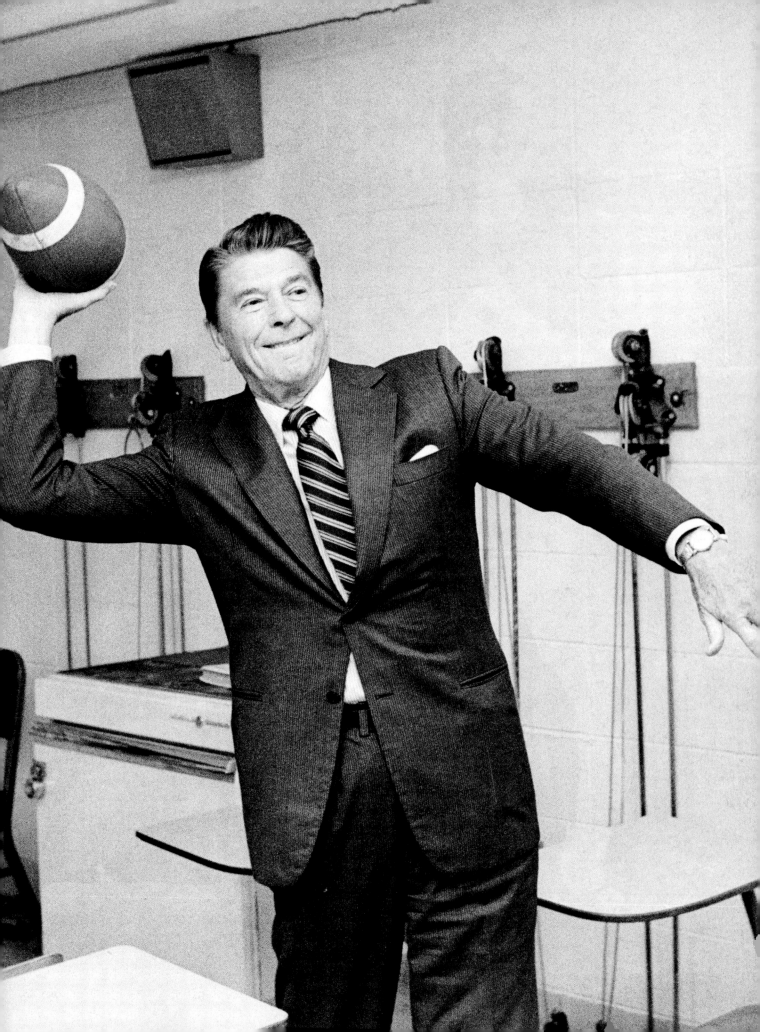

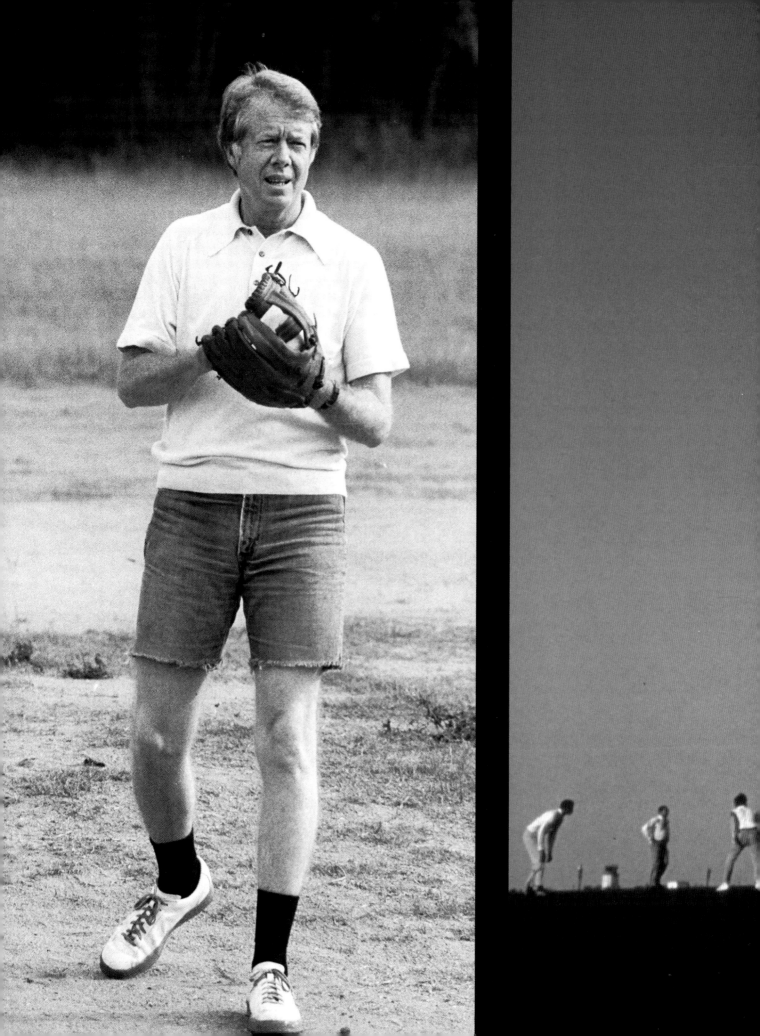

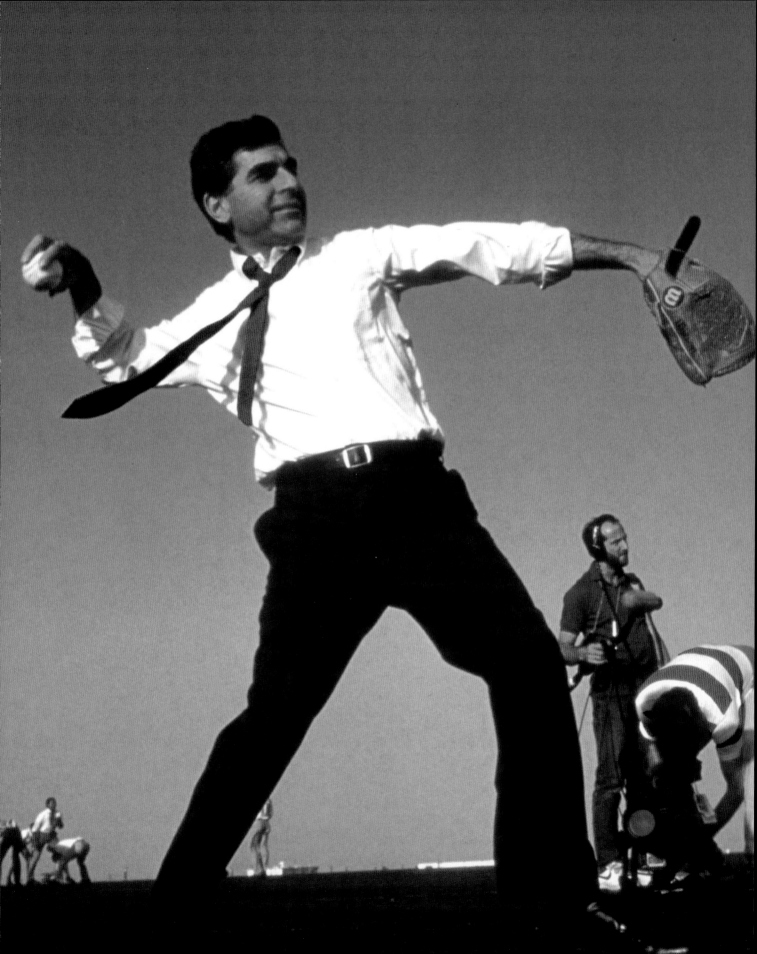

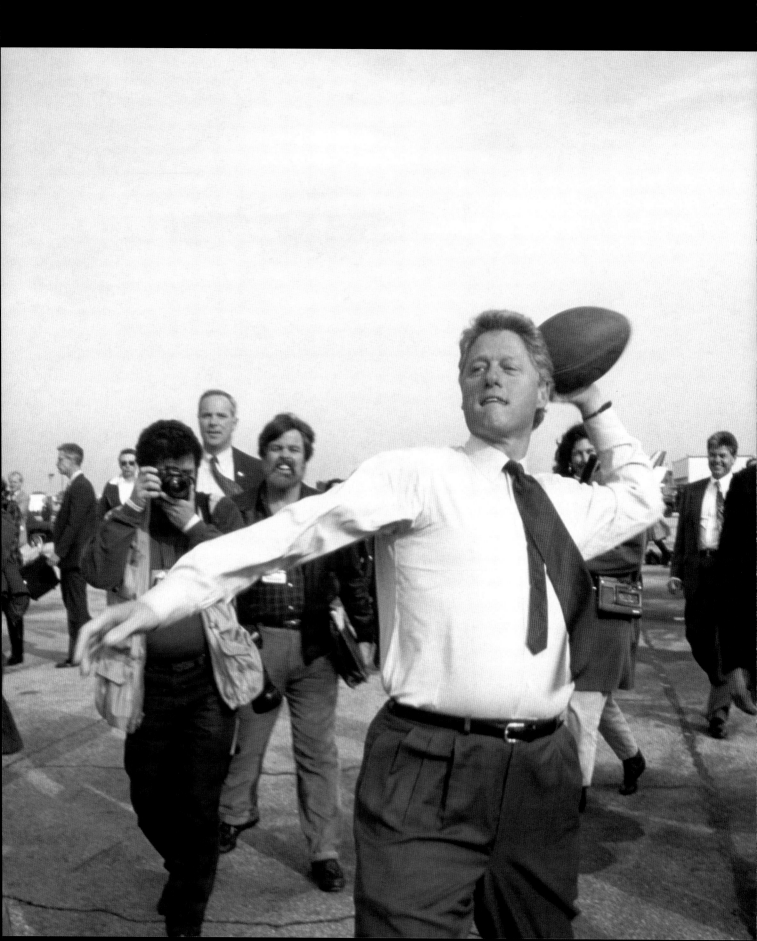

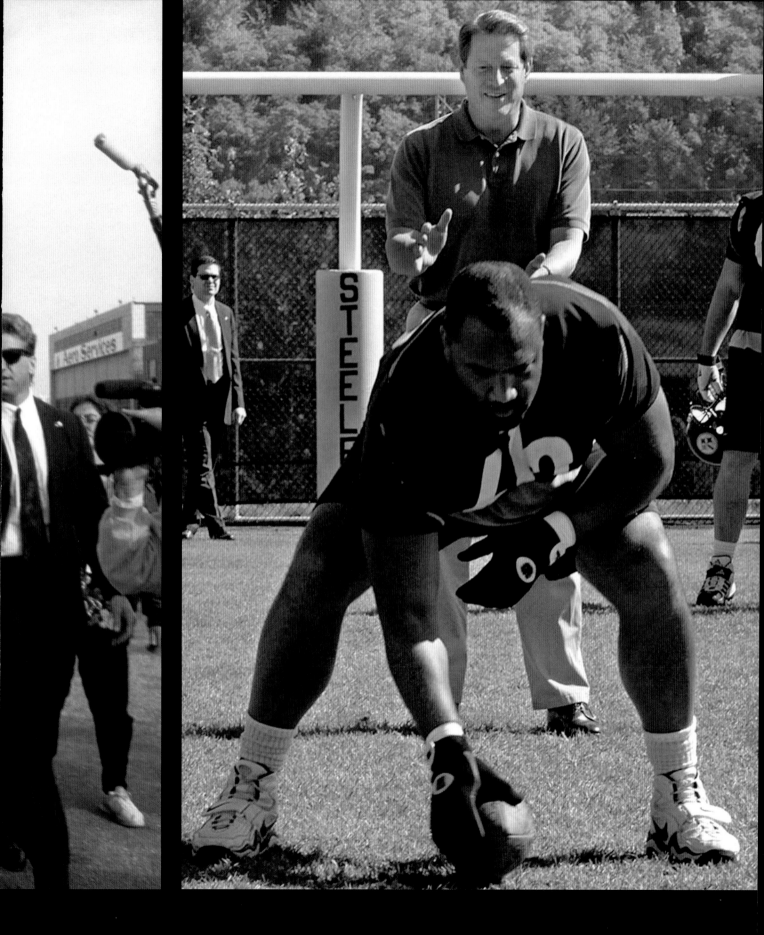

1992-

On October 15, **1992,** George Bush desperately wanted to get out of Richmond, Virginia, and the second presidential debate of the 1992 campaign. It was bad enough that he'd agreed to a town hall debate format, and was forced to share the stage with a billionaire populist bent on derailing his chances for reelection, but now a young woman was asking him how the growing national debt affected him personally. The question confused Bush—but Arkansas governor Bill Clinton seized the opportunity. Clinton walked over to the woman, looked her straight in the eye, and told a heartrending tale of the economic challenges facing his fellow Arkansans. No moment better captured the essence of politics in the 1990s, and the unique political skills of its most dominant personality—Bill Clinton.

The problems facing Bush were as shocking as they were swift. In 1991 it seemed a foregone conclusion that he would ride his smashing victory in the Persian Gulf War to an easy second term. But a weakening economy and growing unemployment spelled trouble for the incumbent. In a weak Democratic field, Clinton quickly emerged as the front-runner, but in New Hampshire he was buffeted by allegations of womanizing and accusations that he dodged the Vietnam War.

Despite the attacks, Bill Clinton refused to withdraw from the race. After an interview on *60 Minutes* with his wife, Hillary, where he admitted problems in the past but recommitted himself to his marriage, Clinton's poll numbers began to rise. Americans, it seemed, were far more interested in Clinton's message of change than they were about the candidate's personal life. In the New Hampshire primary he finished a strong second and quickly dubbed himself the "Comeback Kid."

Nonetheless it was Ross Perot who appeared to pose the greatest challenge to the president. With his homespun aphorisms and quick wit, the wealthy entrepreneur captured the public imagination, and consistently held his own against Bush and Clinton in polls throughout the spring and early summer of 1992.

Perot's success was due in large measure to his unconventional campaign style—he largely eschewed the campaign trail, turning instead to CNN's *Larry King Live* as his personal soapbox. Perot's ability to go over the heads of the press and talk directly to the American people was one of the interesting byproducts of the 1992 race. Bill Clinton followed suit, sparking his campaign with an appearance on *Arsenio Hall;* even George Bush showed up on MTV's *Rock the Vote.*

But things quickly fell apart for Perot, who became angered at the rising costs and increasingly personal nature of American politics. In July, he ended his quixotic bid (at least temporarily) during the midst of the Democratic convention, helping propel Clinton into a lead he never surrendered.

As the campaign heated up, Clinton hewed to a moderate course, particularly in selecting Tennessee senator Al Gore as his running mate. But he also took the offensive, taking Bush to task for his broken "Read my lips—no new taxes" promise, pledging to "end welfare as we know it," and emphasizing his concern for middle-class voters. More importantly, Clinton refused to let any Bush charge go unanswered, creating a new standard in campaign rapid response.

Bush seemed unable to draft a positive message. He criticized Clinton's stewardship in Arkansas and his lack of foreign policy experience, at one point grousing, "My dog Millie knows more about foreign policy than those two bozos." Bush's troubles increased in October, when Ross Perot got back in the race, running a series of wonky infomercials describing his plans for erasing the federal deficit. Though he'd lost any chance of winning, Perot would grab a remarkable 19 percent of the vote and make balancing the budget the nation's top domestic policy issue. In the end, however, Americans were looking for a change. For the first time in twelve years the Democrats were back in the White House.

The Clinton-Gore team would dominate the political landscape in the 1990s—but things did not start off well. When Bill Clinton ran in 1992, he pledged to be a new kind of Democrat. After a series of tax increases and an unwieldy health care plan, the public began to perceive Clinton as just another tax-and-spend liberal. The 1994 midterm election that followed saw the Democrats surrender their forty-year control of Congress under the torrent of the GOP's "Contract with America."

But that defeat gave Clinton the battle he needed to save his political future. Throughout the year, Republicans and Democrats went toe-to-toe over how to balance the budget. The struggles between Clinton and the Republicans continued into the autumn, when Republicans responded to Clinton's veto of their budget by twice shutting down the government. After a month of fruitless negotiations, the GOP conceded defeat and agreed to reopen the government—leaving Clinton at a clear political advantage. "The era of big government is over," declared President Clinton in his State of the Union address. To a large extent, so too was the **1996** presidential election, particularly after a potentially formidable opponent, retired general Colin Powell, declared that he would not seek the presidency.

The Republicans cast their lot with Senator Bob Dole, an early favorite for the GOP nomination. Yet Clinton's team was well ahead of the opposition; in one of the campaign's more interesting innovations, Clinton began running ads more than a year before the election, designed to burnish his centrist image. Aired primarily in smaller media markets in key swing states, this stealth campaign escaped the notice of the press, even as the president's pollsters watched Clinton's approval numbers rise. While Republicans frequently spoke about family values, Clinton turned the tables on them, portraying himself as a defender of "public values." Clinton trumpeted a whole series of small-bore issues as well as his frequently mentioned priorities of Medicare, Medicaid, education, and the environ-

ment—MMEE, as his speechwriters dubbed it.

Bob Dole barely survived a difficult primary season, losing the New Hampshire primary to the conservative commentator Pat Buchanan. After finally winning the nomination, Dole made a dramatic move: Hoping to spark his moribund campaign he resigned from the Senate. Selecting former NFL quarterback Jack Kemp as his running mate, Dole championed a 15 percent across-the-board tax cut. Ross Perot also returned for an encore, under the banner of the newly launched Reform Party. But in the debates—from which Perot was excluded—Clinton's telegenic style bested the stiff and often negative Dole. Promising throughout his campaign to "build a bridge to the twenty-first century," Clinton easily rode to victory in November.

After eight years of prosperity, the stage was set in **2000** for Clinton's vice president, Al Gore, to take the reins. But things would not be that easy. After the impeachment of Bill Clinton in 1998, Gore seemed unable to develop a strategy that associated him with Clinton's policy achievements (22 million jobs, a budget surplus, and America's longest peacetime economic expansion) while distancing himself from the president's personal conduct.

Gore chose to distance himself from Clinton. After handily defeating former New Jersey senator Bill Bradley in the Democratic primaries, he kept Clinton off the campaign trail, missing the opportunity to remind voters of the country's extraordinary economic performance. Instead, he ran a populist campaign that belied his long-held centrist roots. At the Democratic convention in Los Angeles, Gore made political history by picking

Connecticut senator Joe Lieberman as his running mate, making him the first Jewish-American to appear on a national ticket.

On the Republican side, Texas governor George W. Bush drew on public outrage over the impeachment drama. Bush pledged not only to "restore honor" to the White House, but also to bring the country together after eight years of partisan sniping. Like Dole four years earlier, Bush also promised the country a massive tax cut if he won the White House.

After Bush jumped out to a double-digit lead, Gore slowly worked his way back into contention; polls showed the race too close to call, with a slight advantage for Bush. But Gore's momentum was slowed by the presence of Green Party candidate Ralph Nader. Running to the Democrat's left, Nader needled Gore with claims that his two rivals were interchangeable, and fought aggressively through the end of the race.

As the results came in on election night, confusion reigned. In the key swing state of Florida, Gore was initially projected as the winner. Two hours later the call was reversed, and the state was up for grabs. Finally, at 2 A.M., cable's Fox News Channel called Florida, and thus the election, for Bush . . . or so it seemed. Gore was on his way to deliver his concession speech when his aides received a call from his Florida campaign director. "Don't concede," he was told. The margin of Bush's victory was close enough to trigger an automatic recount—and thus began America's most protracted election battle since 1876.

As the recount began, Republicans and Democrats sent teams of lawyers and spin doctors to Florida—a state whose governor was Bush's brother Jeb, and whose secretary of state, Katherine Harris, served as a co-chair for the Bush campaign in Florida. As Harris oversaw the recount process, controversy erupted around every corner. In Palm Beach County, a badly designed "butterfly" ballot had confused voters—many of them Jewish—into casting their vote for Reform Party candidate Pat Buchanan. In other counties, electoral officials were

reduced to determining voter intent from so-called "hanging" or "dimpled" chads, tiny pieces of the ballots that were punched out in the voting process.

On November 26, the deadline for the recounts, Harris certified Bush the winner by a margin of 537 votes. (Many Democrats ruefully noted that Nader had won nearly 100,000 votes in the state.) Bush declared himself president-elect, but Gore, who had won the popular vote by about 500,000 votes, refused to concede. After more legal wrangling, the case went to the Supreme Court.

Gore had reason to be optimistic, but his hopes were quickly scuttled when the court issued a stay of the recount. Days later, with a 5–4 conservative/liberal split, the court ruled in Bush's favor. On a cold night in the nation's capital, as television reporters digested the written decision live on the steps of the Supreme Court, the election was finally over—and George W. Bush was the forty-third president of the United States. As Republicans waved good riddance to the tumultuous Clinton era, and Democrats rejected Bush's presidency as illegitimate, one image seemed to define the times: an electoral map showing the gulf between the heavily Democratic "Blue America" on both coasts, and the solidly Republican "Red America" in between. At the dawn of the twenty-first century, the country was as evenly divided as at any time in its history. ❏

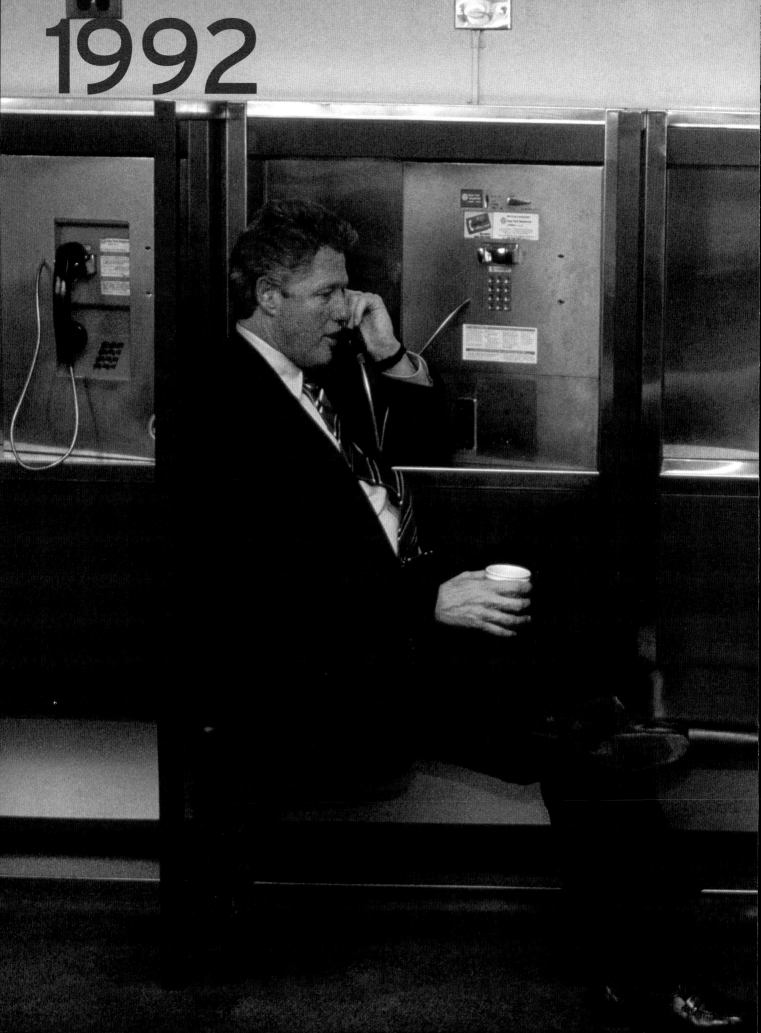

1992

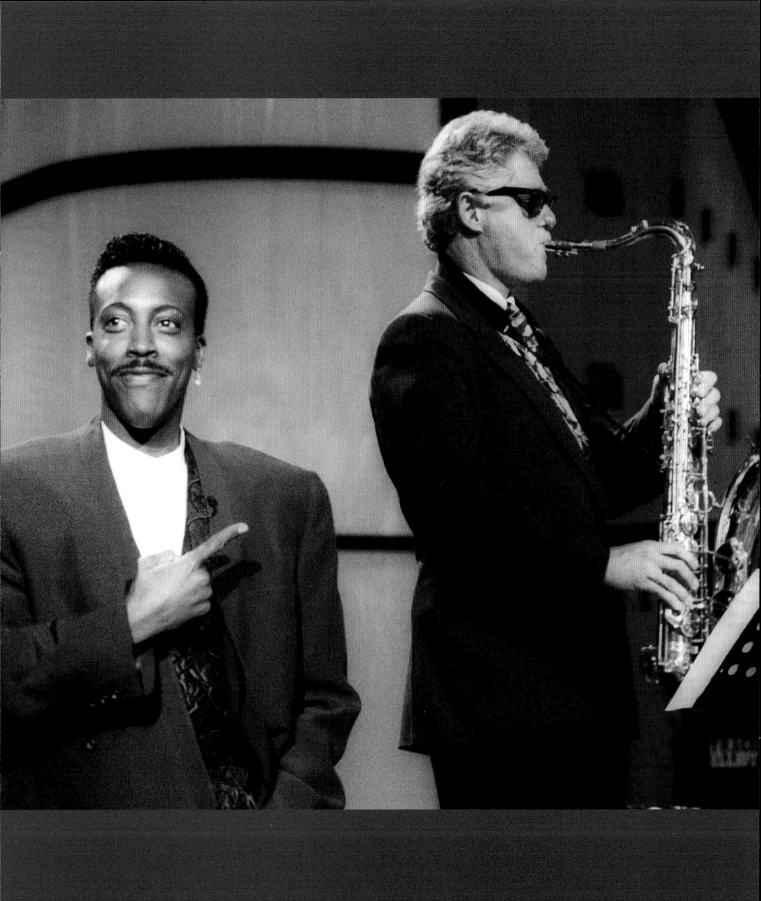

Burdened with an economic recession, George Bush *(opposite)* was faced with a
challenge from a new generation: Bill Clinton *(above,* on *The Arsenio Hall Show).*

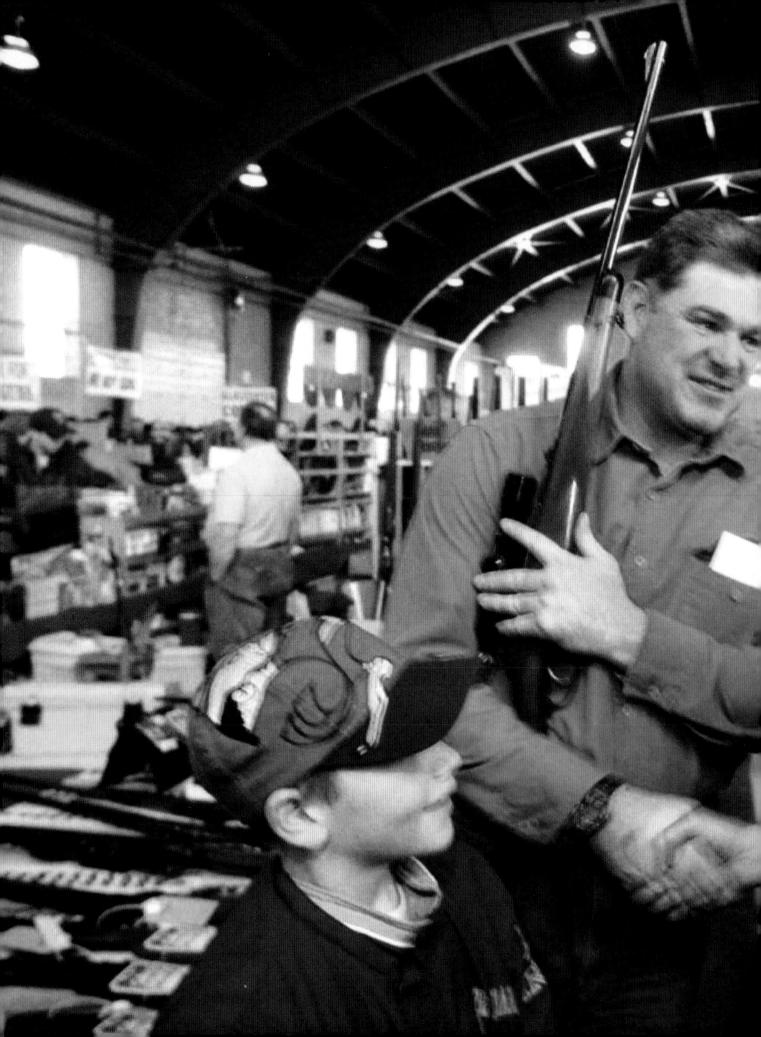

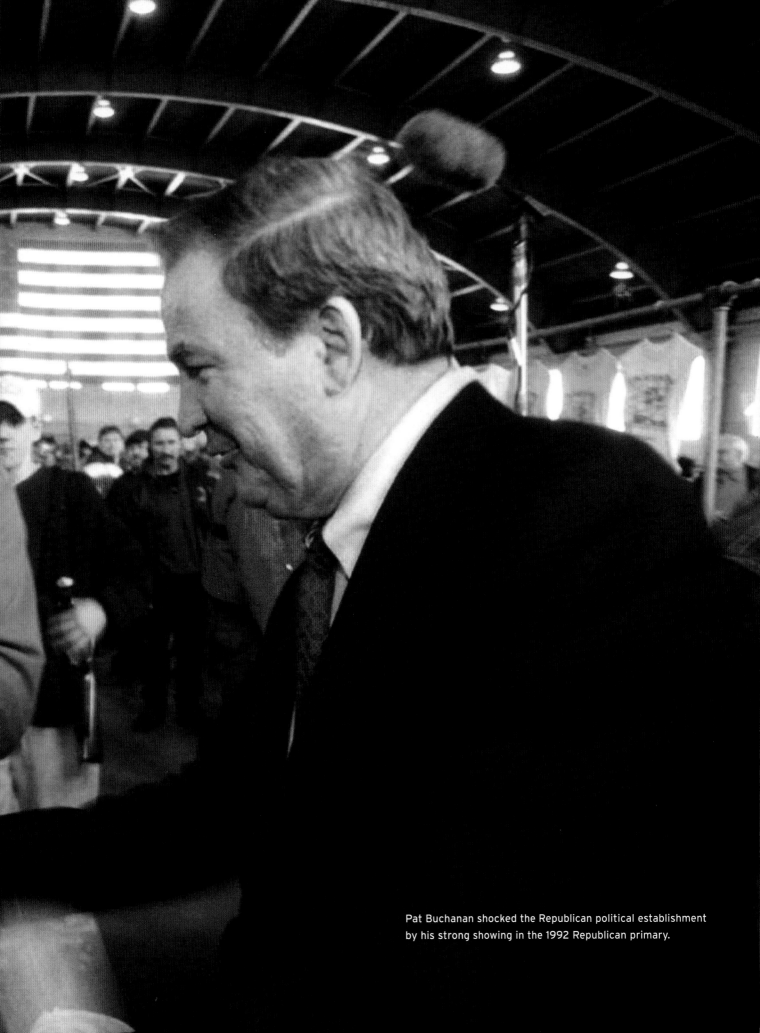

Pat Buchanan shocked the Republican political establishment by his strong showing in the 1992 Republican primary.

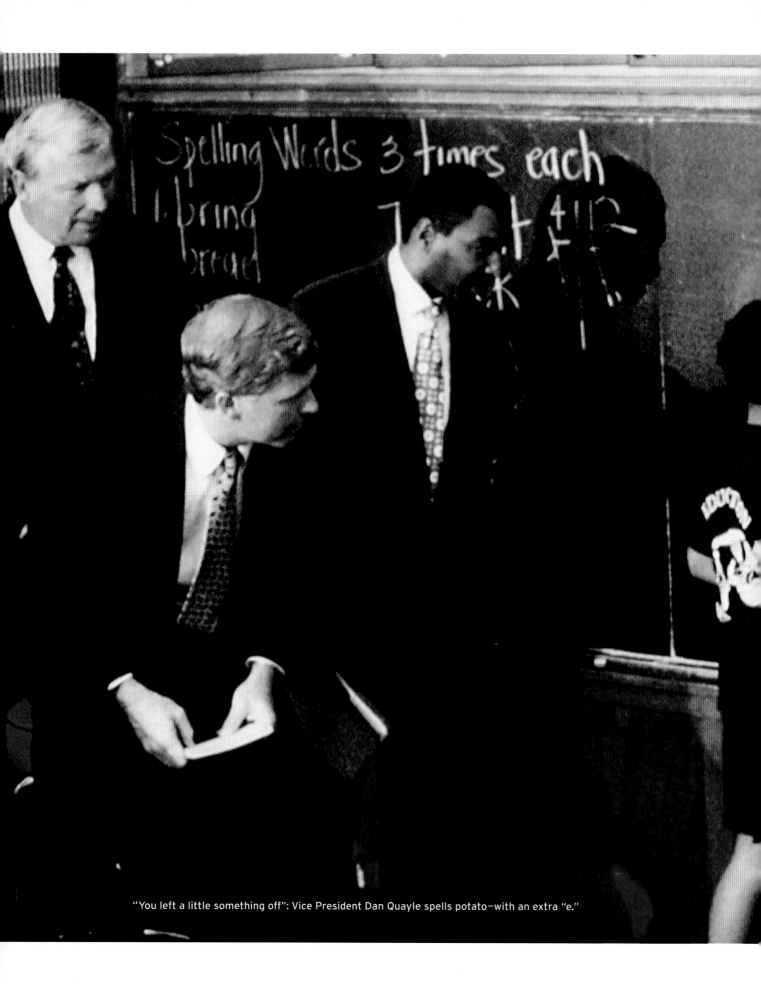

On blackboard: Spelling Words 3 times each
1. bring bread

"You left a little something off": Vice President Dan Quayle spells potato—with an extra "e."

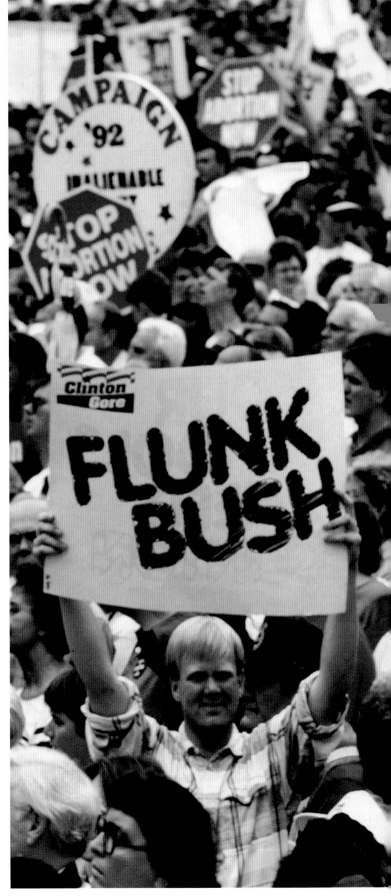

Cameras caught President George Bush
checking his watch during a presidential
debate, giving the Democrats a new campaign
chant: "It's time for them to go."

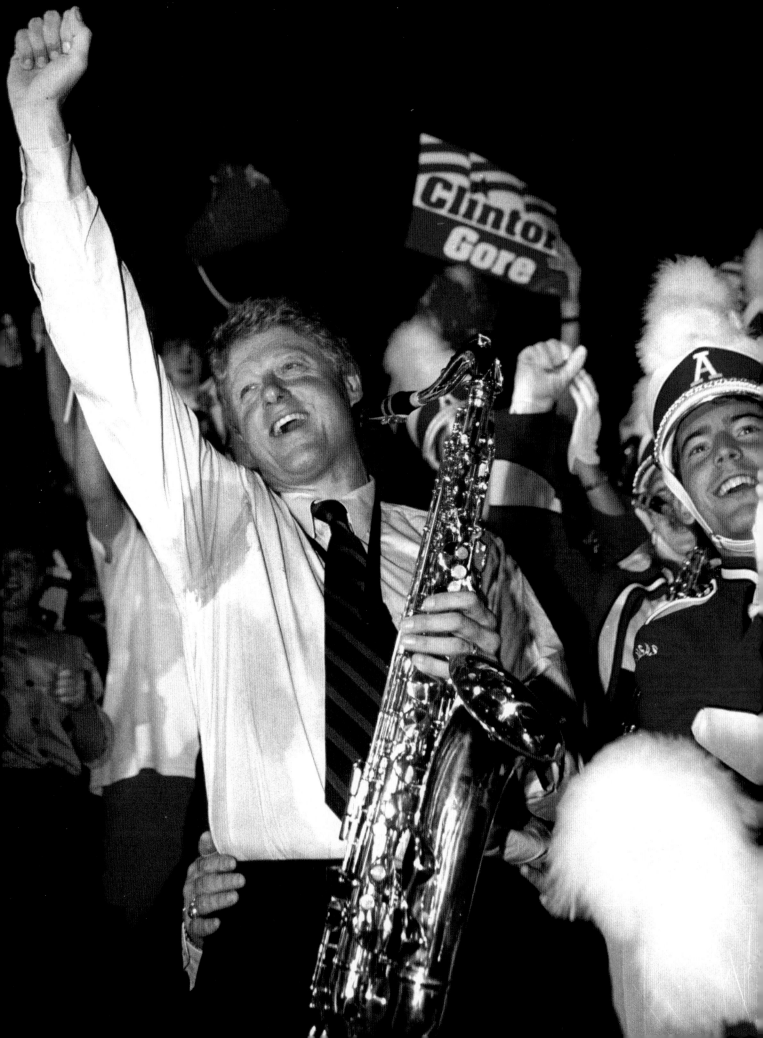

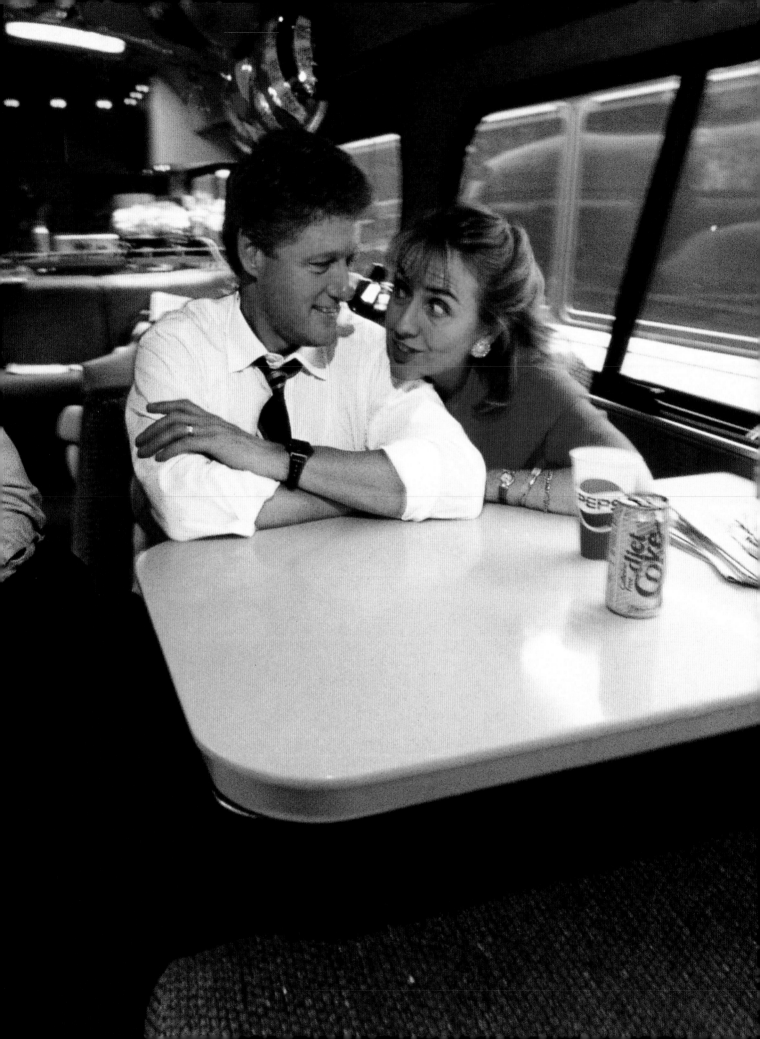

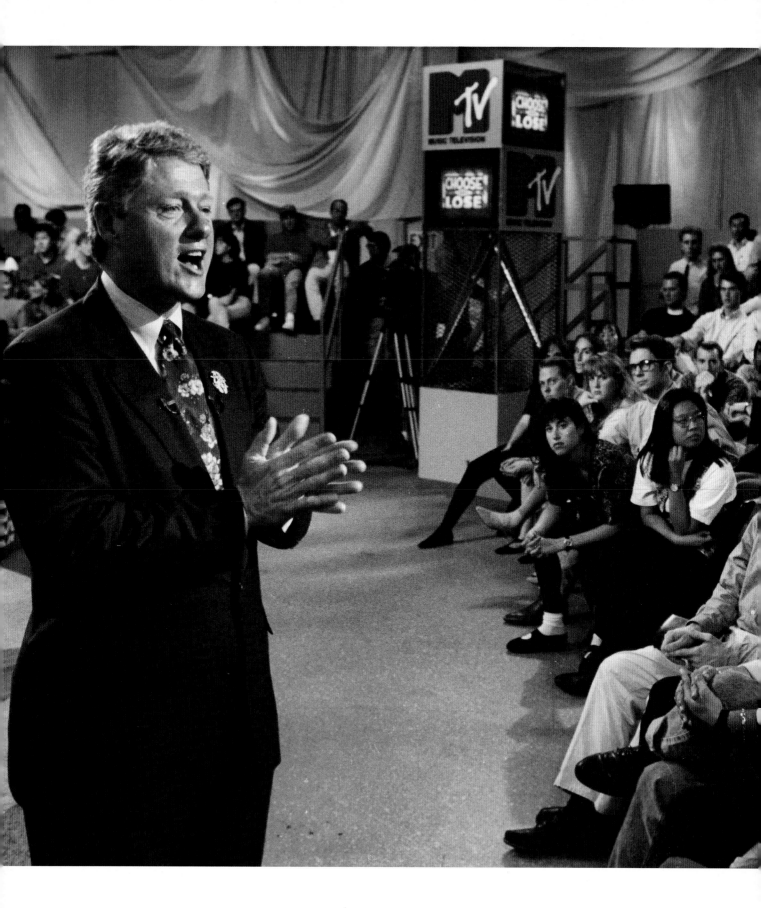

In a campaign dominated by talk show appearances, Bill Clinton took questions on MTV's *Rock the Vote*.

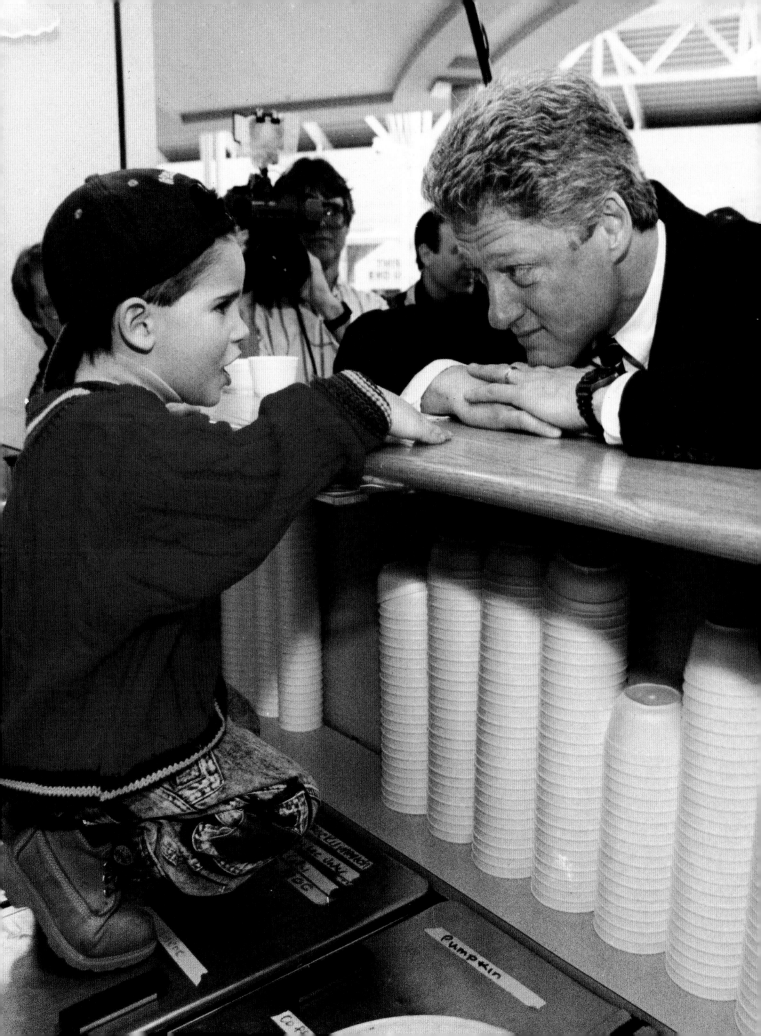

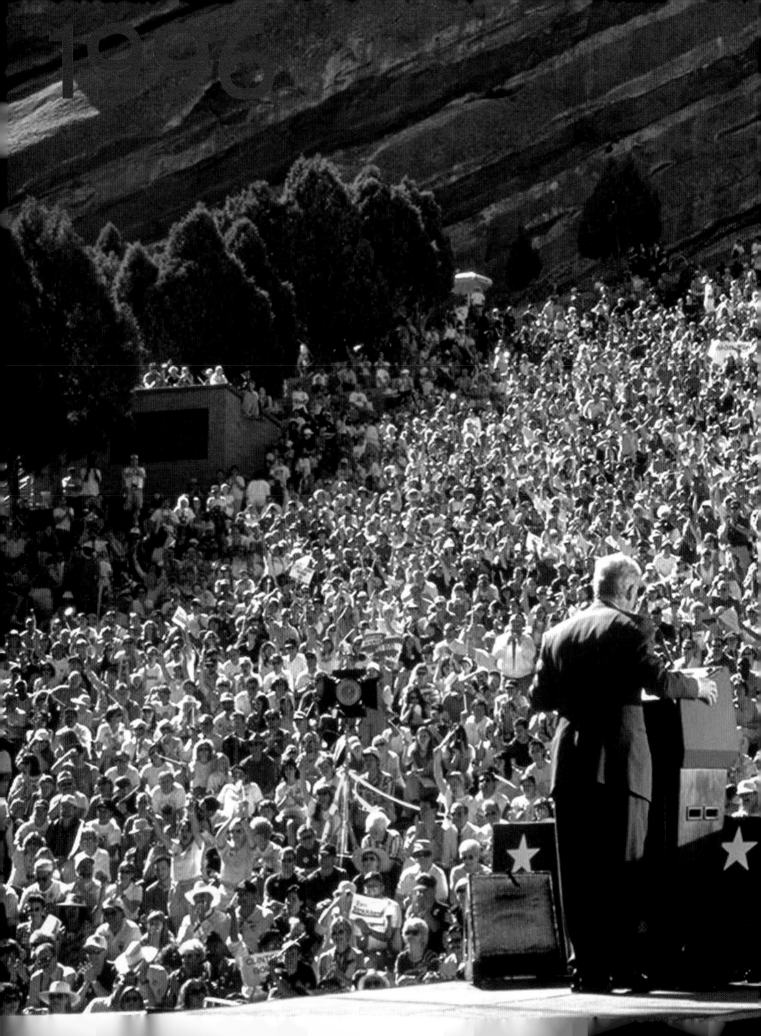

President Clinton at a rally at Colorado's Red Rocks Amphitheater.

With Georgia Senate candidate (and Vietman vet) Max Cleland

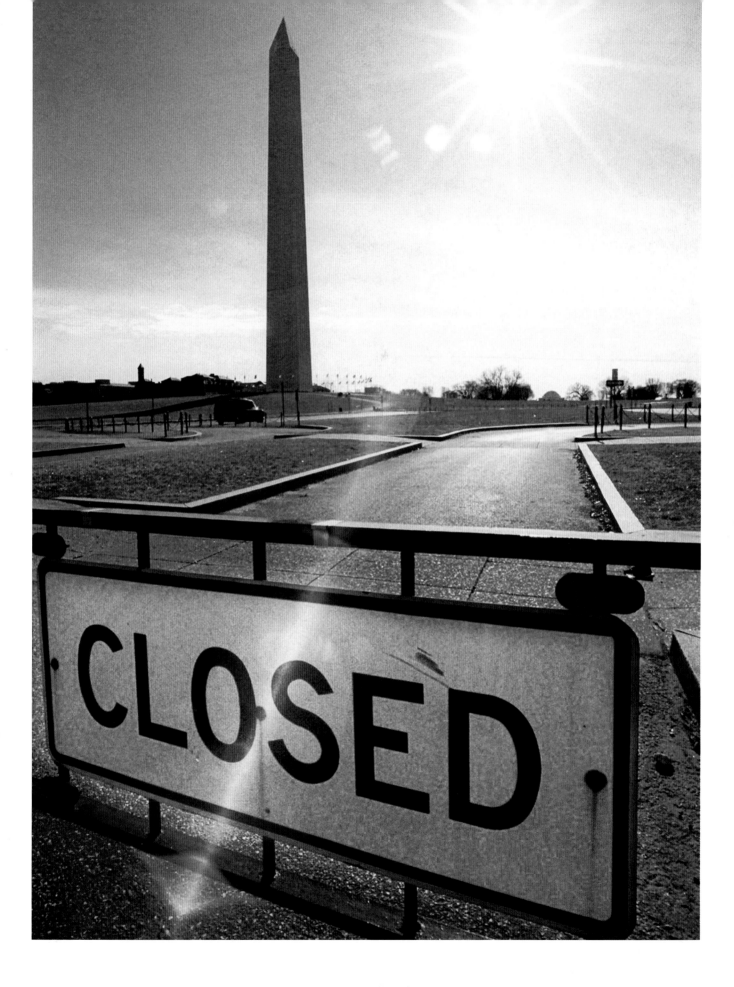

Government shutdowns in 1995 set the backdrop for the 1996 presidential election.

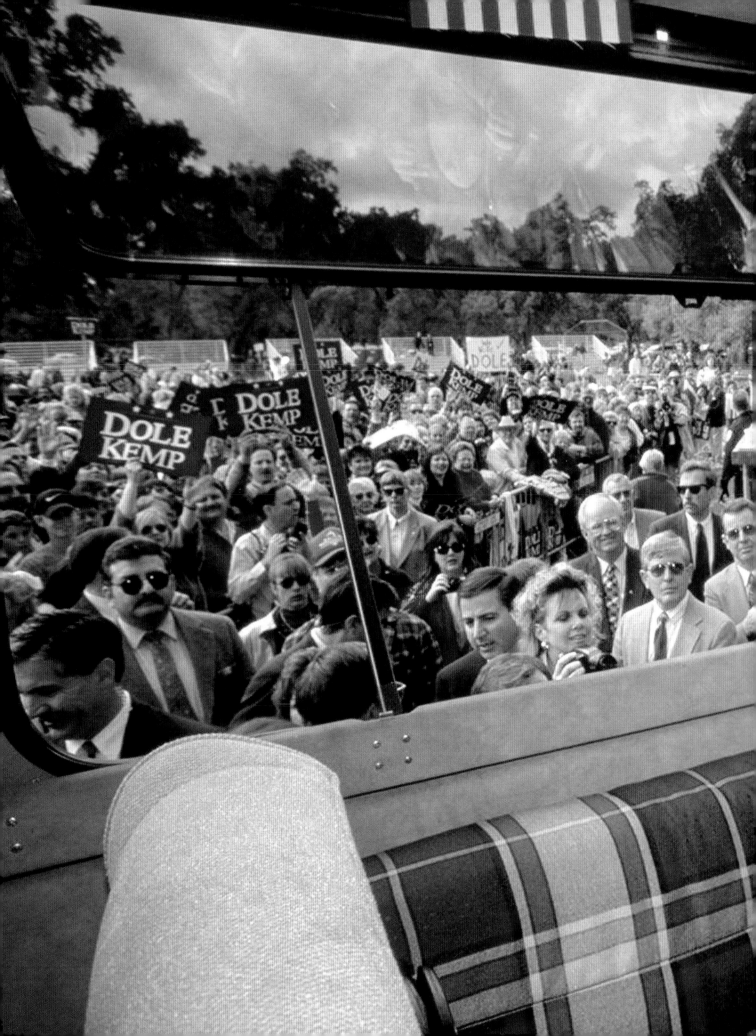

Republican nominee Bob Dole
on the campaign bus

Dole recovered quickly after falling off a stage during a California appearance, but his campaign seemed listless compared to Clinton's victory lap.

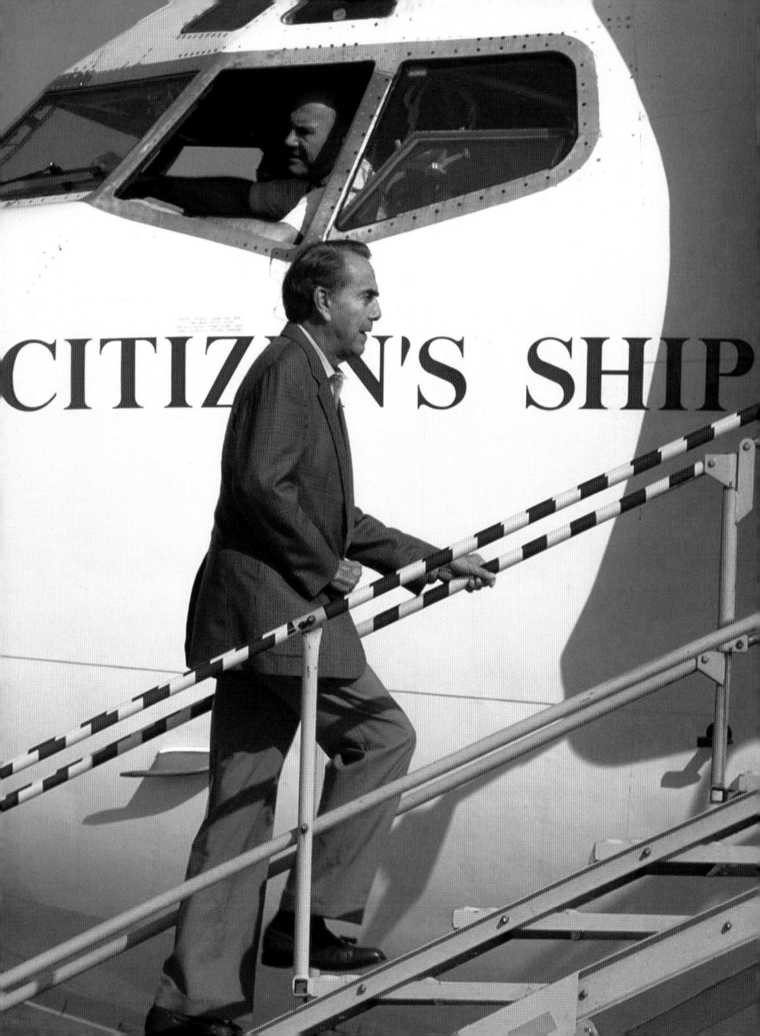

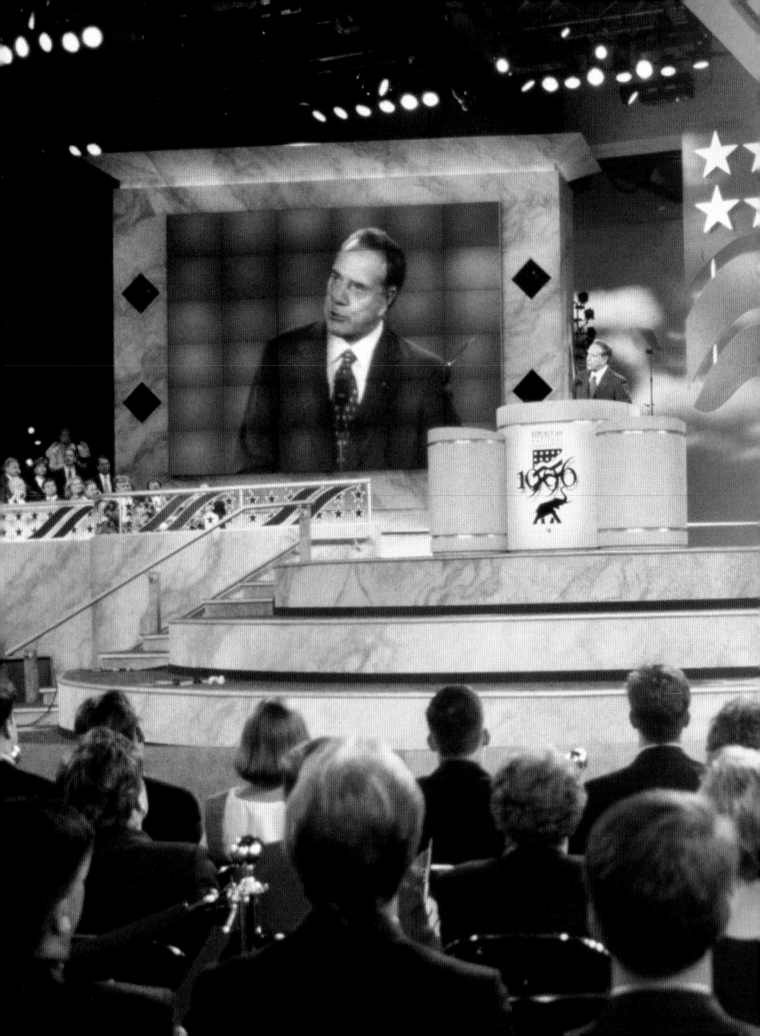

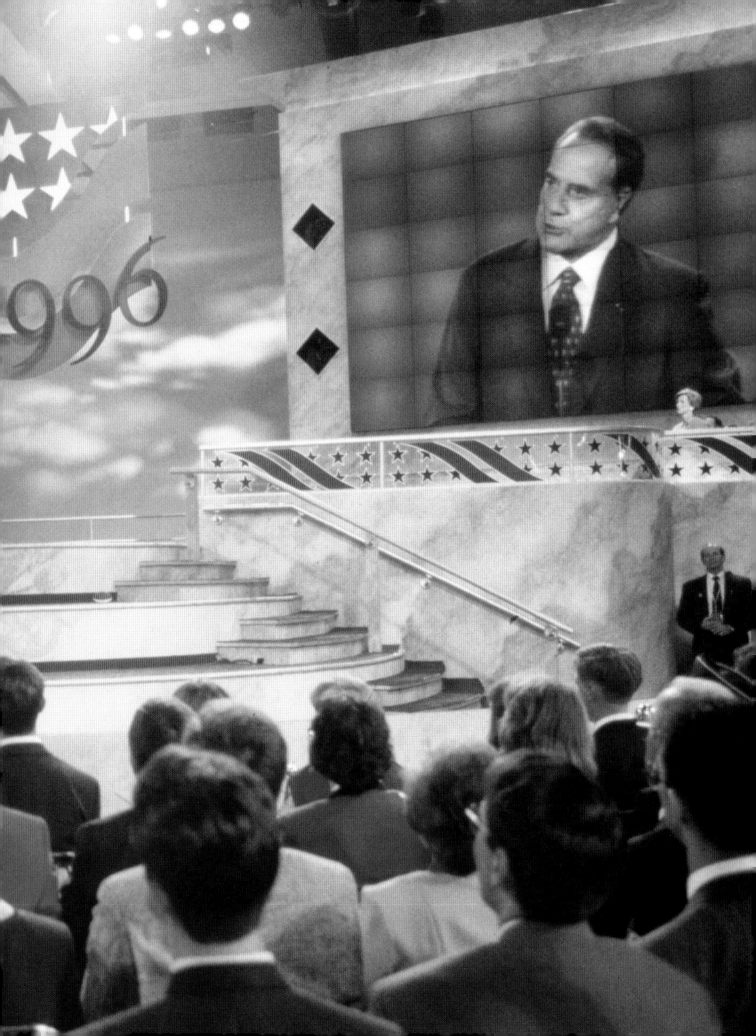

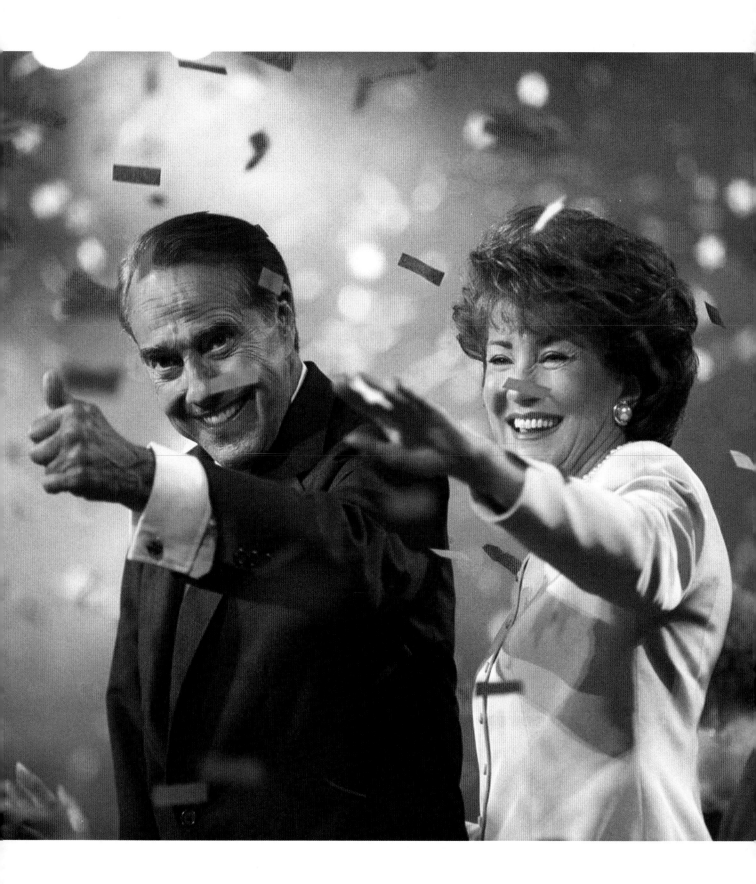

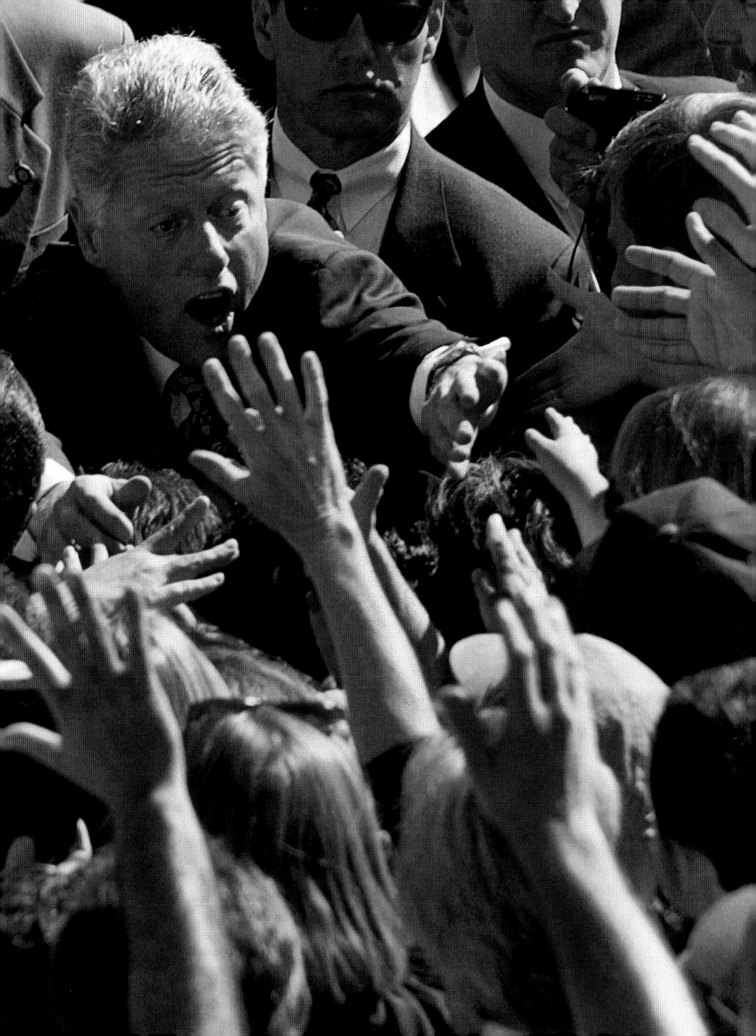

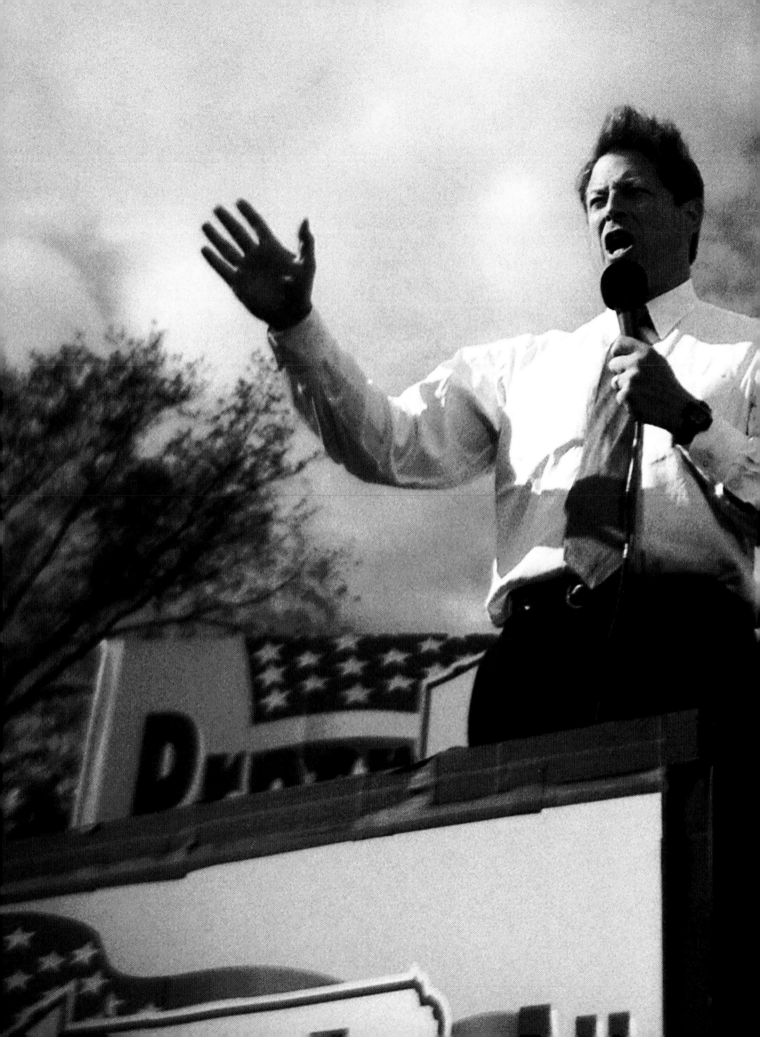

Matt Lauer of NBC's *Today* interviews Republican senator John McCain
on his campaign bus, the "Straight Talk Express."

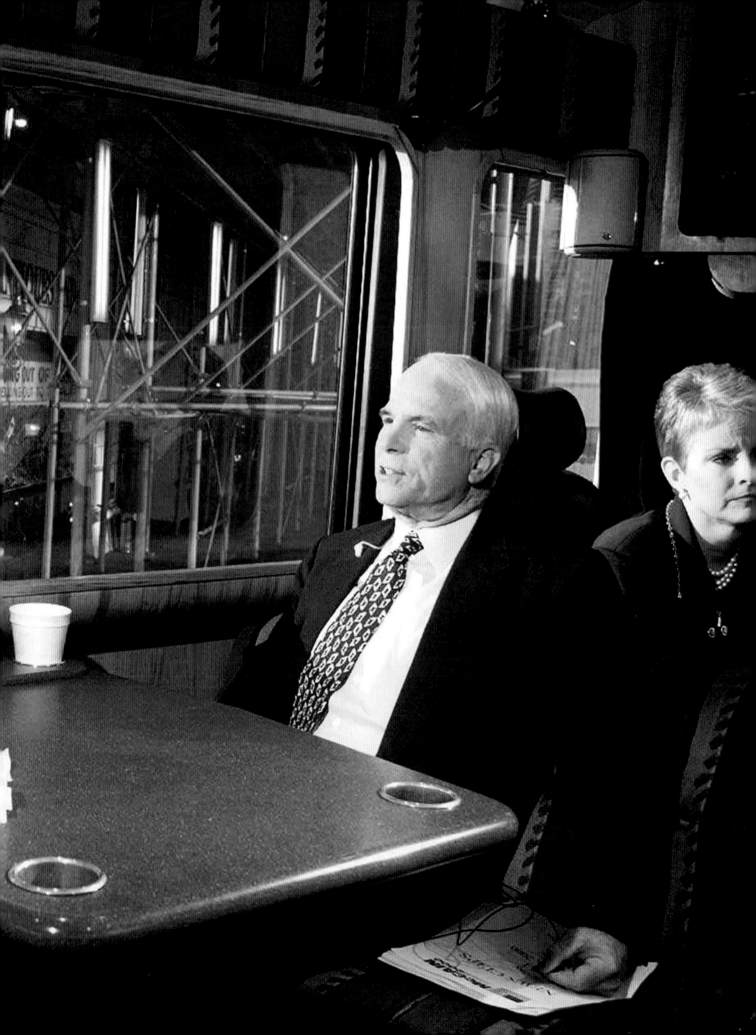

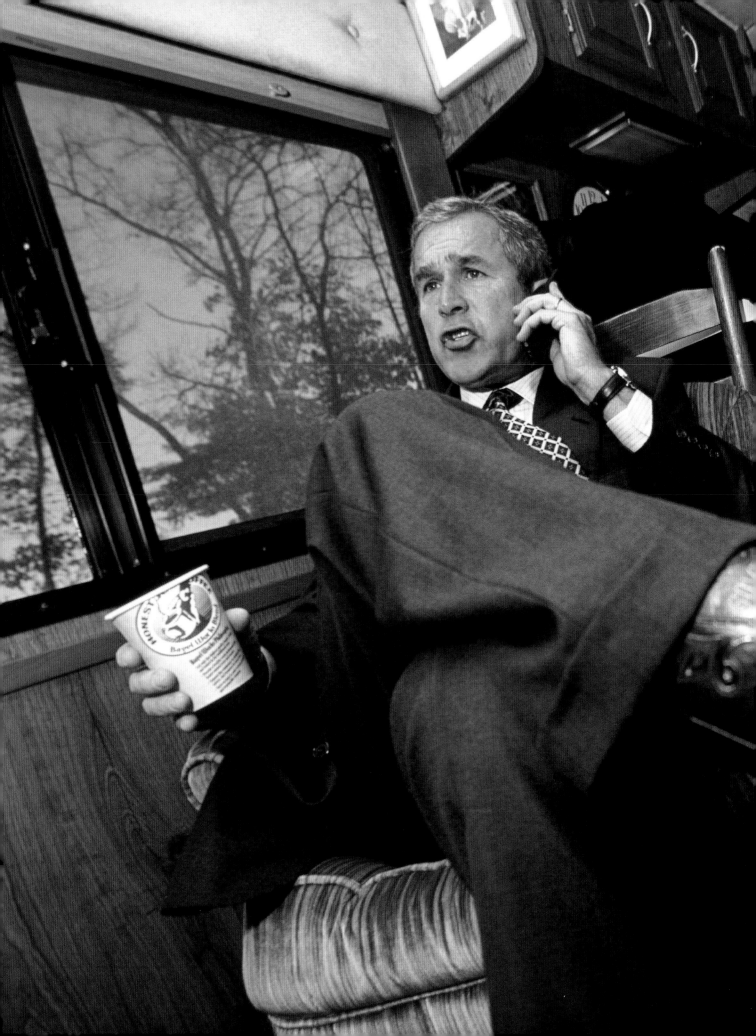

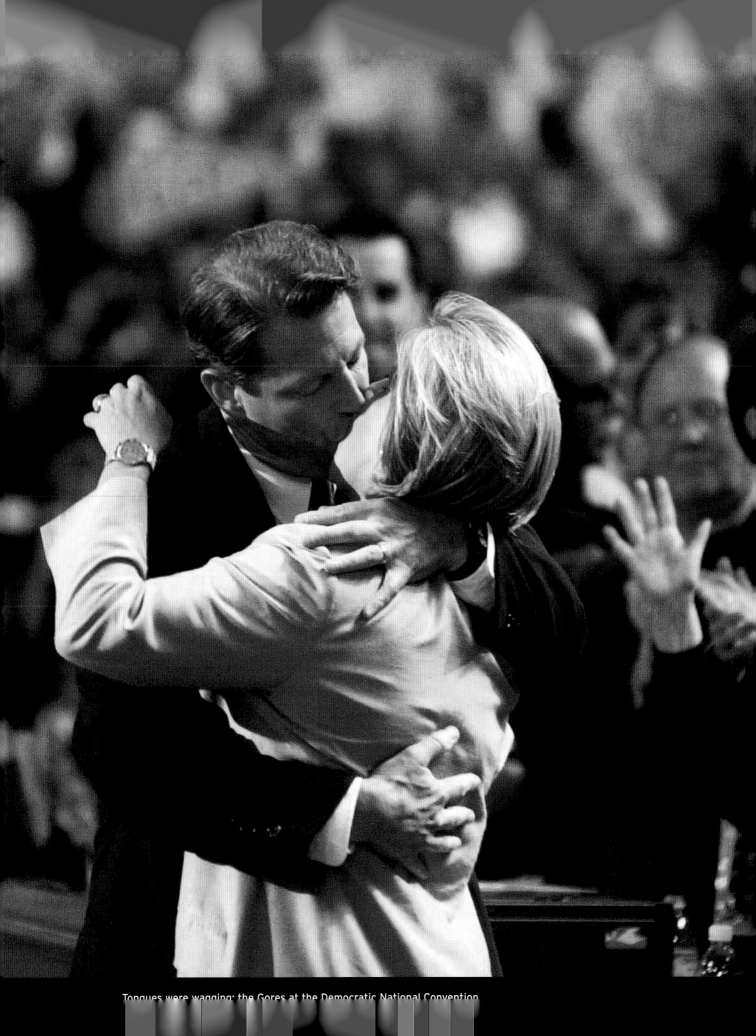

Tongues were wagging: the Gores at the Democratic National Convention

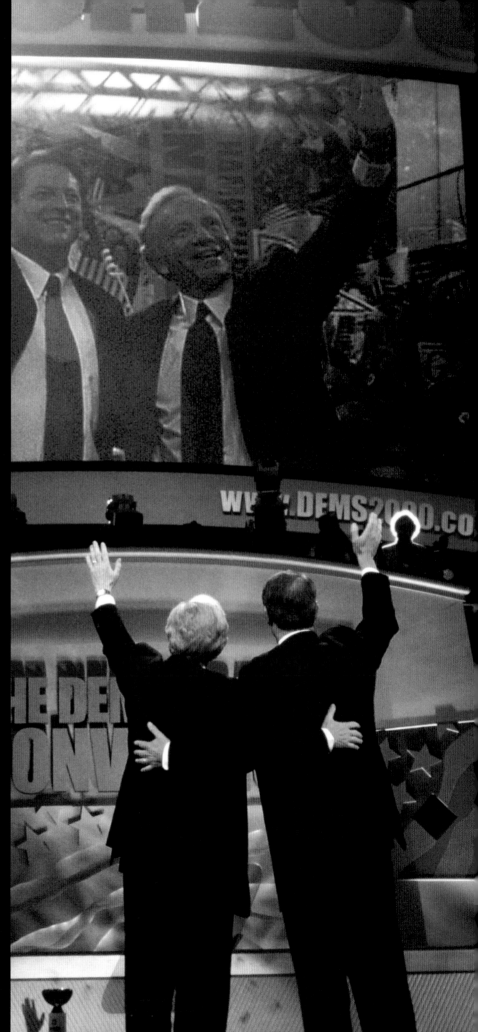

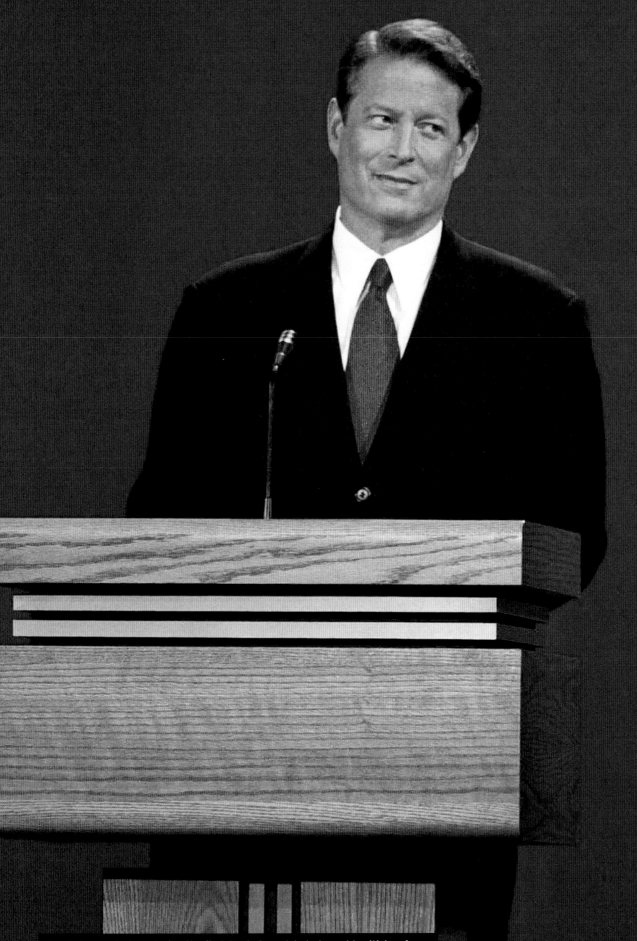

Gore's frequent sighs during the first Bush-Gore debate brought criticism from many political observers, and a biting satire on *Saturday Night Live*.

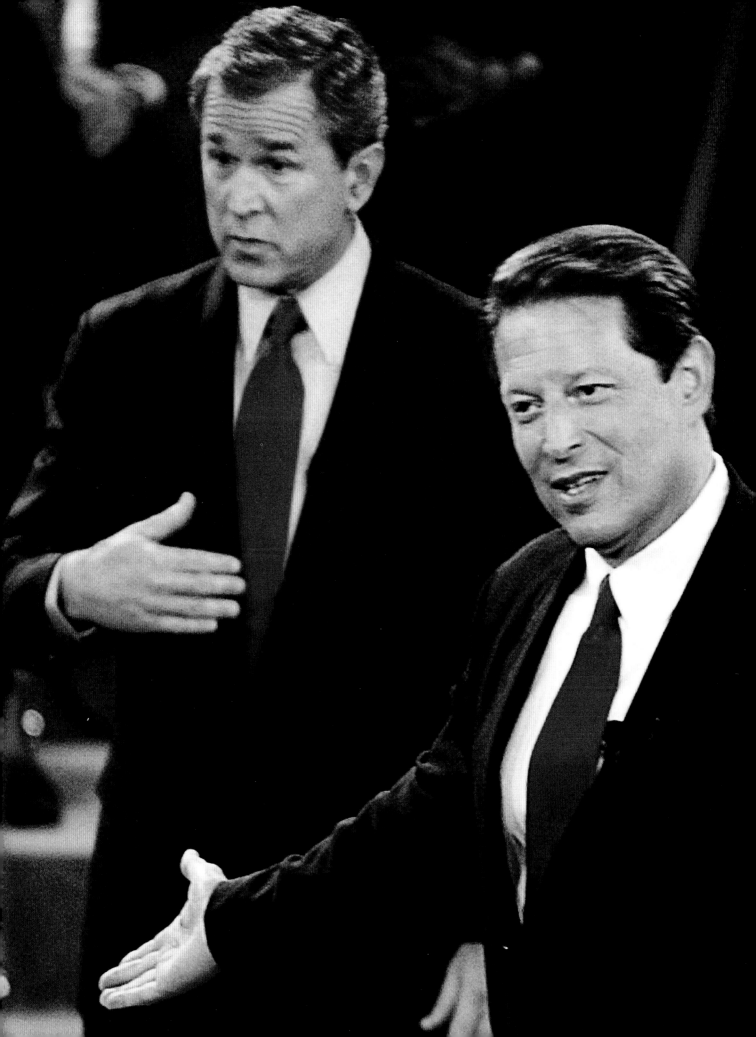

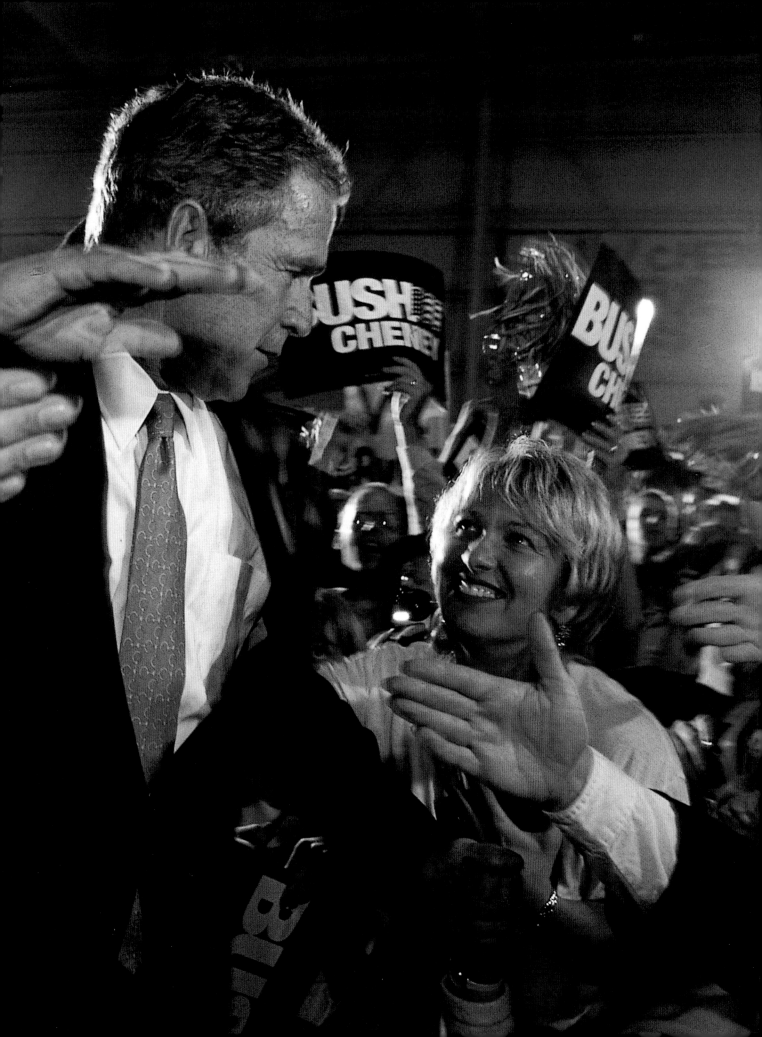

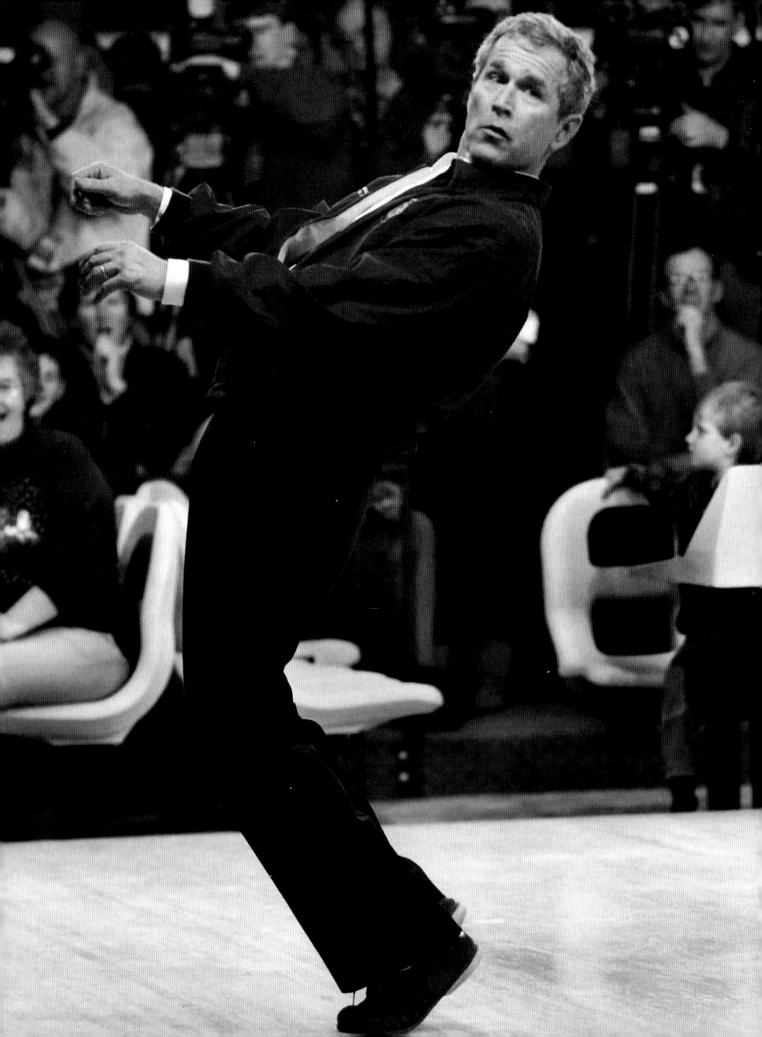

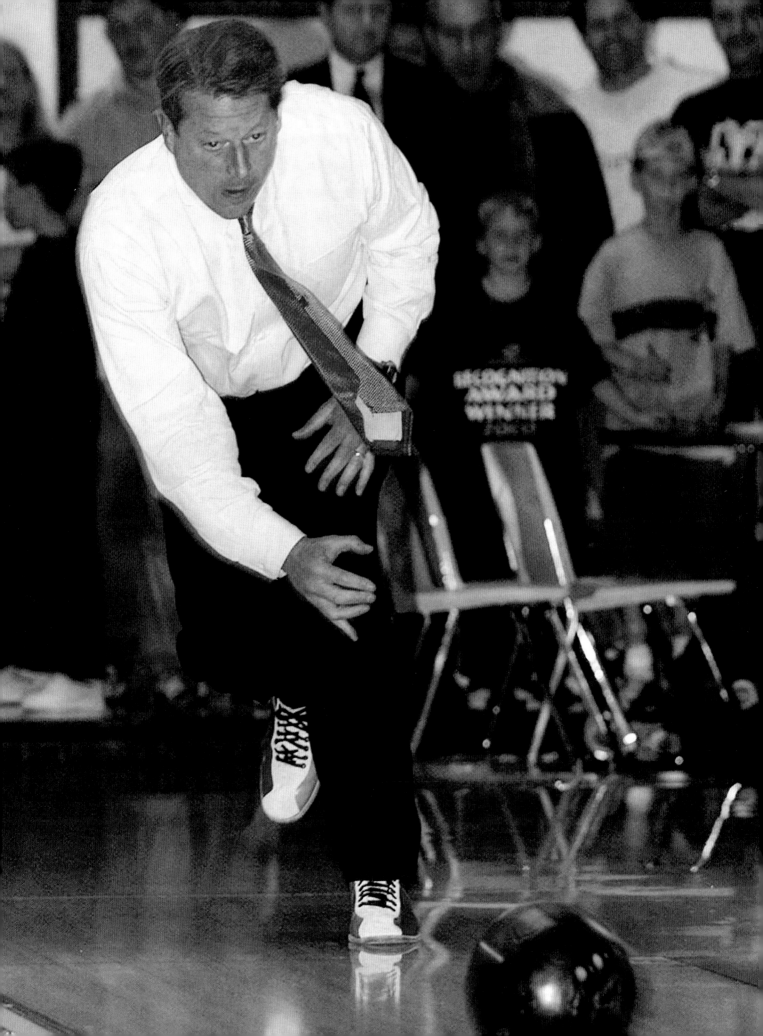

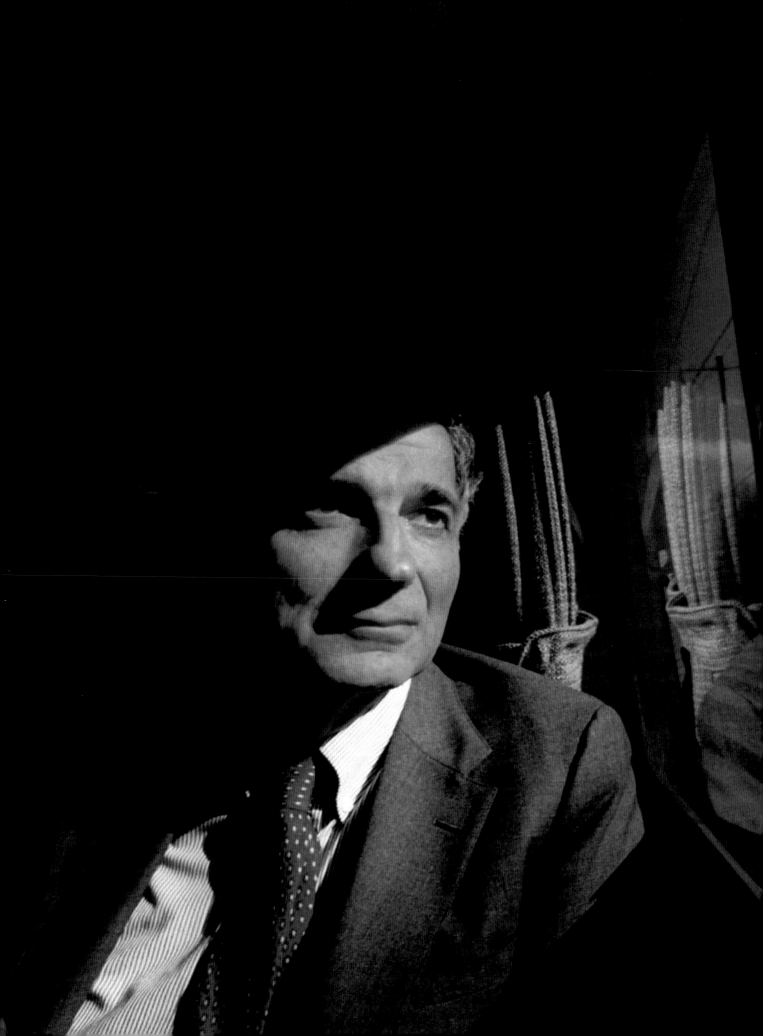

Running to Al Gore's left, Ralph Nader proved a thorn in the Democrats' side. Though he won only 2.7 percent of the vote, Nader probably cost Gore the race. In at least two states—New Hampshire and Florida—his tally exceeded

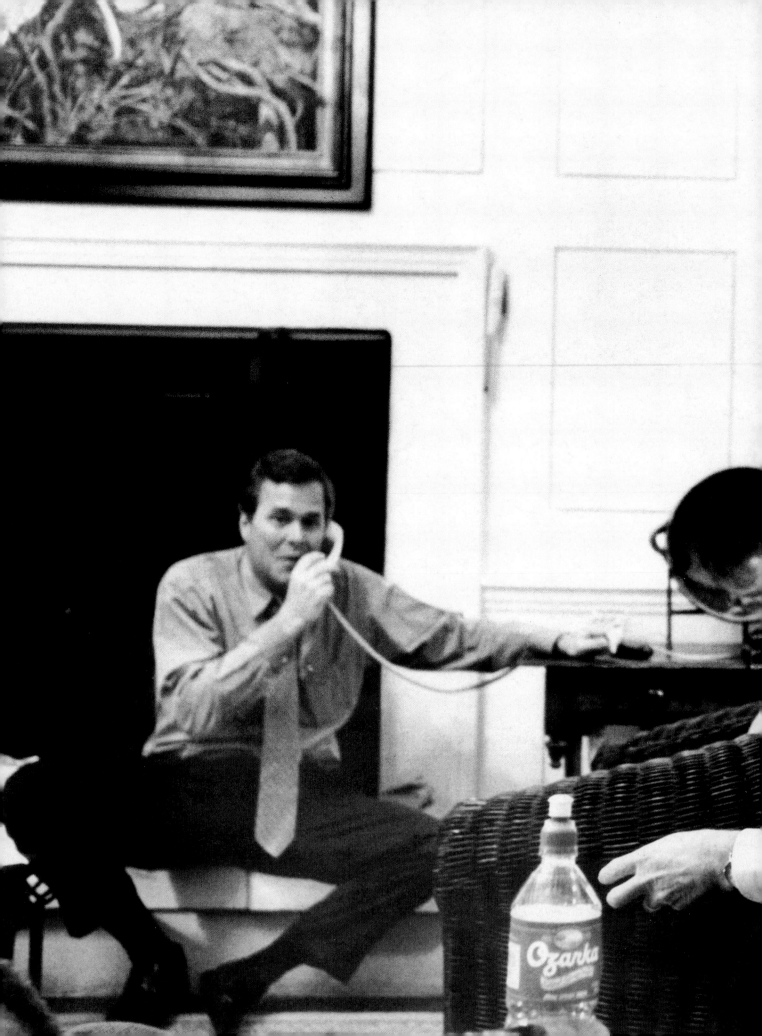

The Bush dynasty,
election night 2000

Hand-recounting ballots

One of the infamous "chads"

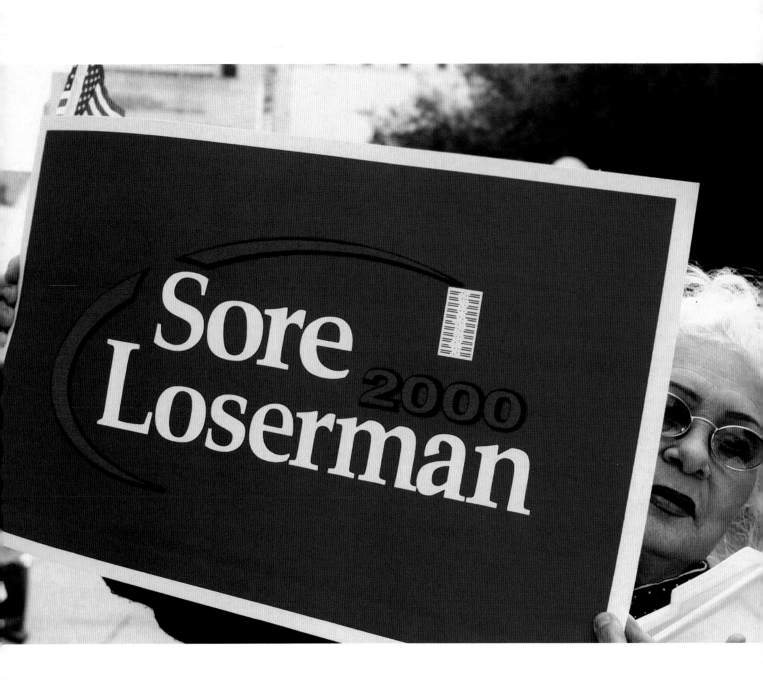

The recount battle lasted more than a month, as demonstrators from both sides duked it out before the media.

Police stand guard outside the Supreme Court as the nation awaits the court's ruling on the Florida recount.

As the media waited outside Al Gore's door, George W. Bush was declared the 43rd president of the United States.

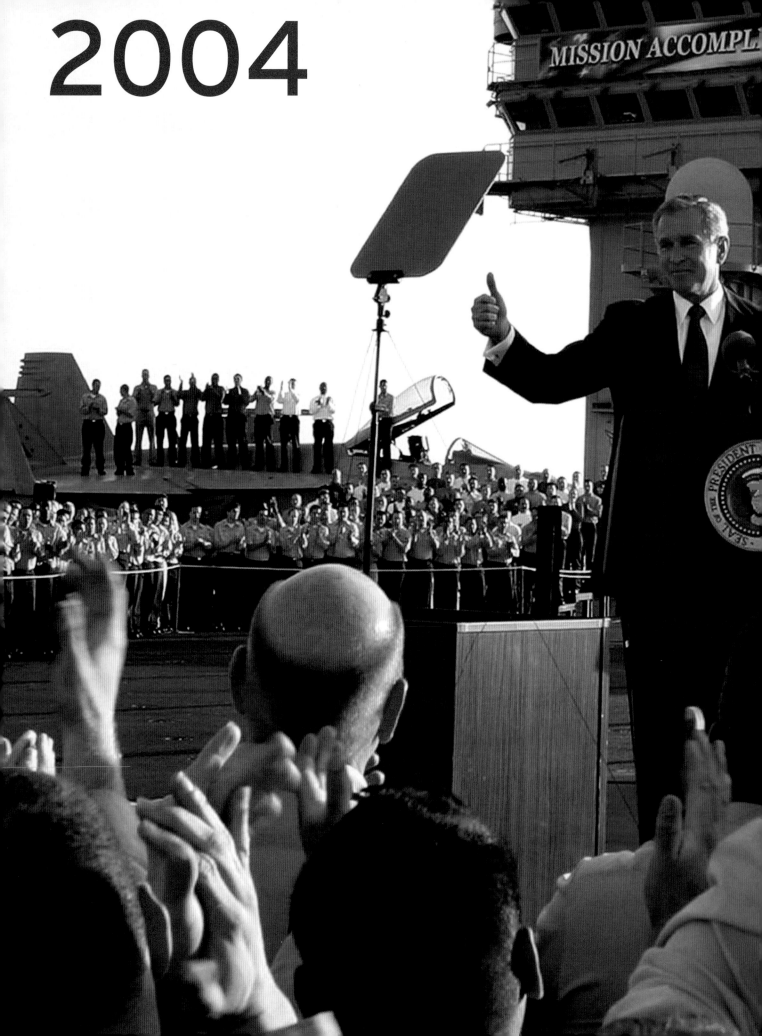

2004

MISSION ACCOMPLI

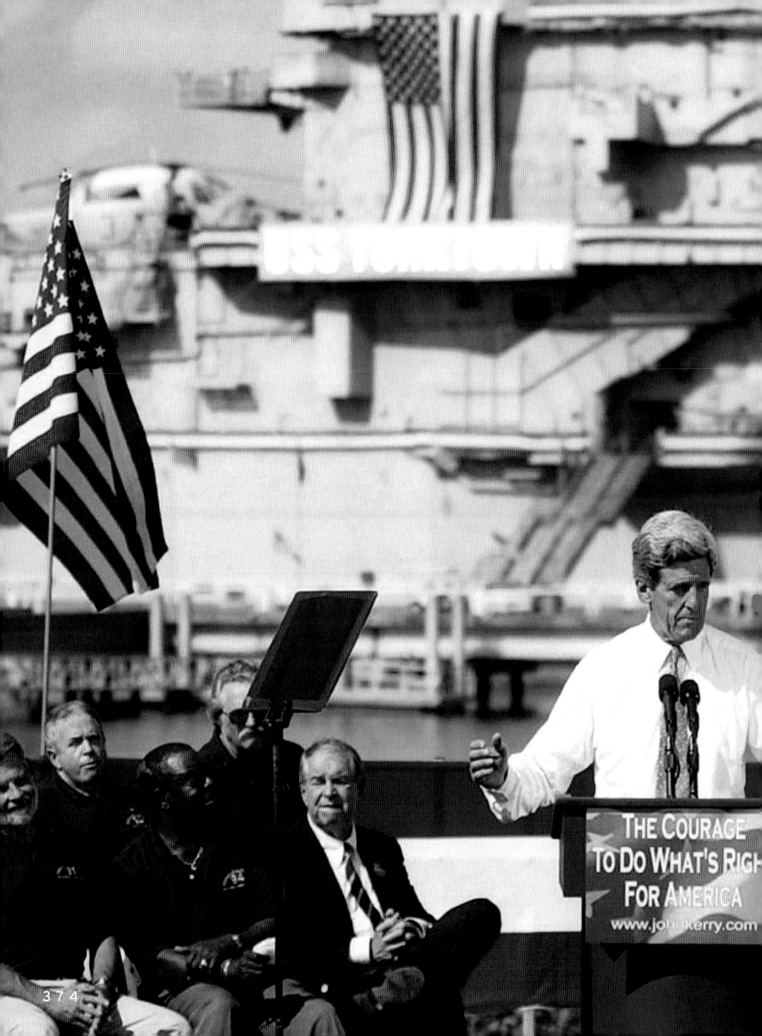

GEORGE W. BUSH
COMMANDER-IN-CHIEF

At the dawn of the twenty-first century, after the most narrowly contested election in American history, the partisan divisions in the country were as stark as any time in recent memory. Over the next four years, they would only grow more pronounced.

For many Democrats, the controversy surrounding the Florida recount remained a fresh source of anger. Quickly, however, the political scene was transformed by the tragic events of September 11, 2001. With the country suddenly on a war footing, President Bush enjoyed a huge political advantage, with stratospherically high poll numbers throughout 2002. While at first the country put aside its political differences, the Bush administration's decision to go to war in Iraq in 2003 drove a deep wedge between Democrats and Republicans.

President Bush appeared to kick off the **2004** presidential election cycle with his appearance aboard the USS Abraham Lincoln, which he boarded after making a dramatic landing there in an F-15 fighter jet. Standing in front of a banner declaring "Mission Accomplished," President Bush affirmed an end to combat operations in Iraq and his approval ratings skyrocketed, giving his candidacy for reelection an air of inevitability. As his father learned in 1991, though, things aren't always that simple.

In fact, anger over the war would soon come to roil Democratic Party politics and play a defining role in the tenor of the 2004 election. Sensing the extraordinary rancor among the Democratic grassroots over the president's decision to go to war—along with the acquiescence of "Washington Democrats"—former Vermont governor Howard Dean emerged with a powerful antiwar message, evoking memories of Eugene McCarthy's campaign for the Democratic nomination in 1968. Buffeted by his aggressive use of the Internet not only to raise money, but to build an online community of support, Dean rocketed to the top of the Democratic pack, surpassing better-known party stalwarts such as 2000 vice presidential nominee Joe Lieberman, former presidential candidate Dick Gephardt, and the early front-runner, Massachusetts senator John Kerry.

In September, General Wesley Clark, NATO commander during the war in Kosovo, declared his candidacy, and temporarily rose to the top of the pack. But his inexperience as a politician (characterized by a perceived indecision over whether he would have voted for the Bush administration's call for war in Iraq), combined with a fateful decision not to compete in the Iowa caucus, quickly imperiled his candidacy.

By the winter of 2003, Dean had the party's largest war chest, the most impassioned support—and the most high-profile endorsements, including that of the 2000 Democratic nominee, former vice president Al Gore. As quickly as it rose, however, Dean's star began to fall just as rapidly by the start of the primary season, with the capture of former Iraqi strongman Saddam Hussein in December 2003 and Dean's own habit of making off-the-cuff, impolitic statements.

In the run-up to the Iowa caucus, Dean and Gephardt began harshly attacking each other. It was MAD—mutually assured destruction—and the beneficiary was none other than John Kerry, whom many political pundits were already writing off. In the face of flagging support, however, Kerry quietly reorganized his campaign and devoted all his energy to the Iowa caucus, even going so far as to take out a $6.4 million loan to fund his effort.

In a stunning turnaround, Kerry emerged as the victor in the Iowa caucus, which propelled him to the top of the Democratic pack. Just as stunning was the performance of North Carolina senator John Edwards; armed with the endorsement of the state's largest paper, the Des Moines Register, Edwards finished second in Iowa.

Finishing a disappointing third, Dean made matters worse by giving an ill-advised concession speech. Rolling his sleeves up and grabbing a handheld microphone, Dean seemed like a man possessed as he ticked off the names of states he pledged to campaign in across the country. At the end of the roll call, the former governor let out a scream that quickly became fodder for late-night comedians. The "I Have a Scream" speech, as it became known, was the death knell of his campaign.

For many, Dean's Iowa performance reflected the concern that he would have a difficult time defeating Bush. In Iowa, New Hampshire, and the subsequent primary states, "electability" became the critical issue. For most Democrats, Kerry's national security experience and senatorial gravitas gave him the best bet to defeat the president in November.

While Edwards emerged as Kerry's chief rival for the nomination, the Massachusetts senator quickly began to separate himself from the pack. Victories in nine out of ten primaries on March 2 helped to boot Edwards from the race and effectively gave the nomination to Kerry.

On the Republican side, things were becoming difficult for President Bush. Public hearings about the administration's track record on terrorist activity before September 11, along with charges by former counterterrorism chief Richard Clarke that the Bush White House was not focused on the Al Qaeda during its first eight months in office, seemed to hurt the president's once-solid image as an anti-terror warrior; meanwhile, growing violence and instability in Iraq led to renewed concerns about the wisdom of the war and the costs of its aftermath. Despite an economic recovery, the continued weakness of employment figures also imperiled his standing with a restive electorate. By the early spring of 2004, George W. Bush's poll numbers had tumbled to the lowest point of his presidency.

Yet President Bush had an extraordinary advantage—a $180 million war chest—and he used it aggressively, running ads that attacked his Democratic opponent for being weak on defense and likely to raise taxes if elected. It was an unusual move for an incumbent president so long before an election he seemed poised to win only a few months earlier. With the help of independent groups—the so-called 527 organizations—countering the Bush offensive with attack ads of their own, by May the race was too close to call. From this vantage point, it was clear that the presidential race of 2004 was once again likely to come down to the wire—reflecting an American electorate as passionate, and as passionately divided, as at any time in its history. ❏

ABOVE: Congressman Dennis Kucinich in Iowa.
BELOW: Al Sharpton with Tracy Morgan on *Saturday Night Live*.

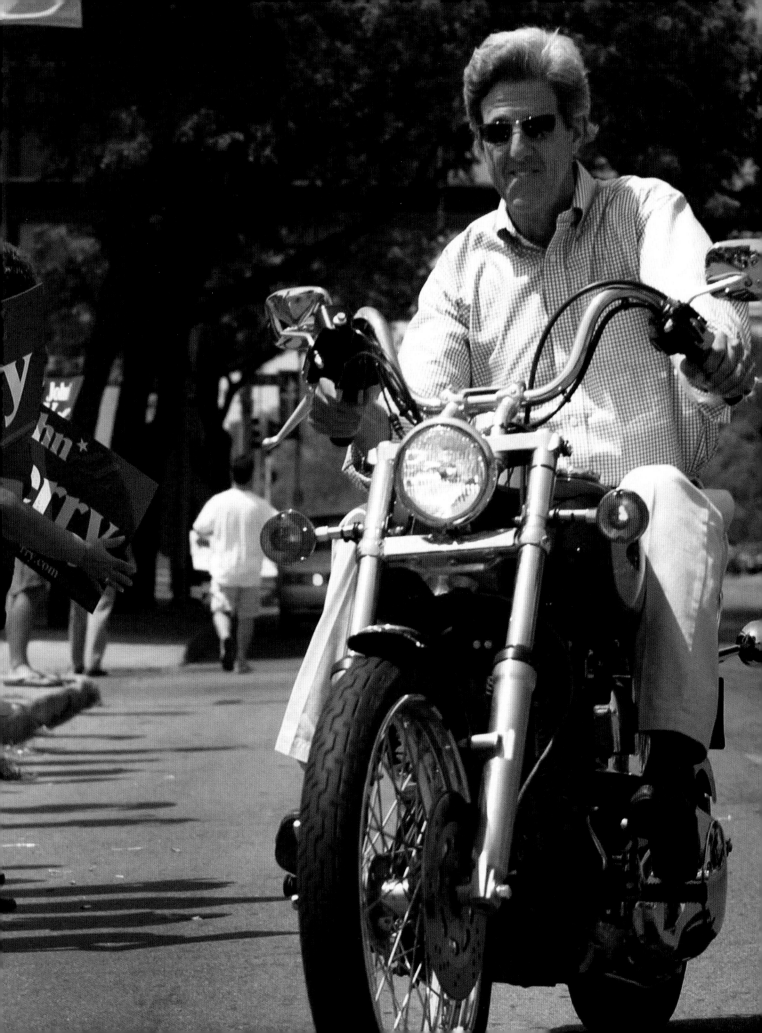

The Howard Dean and
John Kerry camps go at it:
December 2003.

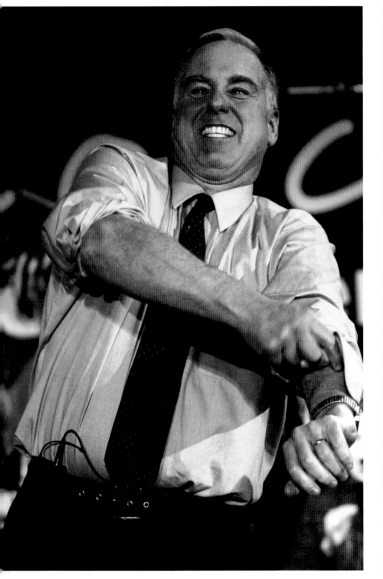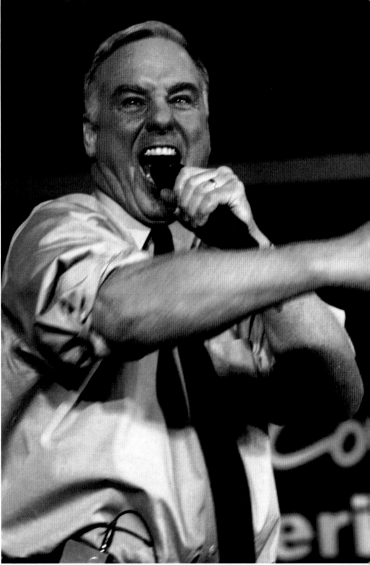

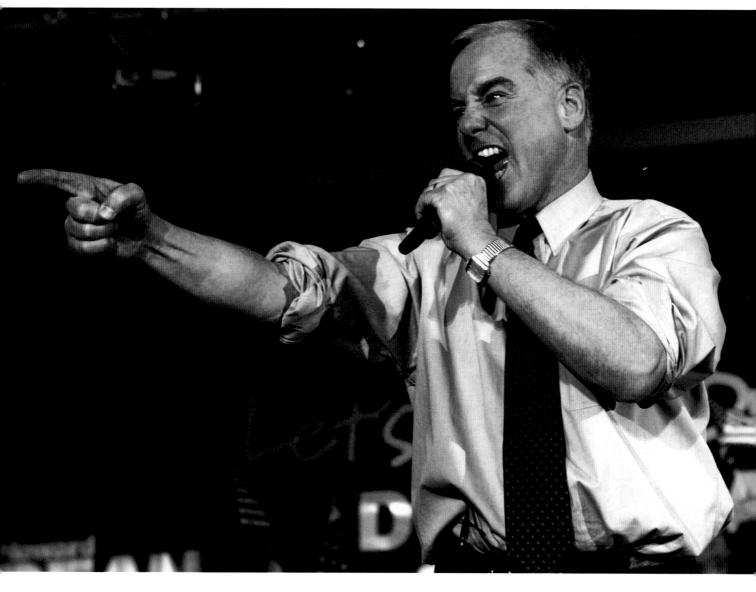

Howard Dean's once-commanding lead dissipated after a disappointing third-place showing in Iowa, and a fiery concession speech that to many seemed unpresidential. Weeks later he dropped out of the race.

John Edwards of North
Carolina addressing students
at South Carolina's
Voorhees College.

ACKNOWLEDGMENTS

This book is dedicated to Mark Penn and Michael Berland, for their professionalism and integrity, which has allowed our firm to play at least some role in six of the elections chronicled here.

First and foremost I would like to thank Judith Regan, who initially conceived of this project and played the central role in conceptualizing, creating, and designing the final product. It is her vision, hard work, and extraordinary creativity that in large measure makes this collection of photos and essays a hopefully distinctive contribution to the growing work on presidential elections and campaigning. I am lucky to have her as a publisher and luckier still to have her as a friend.

I would also like to thank Michael A. Cohen, who did a prodigious amount of research and worked to select the most arresting images. Michael helped draft the essays and played a central role in making sure that all phases of the project were completed on time and with great accuracy and attention to detail. A real student of presidential politics himself, Michael made the work herein inestimably better. I am deeply in his debt for his creativity, thoughtfulness, and good judgment. Costas Panagopoulos contributed to the book's development during a number of important early meetings. In addition, I want to offer a word of thanks to Sharon Roling, who did a wonderful job in helping to proofread and fact-check these essays, and to Larry Schwartz, who fulfilled our every photo request with speed, diligence, and an eye for the memorable image. Beth Tondreau and the BTD staff, Cassie Jones, Michelle Ishay, Kurt Andrews, Aliza Fogelson, Adrienne Makowski, and Siri Silleck of ReganBooks also deserve thanks.

A special word needs to be said about Cal Morgan of ReganBooks. His love of politics and his editorial skill is evident on every page of this book. He brought a student's love of politics and an editor's skill to the endeavor.

A NOTE ON SOURCES

The amount of literature that has been written about America's presidential campaigns is truly exhaustive; however, a few books stand out and were particularly useful in putting together the essays that accompany this work.

First and foremost is Paul F. Boller, Jr.'s *Presidential Campaigns*, the bible of U.S. campaign history. There is no better and more useful history of America's presidential elections. Arthur M. Schlesinger's *History of American Presidential Elections* holds a similar place of honor, and was an invaluable source of information, particularly for the races of the nineteenth and early twentieth centuries. In addition, there were several online sources that proved useful, including the *Harper's Weekly* online site www.Harpweek.com, which provides wonderfully detailed summaries of many of the earlier presidential campaigns, and the *New York Times*'s online archive of day-after-election headlines.

Of course, the history of presidential elections dovetails with the history of our political parties, which made Jules Witcover's *Party of the People: A History of the Democrats* and Lewis L. Gould's *Grand Old Party: A History of the Republicans* essential resources in charting the evolution of the Democratic and Republican parties.

David Herbert Donald's *Lincoln* offered useful insight on the 1860 and 1864 campaigns; David McCullough's *Truman* was equally helpful on 1944 and 1948. David Halberstam's *The Fifties* provided background on Eisenhower's early television ads. Ronald Steel's *Walter Lippmann and the American Century* gave context for many of the early- and mid-twentieth-century races. Michael McGerr's *A Fierce Discontent: The Rise and Fall of the Progressive Movement in America, 1870–1920* served as an excellent overview of the Progressive movement.

Theodore H. White's *The Making of the President, 1960* and *The Making of the President, 1968* helped with the research for those seminal races, as did Jules Witcover's *The Year the Dream Died: Revisiting 1968 in America* and David Greenberg's *Nixon's Shadow: The History of an Image.*

As a student of American politics, I find that many of the more recent races are still fresh in my mind—from the 1980 race, in which I played a minor role, to the 1996 campaign, in which I was integrally involved. Several books, however, helped to jog my memory about the 1988 and 1992 campaigns, including Jack W. Germond and Jules Witcover's *Whose Broad Stripes and Bright Stars: The Trivial Pursuit of the Presidency, 1988* and *Mad as Hell: Revolt at the Ballot Box, 1992*, as well as Richard Ben Cramer's seminal work, *What It Takes: The Way to the White House.*

–DOUGLAS E. SCHOEN

PHOTOGRAPH AND ILLUSTRATION CREDITS

Page i: **Mark Perlstein/Time Life Pictures/Getty Images**

Pages ii–iii: **Arthur Schatz/Time Life Pictures/Getty Images**

Pages iv–v, xiv, xv, xvi, 1 (top left and right), 2–3, 18 (top), 26–27, 32–33, 46, 47, 55, 66–67, 85 (right), 120–121, 122, 127, 134–135, 137 (top), 141, 146 (top), 147, 153, 154 (top and bottom), 157, 163, 166, 174–175 (top), 178–179, 190, 194, 198, 203 (top), 212–13, 220–21, 223 (right), 227, 230, 234–35, 244, 248, 251, 268 (bottom), 270–71, 305, 315 (top), 319, 320–21, 324, 325, 328, 329, 341, 346–47, 350, 353, 356, 357, 363, 365, 366–67, 372–73, 374–75, 377 (top), 378–79, 380, 381, 382–83, 386–87, 390: **AP/Wide World Photos**

Pages vi, viii (right), xii, xiii, xix, 9, 10–11, 11 (right), 12, 13, 20, 21, 22, 24, 25 (top), 28, 29, 30, 31 (top and bottom), 35, 38, 39, 42 (left), 42–43, 44–45, 51, 54, 60, 62, 63, 68, 72–73, 73 (right), 74, 75, 76–77, 78–79, 80, 81, 82–83, 84–85, 86 (left), 88–89, 90, 92, 94–95, 96, 97, 99, 104–5, 107, 108–9, 110–11, 112, 113, 116–17, 118–19, 124–25, 126, 128–29, 132, 140 (bottom), 144–45, 146 (bottom), 148 (top and center), 149 (top and bottom), 160, 162, 164–65, 172–73, 174–75 (bottom), 177 (top and bottom), 182–83, 188, 189 (bottom), 199, 200–201, 203 (bottom), 206, 207, 208–9, 210–11, 214–15, 226, 231, 232, 236, 237 (bottom), 240, 242–43, 249 (top and bottom), 250, 254, 255 (bottom), 256–57, 258–59, 260–61, 272, 276–77, 295 (top left and right), 296–97, 302–3, 306, 307: **Bettmann Archive/Corbis**

Pages vii, 5, 8, 14–15, 23, 25 (bottom), 40–41, 69 (bottom), 106, 152, 280, 299 (right): **David J. and Janice L. Frent Collection/Corbis**

Pages viii (left), ix, x, xi, 48, 49, 114–15, 150–51, 168–69, 269, 304: **The New York Times Company**

Pages xvii, xx (left), 52–53, 56–57, 100 (top and bottom), 101 (top), 102–3, 187, 189 (top), 233 (top and bottom), 264–65, 265 (right), 266–67, 268 (top), 273, 278–79, 281, 286–87, 288, 295 (bottom right), 312–13, 318, 323, 362: **Corbis**

Pages xviii, 34, 50, 252–53: **Hulton Archive/Getty Images**

Pages 1 (bottom), 58–59, 342–43, 348–49, 360–61: **Brooks Kraft/Corbis**

Pages 6–7: **Currier & Ives/ Library of Congress**

Pages 16–17, 18 (bottom), 69 (top), 93: **Library of Congress**

Page 19: **LPW–Woodfin Camp/Aurora**

Pages 36–37, 86–87, 123: **Underwood & Underwood/Corbis**

Page 61: **Ralph Morse/Time Life Pictures/Getty Images**

Pages 64–65, 310, 332: **Peter Turnley/Corbis**

Pages 70–71: **Museum of the City of New York/Archive Photos**

Pages 91, 133, 191, 204–5, 224, 262, 338–39: **Magnum Photos**

Page 98: **Eve Arnold/Magnum Photos**

Pages 101 (bottom), 138–39, 283, 308, 316–17: **Owen Franken/Corbis**

Pages 136 (bottom), 137 (bottom), 311: **Reuters New Media Inc./Corbis**

Pages 130, 131, 136 (top), 140 (top and center), 148 (bottom), 155 (top and bottom), 158–59, 167, 181, 184–85, 186, 196–97, 202, 216–17, 222–23, 284, 292–93, 295 (bottom left), 300, 301: **Time Life Pictures/Getty Images**

Pages 142–43: **Joseph Sohm/ChromoSohm Inc./Corbis**

Page 156: **Carl Iwasaki/Time Life Pictures/ Getty Images**

Page 161: **Ted Streshinsky/Corbis**

Pages 170–71: **John Bryson/Corbis Sygma**

Page 176: **Ed Clark/Time Life Pictures/ Getty Images**

Pages 192–193: **Scholastic Archives**

Page 195 (top): **Art Rickerby/Time Life Pictures/Getty Images**

Page 195 (bottom): **John Dominis/Time Life Pictures/Getty Images**

Pages 218–219, 225, 228–29, 289, 315 (bottom), 330–31: **Wally McNamee/Corbis Sygma**

Page 237 (top): **Joel Katz/Corbis**

Pages 238–39: **Gianfranco Gorgoni/ Contact Press Images**

Page 241: **Getty News/Images**

Page 245: J. **Scott Applewhite/ AP Wide World Photos**

Page 246: **Bob Gomel/Time Life Pictures/ Getty Images**

Page 247: **Dirick Halstead/Time Life Pictures/Getty Images**

Pages 255 (top), 263, 274–75, 344–45, 368–69: **David Burnett/Contact Press Images**

Page 282 (top): **Frank Fournier/ Contact Press Images**

Page 282 (bottom): **Sobol/Sipa Press**

Pages 285: **National Archive**

Pages 290–91, 298–99: **Robert Maass/Corbis**

Page 292: *The National Enquirer*

Page 294: **Jacques M. Chenet/Corbis**

Page 309: **Steve Liss/Time Life Pictures/ Getty Images**

Pages 322–23: **Mancuso Michael/ Corbis Sygma**

Pages 326–27, 370–71: **Tomas Muscionico/ Contact Press**

Page 333: **Dennis Cook/AP/Wide World Photos**

Pages 334–35, 337: **Ira Wyman/Corbis Sygma**

Page 336: **Rick Wilking/Reuters**

Page 340: **Robert Visser/Corbis**

Page 351: **Axel Koester/Corbis**

Pages 352, 362, 364, 396: **AFP/Getty Images**

Page 354–55: **Kenneth Jarecke/ Contact Press Images**

Pages 358–59: **Kike Arnal/Corbis Sygma**

Page 377 (bottom): **NBC Media Village**

Pages 384–85: **G. Fabiano/Sipa Press**

Pages 388–89: **Roberto Schmidt/AFP/ Getty Images**

Page 391: **Charles Krupa/AP Wide World Photos**

Pages 392–93: **Reuters**

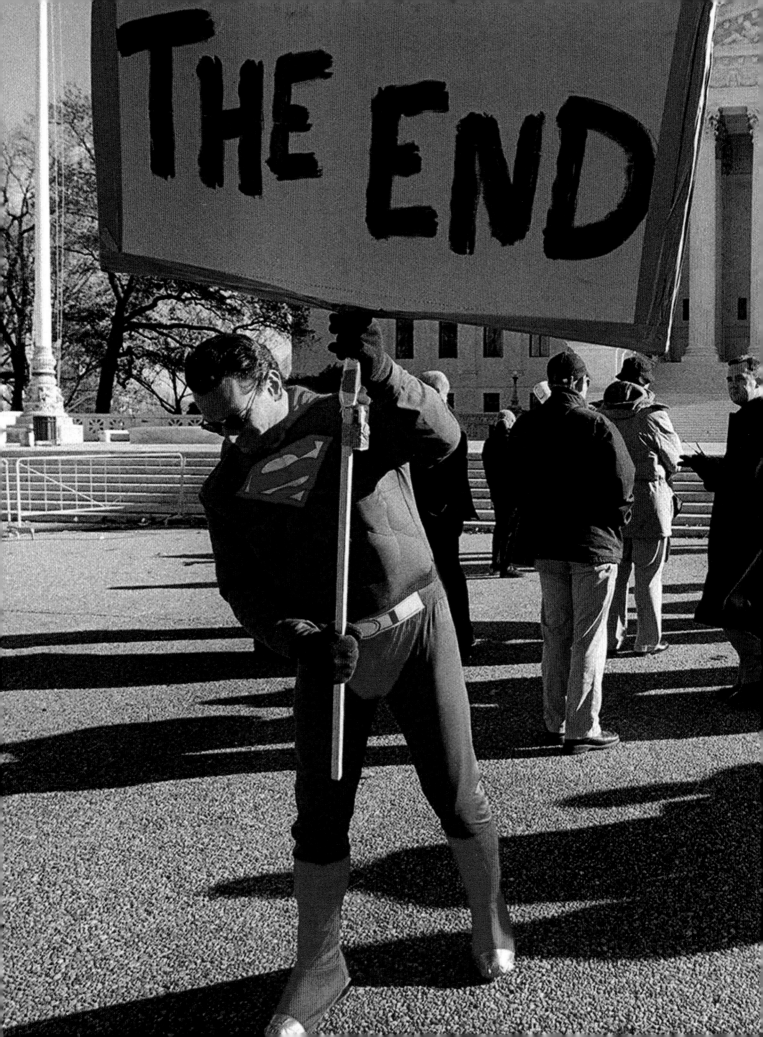